A Leading Spirit in American Art

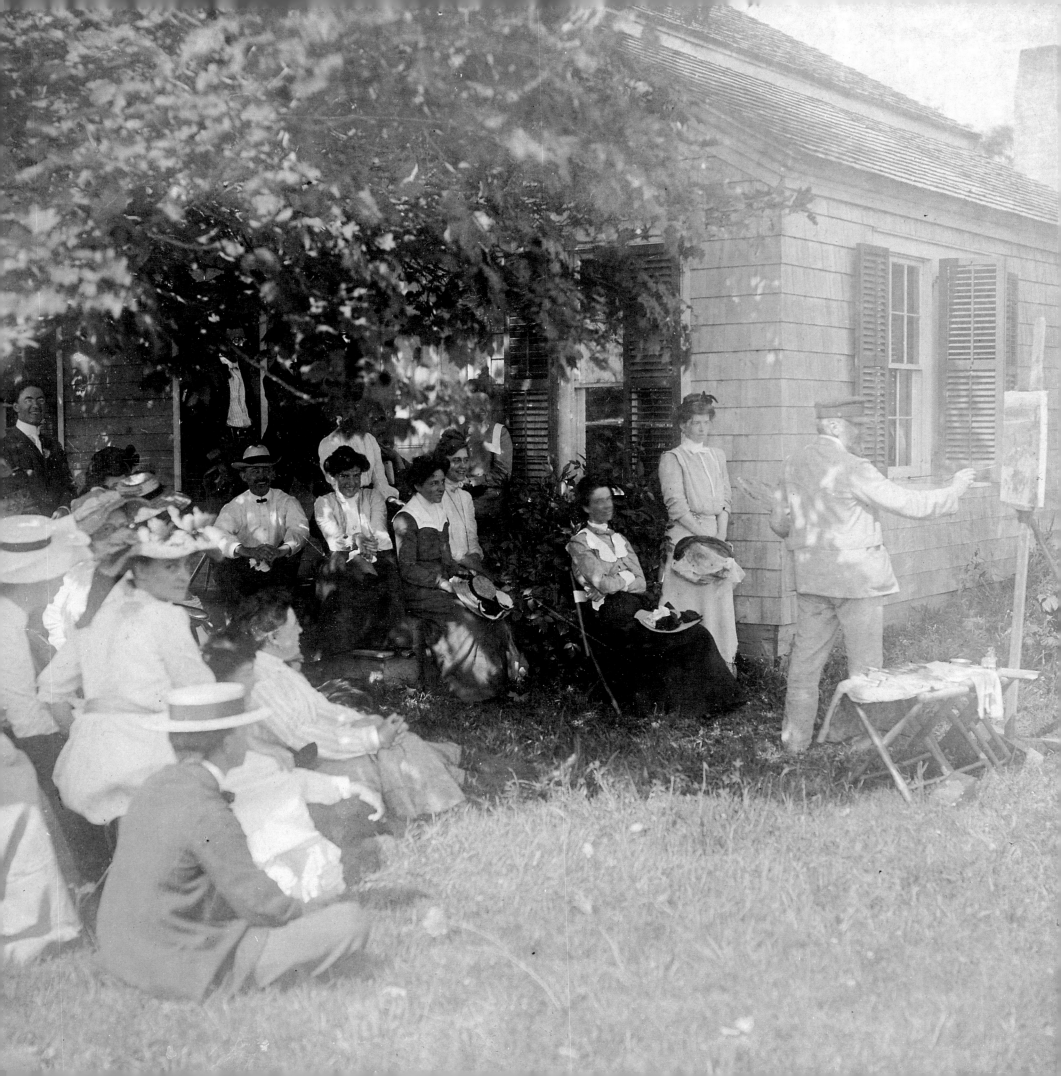

A Leading Spirit in American Art

William Merritt
CHASE
1849 1916

Ronald G. Pisano

Henry Art Gallery
University of Washington · Seattle

Library of Congress Catalog Card Number: 83-82428
ISBN: 0-935558-14-4

This publication has been funded in full
by the Henry Gallery Association.

Henry Art Gallery
University of Washington
Seattle, Washington 98195

Frontispiece:
William Merritt Chase giving an outdoor painting
demonstration before a class, c. 1914.
The William Merritt Chase Archives,
The Parrish Art Museum, Southampton, New York.

Foreword

In February 1980 I asked Richard Boyle, then Director of The Pennsylvania Academy of the Fine Arts, which *major* 19th-century American artist was the least known by the public and most misunderstood by art historians. He said, without a moment's hesitation, "William Merritt Chase." In complete agreement, the following day I telephoned Ronald G. Pisano to tell him of the Henry Art Gallery's interest in organizing a comprehensive Chase retrospective project and asked him to curate the exhibition and write a book to be published in conjunction with it. Since that time, the Gallery has had the rare privilege and pleasure of working closely with Mr. Pisano and a host of exceptional people, including the directors and curators of many museums, scholars, private collectors, dealers, and patrons throughout the United States. Each has shared in our belief that it is now time to present and document Chase's genius.

Ronald Pisano has devoted the past eleven years to the study of Chase, has written extensively about him, and has organized exhibitions of Chase's work and that of his students. *A Leading Spirit in American Art* synthesizes Mr. Pisano's research on Chase's life and career, and his vital contribution to the art of his day. When future generations — with necessarily differing perspectives — write about William Merritt Chase, important new observations will be made about him, the late 19th century, and America's contribution to world art. Yet, this is the first major book-length study of Chase since a 1917 monograph by his student and friend Katherine Metcalf Roof, and it not only is the culmination of Mr. Pisano's extensive research, it benefits from new findings by his colleagues. Perhaps more importantly, it is the first book to be illustrated with the full range of Chase's art, including many little known examples, some of which have not been published or exhibited widely since the artist's death. One group, three paintings that depict children's indoor games, is assembled here for the first time. Such unique opportunities are a tribute to the author and the depth of his research. With the generous cooperation of all involved, we are proud to have gathered what we believe is the most representative body of Chase's work yet, including his finest portraits, figure studies, still lifes, park scenes, and Long Island landscapes. While the illustrations closely mirror the exhibition curated by the author, an early commitment to represent Chase's *oeuvre* as fully as possible necessitated the inclusion of other important pictures as well.

For the Henry Art Gallery, America's leading Chase scholar selected eighty-six oil paintings, eight pastels, four drawings, three watercolors, and two monotypes for the exhibition held at the University of Washington during the fall 1983; it then traveled in a modified form to the American Wing of The Metropolitan Museum of Art in New York for the spring of 1984. It was apparent from the beginning that unless we got approval from the owners to exhibit Chase's finest paintings — aesthetically as well as historically speaking — from both public and private collections, it would be inappropriate to present a retrospective. We were fortunate to receive overwhelming support.

This project has been successful because all who contributed believed deeply that it should be the finest presentation of Chase's art ever, but none more than Ronald G. Pisano and his able assistant, Beverly Rood. At the Henry Art Gallery, Patricia Powell, Secretary to the Director, produced hundreds of letters and forms and worked with all lenders on various matters. Chris Bruce, Manager of Collections and Exhibitions, did an exceptional job arranging for the transportation of the artworks in the exhibition and was responsible for procuring the illustrative material for the book. Vickie R. Maloney, Assistant Director, administered various aspects of the project and organized a very imaginative and effective publicity campaign. The curatorial staff of the Department of American Paintings and Sculpture at The Metropolitan Museum of Art, John K. Howat, Lawrence A. Fleischman Director of the Departments of American Art, Lewis I. Sharp, Curator of American Sculpture and Administrator of the American Wing, and especially Doreen Bolger Burke, Associate Curator of American Paintings and Sculpture, gave generously of their time and expertise during critical periods of planning for the exhibition and book.

The same diligent efforts which shaped the success of the exhibition were directed by Mr. Pisano in writing this biography, assisted by Ms. Rood. Joseph N. Newland, the Gallery's gifted Editor of Publications, worked closely with them and with the talented graphic designer Douglas Wadden to bring the book into final form. This symbiosis continued with the designer and printer, with Loren Bunnell and many others at Graphic Arts Center. Their collective goal of excellence is beautifully visible throughout.

The talents of those mentioned above could not have been exercised without the generosity of the patrons of the project and dedicated collectors of Chase's art, in particular, Mr. and Mrs. Richard Manoogian, Mr. and Mrs. Raymond J. Horowitz, Miss Margaret Mallory, The Metropolitan Museum of Art, and The Parrish Art Museum. I would like to offer a special note of appreciation to the Director of the Henry Gallery Association, Mrs. John E.Z. Caner. She and Mr. H. Raymond Cairncross, the Association's President, skillfully orchestrated the efforts of those who have raised or given the funds needed for the project; special thanks go to Trustees Mrs. David E. Skinner, Mr. David E. Maryatt, Mrs. Peter J. Taggares, Mr. Don Paul Badgley, and Mr. Gilbert C. Powers. Contributions from PONCHO, The Boeing Company, McKinstry Company, the Burlington Northern Foundation, the Kreielsheimer Foundation, Ackerley Communications, the Skinner Foundation, the Henry Gallery Association's Fine Art Patrons, and the University's College of Arts and Sciences — Dr. Ernest M. Henley, Dean, and Dr. Richard L. Lorenzen, Associate Dean — were the financial backbone of the project. Our gratitude is especially due to Mr. and Mrs. William G. Reed, Mrs. Lloyd W. Nordstrom, Mr. and Mrs. Thomas W. Barwick, Mrs. Richard E. Lang, and Dr. and Mrs. Mart Mannik for contributions to this publication. Without them the Henry Art Gallery could not have accomplished this tribute to William Merritt Chase and his artmaking skills.

Harvey West
Director
Henry Art Gallery

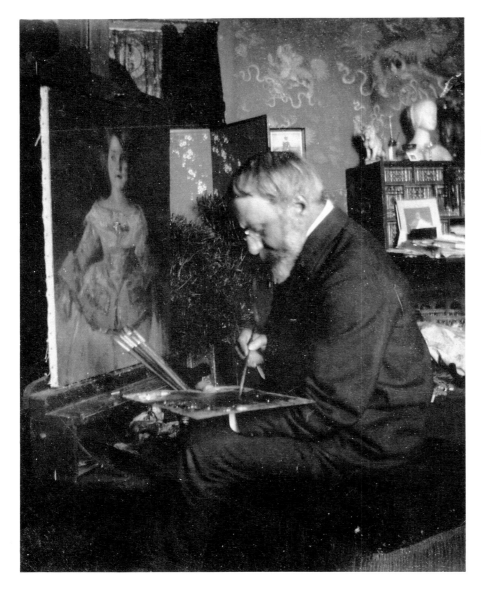

Chase painting in his Shinnecock studio, c. 1889.
The William Merritt Chase Archives,
The Parrish Art Museum, Southampton, New York.

Acknowledgements

In writing this book and curating the exhibition that coincided with its publication, many people have assisted me in my efforts. For their advice, encouragement, and abounding patience I am most grateful. First of all I must thank Harvey West, Director of the Henry Art Gallery, for initiating this project, raising the necessary funds for it, and overseeing all of the administrative details. I am also indebted to Beverly Rood, my assistant, who took an active and diligent role in every stage of the development of the book and the exhibition, from the early research through to the editing of the manuscript, organizing the footnotes, and proofreading the galleys. Such loyal and competent service is rare, and in this case highly valued. I am grateful for the help of Doreen Bolger Burke, Associate Curator of American Paintings and Sculpture, The Metropolitan Museum of Art, whose suggestions greatly improved the structure and clarity of the text. I also value her faith in this project and her patient assistance and sound advice. Among those who have also offered valuable editorial assistance are David Cassedy, Curator of the Museums at Stony Brook, and Sarah Rood. Joseph N. Newland, Editor of Publications, Henry Art Gallery, deserves special credit for his final editing of the text and for overseeing the preparation of the book. I would like to thank Lynn Caddey for editorial assistance and preparing the index, and Paul J. Brown and Karen Courtney for typing the manuscript.

Although I have not had direct contact with all of the members of the staff of the Henry Art Gallery who have worked on this project, I would like to extend my sincere thanks for their fine efforts on my behalf.

Among the scholars who have generously contributed their time by reading the specific sections of the book relating to their areas of expertise, I would like to acknowledge the help of Doreen Burke, for her advice about matters relating directly to J. Alden Weir; Bennard B. Perlman, Professor and Chairman of Fine and Applied Arts, Community College of Baltimore, for reviewing sections relating to Robert Henri; and Bruce Weber, Curator of Collections, Norton Gallery and School of Art, for his contributions relating to Robert Blum. I would also like to thank William H. Gerdts, Executive Officer of the Ph.D. Program in Art History at the City University of New York, for his help in answering questions regarding the early influences on Chase's still life paintings.

The staff members of many museums, libraries, historical societies, and other cultural institutions have been helpful in various stages of the book's preparation. Although it is impossible to thank each of them individually, I would like to acknowledge their help and express my appreciation for their valuable services, most especially the staffs of the Art and Architecture Division of the New York Public Library, the Library of The Metropolitan Museum of Art, and the New York office of the Archives of American Art, where most of the research for this book was conducted. I am especially thankful for the kind cooperation of Abigail Booth Gerdts, National Academy of Design, New York, for providing access to the diaries of J. Carroll Beckwith, housed at that institution.

Finally, I would like to thank the following people for answering specific inquiries and offering special assistance: Harold Acton; D. Frederick Baker; Christine Bergman, The Parrish Art Museum; Kathleen Burnside, Hirschl & Adler Galleries; James Cheevers, U.S. Naval Academy; Kathleen Foster, Pennsylvania Academy of the Fine Arts; Eugene R. Gaddis, Wadsworth Atheneum; William W. Jeffries, U.S. Naval Academy; Sona Johnson, The Baltimore Museum of Art; David Kiehl, The Metropolitan Museum of Art; Barbara Krulik, National Academy of Design; Betty Krulik,

Christie's East; Nancy Little, M. Knoedler & Co.; Dr. Clark Marlor, Adelphi University; Grete Meilman, Sotheby's; Susan Menconi, Hirschl & Adler Galleries; Benjamin Ortiz, Barnum Museum; Vickie Pearson, Indiana State Library; Robert Preato, Grand Central Art Galleries; Marianne Promos, The Free Library of Philadelphia; Linda Walton, Indiana State Library; Ann Weigert, Sotheby's; and Delores Wilson, Indianapolis Museum of Art. Special credit is due Margaret and Raymond Horowitz for their continuing enthusiasm for, and appreciation of, the art of William Merritt Chase. During the course of my research I have been fortunate in having the kind assistance and cooperation of several members of the Chase family; among those who have been particularly helpful are Mr. and Mrs. Robert Chase, Robin Chase, and Mr. and Mrs. Jackson Chase Storm.

Ronald G. Pisano
New York, August 1983

The Nursery. c. 1890
Oil on panel
14$\frac{1}{2}$ x 16 in (36.8 x 40.6 cm)
Manoogian Collection

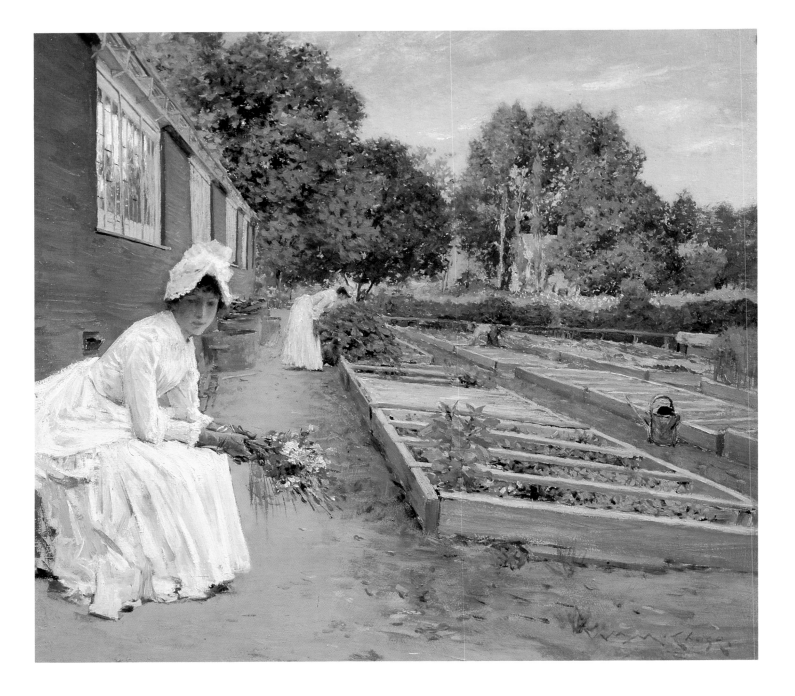

Chronological List of Works Illustrated 10

Introduction 13

I The Early Years

1. Boyhood in Indiana 23

2. An Art Student in New York 24

3. Study Abroad: The Munich Years 27

II Reformer and Iconoclast

4. New York in the 1870s 39

5. The Tile Club 49

6. Artists Abroad 57

7. The Pedestal Fund Exhibition 63

8. The Painters in Pastel 67

9. Chase and Whistler 77

III The Most Magnificent Profession

10. William Merritt Chase the Teacher 87

IV A Leading Spirit in American Art

11. An International Style 149

12. The Ten American Painters 163

13. A Typical American Artist 171

14. The Last Years 179

Chronology 185

Notes 186

Bibliography 198

Index 201

Chronological List of Illustrated Works by William Merritt Chase

A Note on the Titling

Many of William Merritt Chase's paintings have been exhibited and/or published under variant titles over the years, even during Chase's lifetime. In the captions to the illustrations, this book first gives the title initially used by the artist followed by the most widely known variants in parentheses and in chronological order (excluding misidentifications). For the sake of brevity, in the text and this chronological list, a secondary title is given only if it is the more commonly used today or if there is more than one example of the primary title, e.g., "Portrait of Mrs. C."

Boldface title indicates color illustration

1860s

Still Life with Watermelon, 1869. p. 22

1870s

Keying Up — The Court Jester, 1875. p. 31

Boy Smoking (The Apprentice), 1875. p. 31

Unexpected Intrusion (Turkish Page), 1876. p. 26

Sketch for a Picture — Columbus Before the Council at Salamanca (Christopher Columbus Before the Spanish Council), First Version, c. 1876. p. 32

Sketch for a Picture — Columbus Before the Council at Salamanca (Christopher Columbus Before the Spanish Council), Second Version, c. 1876. p. 32

Broken Jug, c. 1876. p. 41

Ready for the Ride, 1877. p. 30

Venice, 1877. p. 33

Portrait of a Woman, 1878. p. 28

A Fishmarket in Venice (Yield of the Waters), 1878; altered c. 1890. p. 34

A Fishmarket in Venice, engraving after the painting's first state, 1878. p. 33

Priam, The Nubian Ganymede, 1879. p. 51

Self Portrait, c. 1879. p. 55

1880s

Interior of the Artist's Studio (The Tenth Street Studio), 1880. p. 38

Portrait Study (Portrait of a Young Woman), c. 1880. p. 45

Portrait of Virginia Gerson, c. 1880. p. 47

The Cloisters (Italian Cloister), c. 1880. p. 35

A Subtle Device, 1881. p. 53

A Countryman, c. 1881. p. 54

The Tenth Street Studio, begun c. 1881. p. 44

Still Life (Still Life with Cockatoo), c. 1881. p. 42

Outskirts of Madrid, 1882. p. 56

At the Shore, c. 1882. p. 60

Azaleas, c. 1882 p. 43

Portrait of Miss Dora Wheeler, 1883. p. 172

The Mirror, c. 1883. p. 98

Mrs. Meigs at the Piano Organ, c. 1883. p. 94

Sunlight and Shadow, 1884. p. 146

In the Studio (Virginia Gerson), c. 1884. p. 73

Garden of the Orphanage, Haarlem, Holland (Courtyard of a Dutch Orphan Asylum), c. 1884. p. 62

James Abbott McNeill Whistler, 1885. p. 79

Seated Woman Seen From the Back, c. 1885. p. 54

Meditation, c. 1885-86. p. 90

Park Scene, c. 1885-86. p. 176

Young Girl with Flowers, c. 1885. p. 93

Lady in Pink, c. 1886. p. 92

Memories (Woman in White), c. 1886. p. 101

Hattie, c. 1886. p. 98

The Tamborine Girl (Mrs. Chase as a Spanish Dancer), c. 1886. p. 109

A Spanish Girl (Portrait of Mrs. William Merritt Chase in a Spanish Shawl), c. 1886. p. 109

The East River, c. 1886. p. 61

Boat House, Prospect Park (Boats on the Lake, Prospect Park), c. 1887. p. 159

Portrait of Mrs. C. (Portrait of a Lady in Black), 1888. p. 84

Hide and Seek, 1888. p. 152

Sketch — Children Playing Parlor Croquet, c. 1888. p. 151

The Blue Kimono (Girl in Blue Kimono), c. 1888. p. 139

The Japanese Print, c. 1888. p. 136

Portrait of a Woman, c. 1888. p. 100

Modern Magdalen, c. 1888. p. 64

Nude, c. 1888. p. 66

Back of a Nude, c. 1888. p. 69

Gravesend Bay, c. 1888. p. 76

Still Life (Brass and Glass), c. 1888. p. 72

Portrait of a Lady in Pink (Portrait of [Mrs.] Leslie Cotton), c. 1888-89. p. 102

Mother and Child in a Park, 1889. p. 157

Making Her Toilet, c. 1889. p. 68

1890s

Portrait of a Lady, c. 1890. p. 99

A Study in Curves (Reclining Nude), c. 1890. p. 65

Mrs. Chase as the Señorita, c. 1890. p. 108

The Nursery, c. 1890. p. 8

Afternoon in the Park, c. 1890. p. 75

Terrace at the Mall, Central Park, c. 1890. p. 158

Bit of the Terrace (Early Morning Stroll), c. 1890. p. 86

Lilliputian Boat-Lake—Central Park (Central Park), c. 1890. p. 91

Portrait of Mrs. C. (Portrait of Mrs. Chase), c. 1892. p. 114

Portrait of Miss E. (Lydia Field Emmet), c. 1892. p. 103

Shinnecock Indian Girl, c. 1892. p. 123

In the Studio, c. 1892. p. 112

Shinnecock Hills, c. 1892. p. 48

At the Seaside, c. 1892. p. 156

Shell Beach at Shinnecock, c. 1892. p. 160

A Sunny Day at Shinnecock Bay, c. 1892. p. 161

Hall at Shinnecock, 1893. p. 74

Portrait of Mrs. C. (Lady with a White Shawl), 1893. p. 173

Portrait of a Lady in White (Emily Clark), c. 1893. p. 170

Reflection (Reflections), c. 1893. p. 155

The Potato Patch (Garden, Shinnecock), c. 1893. p. 122

Children on the Beach, 1894. p. 130

Idle Hours, c. 1894. p. 12

Reverie: A Portrait of a Woman, c. 1890-95. p. 143

A Friendly Call, 1895. p. 165

Portrait of a Woman, c. 1895. p. 115

The Red Sash (Portrait of the Artist's Daughter), c. 1895. p. 107

Mother's Love (Mrs. Chase and Cosy), c. 1895. p. 96

The Bayberry Bush, c. 1895. p. 120

Shinnecock Landscape, c. 1895. p. 124

Swollen Stream at Shinnecock, c. 1895. p. 128

Near the Beach, Shinnecock, c. 1895. p. 129

The Golden Lady, 1896. p. 106

For the Little One, c. 1896. p. 153

Ring Toss, c. 1896. p. 148

Landscape, Shinnecock, Long Island, c. 1896. p. 131

Portrait of the Artist's Daughter (Dorothy), c. 1897. p. 117

Did You Speak to Me? c. 1897. p. 113

Over the Hills and Far Away, c. 1897. p. 132

Portrait of Miss F. DeForest, c. 1898. p. 116

Rest by the Wayside, c. 1898. p. 125

The Big Brass Bowl, c. 1898. p. 167

My Daughter, Alice, 1898-99. p. 111

Girl in White, c. 1898-1901. p. 110

An Infanta, A Souvenir of Velasquez (Helen Velasquez Chase), 1899. p. 127

Head of a Girl (The Artist's Daughter), c. 1899. p. 119

Young Girl in Black (Artist's Daughter Alice in Mother's Dress), c. 1899. p. 118

1900s

Lydia Field Emmet, 1900. p. 104

Still Life, Flowers, c. 1900. p. 43

Fish Still Life, c. 1900. p. 168

Portrait Sketch (Girl in Middy Blouse), 1902. p. 133

Portrait of Miss Frances V. Earle, c. 1905. p. 169

View of Fiesole, 1907. p. 141

A Florentine Villa, c. 1907-09. p. 134

1910s

Self Portrait (Self Portrait with Hat), c. 1911. p. 184

Still Life, Fish, 1912. p. 166

Self Portrait (Portrait of the Artist), 1915-16. p. 162

Idle Hours. c. 1894
Oil on canvas
25½ x 35½ in (64.8 x 90.2 cm)
Amon Carter Museum, Fort Worth

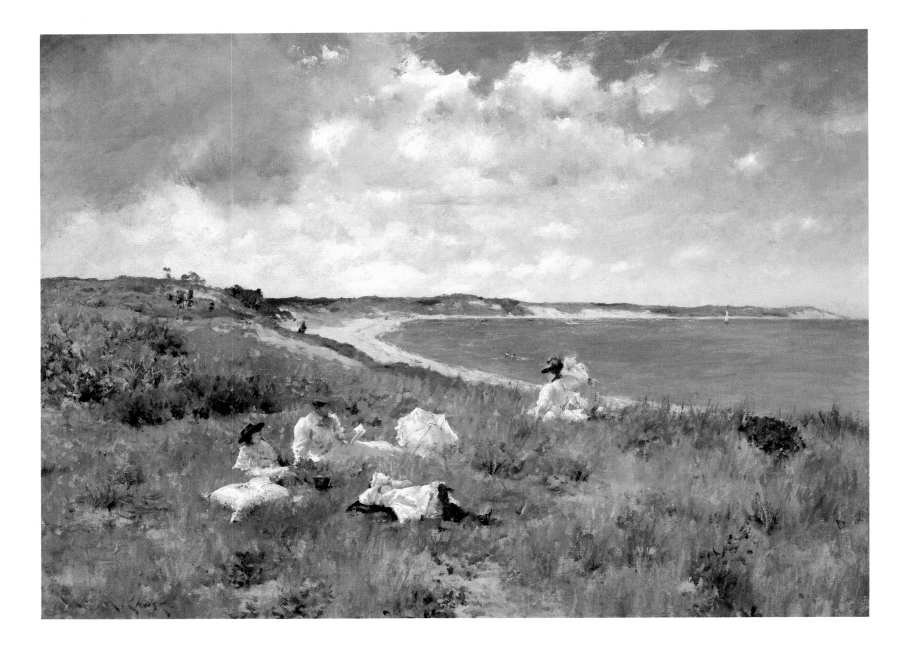

Although born in a small town in Indiana in 1849, William Merritt Chase ultimately became one of the most cosmopolitan figures of his day. In fact, the image he assumed was quite opposite to that of the simple Hoosier-type portrayed in the writing of his contemporary James Whitcomb Riley, Indiana's poet-laureate. In 1872, Chase broke ties with the Midwest permanently, traveling abroad to study at the Royal Academy of Munich. When he returned to America six years later, he chose New York City as his new home. In New York, the art center of the nation, he managed to secure the grandest and most desirable studio available, in the Tenth Street Studio Building, and soon became a celebrity, a trend setter, and a tastemaker. Described by his colleague James Abbott McNeill Whistler as the "Masher of the Avenues," Chase represented the epitome of success: a dapper, conspicuous figure in top hat and cutaway jacket, sporting a carnation in his lapel and wearing an elegant pince-nez. Within a short time he became an international figure, moving in art circles both here and abroad with charm and ease. He was proud and confident in the future of America, which was on the verge of becoming the most powerful nation in the world, and in the future of American art. He even believed that this country would one day become the leader of world art. In addition to his dashing personality, cunning wit and steadfast self-confidence, Chase had dignity, which gained him the respect of others and ultimately greater respect for his profession in general.

Through his constant work and association with fellow artists in the United States and Europe, Chase was determined to make his vision of the future of American art a reality. He was at the forefront of the progressive movement and an energetic and dedicated spokesman for the Society of American Artists, the most advanced art organization of the day. As its president for a total of eleven years, he served in a key position which he used forcefully and effectively to combat conservative ideals. As a founder and active member of the Society of Painters in Pastels, Chase was instrumental in elevating the use of pastels to a new height of expression in this country, placing it on a par with oil painting. Wherever he traveled, he lectured, appealing to wealthy patrons for the support of native talent, a support he found lacking in America in the 1870s. He also gave lectures on the artists he admired most, such as Hals, Velasquez, and Whistler. Through these talks he hoped to promote a better understanding and appreciation of the artists whom he considered to be masters. He also drew the attention of American collectors to such major figures as El Greco and Manet. Further, Chase's own collection of art served as an inspiration not only for himself but also for his colleagues and students at a time when few extensive public collections existed in this country.

One of Chase's deepest concerns was the plight of American art students. He was determined to provide them with a proper and complete training in their own land, an opportunity that was not available when he was a student. This he accomplished by devoting a major portion of his career to teaching. In all, Chase taught painting for thirty-seven years, both formally in leading art schools such as the Art Students' League in New York and the Pennsylvania Academy of the Fine Arts in Philadelphia and informally in his various studios. He even founded two schools of his own: the Shinnecock Summer School of Art, the first formal summer school of its kind in America where students painted directly from nature out-of-doors; and the Chase School of Art (later renamed the New York School of Art) where he taught from 1896 until 1907. During his long and active career as a teacher, Chase taught thousands of students, probably more than any other art teacher of his day. He provided the next generation of American artists with the enthusiasm, confidence, and technical skills needed to assure both their own success and to gain for this country a prominent position in the art world of the twentieth century. Chase encouraged individuality in his teaching, realizing that new ideas and approaches to painting were signs of vitality. As a result, his students developed a wide range of artistic statements rather than slavishly copying their master's style. Although some, to Chase's chagrin, even went on to become avant-garde artists — Georgia O'Keeffe, Charles Demuth, and Joseph Stella among them — they continued to express their indebtedness to Chase as a teacher and masterful technician. Regardless of the direction each student chose, all were well trained by an art teacher who was the most dynamic and popular this country has ever produced.

A Fishmarket in Venice (Venetian Fish Market;
The Yield of the Waters). **1878;** altered c. **1890**
Oil on canvas
The Detroit Institute of Arts, City of Detroit Purchase

Interior of the Artist's Studio
(The Tenth Street Studio). 1880
Oil on canvas
The Saint Louis Art Museum, Bequest of Albert Blair

For these efforts alone — promoting a better appreciation of art in America, developing a greater interest in American art in particular, and teaching a significant number of the next generation of American artists — Chase deserves considerable credit. His greatest contribution to America, however, was his own art.

Few American artists have provided the public with work in such a wide array of styles and subjects, done in so many media. In his early years in the Midwest and New York, Chase concentrated on still life paintings, producing during the late 1860s and early 1870s surprisingly accomplished work in a tight, linear style much like that of the best known American still life painters of the mid-nineteenth century. During his years in Munich, from 1872 to 1878, Chase shifted from painting still lifes to portraits and figure studies, and his style changed dramatically. He adopted the bravura brushwork and dark palette of the Munich School, producing bold paintings emulating the work of the old masters they so revered. After returning to New York in 1878, Chase's style continued to evolve. He abandoned the use of bitumen black, an unstable medium that caused paintings to deteriorate, but continued to paint in a restrained, tonal manner. His primary subjects remained portraits and figure studies, now painted with a more modern flair and having a refined nature especially suitable for the society portraits and studio scenes he began painting at this time. By 1885 Chase's work came under new influences, that of the Dutch and French plein-air painters, and, to a lesser degree, the French Impressionists. His favorite subject became landscapes, among them park scenes — bright, fresh, and colorful. At the same time he also painted views of New York's docks and wharves using more subtle, tonal colors. Thereafter his palette changed with each specific situation, his selection of colors depending on the effects of light and mood he sought to achieve.

In 1891 Chase shifted the location of his landscape subjects to Shinnecock Hills, Long Island, where he spent his summers teaching until 1902. His choice of subject matter became as varied as his choice of palette, with still lifes becoming a major theme in his repertoire; he treated all subjects with equal interest and conviction. The works that have proven the most appealing from this period, however, are the

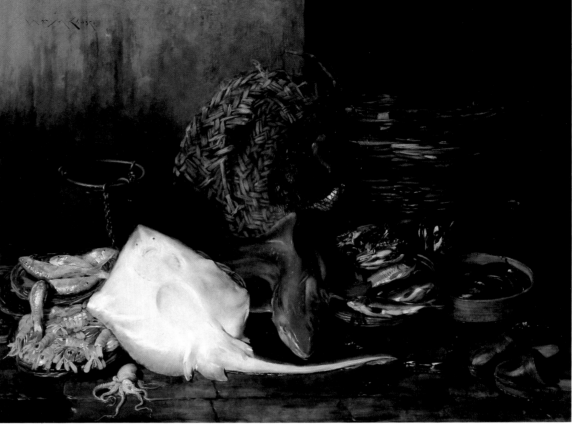

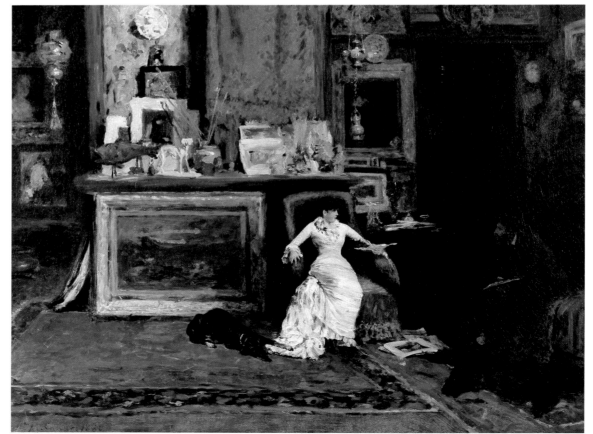

Portrait of Mrs. C. (Lady in Black;
Portrait of a Lady in Black). **1888**
Oil on canvas
The Metropolitan Museum of Art,
Gift of Mrs. William M. Chase, 1891

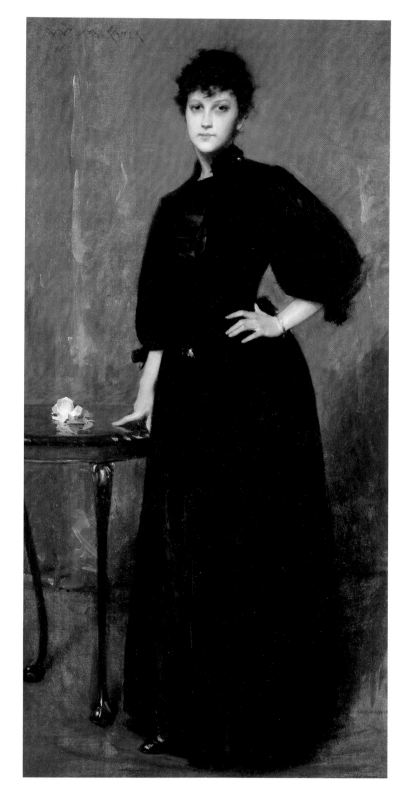

landscapes, interiors, and figure studies in which
he used his wife and their children as models.
In these delicate paintings and pastels Chase
captured carefree, leisurely moments in the life of
his genteel family. The sensitive and very personal
nature of these works make them especially
endearing — and the most sought after by
collectors and museums today. By the 1890s
Chase had reached his height as an artist: he had
proven his ability to treat any subject successfully
and utilize any medium effectively. He was
one of the first Americans to experiment with
monotypes, creating some of the most successful
works in this medium by any artist of his
generation; and his pastels are undeniably among
the finest ever produced in America.

During the final stage of his career as an artist,
from 1900 to his death in 1916, he garnered
numerous accolades, receiving many awards and
honors that acknowledged his important
contribution to American art. At this time he was
best known for his facility in painting still lifes of
fish, many of which were purchased by leading
American museums, and for his society portraits
commissioned by wealthy patrons.

Once recognized simply as an artist of great
technical ability, today Chase is credited with
achieving much more. Americans have now come
to appreciate both the subtle beauty of his
paintings and his special talent in capturing the
essence of the period in which he lived. Chase
did not always enjoy such acclaim. Despite his
eminent position in the art world of his time, his
life remained a constant struggle for financial
security. After his death, his reputation wavered
and then declined before resurging with new
vigor in this past decade.

When Chase died in 1916, the painter Kenyon
Cox predicted that his "place in American art is
fixed, and as long and as widely as that art may
interest mankind so long and so widely will his
name be remembered."[1] Judging by modern
standards and the appreciation accorded Chase's
work today, Cox's prophesy would seem accurate.
This was not, however, always true. Throughout
Chase's career most of his income was derived
from teaching. He initially chose this vocation with
the realization that he would be unable to support
himself through the sale of his paintings alone.

1. Kenyon Cox, "William Merritt Chase, Nov. 1, 1849-Oct.
25, 1916," Kenyon Cox Papers, Avery Library, Columbia
University.

When Chase returned to the United States in 1878, he found that American collectors preferred European art to that of their own country, a situation he and his fellow artists were determined to change. By the turn of the century, there were some who claimed that the battle for American art had been won, but during the intervening years, Chase and his colleagues often saw their work sold for a mere fraction of its true value. This happened repeatedly when Chase offered groups of his paintings for auction. Because of the great number of works that were sold each time, the sales did provide a significant amount of much needed revenue, but, in fact, individual paintings brought very little and the auctions were considered disastrous. At the first sale, held in New York in 1887 at the Moore Gallery, nearly 100 works of art were sold for a total of $10,000, prompting one writer to claim that they had been "cruelly sacrificed."[2] The highest price paid for any painting was $500 for one of Chase's important paintings of his Tenth Street Studio. In contrast, Chase's works sold in annual exhibitions for prices as high as $1,000. A second auction took place in 1891, when sixty-seven paintings and pastels hit the block at the Fifth Avenue Art Galleries, with equally disappointing results. The third and most momentous sale took place five years later at the American Art Galleries when the contents of his celebrated Tenth Street Studio were sold. In spite of extensive presale publicity and high expectations, the outcome of the auction was the most discouraging of all — especially with regard to the sale of sixty-six of Chase's own paintings. *The Old Road to the Sea* brought only $610, at a time when Chase generally asked double that for similar landscapes. Commenting on the pitiful results, one contemporary writer observed that in some instances the prices paid "barely covered the cost of the frames, and it was disheartening to sit and see the utter apathy displayed by the audience."[3] It had been eighteen years since Chase returned to America, and although he was acknowledged as one of the country's leading artists by this time, he was still unable to attain decent prices for his paintings. Disillusioned,

he threatened to relocate in Europe, where he believed he could earn a better living as an expatriate painter. Although he did travel to Spain that spring, he soon returned to America; but he never risked another auction of his paintings. Only in 1917, the year after Chase's death, was his work once again assembled for public sale, this time at the American Art Galleries. The event was enthusiastically described as the "chief topic of the day in the art circles of New York."[4] Attendance was reported to be excellent, with artists, collectors, and dealers present and seemingly prepared to bid. Nevertheless, prices remained relatively low, and one source claimed that there were "many bargains to be obtained."[5] Several of Chase's paintings passed the $1000 mark this time, but most sold for between $150 and $400.

Soon after the artist's death, his friends and admirers commemorated his achievements — first with a memorial exhibition held at The Metropolitan Museum of Art and then in a monograph written by Katherine Metcalf Roof. The exhibition consisted of forty-five of his paintings as well as some drawings, pastels, etchings, and monotypes. This tribute to Chase was considered, at best, "a gratifyingly prompt acknowledgement of the importance of that painter in the artistic life of the community."[6] Some, disturbed by the hasty selection made for the show, considered it an inadequate representation of Chase's accomplishments. "It would have been a true service to the public...as well as to the memory of Chase, had our museum seen fit to properly honor him by bringing together all of the most successful of his pictures," complained one critic.

4. "Three Hundred of His Portraits, Landscapes, Marines, Street Scenes, and Still Life Pieces to be Sold," *Boston Transcript*, 11 May 1917.

5. "William M. Chase Sale," *American Art News* 15 (19 May 1917), p. 7.

6. "The William M. Chase Memorial Exhibition," *The New York Times*, 18 February 1917, Section 5, p. 13.

"Not a single one of the museums throughout the country that owns Chase pictures has contributed!...[and] most of the forty-five are second and third rate examples. It frustrates those like myself who were prepared to wave a flag for Chase."[7] Leo Stein even went so far as to write that "the net result...is to convince one that Chase is not a painter whose work as a body can endure."[8] Another writer, Frank Jewett Mather, disagreed with Stein, predicting instead: "Matisse may fade out of the future histories of painting sooner than Chase."[9]

Although there had been innumerable articles written about Chase during his lifetime, Roof's monograph was the first serious assessment of his life and art. This biography, published in 1917, is a delightful, personal account, written by the artist's friend and former student, who was able to interview many of his family members and close associates while preparing her book. The result is an entertaining view of Chase's life, filled with anecdotes and amusing stories. As the first major appraisal of Chase's art — and indeed one of the relatively few serious monographs published on any American artist early in the century — this book served to enhance his reputation and maintain interest in his work for a number of years. Like many others, Roof realized that Chase's contribution to art was still not fully appreciated. In her closing statement she declared: "The debt of American art to William Merritt Chase has yet to be computed in its entirety. It will gather interest with the years for whatever valuation the future may put upon his work; his lifelong service to the art he loved must last as long as there are records and histories of art."[10]

The exhibition at The Metropolitan Museum and Roof's biography of Chase were not the only tributes that appeared at the time of his death.

7. Henry McBride, "Chase Memorial Exhibition," *Fine Arts Journal* 35 (March 1917), p. 224.

8. Leo Stein, "William M. Chase," *The New Republic* (3 March 1917), p. 134.

9. Frank Jewett Mather, Jr., *Estimates in Art* (New York: Henry Holt and Company, 1931), p. 313.

10. Katherine Metcalf Roof, *The Life and Art of William Merritt Chase* (1917; New York: Hacker Art Books, 1975), p. 325.

2. Montezuma, "My Note Book," *The Art Amateur* 16, no. 5, (April 1887), p. 98.

3. "In the World of Art," *The New York Times*, 19 January 1896, p. 23.

Eulogies were written by artist-friends, former students, and critics; and exhibitions were organized by museums throughout the country as well as by commercial art galleries. Through these exhibitions Chase's artwork was regularly seen in major cities, including New York, Chicago, Cleveland, Los Angeles, and St. Louis. For the two decades following Chase's death moderate interest in his work was sustained by these shows and the press coverage they received. In fact, Newhouse Galleries in St. Louis made a serious effort in 1927 to promote Chase's art and reputation. That year, the gallery organized an exhibition and published a book with fifty-six reproductions of Chase's paintings and pastels. Interest in Chase's work peaked with a large retrospective held in New York in 1928 at the American Academy of Art and Letters. Most prized during this period were his still life paintings of fish and, to a lesser degree, his portraits, both of which were repeatedly praised by critics and writers of major surveys on American art. In *The American Spirit in Art* (1927), for example, Frank Jewett Mather claimed: "William M. Chase's love of colors and textures and rare surfaces found its most joyous expression in his large pictures of still life."[11] Mather gave equal attention to Chase in his section on portrait painting, but did not even mention him in his discussion of landscape painting.

During the 1930s Chase's reputation waned. In part, this was a result of the effects of the Depression and a reflection of prevailing taste. At a time when both representational and abstract artists were striving for particularly "American" statements, Chase's art probably seemed alien — too closely associated with the style and sentiment of nineteenth-century European art. In fact, there was no marked interest in Chase's art until the late 1940s. In 1948, an exhibition was mounted at the American British Art Center in New York, and the following year the John Herron Art Museum in Indianapolis celebrated the centennial of his birth by holding a major retrospective exhibition and publishing a catalogue by Wilbur D. Peat that included a checklist of all known works by Chase. This catalogue was the first significant assessment of Chase's life and art since Roof's book three decades earlier. Critical response to the New York and Indianapolis shows was mixed. One

writer referred to Chase as "the archetype of the late nineteenth century academician."[12] While another critic, Sam Hunter, also ascribed a certain Victorian quality to some of Chase's work, particularly the interiors, he praised Chase's landscapes for their "exquisite sensibility," and was among the first modern writers to champion these works.[13] From this point onward, critics slowly began to appreciate the full range of Chase's art and its diversity. Some, however, continued to attack it for its eclectic style, derived in part from European sources.

Writers and critics had begun categorizing the work of American artists as being either characteristically "American," and thus patriotic, or "Europeanized," and counter to the American experience. James Thomas Flexner was among those who relegated Chase's art to the latter group, claiming that he and others "tried to drop everything American as they ran headlong after foreign fashions." He even labeled Chase "a mental expatriate from the United States" and maintained that he and his colleagues actually retarded the development of a truly American art. Flexner asserted that Chase and other artists of his kind "doomed their movement to failure when, instead of grafting it to the rugged tree of American art, they tried to cut the tree down and start anew. Their attempt to impose on the United States from the outside a ready-made culture ignored the realities of their own experience and imperatives of their environment."[14] This bold criticism was unfounded — or at least overstated — and in contrast to that of critics who, during Chase's lifetime, praised his work as being "typically American" and commended him for his efforts on behalf of American art. In the late 1940s, however,

Chase's art was held to be diametrically opposed to American standards in art — particularly that of the "triumvirate": Albert Pinkham Ryder, Thomas Eakins and Winslow Homer. As a result, Chase's reputation suffered, or at least did not grow at the rate that theirs did. By the time of the next important retrospective exhibition of Chase's work, held in 1957 at The Parrish Art Museum in Southampton, New York, this categorization was still evident, with one critic referring to him as "a prince of the atelier."[15] The prices that Chase's paintings were bringing then — $2,000 for a major landscape and much less for other works — reflect this lingering stigma. However, between this time and 1965, when the next major showing of Chase's paintings and the first retrospective held on the West Coast was curated by Ala Story and circulated by The Art Gallery of the University of Santa Barbara, interest in Chase's art had begun to grow steadily.

My own research on William Merritt Chase began in 1972 when, as a graduate student, I organized the exhibition "The Students of William Merritt Chase," held the following year at the Heckscher Museum, Huntington, New York, and The Parrish Art Museum. A catalogue devoted to showing Chase's contribution to American art as a dynamic teacher accompanied the show. This work led me to other Chase projects: articles; additional exhibitions, including a retrospective of over 100 works of art held at M. Knoedler & Company, New York, in 1976 as a benefit for The Parrish Art Museum; and a monograph published in 1979. By the time of the 1976 show, more than ten years had passed since the retrospective of 1965, and Chase's art was attracting considerable attention. A marked change had occurred, most noticeable in the dramatic escalation in the value of his work, an increase that has continued over the following years.

For the past ten years, my major project has been the compilation of a catalogue raisonné of Chase's art. This has proven to be an arduous task, complicated by the fact that Chase was an extremely prolific artist — producing several thousand paintings, in addition to pastels, watercolors, and works in other media. Since he kept no records, all documentation must be gleaned elsewhere: in contemporary articles,

11. Frank Jewett Mather, Jr., Charles Rufus Morey, and William James Henderson, *The American Spirit in Art*, Vol. 12 of *The Pageant of America*, (New Haven: Yale University Press, 1927), p. 118.

12. "William M. Chase," *Art News* 47, no. 7 (November 1948), p. 45.

13. Sam Hunter, "Traditional to Modern," *The New York Times*, 14 November 1948, Section 2, p. 9.

14. James Thomas Flexner, "The Great Chase," *Art News* 48, no. 8 (December 1949), p. 60.

15. Stuart Preston, "Of Past Renown," *The New York Times*, 21 July 1957, Section 2, p. 6.

Park Scene. c. 1885-86
Oil on canvas
The Art Institute of Chicago, Gift of Dr. John J. Ireland

Still Life (Brass and Glass). **c. 1888**
Pastel on paper
Collection of Mr. and Mrs. George J. Arden

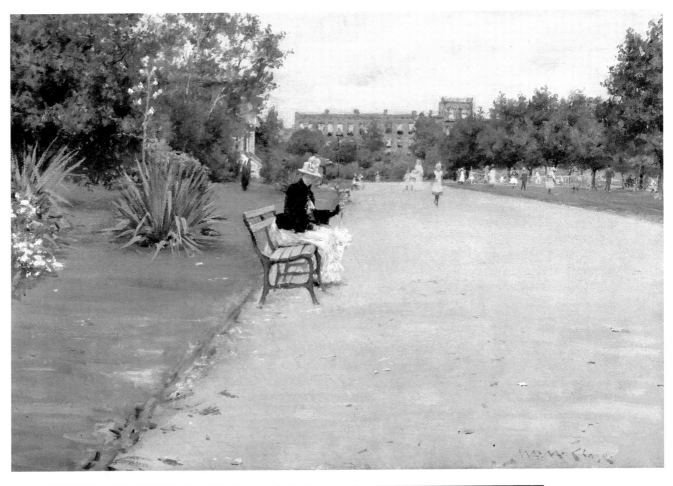

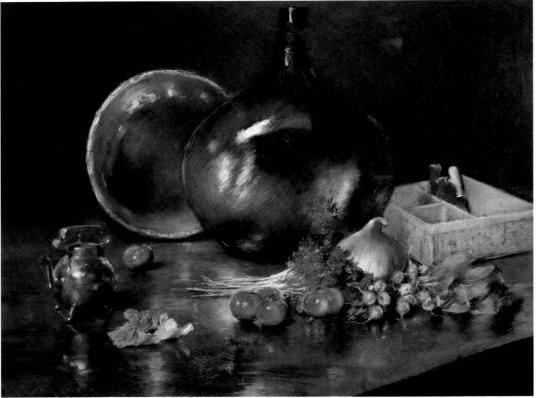

exhibition catalogues, letters, photographs, and
other related material. The most time-consuming
aspect of this project has been sorting out the
fakes, forgeries, and other problematic paintings
from the genuine works of art. In the years I have
devoted to this problem, I have come to realize
that there are as many of these paintings as there
are authentic ones. Most of them were likely
painted by students of Chase and were originally
unsigned; subsequently apocryphal "Chase"
signatures were added to them. In spite of the fact
that I have worked on this project for such a long
period of time, works of art attributed to Chase —
both authentic and problematic — are continually
brought to my attention. By this point, however,
I feel that the situation is well under control;
many of the fakes and forgeries have been taken
off the market, and people now generally seek
professional advice on paintings purported to be
by Chase. Since similar problems have been
associated with information relating to Chase's life
and career, this book was written with the intent
of setting the record straight. Once this has been
accomplished, greater attention can be devoted
to a thorough stylistic analysis of his art. With
spurious works being taken out of circulation —
especially out of important exhibitions and
publications where they have served to damage
Chase's credibility as an artist — and with a
better understanding of Chase's contribution to
American art, his reputation will continue to grow
and his authentic paintings will be appreciated
for their true quality.

The heightened interest in Chase's art in recent
years can be attributed in part to the growing
appreciation of nineteenth-century American
art in general, especially that of the American
Impressionists, a group of artists with whom
Chase has been closely linked. Chase's popularity,
however, has risen at a disproportionately high
rate, far surpassing that of many of his closest
colleagues, such as J. Carroll Beckwith,
Frank Duveneck and Kenyon Cox. What is the
explanation for this? Certainly, Chase's own talent
and technical adroitness deserve special credit,
but there are other factors. For one thing, his art
appeals to the dictates of current taste: he painted
in a direct and fresh way; he had a self-confidence
which is conveyed in the sureness with which he
applied each brushstroke to his canvases; and he
tended to focus on beautiful subjects, presented in
a refined and dignified manner. All of these traits

Portrait of Miss Dora Wheeler. 1883
Oil on canvas
The Cleveland Museum of Art, Gift of Mrs. Boudinot Keith in
memory of Mr. and Mrs. J. H. Wade

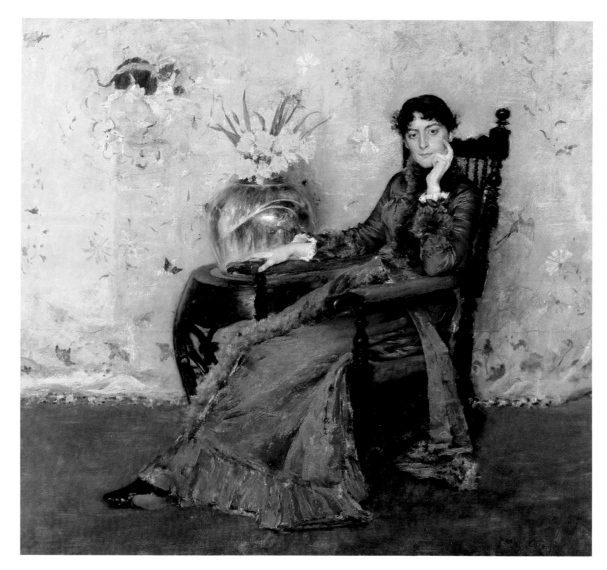

are appealing by today's artistic standards. Chase's vitality and versatility have also contributed significantly to the popularity of his art. He painted every possible subject matter, including portraits, figure studies, landscapes, interiors, genre scenes and still lifes; he utilized almost every known medium; and he worked in a wide variety of styles.

Although in the last decade of Chase's life his art was being eclipsed by more modern developments, he continued to paint in his own strong, bold and dashing manner, always confident that modernism was just a passing fad. This vitality can be seen in his last self portrait, painted when he was sixty-six years old, shortly before his death in 1916. The image he presented was that of a dapper, self-assured and dignified gentleman-artist — an image he had cultivated so successfully as a young man, and one he maintained to the end. Rising from a provincial painter in the Midwest to an international celebrity, Chase was highly esteemed as an artist and art teacher who had gained for his profession a greater level of respect. With great conviction, and a love of art, he proudly declared: "The profession of the artist is one of the most ancient that we know, and, as I tell the students about to enter it, the most dignified."[16] The story of his life and the art he left behind serves as proof of just what can be accomplished with such determination and spirit.

16. William M. Chase, "The Import of Art: An Interview with Walter Pach," *The Outlook* 95 (25 June 1910), p. 444.

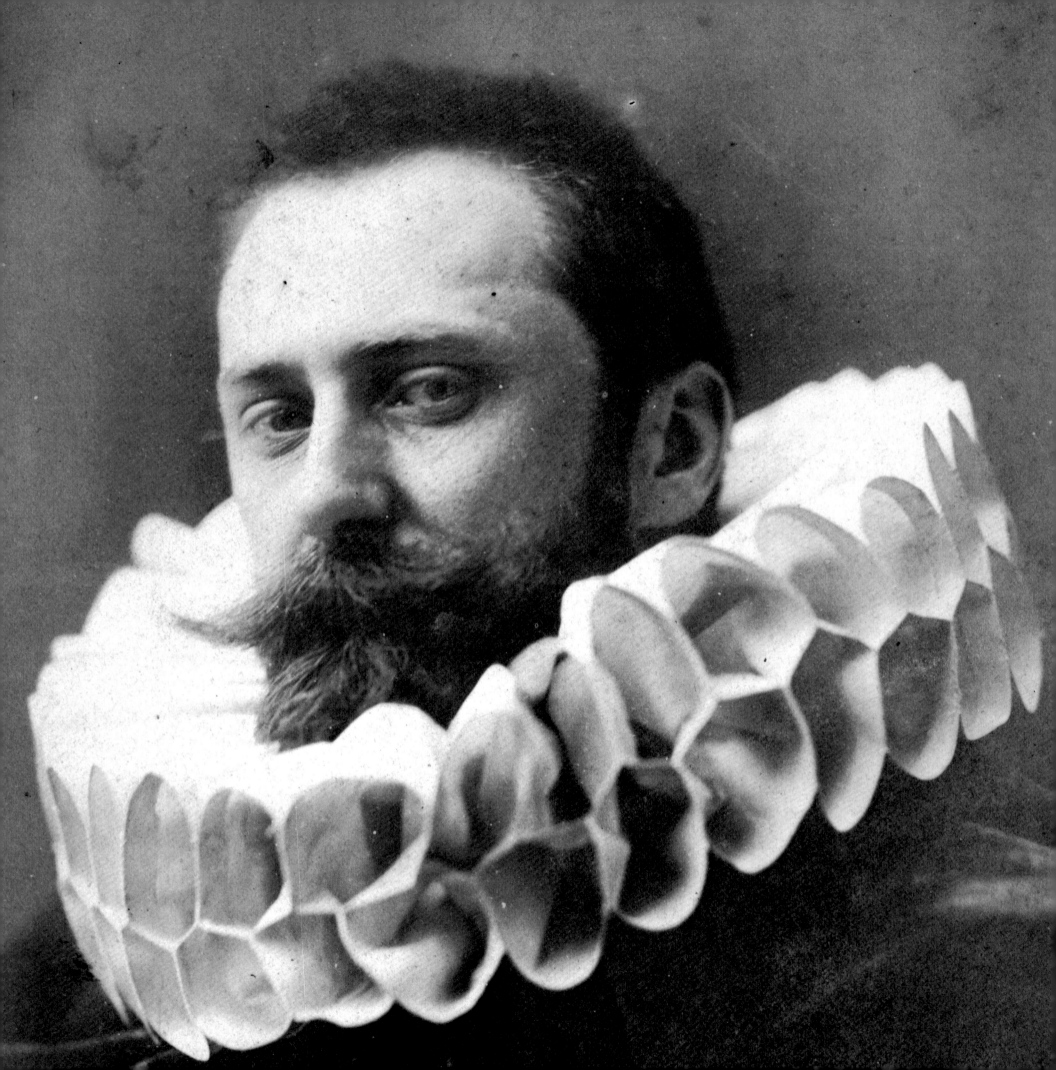

I
The Early Years

1

Boyhood in Indiana

2

An Art Student in New York

3

Study Abroad: The Munich Years

Portrait of Chase in a Frans Hals ruff. Munich. c. 1876.
The William Merritt Chase Archives,
The Parrish Art Museum. Southampton, New York.

Still Life with Watermelon. 1869
Oil on canvas
28 x 24 in (71.1 x 61.0 cm)
Private Collection, Courtesy of the Birmingham Museum of Art

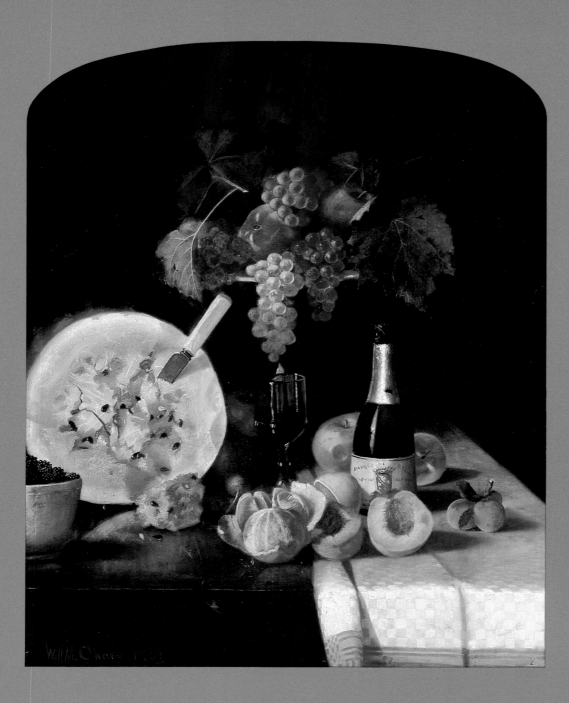

Boyhood in Indiana

William Merritt Chase, the eldest child of David Hester Chase and Sarah Swaim Chase, was born November 1, 1849, in Williamsburg, Indiana.[1] David Chase had moved there from the family farm in Brown County, Indiana, earlier in the century. William was followed by two brothers and three sisters: George, Amanda, Charles, Hattie, and Carrie.[2] On the basis of limited accounts, the fifteen or sixteen years the Chase family lived in Williamsburg were stable ones — even prosperous. During the Civil War, David Chase was a "war democrat" who believed that no concessions should be made to the South and that force should be used to preserve the Union.[3] Although he did not take an active part in the war, it probably contributed to his financial success. Aside from a brief invasion led by the Confederate general John Hunt Morgan in 1863, there was no serious threat to the state.[4] Business flourished in a relatively safe environment during this period of great activity and widespread prosperity in Indiana. Among its most important industries was carriage manufacturing, and consequently David Chase's own business, harnessmaking, thrived.[5] In this business, and later in merchandising dry goods, David Chase became a successful entrepreneur. He also owned 100 acres of land. By 1861 when the Chase family moved to Indianapolis (about thirty-five miles to the north), they had amassed what was then considered a small fortune — according to rumor between ten and twelve thousand dollars.[6]

In 1840, Indianapolis was a small town with a population of just over 2,500, but by the time the Chase family moved there in 1861 the number of residents had increased dramatically to 18,000.[7] This rapid growth was mainly due to the recent completion of a network of railroads that converged on the city. Through its freight yards passed cattle from the West and Southwest, corn and other produce from the Midwest, and valuable raw materials, including coal, iron, and timber.

It was in this booming city that the enterprising David Chase opened the New York Boot and Shoe Store in partnership with Albert C. Dawes. A year later under a new partnership it became the Chase and Cady Ladies Shoe Store,

The notes for the text begin on page 187.

claimed by William Merritt Chase to be the first ladies' shoe store in the West. During the next several years David Chase changed partnerships a number of times in the attempt to avoid financial ruin. Nevertheless, failure came in 1869, probably due to the fluctuation of United States currency following the issuance of paper money during the Civil War. Reflecting on this situation in later years, his son recounted: "When I was twenty years old my father failed in business. He might have taken advantage of the bankruptcy law, and saved a respectable fortune. But it was an honest failure."[8] Mr. Chase accepted defeat and left Indianapolis, moving first to Franklin, Indiana, and then to St. Louis, Missouri.[9]

It is not surprising that during these troubled years the elder Chase was disappointed by his son's lack of concern for the business. From an early age, the boy had expressed a serious interest in art, neglecting his daily responsibilities to draw or paint. Later, when asked how he happened to begin painting, William Merritt Chase replied: "That would indeed be hard to say. It may have been a natural outcropping...for I do not know of any of my forebears who practised it. About the time I was born, decorative work with colored feathers was all the fashion among the ladies, and my mother took it up. It may have been that the first thing my infantile eyes saw was a brush and pigments. However that may be, the desire to draw was born in me, and I believe that my mother still treasures some old school-books whose illustrations are fearfully and wonderfully colored by my hands."[10] As early as his boyhood days in Williamsburg, he drew likenesses of his family and friends who were patient enough to pose for him. Later, when the family moved to the more "cosmopolitan" city of Indianapolis, the youth became even more distracted from his daily chores. "Our father was a fine old gentleman, but he didn't think much of painting as a business," reported the artist's brother George. "Our father started a shoe store and Bill was put to work there. He was a complete failure at this job. He drew pictures on all the shoe boxes. The minute he saw a piece of white, clean space anywhere, he would pull out his pencil and get busy."[11]

Resigned to the fact that his son would never succeed in the shoe business, Mr. Chase finally decided to take him to a local artist, Barton S. Hays, for serious training. "William," he said, "you have spoiled wrapping paper enough here. Put on your hat and come with me. I'm going to take you up to Hays!"[12] Recalling this event later in life,

William Merritt Chase described his father's great dissatisfaction, "how sorry he felt that his endeavors to make a business man of me had failed; that he hadn't much hope or faith in my art predilections, but was willing to give me a chance, and he thought that a studio was a better place for that chance than a shoestore. Thus I began my studies with B.S. Hays."[13]

It is not known why Barton S. Hays was selected, as there were at least a dozen professional painters working in Indianapolis at the time, among them Jacob Cox, James M. Dennis, Thomas B. Glessing, and James F. Gookins.[14] Of course none of these artists, including Hays, would be considered luminaries of their day. Hays, who was born in Greenville, Ohio, in 1826, had been working in Indianapolis for over a decade by this time. Although his portraits, still lifes, and occasional landscapes can hardly be considered accomplished, he was capable of providing the young artist with basic technical training. Chase himself later complained: "Mr. Hays set me to work copying things which were of no earthly advantage to me as an art student. For instance, he had me copy in oil, a steel engraving of one of Rosa Bonheur's pictures."[15]

While there is no way to document what artworks Chase might have seen while living in Indianapolis, the cultural activities available to him would have included exhibitions of paintings in local stores and fairs. The Indianapolis Art Society also displayed and sold the work of local artists, and Herman Lieber's art store was described as "a mecca for painters and art students."[16] Chase later recalled that, "As a little chap I was exceedingly fond of pictures; so much so that I got my toes frostbitten from standing so long on the iron grating at Liebler's [sic] art store in Indianapolis, looking at the wonderful display of pictures — as I thought them then. They were chromos."[17] And, although this can hardly be considered a stimulating environment for a young art student when compared to New York, Philadelphia, or Boston — not to mention foreign art centers — Indianapolis was certainly a step above Williamsburg.

Before Chase left for New York, he was reportedly "seized by the war fever," and on July 22, 1867, he traveled to Philadelphia where he enlisted in the United States Navy.[18] At first he was assigned to the *U.S.S. Vermont,* and a few weeks later, on August 6th, he was transferred to the *U.S.S. Portsmouth* at Annapolis. On the roster for this ship, Chase was listed as a "School boy — 17 9/12 years old — with blue eyes, black hair and dark skin — 5 foot 4 1/2 inches tall — with a small heart [presumably a tattoo] on his left forearm."[19] However, Chase's tour of duty was short-lived; disenchanted with life in the Navy after three unhappy months, he was released following a special appeal from his father, and returned to Indianapolis.

Still Life with Watermelon, dated 1869, one of the few known works done in Indianapolis at this time, reveals Chase's early skill in rendering forms in a clear, precise and linear manner.[20] It is a typical tabletop still life, displaying a wide array of fruits presented both formally, as seen in the compote of grapes in the background, and informally, as in the sliced and peeled fruit strewn across the foreground. In addition to being an attractive and inviting painting, this work also served as a "display piece," demonstrating the artist's talent in capturing a wide range of textures and varying degrees of reflected light. When later describing his early still life paintings to his student Rosina Emmet Sherwood, Chase claimed that they were so highly polished that the fruit reflected the surrounding objects.[21] The picture is a remarkable achievement for a painter with so little formal training.

∎

An Art Student in New York

In 1869 Barton Hays and Jacob Cox, another local artist, convinced David Chase that his son should be sent to New York to continue his training as an artist.[1] Chase departed with several letters of introduction to wholesale shoe dealers, whom he later said "were requested to keep a kindly watch over me," and another to Joseph Oriel Eaton, an Indianapolis artist who had had some success in New York.[2] Chase went to see Eaton, who informed the new arrival that he was about to depart for Europe and offered Chase the use of his studio in the newly opened Y.M.C.A. Building.[3] Chase gladly accepted and quickly joined the circle of artists who had studios there.[4] The building was well situated — on the corner opposite the new building of the National Academy of Design, where Chase was to attend classes and later exhibit. When Eaton returned to New York, Chase procured a studio of his own in the building.[5]

At the school of the National Academy, Chase worked under Lemuel E. Wilmarth. Little is known about his studies there, but like the other students at the Academy, he began by making drawings of plaster casts of antique sculpture. It is obvious that Chase disapproved of this sort of rigorous training. Many years later, in advising his own students he stated: "I am convinced that the manner in which the study of art has been conducted, by making the beginner draw first from the antique before he knows anything about art, is wrong....I prefer that my pupils begin to draw from life....For a youngster to go into a classroom filled with casts of the antique is as disheartening as to go to a graveyard....I know how it was with myself: as much as I appreciate the antique now, I know very well that I do not appreciate it as much as if I had not once hated it, when I knew it was a task that had to be done, something that had to be gone through with."[6]

Chase resigned himself to mastering this discipline while continuing to paint on his own. By 1871 he was exhibiting in the Academy's annual exhibition; that year he showed three paintings, a portrait and two still lifes, *Blue Plums* and *Catawba Grapes,* both listed for sale.[7] Although neither can be identified positively today, two others from that year, *Still Life with Fruit* and *Still Life with Fruit and Pitcher,* do exist.[8] These paintings are more polished in execution than the still life Chase painted in Indianapolis in 1869 and

display greater technical skill. They represent variations on a theme. The first is presented in an outdoor setting, in which the landscape serves as "nature's table," much in the manner of American still life painters who were influenced by the ideas of John Ruskin.[9] In the second painting Chase presents the viewer with a more ambitious composition. Displayed on a marble table is a wide variety of fruits, a glass of wine, bread, and decorative objects, all carefully arranged around a classicized pitcher (perhaps inspired by his study of antique casts). This painting also indicates the major influence on Chase's early still life paintings — William Mason Brown. William H. Gerdts, who pointed out this influence, has stated that at this time Brown was emerging as an important American still life painter and was attracting considerable attention. Referring to Chase's *Still Life with Fruit and Pitcher,* Gerdts has noted that "the composition here, for instance, is very much like Brown — grand but slightly cluttered; very contained; and specific motifs are Brown's — the heavy drapery, the almost photographic, immaculately polished grapes...the covering on the elegant table, and overall especially, the combination of marvelously rendered fruit and elegant man-made objects — either antiques or at least *objets de virtu.*"[10]

These still life paintings, influenced by the work of popular American artists of the day, became a welcome source of income for Chase just when he needed it most. It was at this time, 1869-70, that his father's business failed, and Chase could no longer depend upon the financial support he had been receiving for his artistic training. Explaining this dilemma, Chase later recalled his father's serious concern:
He regretted that he could not continue supporting me, and he wondered what use I could make of my art training. I didn't know exactly what to do. I gave the matter considerable thought. I had one year's experience in the shoe business, and I had learned how to sell a woman a pair of shoes two sizes too small for her. I was very successful in that, and I had made up my mind that if it came to the worst, I would go into a shoe store as a clerk. But fortunately, I didn't have to. I laid the matter before Mr. Eaton, and he advised me to paint flowers and fruits, in which line of work I had been moderately successful. Through his influence I was able to sell some of these. There are a number of them now up around Yonkers,

which I would like to recall. I was so successful that by Christmas I had saved up enough money to go to St. Louis, where my father had re-established himself in business, and I decided after looking over the field, to open a studio in that city.[11]
This move took place in 1871, at which point Chase opened a studio in the old Insurance Exchange Building at Broadway and Olive Street.[12] In the same building were the offices of Captain W.R. Hodges, an architect of public monuments, and the studios of several artists, including Alban Jasper Conant, George Calder Eichbaum, and Joseph Rusling Meeker. Since none of these artists specialized in painting still lifes, it seems there would have been little competition for Chase in this area, which had served him well back East. And, according to his brother George, Chase worked hard at painting still life compositions during this period, "but the financial returns were meager. Occasionally he made paintings for merchants in return for suits of clothes and other necessaries."[13]

It was through Captain Hodges (described by Chase's brother George as an "art connoisseur") that the struggling young artist met Samuel M. Dodd, a wealthy St. Louis merchant.[14] Describing this propitious encounter and a subsequent visit by these two men to Chase's studio, the artist later noted: "Now, in every large city where I have been there are one or more men who feel a personal interest in art. They are natural art patrons; I met two such men in St. Louis. One of them was named Hodges and the other was Samuel Dodd. They were both wealthy. One day I overheard them talking in my studio about me. 'What do you think we had better do?' said Mr. Hodges. 'Send him abroad,' answered Mr. Dodd. 'We'll get commissions for him to be executed on the other side, and we will have money advanced to him for his studies.'"[15]

Apparently several other patrons were engaged, including Charles Parsons, Samuel A. Coale and William Jones.[16] In addition to providing these men with his own works, Chase was to act as their agent while abroad, seeking suitable European paintings for their collections.

This was particularly true in the case of Samuel Coale, who had just built a new house in St. Louis and wanted European paintings to decorate its walls. When the sum of $2,100 was raised by the group, one of the men asked Chase, "Well, my boy, how would you like to go to Europe?" Chase's legendary response was "My God, I'd rather go to Europe than go to heaven."[17]

Chase's decision to study at the Royal Academy of Munich rather than one of the many other popular art schools is generally credited to the artist John Mulvaney, whom Chase met in St. Louis in 1871. Mulvaney, an Irishman, had visited most of the art centers of the Continent — including Paris, Berlin, The Hague, Amsterdam, Vienna and Munich — before traveling to St. Louis. Based on his experiences in these cities, he informed Chase that the Royal Academy in Munich offered the most adventurous and least doctrinaire course of study available.[18] Beyond this advice, Chase had seen the Munich influence in Mulvaney's own freely sketched studies. When asked why he had chosen Munich as his destination, Chase responded: "I went to Munich instead of Paris because I could saw wood in Munich, instead of frittering in the Latin merry-go-round."[19] Encouraged by what he had seen, and backed by supportive patrons, Chase embarked for Munich, and the final and most influential phase of his artistic training.

■

Unexpected Intrusion (Boy Feeding a
Cockatoo; Turkish Page). **1876**

Oil on canvas
48½ x 37½ in (123.2 x 95.3 cm)
Cincinnati Art Museum, Gift of J. Levy Galleries

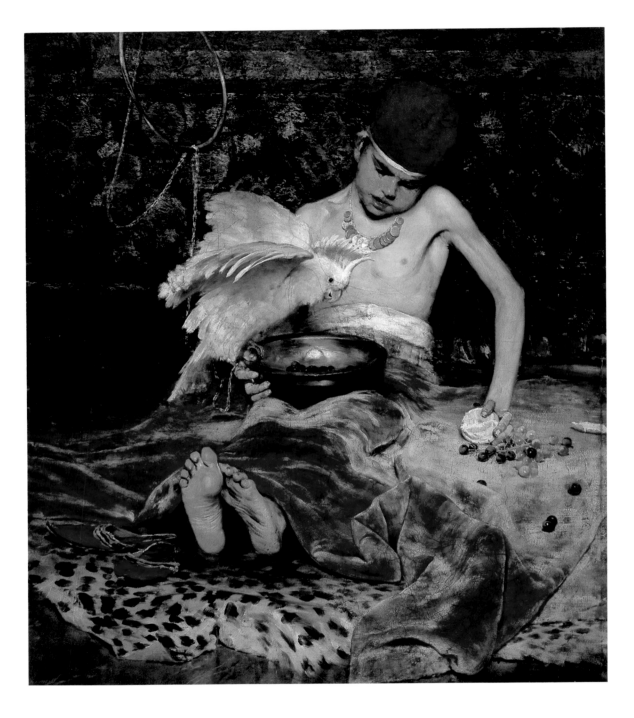

Study Abroad: The Munich Years

In the fall of 1872 William Merritt Chase enrolled in the classes of the Royal Academy in Munich. This was an opportune moment — the Bavarian city was enjoying an economic boom and a period of high morale, generated by the German victory in the Franco-Prussian War (1870) and the consequent unification of Germany under King Ludwig.[1] Commenting on the generous patronage of this monarch, a contemporary writer described him as "the most enthusiastic royal patron art has met since Lorenzo de'Medici."[2] This writer then compared Munich favorably with Paris, qualifying his statement by pointing out the difference in the size of the two cities: "Although on a much smaller scale, there is enough of the art of the past ages collected and arranged in Munich to satisfy the most craving art appetite, while the number of artists living, studying, and painting there — over two thousand — exceeds, in proportion to the population, the art guilds of any other city."[3]

A catalogue of the collection of Munich's principal art gallery, the Alte Pinakothek, published in 1871, lends substance to this writer's comparison, and lists such major figures as Botticelli, Bronzino, Giorgione, Titian, Tintoretto, Dürer, Holbein, Van Dyck, Murillo, and Hals, as well as a generous selection of paintings by Rembrandt and Velasquez.[4] In all, there was a plentiful supply of masterworks available for the most aspiring of young artists to study.

Later in life, recalling his first exposure to the treasures of the Alte Pinakothek, Chase confessed: "When I first reached Munich I went first to the old gallery where the old masters were; and I distinctly remember that at that day I thought it was all nonsense — that these dark, terrible things were not all they were claimed to be....Then the next thought I had was: 'There must be a reason why all these things are here, and so cherished and so placed and so guarded as they are.' And I thought, 'I think, William, it would be wise for you to keep a hold upon your counsel, and not to say this out loud, or even whisper such a thought.'"[5] As part of his regular study at the Royal Academy, Chase was advised by his instructors to go back to the museum to study the works of the masters. A common practice of the students was to select a painting in the museum and return to their studios to paint a copy from memory or with the aid of a reproduction. Although Chase later admitted that he did not enjoy this aspect of artistic training at first, he eventually reversed his opinion, claiming: "I am so glad I did not tell my first impression about these paintings. Before I knew it a spell came over me — I likened it to the sensation I once had in being converted to a religion, to a raw, wrong person being converted to something right, as compared with something he had thought right but which was all wrong....I went to the pictures I loved and drank them in — drank them in to the fullest extent; and when I went away I went consoled with the thought that I cared for a picture that was in the museum."[6] This conversion was total and complete; by the time of his death Chase had copied at least 25 paintings by the old masters, and probably many more.[7] Moreover, their influence was obvious in his work for nearly a decade after his return to America.

The basic curriculum of the Royal Academy dictated that each student go through three stages of study: drawing, painting, and composition. In the drawing classes the students first copied casts of ancient sculpture and then drew from the model. Since Chase had already received such training at the National Academy of Design in New York, it is possible that he was allowed to proceed quickly to the next stage, painting technique, in which portrait studies as well as studies of the nude were painted. After attaining a degree of proficiency here, the aspiring painter moved on to the final stage of study, the composition class, in which he worked under the professor of his choice. Judging from Chase's letters to his patron Samuel A. Coale, the professor had the final right of acceptance of a student at this point. It was at this level that each student had to display his skills in composing elaborate history paintings.

When Chase entered the Royal Academy in 1872, Wilhelm von Kaulbach, a proponent of the classical style associated with the late phase of the Nazarene movement, was the school's director. Although Chase first studied with Alexander von Wagner, he was drawn to the school's leading teacher, Karl von Piloty, who had joined the Royal Academy in 1856. Piloty, referred to as a "realist," was a disciple of the romantic French artist Paul Delaróche. Like Delaróche, he specialized in melodramatic historical scenes. Stylistically, he was inspired by the masters of Baroque art, among them Rubens, Ribera and Zurbarán. These interests were passed on to his students. In 1874, Kaulbach died, and Piloty became the Royal Academy's director. This appointment defined the direction of the Academy for the next two decades: realism. Although the term "realism" is applied to a wide range of artistic statements, Piloty's style has been described as "coloristic realism," characterized by vigorously applied broad brush strokes that capture the coloristic properties and appearances of objects.[8]

Based on the letters that Chase sent to Coale in 1873, it is clear that Chase had direct contact with both Kaulbach and Piloty. In a letter dated June 12, 1873, he informed Coale of his efforts to obtain a sketch by the former at a good price: "I told him that it would be in his interest to let you have a large sketch *cheap*, that you would be the means of his sending a great many more pictures and sketches to St. Louis."[9] In the same letter he mentioned purchasing a work by Piloty, as well as small paintings, sketches, and drawings by other artists. It is obvious in retrospect that Kaulbach had no significant influence on Chase's artistic development, and the young artist ultimately chose Piloty as his mentor. Yet, to understand the primary influences on Chase in Munich at this time, one has to examine the years that preceded his arrival in 1872, the development of German realism, and its leading figure, Wilhelm Leibl.

Munich opened its first international art exhibition — with over 1,600 paintings — on July 20, 1869. The show included an especially fine representation of French paintings in a wide range of styles, from the academic paintings of such artists as Gérôme and Meissonier to the more progressive realism of Manet. It was the work of Gustave Courbet however that had the greatest impact on the young German artists who attended the show. When Courbet himself visited the exhibition in late 1869, he in turn expressed his admiration for the work of Wilhelm Leibl.[10] Like the French realist, Leibl rejected the drama and sentiment with which many of the artists of the period imbued their paintings; instead he sought to attain what he referred to as "artistic truth" through technical excellence, with no attempt to beautify or embellish subject matter. The presence of Courbet's paintings and the artist himself in Munich reinforced Leibl's beliefs, which were influential among a circle of artists that formed around him. Although Chase never became a member of this group, known as the *Leibl-Kreis*, he was affected by them, and his admiration for Leibl's work is demonstrated by the fact that he purchased two of his paintings. One of these, *Kokotte*, had an obvious effect on several of Chase's own paintings, including *Portrait of a Woman*, 1878, and Chase's own *Coquette*, 1879.[11]

Portrait of a Woman. 1878

Oil on canvas
26⅛ x 15⁷/₁₆ in (66.4 x 39.2 cm)
Wadsworth Atheneum, Hartford,
Bequest of Mrs. Clara Hinton Gould

Leibl's influence can also be seen in the *alla prima* technique adopted by Chase. Like Leibl, who has been called the first artist to exhibit seemingly unfinished paintings, Chase left a number of his works from this period in a sketch-like state. His painting *Woman with a Basket*, 1875, is an example.[12]

In fact, in reviewing Chase's later principles of teaching, one can identify parallels to Leibl's philosophy. Leibl maintained that "if a picture is painted well the soul would anyway be present."[13] In a similar vein, Chase instructed his own students "when the outside is rightly seen, the thing that lies under the surface will be found upon your canvas."[14] To some this was a cold and calculated point of view, lacking in poetry, with too much concern for technique at the expense of sentiment — but for Leibl, and subsequently for Chase, this was artistic truth.

By the last quarter of the nineteenth century Munich had displaced Düsseldorf as the major art center in Germany, and for a brief time in the early 1870s it even rivaled Paris in the number of art

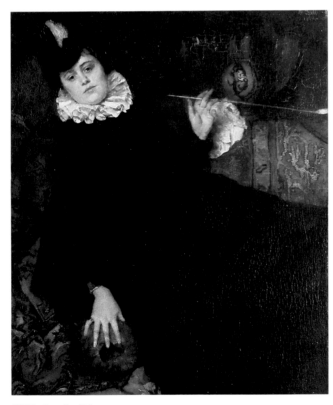

Wilhelm Leibl
Kokotte (Die junge Pariserin). 1869
Oil on canvas
Wallraf-Richartz-Museum, Köln

students it attracted from the United States.[15] At the time Chase enrolled in Munich's Royal Academy, forty Americans were reported to be in attendance. Among them were: Frederick Dielman, who registered the same day as Chase; Walter Shirlaw, who shared rooms with Chase on the Promenade Platz; Frank Duveneck; J. Frank Currier; and Toby Rosenthal.[16] Later John H. Twachtman, who came to Munich at the urging of Frank Duveneck, joined this tight-knit group.

Bound by a common language and culture, the American students worked closely together — in one another's studios, where they often shared models, and on excursions to the countryside. In fact, Duveneck, Shirlaw and Chase were so closely associated that their fellow students referred to them as "the Father, Son and Holy Ghost." This camaraderie was as important in the development of Chase's mature style of painting as his formal studies.

The philosophy of common learning through group experimentation, as practiced by the more advanced artists of the Leibl-Kreis, was encouraged by another important Academy professor, Wilhelm von Diez. In fact, such casual associations of artists in shared studios and on sketching trips were considered a natural extension of the academic curriculum in Munich. Student dinners were organized about every two weeks. At these dinners reproductions of paintings by old and modern masters were displayed, and those who attended were expected to comment on these works of art. Out of such gatherings evolved the American Art Club in Munich, of which Chase was a member.

Painting portraits of their fellow students was another common practice. Among the many painted by Chase are *Hugo von Habermann*, 1875, *The Artist Eduard Grützner*, c.1875, and several portraits of Frank Duveneck.[17] Chase's most famous portrait of Duveneck, *The Smoker*, 1876, was painted while the two artists were working closely together, often in the same studio.[18] During this time both artists used local youths as models, depicting them in leisure moments away from their daily chores. Duveneck began his paintings of this subject as early as 1872, when he painted *The Whistling Boy*.[19] Chase soon followed his example, painting *The Leader* around 1873.[20] Both continued to paint in this genre, resulting in what might be described as the apprentice series, since the models used were generally young apprentices of local

tradesmen. In 1876, this series culminated in the two artists' representations of one of these boys dressed as a "Turkish page," by far the most elaborate of these paintings.[21] Excited by the find of this youth, Chase engaged him as a model, decked him out in exotic costume, and created an elaborate setting. He then beckoned Duveneck to his studio: "Here's a Turk — the real thing!"[22] Chase then proceeded to paint his version, entitled *Unexpected Intrusion*. And, to commemorate the momentous occasion, he also made a sketch of Duveneck in the act of painting his version of the model, *The Turkish Page*.[23]

Although Chase benefited from the influence of Wilhelm von Diez and, less directly, Wilhelm Leibl, it is clear from his letters at the time that it was Karl von Piloty who inspired him most. Even before Piloty became the director of the Royal Academy, Chase strove to be eligible for his instruction. Writing to Samuel Coale on March 27, 1873, Chase noted: "I am hard at work in the Academy, not losing a moment's time...[and] am encouraged by all who know me. You are right, I could not have better tutelage anywhere than here. I shall try and become a pupil of Piloty's. I think him the greatest painter living."[24] He also reported that Piloty had offered to criticize his work. On May 15, 1873, Chase informed Coale that he had been awarded a bronze medal, the first prize in a class contest. "I am still working hard improving every moment in study....I will do all I can to get with Piloty," he wrote determinedly.[25] And by January 20, 1874, Chase proudly announced, "I am diligently at work in the Academy except three days of each week, I spend in working on a head which I am painting under the correction of Piloty. He has promised me a place with him as soon as possible."[26]

Reflecting on a less positive aspect of this period, Chase later recounted: "After entering the academy I had a pretty hard time of it. I foresaw my money would be spent long before I had acquired the requisite training, and try as hard as I might, I could not sell my work to local dealers."[27] Explaining his predicament, Chase went on to describe himself as a "revolutionist" who refused to paint pictures "to order." As a result of this renegade attitude, he reached the point where he was down to bread and cheese for sustenance, and dependent on the generosity of friends and other art students for room and board — as well as the very materials he needed to continue painting. His financial situation was bleak, but this was soon remedied by the success of his painting, *Ready for the Ride* of 1877.[28] Based on the merit of this

painting, Piloty commissioned Chase to paint portraits of his four children, and advanced him one-half of the total payment. This commission was important not only because it made him solvent once again, but also because it established his worth as an artist. Chase later acknowledged this turn of events to be a critical juncture in his life: "The dealers who refused to notice me crowded my studio and asked for paintings, studies, anything that I had. The seal of approval had been set by the highest authority of his day. I had money — Piloty's money — and I was independent, so I told those dealers 'No,' to go away, to let me alone; that I would have nothing to do with them....I paid my rent. I walked on air. The whole world looked bright, there was sunlight everywhere...."[29]

Although Chase cited Piloty's approval of *Ready for the Ride* as the basis for the major portrait commission, it is evident that the German master had recognized the young American artist's talent long before he saw this painting. He had met him as early as 1873, as documented by Chase's letter to Coale, and Piloty certainly would have been aware of works that won Chase medals in Munich every year between 1873 and 1876.[30] In fact, several accomplished paintings by Chase predate *Ready for the Ride*, including *The Dowager*, 1874, and *Keying Up — The Court Jester*, 1875.[31]

Chase's commission to paint Piloty's children came despite a serious altercation between the two men the previous year. Chase, who prided himself on his iconoclastic nature — "I resented almost everything"[32] — had agonized over an assignment to paint an event in the life of Christopher Columbus. He finally submitted to the jury *Sketch For A Picture — Columbus before the Council at Salamanca (Christopher Columbus Before the Spanish Council)*, in which Columbus appears with his back to the viewer. Explaining his intent, Chase later stated, "Instead of painting the regulation academic picture...I sketched what I believed really occurred. I showed Columbus from the back as he stood before the Court, striving to knock his conviction into the dull minds of the priests and courtiers. The various impressions of his hearers, their incredulity, their scorn, their derision, were expressed in their faces. It was in short a satire."[33] In effect, the painting was a

Ready for the Ride. 1877
Oil on canvas
54 x 34 in (137.2 x 86.4 cm)
The Union League Club, New York

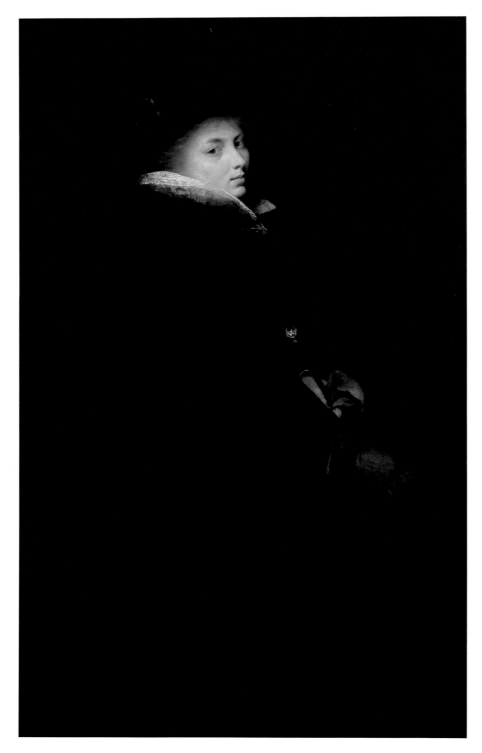

parody of his own plight at the Academy, and
signaled the end of his academic training. In spite
of the fact that the radical composition won a
prize, Piloty was furious with his gifted student
and implored him to compose a more dignified
version in which Columbus' face could be seen.
Chase complied by painting one with Columbus'
face in profile — a reasonable compromise.[34]
Impressed with this revised version, Piloty
encouraged Chase to paint a full scale mural for
the Capitol in Washington — a proposal Chase
rejected.[35]

During this time, 1876-77, Frank Duveneck
suggested that American art students living and
working in Europe organize a summer trip to Italy.
Although nothing is known about the details of
his effort, he did persuade Chase and Twachtman
to accompany him to Venice.[36] Chase, flush with
the money he had received from the Piloty
commission, not only went to Venice, but turned
the trip into a buying spree. He bought paintings,
old furniture, brasses, and assorted studio props.
To some extent this spree probably eased the more
grievous aspects of his earlier frugality. It also
signaled his resolve to live in grand style. At the
time he told a friend: "I intend to have the finest
studio in New York."[37] He also knew by this time
that he had a job waiting for him in the United
States. Both he and Duveneck had been offered
teaching positions at the newly formed Art
Students' League in New York. Before returning to
Munich to prepare for the journey home, Chase
and his friends stayed in Venice for nine
months.[38]

The paintings that Chase completed there vary
greatly in subject matter, size, and quality. Some,
of an experimental nature, can be considered
transitional pieces. Instead of painting portraits
and figure studies as he had in Munich, Chase
devoted his time to painting street scenes, canals,
building façades, and still lifes. Two unusual still
life paintings from this period are *Monkeying
with Literature* and *A Fishmarket in Venice (The
Yield of the Waters)*, both of which are ambitious
in scale and more like genre paintings than typical
still lifes.[39] In the first, the artist presents his
mischievous pet monkey, Jocko, amid an array of
tumbling books. *The Yield of the Waters* deals
with a subject for which Chase would later become
famous — fish. But unlike his later tabletop still
lifes of fish, this work is set out-of-doors — a
fishmonger's display. Originally the painting
included a young boy reaching into the basket;

31 **Boy Smoking** (The Apprentice). **1875**

Oil on canvas
37¹/₁₆ x 23 in (94.1 x 58.4 cm)
Wadsworth Atheneum, Hartford,
The James J. Goodwin Fund

Keying Up—The Court Jester. 1875

Oil on canvas
39³/₄ x 24⁷/₈ in (101.0 x 63.2 cm)
The Pennsylvania Academy of the Fine Arts,
Gift of the Chapellier Gallery

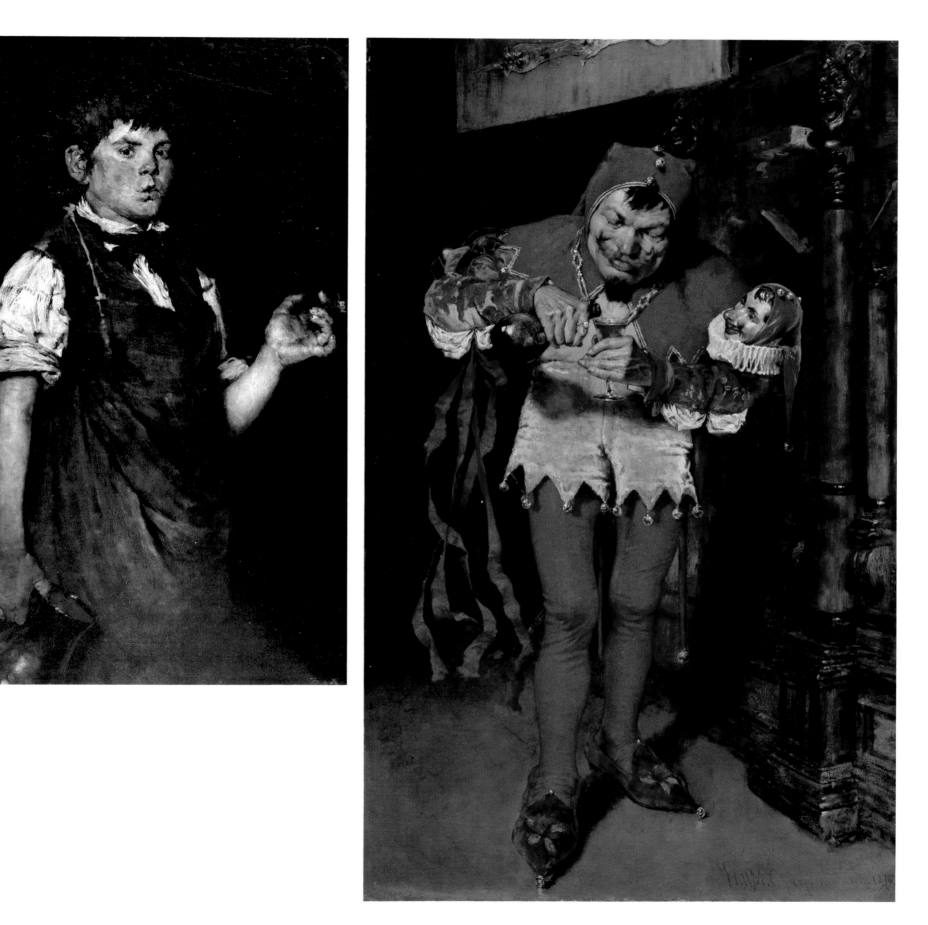

32 **Sketch for a Picture—Columbus Before the Council at Salamanca** (Christopher Columbus Before the Spanish Council). (First Version) **c. 1876**

Oil on canvas
23 x 37¼ in (58.4 x 94.6 cm)
Collection of Mr. and Mrs. Larry Thompson

Sketch for a Picture—Columbus Before the Council at Salamanca (Christopher Columbus Before the Spanish Council). (Second Version) **c. 1876**

Oil on canvas
22½ x 36¼ in (57.2 x 92.1 cm)
Collection of Mr. and Mrs. Larry Thompson

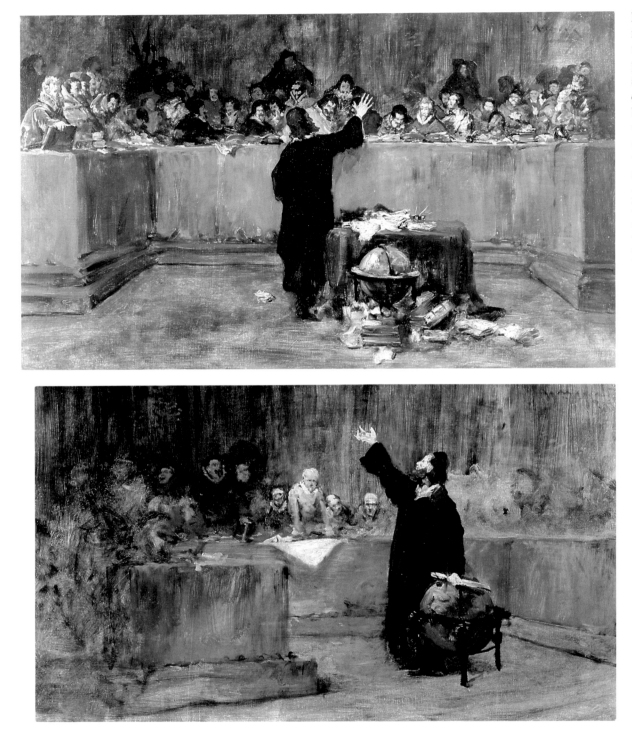

however, Chase later altered it by painting the figure out of the composition, creating a more traditional still life. In addition to these two paintings, Chase completed several interiors and street scenes. Among these are *In the Baptistery of St. Marks*, which depicts a man polishing a brass candle stick, and *The Antiquary Shop*, which displays the artist's technical skill in capturing a wide array of textures.[40] Aside from these paintings, which are quite large, most of Chase's works from this period are small sketches painted in the somber tones of the Munich school. However, at least one painting, *Venice*, a sunfilled composition depicting the façade of a building with decorative balconies and potted plants, is lighter in palette.[41]

While in Venice, Chase became very ill, and money had to be raised to provide medical assistance and transportation back to Munich. Through the assistance of Mrs. Arthur Bronson, the sister of Richard Watson Gilder, a wealthy New York poet, editor, and journalist, Frank Duveneck was able to secure a portrait commission that provided the necessary funds.[42] They went back to Munich, where Chase began to make plans for his return to America. Before Chase left Germany, Duveneck organized a farewell celebration that took place in the small town of Polling, outside of Munich. Elaborate preparations were somehow kept secret from the unsuspecting Chase. The guest of honor arrived by train in a small town nearby, was swept up by a crowd of friends and set upon a makeshift throne placed upon an ox cart. However, "in order not to be too flatteringly saccharine," a large caricature of Chase was mounted above his head.[43] An account of the party was apparently published in an American paper, adding to the aura which surrounded Chase even before he returned to New York.

■

Oil on canvas
22 x 13 in (55.9 x 33.0 cm)
Collection of Mr. and Mrs. Jerome Westheimer

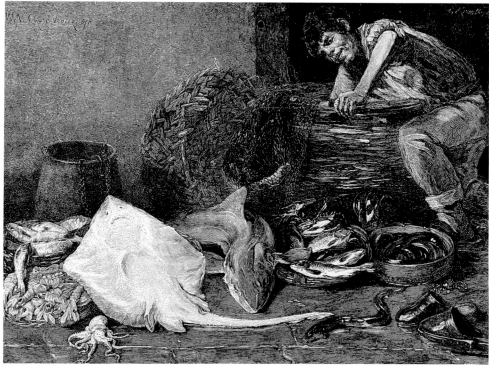

Engraving after William Merritt Chase,
A Fishmarket in Venice, 1878;
published to illustrate "The Collection of Mr. S.A. Coale, Jr.,
St. Louis," in *American Art Review,* Vol. 1 (1881), opposite p. 425.

A Fishmarket in Venice (Venetian Fish
Market; The Yield of the Waters). **1878**; altered **c. 1890**
Oil on canvas
49 x 65 in (124.5 x 165.1 cm)
The Detroit Institute of Arts, City of Detroit Purchase

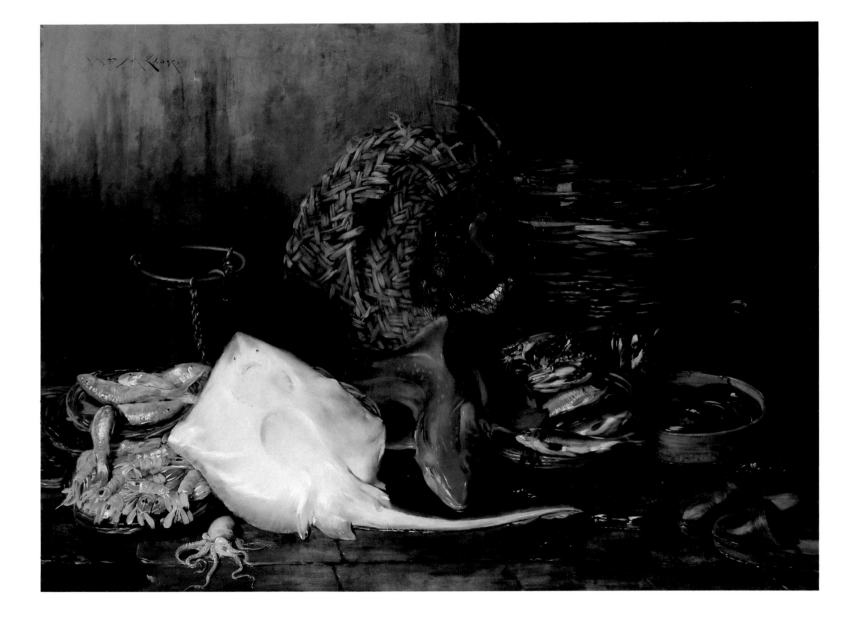

The Cloisters (Italian Cloister). **c. 1880**
Oil on canvas
14⅝ x 27⅝ in (37.2 x 70.2 cm)
The Arkansas Arts Center Foundation Collection,
Gift of Mrs. Frank Tillar, Little Rock, Arkansas, 1940

II
Reformer and Iconoclast

4

New York in the 1870s

5

The Tile Club

6

Artists Abroad

7

The Pedestal Fund Exhibition

8

The Painters in Pastel

9

Chase and Whistler

Detail of *The Tenth Street Studio*
(Museum of Art, Carnegie Institute).
See page 44 for full illustration.

**Interior of the Artist's Studio
(The Tenth Street Studio). 1880**

Oil on canvas
36 x 48 in (91.4 x 121.9 cm)
The Saint Louis Art Museum,
Bequest of Albert Blair

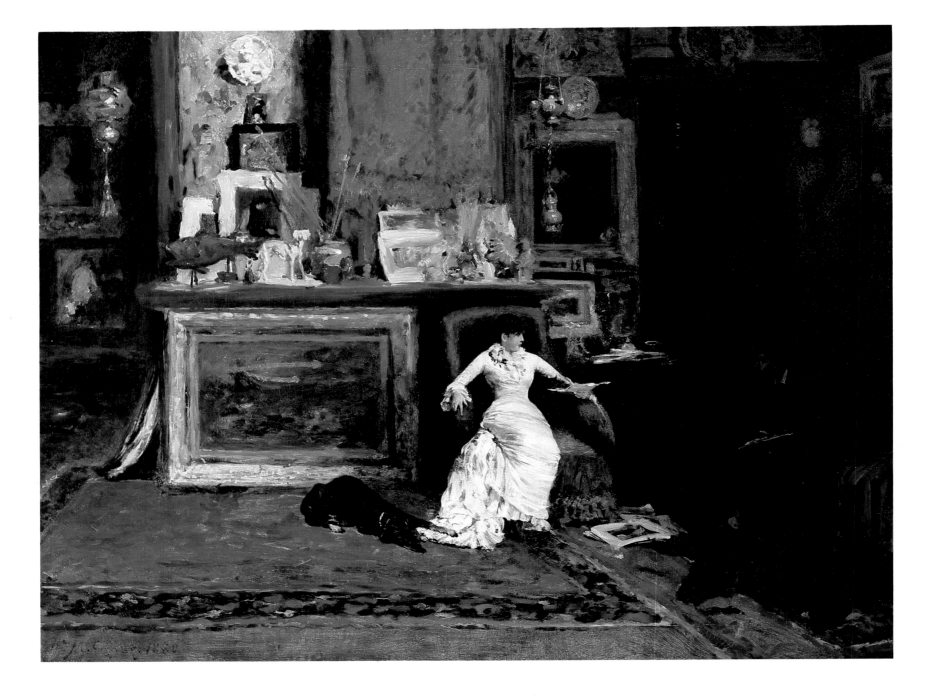

New York in the 1870s

Chase's Tenth Street Studio.
The William Merritt Chase Archives,
The Parrish Art Museum, Southampton, New York.

Faced with the choice of becoming a professor at the prestigious Royal Academy in Munich or returning to New York to teach at the newly established Art Students' League, William Merritt Chase decided to return home. "I was young; American art was young; I had faith in it," he explained.[1] This belief was prompted in part by Piloty, who had assured his pupil: "Yours will yet be the great country of artists and art lovers...everything points to it; you have the subjects, and you have the great inspiration of the place where life is being lived. Italy, France, Germany, Spain, England, these have had their day, the future is to America."[2]

The United States was rapidly becoming the world's greatest industrial power, and enterprising businessmen and financiers were amassing great fortunes. These wealthy individuals proudly displayed their success in grand mansions filled with fine art and *objets de virtu* imported from abroad. The remarkable rate at which affluent Americans acquired art is documented in the diaries of two prominent art dealers of the day, George A. Lucas and Samuel P. Avery,[3] and further evidenced in Earl Shinn's *Art Treasures of America* (1879-81) a three volume set which celebrated the most prominent collections.[4] From the selections featured in Shinn's book, it is clear that American collectors favored French academic art and paintings of the Barbizon school. Among the other artists who were popular were the Spaniards Fortuny and Zamacois; the Italians De Nittis, Boldini, and Simonetti; the Belgians Kaemmerer and Stevens; the Dutch Israëls and Koekkoek; and the Hungarian Munkácsy. Although Piloty and his Munich colleagues were represented in several American collections, the Düsseldorf school was more popular in the United States. Unfortunately, few collectors had a serious interest in the work of American artists. Criticizing patrons for their lack of attention to native artists, one writer asserted: "We are spending our money for the odds and ends of the foreign picture market, and neglecting the magnificent possibilities of art in our own country....The incubus which rests upon American art is lack of support and encouragement, arising from an ignorant and perverted preference for whatever is foreign."[5]

Explaining why so many American artists became expatriates at this time, another writer noted that "Americans stay in Europe because they find appreciation and reward. They fritter themselves away on European subjects and strive after a European style because the demand is for these...."[6]

By the end of the 1870s, however, things began to change. One contemporary writer declared, "The day of Dusseldorf...has gone by; and to say that the long-continued and triumphant influence of Dusseldorf in American art has at last perished or greatly declined is to note progress."[7] Another contemporary critic was equally optimistic about the future of American art: "No country is richer than ours in the material for landscape art, infinite in variety and essentially different from that of other lands, and inviting the highest skill and the finest conception in the delineation of the poetic and romantic aspects of nature."[8] Inspiring subject matter was not, however, enough. The same writer continued: "We need galleries and museums accessible to the people, in which may be presented and accumulated the works of native artists, and we need schools of art, generously endowed and supported. We can expect little in this direction from the State, but public spirit and private munificence might do the work in which in European countries the Government has taken a liberal share."[9]

Wealthy patrons responded by forming major art museums, among them the Museum of Fine Arts in Boston, the Corcoran Gallery of Art in Washington, D.C., and The Metropolitan Museum of Art in New York. Among those who supported these institutions were collectors such as William Henry Vanderbilt, John Taylor Johnston, August Belmont, John Pierpont Morgan, Alexander Turney Stewart, and Horace O. Havemeyer, to name just a few.[10] This prosperous period of the nation's development has been referred to as a time of "artistic awakening" and an "American Renaissance"; its center was New York, where most of the wealth was concentrated. Commenting on the situation as it was the year Chase returned to that city, one writer observed that "There had never been a year in the history of New York...when art matters created so much attention...."[11]

During the six years that Chase had been abroad, the New York art scene had changed considerably. New schools were formed, more exhibitions were scheduled, and the city was alive with activity. In 1875 a group of art students, with

their instructor Lemuel E. Wilmarth, left the school of the National Academy of Design to form their own school, the Art Students' League. They had been dissatisfied with the restrictive conditions of the Academy's school, and feared that the Academy would soon discontinue its classes because of financial problems. When the announcement of the new art school was released, it provoked the disapproval of the Academy's president Worthington Whittredge and other academicians who believed that such a move would be counterproductive. Appraising the situation, the sculptor John Quincy Adams Ward reported to the *Herald*: "It is difficult enough for art to exist and make any progress in this country without being retarded by internal dissensions of its votaries. They all have the true interest of art at heart and should, if possible, work together for its encouragement."[12] Despite opposition, Wilmarth and his students went ahead with their plans. The school was an immediate success, and by its second year, 1876, it attracted an enrollment of 135 students.

In the spring of 1877, however, the Academy announced that it would reopen its classes the next season. This presented an immediate threat to the future of the Art Students' League, since the Academy's classes were free and the League was forced to charge tuition fees to cover its expenses. Worse yet, Wilmarth announced that he was resigning his position at the League to resume teaching at the Academy. On April 27, 1877, a meeting was scheduled by the students to consider the issue: "SHALL THE STUDENTS RETURN TO THE ACADEMY TO STUDY NEXT YEAR?" The decision was: "NO."[13] Frank Waller was elected president of the League, and Walter Shirlaw replaced Wilmarth as its instructor. Classes resumed in October 1877.

Another controversy arose over the National Academy's annual exhibition of 1877. A generous portion of the best wall space had been allotted to younger artists, apparently because of the superior quality of the work they had submitted. Long-term members of the Academy objected to being displaced and were determined to prevent similar treatment thereafter. A new rule was instituted guaranteeing academicians preferential treatment and assuring them of favorable placement in the future.[14] In response to this

discriminatory act, a number of artists — many of them trained abroad in Munich and Paris — formed their own organization, the Society of American Artists, which held its first exhibition in 1878.

Even before the formation of the Society of American Artists, the rising generation of artists who returned from abroad with new ideas had expressed growing dissatisfaction with the complacency of the conservative Academy. As early as 1874 a group of them gathered at the home of the respected editor of *The Century Magazine*, Richard Watson Gilder, who, with his wife Helena de Kay Gilder, supported their cause.[15] At the Gilders' home on East Fifteenth Street they could discuss the new theories of art and their concerns about the lack of opportunities available to artists in America. Will H. Low, who attended these gatherings, referred to the Gilders' home as "an oasis in the first years of our return to our desert home, as it appeared to us in comparison to the flowery regions of art whence we came."[16] In fact, it was at the Gilders' that the rebellious artists met in 1877 to discuss the formation of the Society of American Artists.

The overriding European influence apparent in the work exhibited in the Society's first exhibition was noted by one critic who observed that most of the paintings had been done abroad.[17] Similar observations were made by subsequent critics, and by the time of the Society's third exhibition in 1880, it was reported that "the experiment was felt — even by its friends — to be daring and hazardous."[18] According to Low, sales were dismal: "No one sold anything; we were popularly supposed to be producing art for art's sake, and we were left severely alone to that delightful occupation."[19] Somehow the Society managed to continue, and later, under the leadership of William Merritt Chase, it thrived.

Two years after Chase's return to New York in 1878, he was elected president of the Society. He served in this capacity for one year, and later resumed the presidency for another ten years beginning in 1885. The meeting place of the Society shifted from the Gilders' home to Chase's Tenth Street Studio, and by 1884 it was clear to all that Chase was the dominant figure in the group. In July of that year, a writer for *The Art Amateur* criticized the Society for showing "deference to Mr. Chase...in placing his works on the line in such superabundance." This writer also claimed: "The admirers of Mr. Chase are, as was to be expected, in a majority of the exhibitors."[20]

Even before he returned to New York in 1878, Chase had achieved some degree of notoriety in America due to the success of the paintings he sent from Munich to major American exhibitions. In 1875 he exhibited *The Dowager* at the National Academy of Design, where it caught the attention of the artist Eastman Johnson, who purchased it.[21] The following year Chase's *Keying Up — The Court Jester*, a bold painting conceived, in part, to call attention to itself and its maker, was included in the Centennial Exhibition in Philadelphia, where it was awarded a medal. In 1877 he again exhibited at the National Academy, this time two works: *Broken Jug*, purchased by the artist Charles Henry Miller, and *Unexpected Intrusion (Turkish Page)*.[22] A critic for *The New York Times* praised these two works and reported the "signal honor" of Chase's commission to paint Piloty's children, calling it "not only a recognition of the artist's ability, but a compliment to America...."[23]

Chase's career continued to gain momentum. In 1877 three works were included in Chicago's Inter-State Industrial Exposition: *Keying Up — The Court Jester*, *Unexpected Intrusion (Turkish Page)*, and *Flower Girl* (making its debut in this country).[24] The two named last were then sent on to the Brooklyn Art Association's exhibition that December; *Keying Up — The Court Jester* went on to the National Academy of Design's annual exhibition of 1878. Once again this painting drew critical acclaim, being heralded as "one of the most vigorous specimens of figure-painting seen in the American Department of the Fine Arts at the Centennial Exhibition, and in the National Academy of Design...."[25] Continuing his praise for this painting, the writer declared: "The *Court Jester* is no fossilised type, but a distinct and original creation....In short, Chase's *Court Jester* is one of the most striking of recent American works, and from the genius that produced it the public have reason to expect much that will please."[26]

Broken Jug. c. 1876

Oil on canvas
61 x 25⅛ in (154.9 x 63.8 cm)
The Baltimore Museum of Art, Gift of Dr. and
Mrs. Donald Houghton Hooker in loving memory of
Dr. and Mrs. Donald Russell Hooker

Characteristically, Chase obliged the public's expectations by exhibiting what was then his most famous painting, *Ready for the Ride*, at the inaugural exhibition of the Society of American Artists in 1878. This painting created a sensation, attracted critical acclaim, and was quickly purchased by an art dealer. A leading critic of the day, Mariana Griswold van Rensselaer, noted that this was "a strange thing...to happen to the work of a new American painter, — it soon became the property of the Union League Club, and did more than anything else to introduce the young artist to his public...."[27] Interestingly, the dealer who purchased the painting was Samuel P. Avery, who was noted for his purchases of European art for wealthy Americans.[28]

On August 30, 1878, Chase set sail aboard the *Switzerland*, bound from Antwerp to New York.[29] Over a week passed before he realized that a fellow artist and friend, James Carroll Beckwith, was aboard the same ship. This surprise encounter was noted by Beckwith in his diary: "As I was aft I suddenly heard a voice shout out Hallo Beckwith and what was my astonishment to see Will Chase from Munich among our fellow passengers. Nothing could have more staggered me. He was going home like myself to try America after his six years in Germany."[30] Beckwith was returning from his own studies in Paris at the Ecole des Beaux-Arts. The two had met previously in Munich. Explaining why they had not encountered each other earlier in the trip, Beckwith noted: "The first eight days of our trip were abominable, a villainous sea — everyone seasick, and so much rain it was impossible to come on deck."[31] Presumably better days followed, during which the two artists were able to catch up on the past and discuss their plans for the future in New York. Both were returning to teach at the Art Students' League, where their friend Walter Shirlaw was the only instuctor.

Although Chase initially doubted his ability to teach, he was an immediate success. He arrived at just the right moment and possessed the right skills and personality to quickly become the most popular teacher in America. At this time there were reported to be at least thirteen art schools or clubs in New York that offered a program of instruction in painting, drawing, modeling, or various forms of the applied arts.[32] In joining the staff of the Art Students' League, Chase aligned himself with the most active and progressive of them. He also joined virtually every art club and organization New York had to offer; in the late 1870s he was active in the Society of American Artists, the American Watercolor Society, the Brooklyn Art Association, the Salmagundi Club, the New York Etching Club, the Tile Club, and the Art Club.[33] A gregarious and dynamic man, Chase moved in art circles with ease and charm, soon becoming one of the leading artistic figures of his day. By 1881 he was already placed by one critic "in the very first rank of his contemporaries — a reputation of ever-growing breadth as among the strongest and most satisfactorily productive of American artists, past or present."[34]

To understand Chase's remarkable ascendancy in so short a time, several factors must be considered. In addition to being an artist of exceptional talent and skill, he had a winning personality combined with ingenuity and abounding vitality. Beyond his convivial nature, which endeared him to many, he had the qualities of a true leader: strong beliefs, which he expressed boldly and articulately; assertiveness; tremendous energy; and great wit. Everything he accomplished in life was achieved through the most vigorous of actions. In fact, all aspects of his life reflected his dynamic spirit: his bravura brushwork, his forceful teaching, and his constant travel. With confidence and assurance he could complete a painting easily in an hour, a feat he willingly demonstrated to students, critics, and fellow artists. As soon as major works were finished they were sent off to important exhibitions around the country — often to be displayed in several cities the same year. Chase also managed to handle a full schedule of classes — at times teaching in several different cities during the same week.

Perhaps the most important factor contributing to Chase's immediate success was the impressive image he projected. Realizing the value of outward appearances and first impressions, Chase was quick to create a sophisticated and cosmopolitan image for himself — one that was probably intended to counter any references that might be made to his small-town upbringing. He accomplished this, in part, with his elegant attire: cutaway coat and trousers, a scarf drawn through a bejeweled ring securing his shirt, spats, a top hat, and a flower in his lapel.

Still Life (Still Life with Cockatoo). c. 1881
Oil on canvas
31³/₄ x 45⁷/₈ in (80.7 x 116.5 cm)
The Parrish Art Museum, Southampton, New York,
Littlejohn Collection

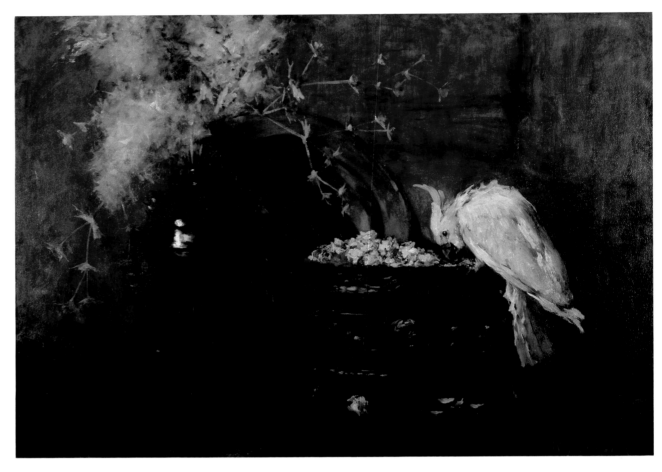

Wherever he went he was sure to attract attention, particularly when he strode down the avenues with several Russian wolfhounds in tow. The setting he created for himself was equally exotic and impressive. His studio, tended by a Negro servant dressed like a Nubian prince, soon became the most talked about studio in America. Whether calculated or not, this grand style of living drew the attention of the rich and fashionable, some of whom were invited to entertainments there, returning later to buy paintings or to sit for their portraits.

Just how Chase managed to seize the most desirable studio space in New York remains a mystery. The impact of his coup, however, is well recorded. In one account the artist Charles Henry Miller noted: "Mr. Chase upon returning to New York virtually took the town by storm, capturing its chief artistic citadel, and the exhibition gallery of the Tenth Street Studio Building became the sanctum sanctorum of the aesthetic fraternity, affording midst painting, statuary, music, flowers, and flamingos...symposia most unique and felicitous, never to be forgotten by charmed participants...."[35] The Tenth Street Studio Building was designed by Richard Morris Hunt and built in 1857 by the art collector and patron James Boorman Johnston. Chase's studio consisted of one spacious room adjoining an even larger one, which originally had been intended as an exhibition space for all of the artists living in the building. At some point this vast space had fallen into disuse and was secured by Albert Bierstadt, who composed his monumental landscape paintings there.[36] Chase, whose paintings were on a more modest scale, adapted this space to create an artistic environment for himself, filling it with a wide array of paintings, furnishings, and objets d'art.

In 1879, the *Art Journal* published a detailed account of the extraordinary paraphernalia to be found in this studio. Included in the lengthy inventory were: a piece of 17th-century German stained glass, a number of Japanese umbrellas, Egyptian pots, a Nuremberg chair, a Venetian tapestry, Italian swords, East Indian drums, a Renaissance chest, a Turkish coffee pot, a German silver lamp, and a Greek bronze of Apollo. Also mentioned were paintings by both old and modern masters, copies of old master paintings by Chase, and "a multitude of miscellaneous bric-à-brac."[37]

Azaleas. c. 1882
Oil on canvas
31 x 37 in (78.7 x 94.0 cm)
Collection of Mr. and Mrs. Aaron J. Boggs

Still Life, Flowers. c. 1900
Oil on panel
26 x 21 in (66.0 x 53.3 cm)
Collection of Mr. and Mrs. Walter H. Rubin

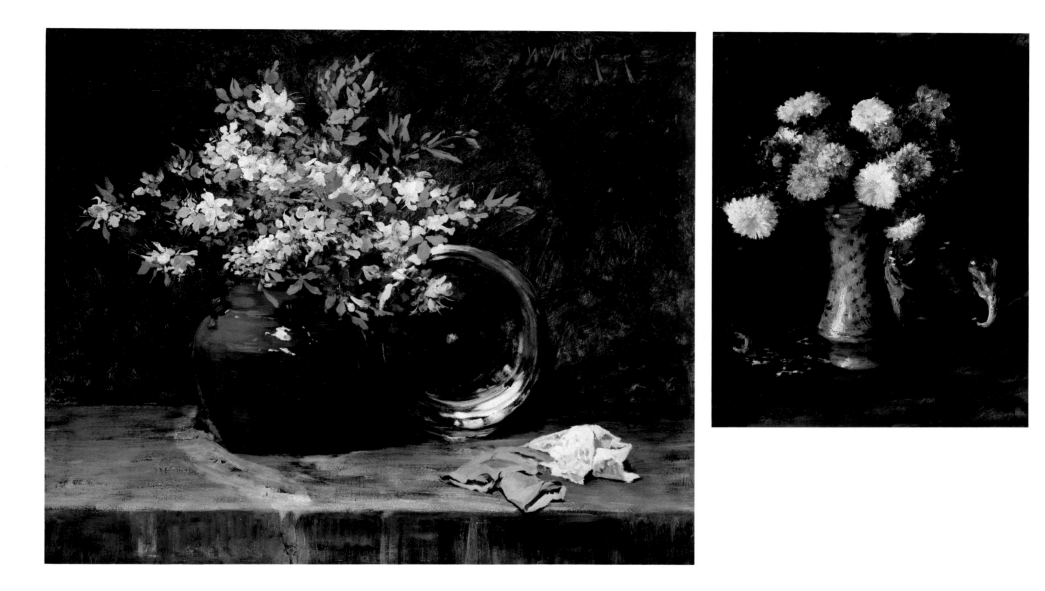

The Tenth Street Studio. begun c. 1881

Oil on canvas
47 x 66 in (119.4 x 167.6 cm)
Museum of Art, Carnegie Institute,
Pittsburgh, Purchase, 1917

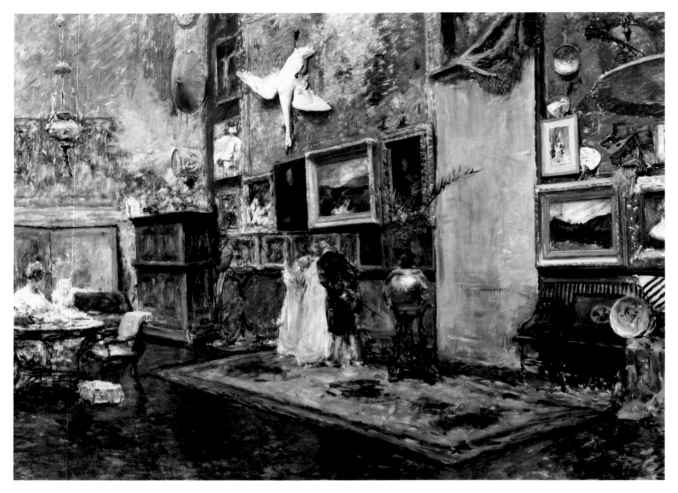

If an inventory was not enough to satisfy the public's curiosity — or to stimulate the interest of wealthy members of New York Society — a "guided tour" of the studio was provided in another article: *As you enter from the street, at the end of the hallway you will see a door, with a curiously carved bronze knocker. On the door is the painter's name, and the announcement that he is only at home to visitors on Saturdays. Turn to the left, and at the end of another passage you will find a second door, usually ajar. As you push it, an ingenious mechanism sets a musical instrument in motion, and [the] next moment you will find yourself face to face with the artist, in a dark, but sumptuous room, filled with treasures gathered together from half the curiosity shops in the old world.*

From this outer temple you pass through a doorway into a second and larger room, the studio proper. It is lighter and loftier than the first, less cumbered with curios, and contains the artist's most cherished paintings.[38]

Aside from patrons and art critics, the studio attracted art students who were privileged to receive personal instruction in this inspiring setting. Among them were Dora Wheeler, Henry Grinnell Thomson, Irving Wiles, and Reynolds Beal. In the book *Witch Winnie's Studio*, Elizabeth Champney has provided a typical student's response to Chase's studio: "a knock at Mr. Chase's door was the 'open sesame' to a magical change. A high studded room hung with tapestries and armour, and filled with beautiful carved furniture and rare old bric-à-brac, opened before us. This proved to be only an ante-room, for the servant, a negro in buttons, who reminded the imaginative Winnie of a Nubian slave, showed us into the studio proper, formerly the picture gallery of the building."[39]

For those who were not invited to the "temple of the arts," Chase provided an glimpse into it in the form of at least two drawings and several paintings. [40] In addition to providing the public with a visual account of the studio, the studio paintings, which were exhibited in various cities, introduced Chase to the art scene as well as to society.

Through these lavish paintings, Chase presented himself as a successful artist-gentleman, as well as a collector with refined taste. In part, these paintings also advertised Chase's services as an artist on a grand scale and in a dignified manner. In one, *Interior of the Artist's Studio (The Tenth Street Studio)*, 1880, Chase provides a scene

Portrait Study (Portrait of a Young Woman). **c. 1880**
Watercolor on paper
14³/₄ x 10³/₈ in (37.5 x 26.4 cm)
Collection of Mr. and Mrs. Raymond J. Horowitz

in which he himself appears. Seated with palette in hand, he has taken a break to chat with an elegant woman, suggesting that the studio was the proper setting for such visits, and that they were encouraged. Another view, *The Tenth Street Studio*, goes a step further by portraying several visitors actually inspecting the paintings on the walls. [41] After all, the artist's studio was also his salesroom, since at the time most dealers had no interest in representing American artists. Recounting the studio life of the period, John Moran aptly described the types of visitors an artist might expect: "loungers" (usually friends or fellow artists), "reporters" (critics), "sightseers," and "buyers" — "he it is who most frequently puts the artist out of temper." [42] As contentious as the last group of visitors may have been, they were the most necessary for the artist's survival.

Among the entertainments arranged by Chase to attract the city's social elite was a recital by Paderewski, held under the auspices of the Music Club. The invitation list was designed to include only "the most select set in New York." [43] Certainly the greatest of all the events staged at the Tenth Street Studio was the 1890 performance of Carmencita, "The Pearl of Seville," who dazzled Chase's wealthy guests with her fiery personality and spirited dances. It was inspired by two earlier performances by the dancer — one in the studio of J. Carroll Beckwith and the other in that of John Singer Sargent. Sargent was approached by the noted Boston collector Mrs. Jack (Isabella Stewart) Gardner to arrange another performance that she might attend. In an attempt to entertain Mrs. Gardner in a suitably grand setting, Sargent contacted Chase and requested the use of his Tenth Street Studio for the performance. Of course Chase agreed, and on April first the fête was held. According to Beckwith's diary entry for that day, things did not go well and the audience was rather "stiffish." Thus, a second performance was scheduled for April twenty-fourth. This time seventy-five people attended the event which Beckwith proclamined to be "a great success...passed off charmingly." Chase recorded it for posterity in his lively portrayal of the Spanish dancer, *Carmencita*. [44]

It was during Chase's early years in New York that his friend, the painter Frederick S. Church introduced him to Julius Gerson and his family,

cultured individuals who were supportive of young artists and writers.[45] By this time, Mr. Gerson's wife had died and the family consisted of three daughters — Virginia, Minnie, and Alice — and one son, Julius. Other artists who frequented the Gerson home were Walter Shirlaw, Frederick Dielman, Napoleon Sarony, and James Kelly.[46] Later the group included the artist Robert Blum and the writer Joaquin Miller.[47]

In 1878 the Gerson girls had been impressed by Chase's painting *Ready for the Ride*, which they saw at the Society of American Artists' exhibition. At their prompting, an invitation to the Gerson home was extended to Chase. Perhaps because of his active schedule, Chase did not accept the first invitation he received, or several others. Finally, in 1880, he visited the Gersons and met for the first time the young girl who would become his wife — Alice Gerson. At the time, Alice was about fourteen years old; Chase was thirty-one.[48] Her delicate beauty immediately attracted the artist's attention, and with the permission of her eldest sister, Chase soon engaged Alice as a model. Subsequently, he joined the "Gerson Circle" on numerous occasions.

A description of one of the *tableaux vivants* presented at the Gerson home suggests the spirit of their gatherings:

Juanita [Miller] opened their tableaux by being on a stage moon, draped with gauze, her chubby little arms about the crescent. It was after one of F.S. Church's paintings. Young Gerson played Gounod's "Reine de Saba" exquisitely during the showing. I like best of all their "Dejeuner à la Fourchette." Minnie and Virginia looked so very chic in their Parisian frocks. Then the beautiful Alice Gerson...posed as an Indian Maiden, scanning the landscape for her lover. It was all delightful, but it seems to me that the audience was as interesting as the performers...all their artist friends are so picturesque. There was Robert Blum with his just-graying, blond, Van Dyke beard. One could almost smell the cherry-blossoms he had been recently painting; carelessly groomed, and shaggy gray-mustached F.S. Church sat next to Minnie Gerson, and the carefully correct and immaculate William M. Chase was seated very close to Alice Gerson. Abbie, do you think they were holding hands?[49]

There was reputed to be some jealousy between Chase and his friend Church as they vied for young Alice's attention. The playful rivalry between the two has been humorously documented in a number of letters and caricatures inscribed to Alice, affectionately referred to as "Toady."[50] Eventually, Chase won out.

For six years his affection for the Gerson family, and particularly Alice, grew. Finally, in 1886, when she had reached the acceptable age of 20, Chase asked her to marry him. By this time, considered "a bachelor of the most confirmed type," Chase was a mature man of thirty-seven and a well-established artist.[51] Alice was described as "a handsome and spirited brunette of good family....Her figure is lithe and well rounded, and altogether she has the quality attaching to all good models, which is described among artists as paintable."[52] More than a lovely model, Alice proved to be a protective wife and a devoted mother to their nine children.[53] According to Katherine Metcalf Roof, who knew both the artist and his wife, Chase valued Alice's criticism above all others, and there were "countless ways in which her devotion...contributed to his success...." Roof explained: "She built around him, a wall that defended, but never restricted; a barrier that he might pass at will, but through which things hostile and antagonistic could not reach him. And if the absorbed artist was often unaware of the specific act, he was fully aware of the atmosphere created about him, and gave in return not only an amusingly abject personal dependence and unreserved artistic deference, but an absolute and truly romantic devotion to his wife."[54] This devotion and love was shared with their children, especially the first born, Alice Dieudonnée, her mother's name-sake. When asked why he singled out this one daughter as a special companion and the subject for many of his paintings, Chase replied: "Why, I don't know. She very much resembles her mother."[55] His many letters to his wife and children, written while he was away on trips, attest to the strong affection and concern he had for his family. The artist's successful career in the 1880s and 1890s must be considered against this personal background of his family and growing circle of friends.

■

Cyanotype of the Chase family in front of their Shinnecock Hills home, c. 1910.
From left: Mary Content, Roland Dana, Robert Stuart, Hazel Neamaug, Helen Velasquez, Dorothy Bremond, Koto Robertine, and Alice Dieudonnée (Cosy). In background, William Merritt and Alice Gerson Chase.
The William Merritt Chase Archives,
The Parrish Art Museum, Southampton, New York.

Portrait of Virginia Gerson. c. 1880
Oil on canvas
20¼ x 16⅛ in (51.4 x 41 cm)
Private Collection

Shinnecock Hills. c. 1892

Oil on canvas
20 x 46½ in (50.8 x 118.1 cm) (sight)

University of Georgia, Eva Underhill
Holbrook Collection of American Art,
Gift of Alfred H. Holbrook, 1945

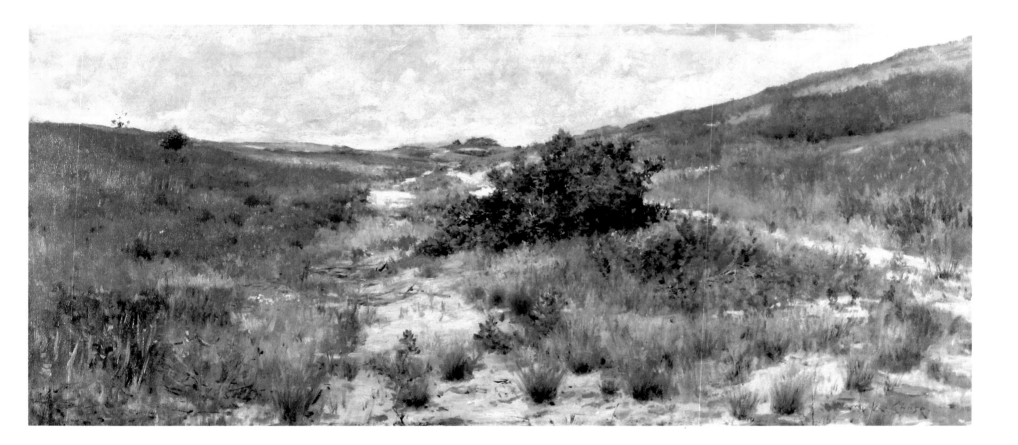

The Tile Club

"That sand place"—Long Island, where the Tile Club went in the summer of 1878 and again in 1881.

In 1877, the year before William Merritt Chase returned to New York from abroad, a group of artists in that city formed a club for producing art work of a decorative nature. "This was early in the autumn of 1877, when studios were being dusted out and men were going around and smoking fraternal pipes with one another and comparing notes about the results of the summer work out-of-doors."[1] Explaining the *raison d'être* of the club, one of the earliest members asserted "this is a decorative age....We should do something decorative, if we would not be behind the times." Another disagreed, claiming, "It is only a temporary craze, a phase of popular insanity that will wear itself out as soon as a new hobby is presented to take its place."[2] Once having agreed to form a club, the next item of discussion was just what type of decorative art should be practiced. Suggestions included fresco, wallpaper, and fabric design — all of which were vetoed. Finally the group agreed upon tiles, Spanish tiles of a cream-white color, glazed on one side and eight inches square.[3] Designs were to be drawn upon them in mineral colors, and then they were fired in an oven. Nearly all the finished tiles were monochrome, "Victoria blue" being the favorite color. It was determined that the club should be an informal group with no officers, no entrance fees or dues, and that membership should be limited to twelve. Meetings were to be held on Wednesday evenings at the studios of member artists on a rotating basis. Art supplies, consisting of tiles and a variety of German inks, and refreshments were to be supplied by one of those attending, who would receive in return the results of the evening's efforts. For refreshments "cheese and certain familiar species of crackers were admissible.

Sardines were not prohibited. Clay or corn-cob pipes and tobacco, and stone bottles of cider...completed the list."[4] The "Tile Club" was the name adopted by this organization, which was intended from the start to be very casual. When one "dangerous" member of the Club suggested changing the name to the "Anglo-American-Hibernian Association of Painters on Tiles, Limited," the others objected and "a title suggestive of an unwholesome ambition and otherwise of a generally inflammatory character was avoided."[5] In a similar vein, when one artist suggested that the members of the Club attend evening sessions in formal attire, he "only escaped expulsion by an abject apology and the payment of a fine of twelve bottles of ink."[6] This informality carried over to the demands placed upon each member — no number of completed tiles was specified, nor was any single subject dictated. The result was a wonderful array of spontaneous, and at times whimsical, designs created by some of America's leading artists. The efforts of these artists were featured in several articles discussing the activities of the Tile Club in *Scribner's Monthly* and *The Century Magazine* in the late 1870s and early 1880s.[7]

By the time the first article, "The Tile Club at Work," appeared in January 1879, William Merritt Chase had become a member of the Club. The article, which included one illustration by him, *Cockatoo Tile*, explained the genesis of the club, its general nature, and its plans for the future. Among the artists who were mentioned, by their Tile Club names, were the founding members: "The Bard" (Winslow Homer), "O'Donoghue" (William O'Donovan), "The Gaul" (Walter Paris), and "The Grasshopper" (Edward Wimbridge). Other artist-members included: "The Owl" (F. Hopkinson Smith), "The Chestnut" (Edwin Austin Abbey), "Sirius" (Charles Stanley Reinhart), "Cadmium" (J. Alden Weir), "The Marine" (Arthur Quartley), and "The Griffin" (R. Swain Gifford). Among the writer/journalists were "The Bone" (Earl Shinn), "Polyphemus" (William Laffan), and "The Husk" (Gustav Kobbe). Several members with "musical talent" included "The Horse Hair" (Antonio Knauth), "Catgut" (Dr. Lewenburg), and "The Barytone" (William C. Baird). Although Chase's tile was reproduced in the article, there was no

mention of his Tile Club name, "Briareus," in the text, which suggests that he was a recent addition to the group.[8] At the end of the article, F. Hopkinson Smith suggested that the group "go on a journey in search of the picturesque."[9] The destination was then discussed. Edwin Austin Abbey recommended the Catskills; R. Swain Gifford favored the Adirondacks; Arthur Quartley proposed the Isle of Shoals. The coast of Maine was the choice of Charles Reinhart. Finally, William Laffan asked: "Why not go to Long Island?" The others retorted: "That sand place?...There's nothing there...nobody ever was known to go there!" At that point, Smith exclaimed: "What! Nobody ever went there! Then that's the place of all others to go to!"[10] The other members agreed, and Smith then suggested that they produce an article documenting this journey, with the writer members of the Club providing the text and the artists the illustrations. He was sure they could sell it to a "grasping publisher."[11] Earl Shinn and William Laffan then debated the likelihood of such an interest on the part of a publisher. With the backing of *Scribner's Monthly*, their plans were realized.

In actuality, the Tile Club had made their summer journey to Long Island in 1878. The January 1879 article in *Scribner's Monthly* was merely intended to introduce the Tile Club to its readers, and serve as a lead-on to the account of their summer trip, "The Tile Club at Play," which would be featured in the next issue, February 1879. In this article the group's activities during the summer of 1878 are fully described and illustrated. The Club embarked from Hunter's Point, Long Island. Among those who participated were Laffan, Gifford, Reinhart, Quartley, Smith, Wimbridge, and Walter Paris. The first stop on their journey was "Castle Conklin" on Captree Island, which they reached via Babylon. The next stop was Mrs. Carpenter's Hotel in Ronkonkoma, which they reached by way of Sayville. They then traveled by train to Bridgehampton and walked, or rode in wagons, to East Hampton — which they referred to as "a painter's gold-mine."[12] After a stop at Gardiner's Tavern, the group proceeded to Montauk where they came upon a "scene of freshness and uncontaminated splendor, such as they had no idea existed a hundred miles from New York."[13] Their final stop before returning home was Shelter Island.

During the winter of 1878-79, the members of the Tile Club discussed plans for their next summer excursion. One member proposed that they "hire a schooner, and explore Long Island Sound, in search of literary and artistic remains; but the undulating character of the Sound waters caused the idea to be rejected."[14] Another "Tiler" suggested the Jersey shore, a proposal that was also rejected because of the preponderance of mosquitos and other insects. O'Donovan then "feebly" suggested a canal voyage, but no decision was made for several meetings. Finally, Smith reintroduced the idea of a canal trip, proposing that they hire a boat and travel up the Erie Canal. "After the first blush of insanity had faded away...the Club became deeply impressed with its practicability and attractiveness."[15] Smith and Laffan assumed responsibility for the arrangements.

The activities of the Tilers during their summer trip to upstate New York were fully recorded in "The Tile Club Afloat," published in *Scribner's Monthly*, March 1880. Those who attended (approximately twelve) met at the wharf at West Tenth Street on June 23, 1879. Present were: Smith, Reinhart, Quartley, O'Donovan, Weir, Gifford, Chase, Frederick Dielman, and Napoleon Sarony. A barge, the *John C. Earle*, was engaged for twenty days at seven dollars a day. It was lavishly decorated by the "Committee on Decoration and Home Comforts," with artistic trappings reportedly gleaned from the studios of Chase and Sarony. As might be expected "the artistic and decorative effect that was produced was excellent....The divans, that were easily translated into beds; the cushions, that were but pretexts for the diurnal concealment of pillows; the piano, the violins, the big dining-table, the arm-chairs and hammocks, the neat pile of fresh table-cloths and napkins, the excellent glassware on the side-board, the decency of the cutlery, the neat student-lamps and Chinese lanterns, and a certain grace in the profusion and a quality of ease in the general disposition, were extremely alluring."[16] The "major domo and brushwasher"[17] of this sumptuous setting, a black servant named Daniel, was bedecked with a "snowy linen cap and jacket and a long white apron."[18] Assisting him was a second servant named Deuteronomy.

The *John C. Earle*, with its exotic decor, attracted considerable attention as it wound its way up the Hudson. Passing Haverstraw Bay, it continued on to Albany, then to West Troy, where it stopped for supplies. At Troy, where the Erie Canal parts from the Northern Canal, the boat was pulled by colorfully decorated mules. "The Club felt a new sensation; it was as if the expedition had had a new and better beginning...."[19] At this point the Tilers hired a third attendant, Priam, who was appointed the "custodian of its bric-à-brac" and dressed in a decorative robe and fez.[20] Quite naturally, this exotic creature attracted the attention of Chase, who painted his portrait, which was later used as an illustration in the article with the identifying caption *Priam, The Nubian Ganymede*.[21]

For a time the group tied up at Weaver's Basin. On the Fourth of July they reached Saratoga, where they were honored by a visit from the mayor and councils of Schuylerville. The town fathers reciprocated the hospitality of the artists by sending carriages for them, "each of which had thoughtfully been furnished with...an elderly and communicative native."[22] The artists were also entertained by a re-enactment of Burgoyne's attack against the Americans and visits to historic homes in the area. These holiday festivities were topped by a strawberry festival and a visit to the barge by young ladies of the town, who delighted in trying on "the choicest morsels of the artistic shop."[23] Among the accessories available to choose from were a mandarin's crape robe embroidered with silk puppies, Mongolian pagoda hats, and Frans Hals ruffs.

Priam, The Nubian Ganymede. 1879
Oil on canvas
36 x 20 in (91.4 x 50.8 cm)
The University of Montana

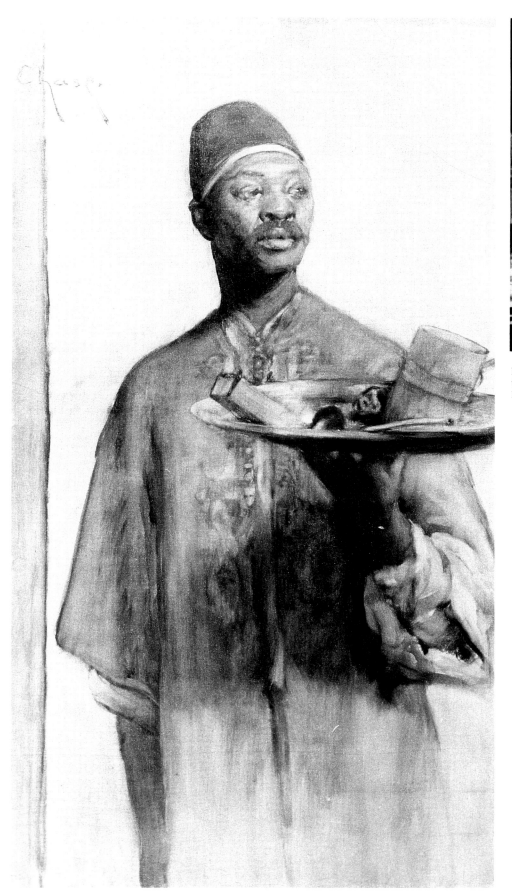

Interior of the *John C. Earle,* the barge the Tile Club
took on its canal trip in 1879.
Private Collection.

From Saratoga the Club proceeded along the canal, passing small towns where they were welcomed by local residents who, advised of their coming, gave them gifts of flowers and fruit. The artists reponded by admitting the townspeople to their floating museum of decorative arts and curiosities. Spotting a watercolor by Giovanni Boldini, one "astute lady" observed: "It is exactly like Frank Overton's wife paints on fans...,"[24] a naive comment that must have particularly amused Chase. After visiting a tile factory, the artists went on to Fort Edward, Fort Ann, and then to Lake Champlain. Soon bored by the lake, they turned and retraced their route to home. Colorful stories about the Revolutionary War, loyalists, and Indian attacks were enjoyed by all. Naturally, discussions also included talk about the Hudson River School, and the work of its members, "the good old mossy, geographical landscapes which used to crowd the holy precincts of the National Academy."[25] The Tile Club's own artistic endeavors were reported by the captain's wife, who claimed "they took sketches of the strangest objects and not of pretty ones. For example: they caught her over the wash tub one day, and, directly she appeared in a picture. Her daughter was feeding chickens one day, and they sketched her in that art. Every old mill or old shed delighted them...."[26]

The fact that Chase was represented by only one illustration in this article, and that there is no mention of him in the text, suggests that he was still not a major figure in the group, which was apparently dominated by the artist/illustrators and writers. In fact, it was not until the Club's trip in 1881 that Chase assumed a more visible role in the group's activities.

In the article that documented the summer trip of 1881, "The Tile Club Ashore," published in *The Century Magazine,* February 1882, the lapse in the accounts of the Club's activities is explained. "Since last these pages chronicled...the guileless Tilers, two years have gone. If in that interval nothing has been heard of the Tile Club, it is because the unostentatious practices and modest habits of that worthy body have led it to avoid the public gaze and to prefer the seclusive charm to be found within itself alone."[27] Although some changes are then noted, the reader is assured that the "spirit...remains the same."[28] Explaining

some of the changes, the article continues: "It began by painting tiles for mantelpieces and other and more obscure decorative purposes; and it will be recalled that, every member being the embarrassed owner of several mantelpieces and stacks of tiles, the Club took to decorating plaques....From plaques, the Club proceeded to matters more promiscuous. Its Wednesday night table would be covered with drawing boards, blocks of water-color paper, small canvases, charcoal and pencil paper, tiles and plaques; and brushes, paints, 'turps,' and materials of all kinds."[29]

In discussing their choice for a summer excursion in 1881, it was reported that "one-half of the members would be satisfied with nothing short of an ocean voyage."[30] It was only a matter of expense that prevented them from pursuing such a course. Especially pressed for funds, William O'Donovan announced to the others that spring: "You fellows...can go to Europe if you want to.... I propose to retire to a wind-swept beach."[31] He then proceeded to describe in picturesque detail a schooner, the *Two Sisters,* which had been cast up on a desolate beach on Fire Island by a winter storm. The site was about fifty miles by tugboat, and fresh spring water was available near the wreckage. In addition to providing a most picturesque setting, this stranded boat would provide a shelter from rain. Excited by the artistic prospects of this proposal, the Club agreed to join O'Donovan. The trip was scheduled for late spring; the Tilers met at the foot of West Tenth Street once again — this time to board the *P.B. Casket.*[32] Among those who attended were Laffan, Weir, Smith, Quartley, Gifford, Dielman, Shinn, Sarony, Chase, and John H. Twachtman. Accompanying the group was the ever-faithful servant Daniel, the *"cordon noir"* of the Club, who oversaw the loading of supplies needed for the excursion. The list of necessities included: "a refrigerator nearly as big as a parlor in a French flat, a capacious kitchen stove, pots, kettles, pans, broilers, some stovepipe, the decorated awning of the canal-boat, five or six tons of ice, sacks of sawdust and coal, packages of meats, two coops of chickens, and boxes of groceries without number."[33] Barely enough room was left for the passengers, who fortunately showed up in "light marching order."[34] The trip did not begin well. It was an unbearably hot day, and as the artists embarked, "the broiled citizens on the dock cheered with a dry and crackly cheer and waved their hats, and boys in the water played about the bow like the fry of mermaids."[35]

O'Donovan guided the captain to the selected site. Upon arriving, however, they noticed there was no wharf at which to dock the ship, so they were forced to reach the shore in a small boat that could only accommodate a few at a time. Chase was accompanied by Shinn and Laffan. Confronted by a rebellious wave, they reached shore "battered, punched, buffeted, and banged to pieces; breathless, dizzy, drenched, and full of salt water...."[36] Exhausted by their journey and the unloading of the endless supplies, the artists soon retired. The next afternoon, however, they were assaulted by another force of nature — the dreaded mosquito.

"It was a dispensation like one of the plagues of Egypt," complained one of the artists. "They bit at every available point. They betrayed no sense of fear, but went right to work without regard to the consequences. As fast as a whisk of a towel or a slap of a handkerchief killed or swept them off, others promptly took their places...every device and exertion [was] resorted to to mitigate the infliction. Nothing availed against them, and supper was eaten with a running accompaniment of gymnastics."[37] The next day another member of the Club arrived with nets. The ingenious Chase managed to utilize the newly arrived material to concoct a makeshift tent, under which he could sketch, unencumbered by the pesky insects. This contraption, inside of which is the artist at work on the beach, is depicted in his painting *A Subtle Device,* the lead illustration in the article.[38] Before abandoning this dreadful setting, the artists managed to paint a number of fantastic renditions of an imaginary sea serpent. Chase's was chosen for inclusion in the article.[39]

In an attempt to escape their misery, the Tilers decided to move on to Port Jefferson, "a 'tiley' town by the sea, not far away — a place of peace and cheapness" that had been suggested by Arthur Quartley. On the north shore of Long Island, the

A Subtle Device. 1881
Oil on canvas
11½ x 18½ in (29.2 x 46.2 cm)
Private Collection

Tile Club found relief. They discovered an inn that was large enough to contain all of them, and a landlord who received them kindly and gave them neat and comfortable bedrooms at an astonishingly low rate. At the inn a piano and an organ were put to "active employment" by the club members with musical talents. The artists were pleased with their new surroundings, with picturesque subject matter in abundance and comfortable quarters at hand. Before leaving they paid homage to the area's most celebrated artist by visiting the homestead of William Sidney Mount. Describing this segment of the trip, the article ends: "They were happy days about the shipyards, the old houses, and the orchards; days of extemporized clam-bakes on the pebbly beach, of long swims in the clear blue waters of the harbor, of excursions through the hills and the valleys by the Sound, of sketchbooks filled to overflowing...."[40]

This was Chase's first trip to eastern Long Island — an introduction to the broad expanses of land and ever-changing skies. It was also a time when he began to take a serious interest in painting landscapes out-of-doors. His painting *A Subtle Device* — which may be considered a self-portrait of the artist as a plein-air painter — was a precursor of things to come. In the early 1880s landscape painting became a major theme for Chase during several summer trips to Holland; in the 1890s he would return to Long Island, where he was to produce some of the most accomplished and beautiful landscapes painted at the turn of the century.

■

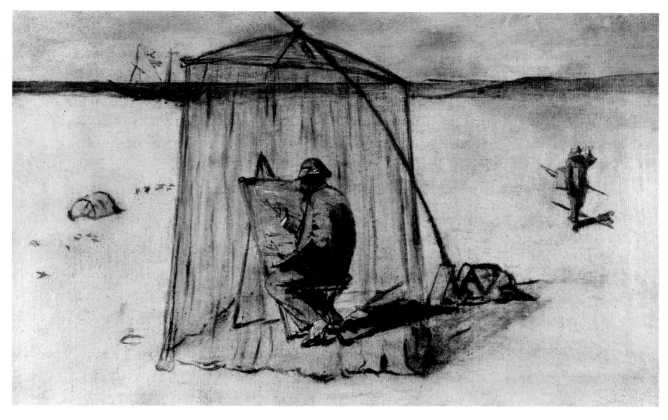

A Countryman. c. 1881

Ink and crayon on paper
15 x 11 in (38.1 x 27.9 cm) (sight)
Collection of Herbert and Susan Adler

Seated Woman Seen from the Back. c. 1885

Brush and black wash on paper
16⁷/₈ x 13⁵/₈ in (43.0 x 34.8 cm)
The Cooper-Hewitt Museum, The Smithsonian
Institution's National Museum of Design,
Gift of the Day Art School, Cooper Union, 1938

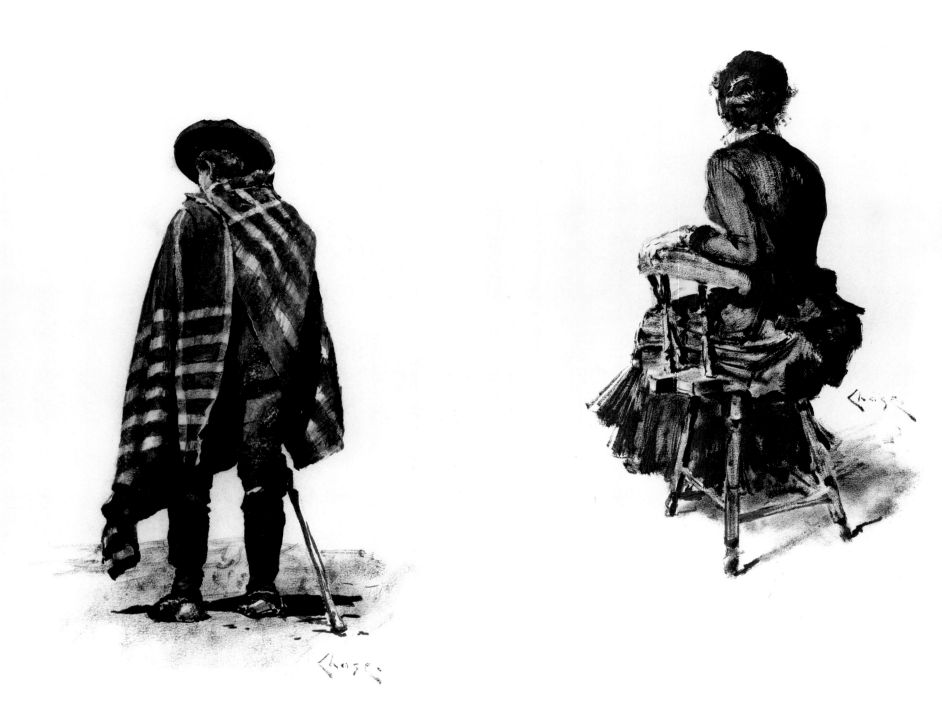

Self Portrait. c. 1879
Pencil on paper
15¼ x 11⅞ in (38.7 x 30.2 cm)
Private Collection

Outskirts of Madrid. 1882

Oil on canvas
32¼ x 46 in (81.9 x 116.8 cm)

Yale University Art Gallery,
Gift of Duncan Phillips, B.A. 1908

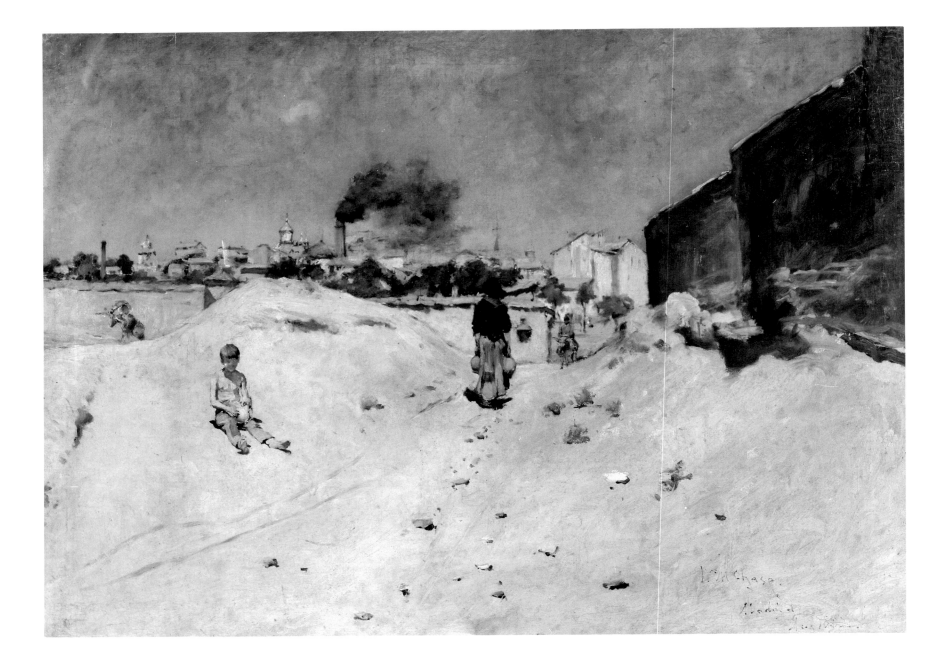

Artists Abroad

When in the early spring of 1881 the Tile Club discussed the possibility of a trip to Europe that summer, Chase was no doubt one of the prime advocates of this proposal. After the Club decided on Long Island as their destination, Chase yielded to popular demand and accompanied the group to the island's sandy shores. It is not surprising, however, that Chase still managed to get his own way, returning to New York by the first week in June to accompany J. Carroll Beckwith and another group of artist-friends on a trip abroad. This trip would be Chase's first return visit since he had left Europe in the summer of 1878. Several factors probably prompted Chase's decision to make the journey. He was undoubtedly disappointed by the Tile Club's ultimate decision to remain home that year, and he yearned to see the work of the old masters which were so plentiful in the galleries of the Continent. This desire was heightened by J. Carroll Beckwith's animated descriptions of Velasquez' paintings, which he had seen at the Prado the previous summer.[1]

Learning of Beckwith's plans to return to Europe that year, Chase, "one of the most ardent admirers of Velasquez," decided to take advantage of the opportunity to join his friend.[2] Other members of the party included Robert Blum, Herbert Denman, Abraham Archibald Anderson, and a decorator by the name of Lawrence.[3] En route to Madrid, Chase planned to visit Paris, where his painting of Frank Duveneck, *The Smoker*, had been awarded an honorable mention in the Paris Salon exhibition of that year. The group departed on June 4, 1881.

Although Chase apparently kept no record of this trip, bits and pieces of his daily activities can be gleaned from Beckwith's diary. According to Beckwith's notes, Chase suggested that the artists entertain themselves aboard ship by decorating the wall panels of the ladies' cabin with their paintings. Initially Beckwith was reluctant to take part in this venture, but he eventually joined in, admitting "all went to work at our panels to the great interest of the passengers and our own infinite amusement."[4] The captain of the ship was equally delighted with the results of the artists' efforts; and "the ladies' cabin became a showroom while the pictures were allowed to remain."[5]

On June sixteenth the group landed in Antwerp and went directly to Paris, arriving the next day. While in Paris, Beckwith took Chase to meet Emile Auguste Carolus-Duran, who had been Beckwith's teacher.[6] They also visited John Singer Sargent, who, as a fellow student, joined Beckwith in assisting Carolus-Duran in painting a large ceiling decoration for the Louvre in 1877.[7] Chase parted from Beckwith on July second, bound for Madrid to see the Velasquez paintings at the Prado. While there, he corresponded with his friend Robert Blum, who had gone on to Venice.[8] He also wrote to his beloved "Toady" (Alice Gerson). Apparently she had not written to him, and feeling a bit lonely, he chided her: "Perhaps my friends have found someone else who pleases them better than I do and that is the reason why I do not receive a letter...." He then reminded her that there was still time to get a letter from her if it were written *"immediately."* In closing, he declared himself to be one of her "most ardent admirers."[9]

According to Katherine Metcalf Roof, Chase did not complete many paintings during his two-month visit to Spain, occupying himself instead with the study of Velasquez and other masters of Spanish painting. A contemporary report supports this, noting, "As the results of his recent stay in Madrid he has brought back a street scene, which is a study of luminous sunlight, a sketch of a dancing girl, and some large copies of Velasquez."[10] On September fourth, Chase returned to Paris, where he spent another week before leaving for home. The day of his arrival in the French capital he accompanied Beckwith to the Louvre and visited John Singer Sargent once again. The three artists were then joined by Abraham Archibald Anderson for breakfast at Lavenue's. Before turning in that night, Beckwith noted in his diary the improvident means by which Chase maintained his finances. Comparing Chase's casual approach to his own meticulous method of budgeting, Beckwith wrote: "I calculate my money with a cold perspiration and Chase landed here without enough to go to Antwerp."[11] Undaunted by this state of affairs, Chase accompanied Beckwith the next day on visits to galleries and to call upon the artist Alfred Stevens, a Belgian painter who had gained considerable acclaim in Paris. Among the topics of discussion was the Paris Salon exhibition, and specifically Chase's painting *The Smoker.* Reportedly "Stevens gave the highest praise to Chase's beautiful portrait of Duveneck...."[12] However, he then went on to criticize its antiquated look: "Chase, it is good work, but don't try to make your pictures look as if they had been done by the old masters."[13]

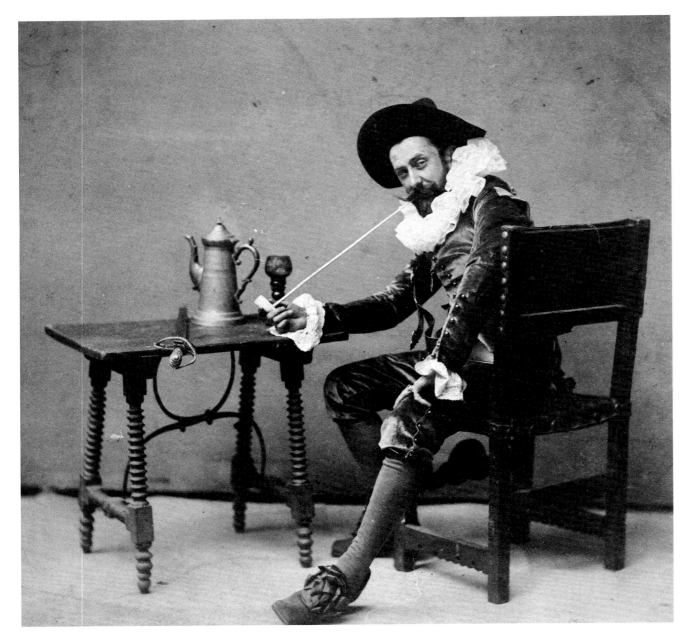

Chase in period costume, Munich, c. 1876.
The William Merritt Chase Archives,
The Parrish Art Museum, Southampton, New York.

Later Chase credited Stevens for opening his eyes to this fault of Munich-trained artists and went on to lighten his palette and paint more modern subjects. However, he must have been suprised initially by Stevens' criticism. After all, he had just been awarded a prestigious honor for *The Smoker*, and he had dedicated his entire summer to the study of Velasquez. Another likely topic of conversation during this visit was their mutual admiration for the work of Edouard Manet, whom Stevens knew personally.

In anticipation of their return to New York, Chase and Beckwith spent September sixth running a number of last minute errands. That evening they joined Anderson for dinner at the "Boeuf à la Môde" and then went on to the Opéra Comique. The next morning Anderson provided his two friends with a "stunning brake-fast," which was followed by another afternoon of errands and topped by a dinner arranged by J. Alden Weir — apparently in honor of their departure. Although this is the first mention of Weir in Beckwith's notes on this trip, Chase had probably met him in Paris before that evening. According to Roof, it was Chase who had encouraged Weir to purchase two paintings by Manet, *Boy with a Sword* and *Woman with a Parrot,* for the wealthy New York collector Erwin Davis. [14] Although there is no documentation for Roof's claim, Dorothy Weir Young quoted Weir's own version of the transaction, which confirms that Chase and Weir saw the pictures together. [15] In either case, Chase's role in the acquisition of these two major paintings for Davis is significant. They were the first works by Manet to enter a private collection in America, and shortly afterwards, when given by Davis to The Metropolitan Museum, they became the first Manets in a public collection in this country. As noted by Frances Weitzenhoffer, "it took quite some time until the two Manet paintings would begin to win acceptance, let alone appreciation. For close to two decades they hung in the museum's nineteenth century galleries as the sole representatives of modern French art....During that period of neglect William Merritt Chase was one of the few steadfast champions of Manet's canvases...." [16]

Chase departed Paris in ill health, arriving in Antwerp on September ninth with a "fearful headache." The next day the artists were once again aboard the steamship *S.S. Belgenland* and bound for home. Beckwith was delighted that he was able to get the same stateroom he had enjoyed on the trip over, which this time he shared with

Chase. In his final diary comments on the trip, Beckwith recorded that Chase generally turned in early at night (unlike himself) and that they were getting along "admirably together."[17]

In the summer of 1882, Chase and a group of artist-friends planned another trip abroad, similar to the voyage of 1881. The party consisted of the regulars: Chase, Beckwith, Blum, and Anderson, who were joined by the artists Arthur Quartley, Frederick Vinton, Ferdinand Lungren, and George Wharton Edwards, and the writer Clarence C. Buel.[18] Their aim was to visit the Paris Salon exhibition and then go on to Spain and Holland to study the work of the old masters. While aboard ship they had intended to decorate one of the cabins, much in the manner of the previous year's work. Afterwards, these paintings were used to illustrate an article describing their journey. Written by Buel, it was later published in *The Century Magazine* in January of 1884, under the title "Log of an Ocean Studio." This procedure was, of course, similar to that which had been practiced by the Tile Club.

The group left from the Jersey City Wharf aboard the *S.S. Pennland* on June 3, 1882. Buel characterized the affair as "the vacation fancies of seven artists voyaging to Antwerp,"[19] crediting Chase, Beckwith, Blum, and Anderson for originating the idea of decorating one of the cabins of the ship. A special attempt was made to secure the ladies' cabin once again as the setting for their decorative efforts. This novel scheme, he pointed out, had been based on a new principle developed by the young artists: "art for the sake of the ladies' cabin."[20] However, Buel reported: "It was a bitter disappointment...to learn after we were well out to sea, that — excepting the little lounging room at the head of the main companion-way — the ladies' cabin was an artifically lighted room between decks. Both were impracticable. So the enterprise had to be remodeled on the basis of 'art for art's sake,' which any artist will tell you is something of a humbug."[21] After exploring several other possibilities which proved to be equally unsatisfactory, the artists finally accepted the captain's offer of his cabin.

The space was described as "uncommonly large....It had a cozy look, with its sofa alcove and its red curtains, despite the overplus of chronometers and barometers. A miniature hall, with outer and inner doors, connected with the deck on the port and the starboard sides. Windows on three sides...commanded a view of the sea for half the circle of the horizon, and of the forward deck...."[22] Although there was no set schedule for their work, and social activities took up a good part of the time, it was reported that "no day passed without a little serious work with brush and palette."[23] The cabin was spacious enough for three artists to paint at one time, but Buel observed that this was rarely the case: "If one was at work, the rest were content to sit in the captain's easy-chair and on his camp-stools, and even on his narrow bed...and keep up a ripple of chat and criticism."[24]

Five of the six panels over the sofa in the alcove were sketched in within a few hours. Their completion, however, depended on a matter of "mood, with the results of fluctuating value."[25] The range of subjects in this decorative ensemble was actually quite broad. Several artists created illustrations directly related to their experiences on the trip. Among these was Anderson's *Farewell to Sandy Hook*, in which he presented a fair maiden aboard ship bidding adieu to her native land as the ship departs for sea.[26] Other artists depicted actual personages aboard ship, with Frederick Vinton choosing the captain as his subject and Robert Blum painting a figure titled *The Emigrant Model*.[27] Another work by Blum, *Flying the Great Kite*, illustrated an event on the journey.[28] During the course of the trip the artists enjoyed flying kites off the deck of the ship, generally with limited success. These experiments culminated in the construction of an enormous kite made of ash sticks and a linen sheet, five feet long. "On its face was painted a red-eyed monster intended to resemble the legendary dolphin."[29] After several attempts to launch this grand monstrosity, their efforts were thwarted: "With a grand sweep 'The Flying Dolphin' dove to port, skimmed the water and soared again, but only to snap the quarter-inch hemp cord at the deck ring. Then with a back somersault it fluttered into the water and was lost to view in the froth of a wake."[30] In a similar manner, other experiences were recorded by the marine painter Arthur Quartley in his panel *Moonlight through the Lifting Fog* and his painting *Petrels Following in the Steamer's Wake*.[31] In the latter Quartley depicted a flock of birds that had followed in the wake of the ship living off the scullery refuse that was thrown overboard on a regular basis. Buel noted that "every night at sunset they disappeared, dropping, as we supposed, upon the water to sleep; but every morning before eight o'clock they would be in their old places, sailing back and forth over the wake in figure-eight curves."[32]

In a more fanciful vein, Beckwith contributed *The Comet*, an allegorical figure representing a comet that had pierced the sky the previous winter.[33] Chase's own contributions — *Under a French Sky* and *A Mediterranean Memory* — were somewhat nostalgic, reflecting his fond memories of the journey the year before.[34] To complete the decorative scheme, the artists had to contend with the panels holding a chronometer and barometer. Beckwith and Chase soon resolved this problem in a clever fashion. The barometer, "being in a round metallic case," was treated as a "cylinder revolving on the feet of a juggling clown, who lying supinely beneath it, applied the rotary motion with two remarkably expressive black-and-yellow-striped legs. Underneath was painted the punning motto, 'One fair turn deserves another.'"[35] The companion panel presented "a frivolous young man in full dress, dancing a jig with the chronometer held in his hands over his head. The motto was 'A Good Time.'"[36] The finishing touch was a ceiling decoration of spreading branches of Japanese quince painted by Robert Blum.

One of the most memorable social events that took place on the ocean voyage was a dinner in honor of the birthday of Mariano Fortuny y Carbó, arranged by "a disciple of Fortuny" (Blum) and "a disciple of Velasquez" (undoubtedly Chase).[37] The gala affair, held on the evening of June ninth, was a lavish feast, accompanied by hand-decorated menus and speeches in tribute to this Spanish artist. On the fourteenth day of their journey, upon landing in Antwerp, the group honored another artist, the Flemish Peter Paul Rubens.

At the Shore. c. 1882
Oil on canvas
22¼ x 34¼ in (56.5 x 87.0 cm)
Collection of Mr. and Mrs. Prentis B. Tomlinson, Jr.

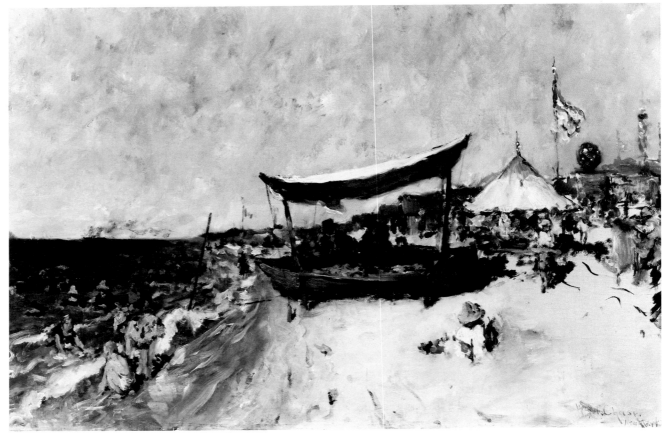

Since Chase did not keep a personal record of this trip, an account of his activities is once again limited to information provided in Beckwith's diary and letters written by the other artists involved. According to Beckwith, they arrived in Paris June seventeenth and immediately visited the Paris Salon exhibition.[38] Included in this show was Chase's *Portrait of Peter Cooper (The Burgomaster)*, painted in the style of the old masters despite Stevens' reprimand of the previous year.[39] The group then dined at their favorite restaurant, the "Boeuf à la Môde." The next day Chase and Beckwith were joined by Sargent for lunch. Five days later (June twenty-third) Chase, accompanied by Blum and Vinton, departed for Spain. Their destination was Madrid, where they studied the works of the old masters and more modern Spanish artists such as Fortuny. By late July, Chase had convinced Blum and Vinton that they should also visit Toledo, which Blum later described as an old place that provided him with a state of mental serenity.[40] By the time Blum returned to Madrid, Chase and Vinton were already on their way to Holland, stopping in Paris en route.[41] Before leaving Paris, Chase planned to visit Giovanni Boldini.[42] The three artists were reunited on the *S.S. Pennland* September sixteenth.

On the return trip, Beckwith noted: "Our party is particularly social and Chase, Blum, and I have jolly chats together."[43] His last pertinent comment about the trip was made on September twenty-ninth, when he mentioned the trouble that Chase, Vinton, and he had had in getting their belongings through customs. As might be expected, Chase had "collected a vast amount of bric-à-brac, stuffs, curios, and pictures in Spain."[44] He was able to take only a portion of it back with him; the rest was sent on later. It is unlikely that Chase actually completed many paintings during this trip, although at least one ambitious work, *Outskirts of Madrid*, is documented to this time.[45]

■

The East River. c. 1886
Oil on panel
10 x 15³/₄ in (25.4 x 40.0 cm)
Collection of Thomas and Rebecca Colville

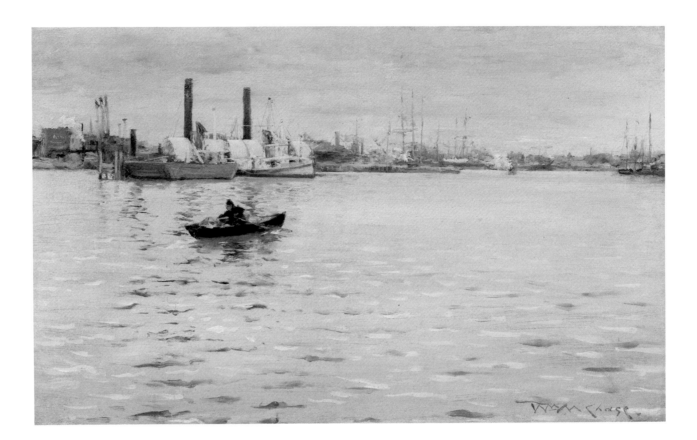

Garden of the Orphanage, Haarlem, Holland
(The Garden of the Orphans;
Courtyard of a Dutch Orphan Asylum). **c. 1884**

Oil on canvas
66⁷/₈ x 79¹/₈ in (169.9 x 201.0 cm)
Washington University Gallery of Art, St. Louis, Missouri

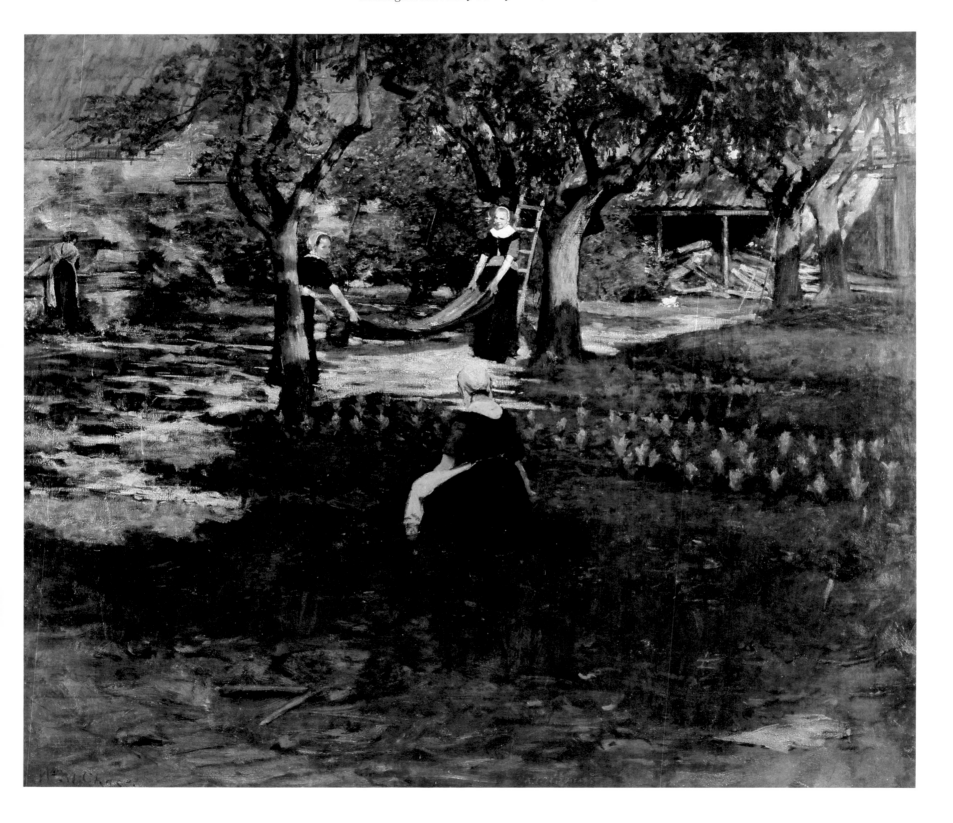

The Pedestal Fund Exhibition

In 1883 William Merritt Chase spent a great deal of time and energy on the organization of two important exhibitions. As a member of the "Munich Jury," Chase joined his associates in selecting American paintings for the Munich Crystal Palace exhibition of 1883. Judging from J. Carroll Beckwith's notes, work on this project had begun by April of that year.[1] By May first the jury had been chosen, and the following week Beckwith, Chase, and Augustus Saint-Gaudens departed for Boston to make selections for the show; Frederick Vinton joined them there. Apparently the jury's work was completed quickly since Beckwith's notes on May twelfth shift to the artists' work on another committee. This group, of which he and Chase were also active members, was responsible for organizing the Bartholdi Pedestal Fund Art Loan Exhibition. The major purpose of this show, scheduled to open in New York in December of 1883, was to raise funds to construct a pedestal for the Statue of Liberty. This monument, designed by the sculptor Frédéric-Auguste Bartholdi, was presented to the American people by the French government to commemorate the anniversary of America's independence. The committee held several preliminary meetings before Chase left for Europe on June 2, 1883.[2] Frederick Freer accompanied Chase, and H. Siddons Mowbray met them on board ship.[3] They traveled aboard the S.S. *Pennland*, the same steamship Chase and his associates had decorated with their paintings the previous summer. Chase insisted that Freer and Mowbray take part in a similar venture on this journey.[4] This time the smoking-room was singled out for their decorative scheme, with Chase contributing a painting of a Spaniard in a large hat.

Unfortunately there is no record of Chase's activities while he was in Europe; one can only speculate on his itinerary. It seems plausible that he would have visited Paris, where two of his paintings, *Portrait of Miss Dora Wheeler* and *Young Girl Reading*, were on view at the Paris Salon exhibition — especially since the former was awarded an honorable mention.[5] Judging from the subjects of paintings he exhibited after returning home from this trip, *Spanish Bric-à-Brac Shop* and *Garden of the Orphanage, Haarlem, Holland (Courtyard of a Dutch Orphan Asylum)*, it is also fair to assume that he visited Spain and Holland.[6] A series of pastels depicting scenes in Holland has also been ascribed to the summer of 1883. Among

these are: *Dutch Orphan, Bit of Holland Meadow, Canal in Holland, Dutch Canal* and *North Sea, Holland.*[7] Another pastel, *The Dividing Line*, was drawn on board ship while Chase was returning to New York.[8] A contemporary writer described this work as "a view on the deck, where a sail hung across from the cabin to the side separated the steerage passengers from those of the cabin. A few heads and feet of the steerage people are seen close to the canvas as they peer over and at the side, and there is a glimpse of the feet and part of the skirts of a young lady as she passes up a bridge ladder."[9] The same writer observed that these pastels had attracted considerable attention from the artists who had seen them.

Once back in New York Chase began working closely with Beckwith on final arrangements for the Bartholdi Pedestal Fund Art Loan Exhibition; their diligence is discernible from Beckwith's diary entries. They met regularly and sought out collectors who would lend their paintings to the exhibit. Noting his own dedication to this project, Beckwith wrote on November fourteenth, "I am so resolved to make this Loan for the Pedestal a success that I have given about all of my time." At another point he said less patiently: "I am heartily sick of committees and meetings."[10] However, the two artists persevered. Among the important collectors they visited was Erwin Davis, who agreed to lend his two paintings by Manet, *Boy with a Sword* and *Woman with a Parrot*.

In preparation for this major display of art and artifacts, Chase served on five committees: the Executive Committee, the Committee on the Admission of Objects, the Committee on Painting and Sculpture, the Committee on Decoration, and the Reception Committee.[11] As chairman of the Committee on the Admission of Objects, Chase oversaw the selection and arrangement of all items falling into this category. Quite naturally, he was also an important lender to this section of the show. The various objects he lent, which reflect his eclectic taste, included: a bullfighter's sword, a Persian dagger, an Algerian gun, a Spanish lock, a Dutch snuffer, a Japanese bell, an Italian lantern, and a collection of thirty-four rings.[12]

The most important committee, Painting and Sculpture, was chaired by Beckwith. Evidently Chase was also very active in selecting artworks for the show. A contemporary writer referred to the two artists as "the working members" of this committee. Praising their discrimination, this writer continued, "great credit is also due for their determination to admit nothing that was mediocre in execution or of low artistic aim."[13] In a similar

vein, another writer declared that this "remarkable collection of paintings will be the most purely artistic that has yet been shown in this country and take rank with that of the 'Hundred Masterpieces,' which was a late Paris sensation." He then noted, however, that the selection was "a little one-sided in its views...but the error is on the right side, and such a triumphant array of the work of the poet painters, the modern masters who rank with those of old time, will not be seen for many a long day."[14]

There were 194 works of art listed in the catalogue, borrowed from fourteen collectors and eight dealers.[15] The selection was dominated by paintings of the French Barbizon school and their Dutch counterparts. Other French artists generously represented included Antoine Vollon, Ferdinand Roybet, Augustin Théodule Ribot, and Adolphe Monticelli — all greatly favored by Chase. Other painters he admired who were represented were Alfred Stevens, Giovanni Boldini, Alberto Pasini, James Joseph Jaques Tissot, Gaston La Touche, and Pascal Adolphe Jean Dagnan-Bouveret. Although more academic paintings by artists such as Jean-Baptiste Edouard Detaille and Jean Louis Ernest Meissonier were included, their placement under the stairway reflected the low regard Chase and Beckwith had for such art. Defending this isolated placement, they explained that the paintings were "somewhat out of keeping in general character with those in the chief picture gallery."[16] In contrast, the position of honor was granted to Manet's *Boy with a Sword*; his *Woman with A Parrot* was placed nearby. The watercolor *Toreador* completed the selection of his work. Among the other works by the French Impressionists and their circle were Edgar Degas' *The Ballet*, Giuseppe De Nittis' *Place de la Concorde, Paris*, and James Abbott McNeill Whistler's watercolor *Snow*. As the opening day neared, all were reported busy with the final arrangements. Beckwith and Chase were described as "gayly singing about their task of hanging the superb collection of works which they...selected."[17] It was also observed that they stopped now and then to "ecstacize" over some masterwork. Others tended to more mundane details: "the laymen and ladies in the smaller galleries and the corridor arrange the sections and cases allotted to their care, cut up the sheets of numbers, compare lists, and correct the catalogue proofs."[18] As soon as the objects were in place, the Decorations Committee, consisting of Beckwith,

Modern Magdalen. c. 1888
Oil on canvas
19 x 15¼ in (48.3 x 38.7 cm)
Private Collection

Chase, and Louis C. Tiffany, added the finishing touches. A contemporary critic noted that they chose to keep the decorations in the main gallery simple, but "elsewhere they promise to be rich and effective."[19]

The Reception Committee was carefully balanced between New York's most prominent artists and collectors. The artists included: Chase, Beckwith, Saint-Gaudens, Eastman Johnson, Daniel Huntington, Worthington Whittredge, F. Hopkinson Smith, and Candace Wheeler. Cornelius Vanderbilt, J. Pierpont Morgan, and John Taylor Johnston were among the wealthy collectors.[20] The opening reception was a gala affair, with an introductory speech given by F. Hopkinson Smith.

Midway through the exhibition, Beckwith noted that the show was actually "losing $100 a day."[21] In a controversial move, the committee decided to open the exhibition on Sundays, in hopes that the attendance of the working classes would increase door receipts. Smith, Beckwith, Chase, and several other members of the Executive Committee even volunteered to risk arrest if the "Sunday Closing League" demanded police action.[22] Attendance was overwhelming on the first Sunday, and since no arrests were made, the doors were kept open the following Sunday as well. One reporter noted "that the hosts of Satan gained not a single recruit through this departure from the [Sunday closing] rule...."[23]

In addition to door receipts, there were proceeds from the sale of a "richly bound" album with contributions from artistic, literary and political figures. Chase and many artists from his circle donated sketches in watercolor or ink.[24] In all, the exhibition was reported to have raised over $12,000.[25]

Beyond providing money for a worthy cause, this exhibition had other important effects. It united American artists and wealthy collectors in a common effort. It also provided the general public with a view of fine nineteenth-century European art, and served to stimulate more interest in art in general. And, by including several paintings by the French Impressionists and placing Manet's work in a prominent position, attention was drawn to some of the more progressive trends in art. Although Boston had been host to a more extensive and comprehensive showing of French Impressionist paintings organized by Durand-Ruel earlier that year, the New York show was selected by American artists — and it would be another three years before French Impressionist paintings would be displayed again in New York.

■

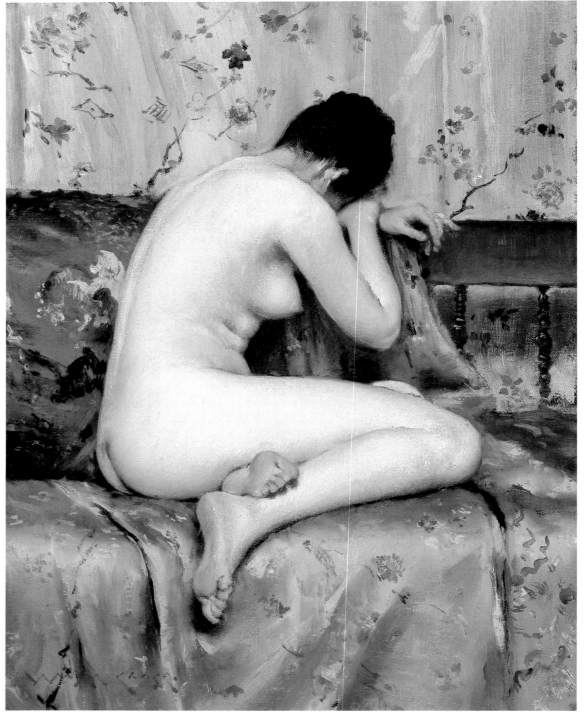

A Study in Curves (Reclining Nude). c. 1890
Oil on canvas
22 x 40 in (55.9 x 101.6 cm)
Collection of Jason Schoen

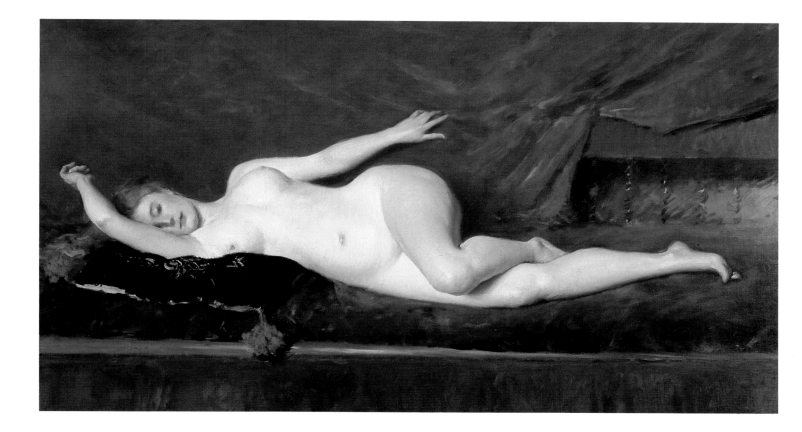

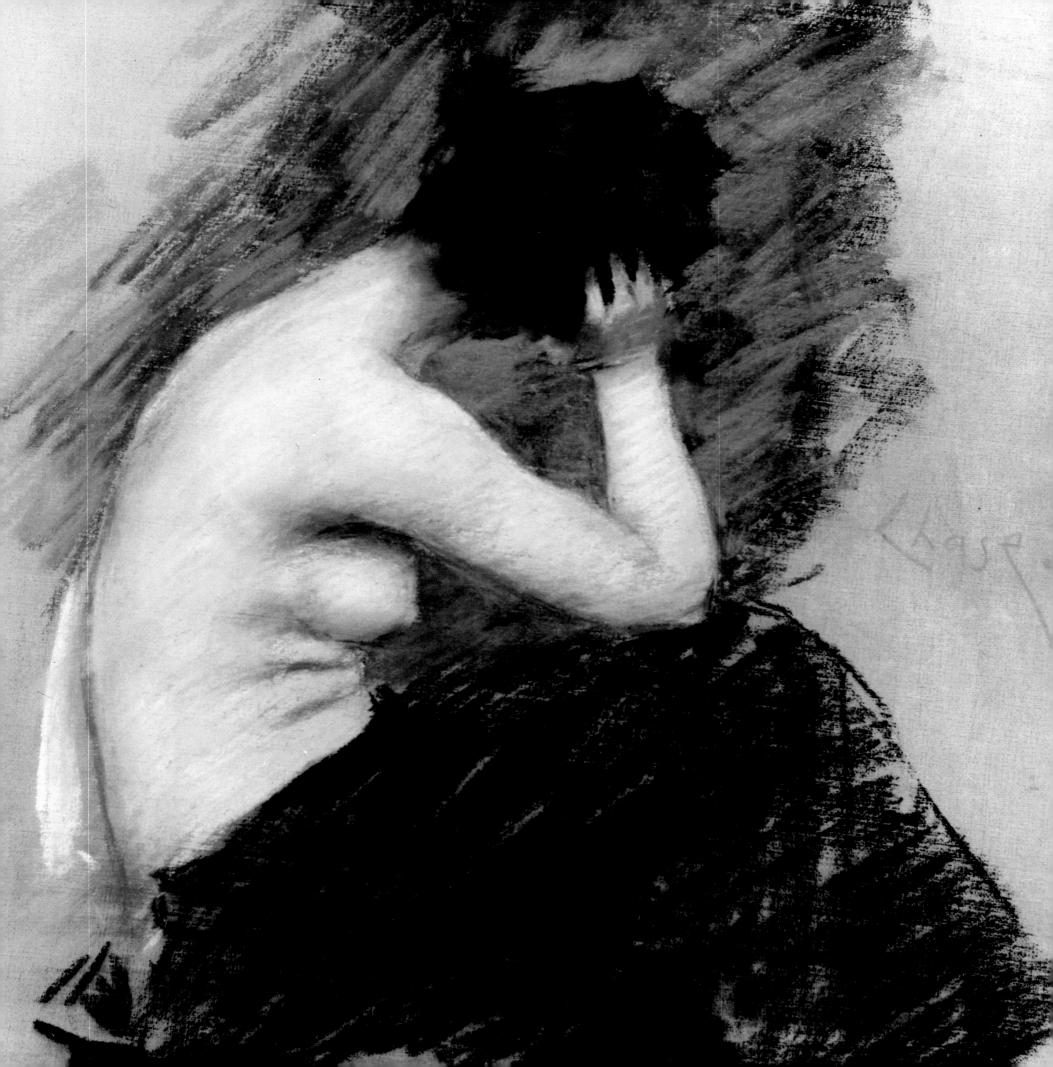

Nude. c. 1888

Pastel on canvas
13 x 13 in (33.0 x 33.0 cm)
Private Collection

The Painters in Pastel

The idea of establishing a special organization devoted to the exhibition of pastels was first discussed by Chase and Robert Blum in 1882, and their plans began to take shape the following year as the artists prepared for their premier exhibition. Although all agreed on the explicit purpose of the organization — to elevate the medium of pastel to a respectable level on a par with oil painting — there were other problems that had to be resolved. At first there was some debate over the title of the organization: the Society of Painters in Pastel. "Could a worker in pastels be called a 'painter'? Some of the men thought he could, because colors are used, others thought that, as pencils and not brushes are employed, the word 'painter' would be misleading."[1] When it was pointed out that the French used the term *peintre en pastel* and the Germans *Pastellmaler,* it was agreed that the title chosen for the American organization was a valid one. Evidently, the Society of Painters in Pastel had planned to hold their first exhibition in the spring of 1883. A message in the January issue of *The Art Amateur* announced their plans. In the April issue of the same magazine, there appeared a notice that the group had postponed the show until the fall; and when that did not materialize, another delay was announced in the February 1884 issue. This time the public was assured that the long-awaited exhibition would indeed take place soon. As proof of this, it was noted that a gallery had been selected and that the works to be included in the show actually had been seen by the writer.[2]

Apparently the time the artists had devoted to the Bartholdi Pedestal Fund Exhibition had prevented them from working on the pastel show. The last meeting of the Exhibition Committee took place on January 18, 1884.[3] Exactly a week later a meeting was held to discuss final plans for the pastel exhibition.[4] The following week an opening date was set; and on February fifteenth J. Carroll Beckwith reported that all of the arrangements for the show had been settled.[5] The last week in February the catalogue was prepared and invitations to a preview reception were sent out, and the gallery of W.P. Moore was selected as the location for the show. The preview was finally held on March fifteenth.[6] Beckwith declared the event to be a "brilliant success" with the "most select" crowd attending. He also noted that many sales were made — but none of his own works.[7]

The show opened to the general public two days later. Sixty-three pastels by twenty-five artists were included, with Chase (the principal exhibitor), contributing seventeen works spanning a broad range of subjects and sizes. Other major exhibitors included Blum (twelve) and Beckwith (ten). Also participating in the exhibition were: Edwin Blashfield, Hugh Bolton Jones, Francis Miller, Charles Ulrich, S.G. McCutcheon, Kate H. Greatorex, Caroline Hecker, Francis Coates Jones, Walter McEwen, John H. Niemeyer, Walter Palmer, and Ross Turner.[8] As a means of identifying their works, the group designed a stamp with the insignia "P.P.", standing for Painters in Pastel. Although not everyone used it, those who did apparently affixed it to the mats of their pastels except for Chase, who applied it directly to the surfaces of his works, integrating it into the compositional scheme.

As a whole, the show was greeted with critical acclaim. One critic reported, "Scarcely one of [the works] lacked interest, and...they proved that their painters had understood the nature of the method — not only its technical management, but its expressional possibilities...."[9] Chase's pastels were singled out for special comment: "Mr. Chase's work has the preeminent distinction of being always interesting. In this direction of pastel drawing it appears as if he had been engaged in proving to himself the range of his versatility and his cleverness."[10] Another critic similarly observed that "Mr. W.M. Chase, who flits from oils to monotypes and from water-colors and etchings to charcoals, is understood to have the success of the Pastel Exhibition much at heart...."[11] The majority of Chase's subjects were figure studies, in both indoor and outdoor settings; also included were several still lifes and a self-portrait. At least six of the pastels were of Dutch subjects, executed during his trip to Holland in 1883.[12]

Making Her Toilet. c. 1889
Pastel on paper mounted on board
19 x 9⅝ in (48.3 x 24.5 cm)
Frank S. Schwarz and Son, Philadelphia

Although the preview of the show was considered successful, with a number of sales, the final results were disappointing. Despite favorable press coverage, general attendance proved to be poor; and, aside from the initial rush of sales on opening day, few works were sold. Depressed by this situation, Beckwith summed up the general feeling of the group on the last day of the exhibition: "How blue we all are on the result of the Pastel show. What on earth is the use of having an exhibition anyway."[13] Four years would pass before the Painters in Pastel would hold another exhibition.

When questions as to why the organization did not schedule a second exhibition in 1885 arose, one critic explained: "The members are somewhat scattered, Messrs. Ulrich and Blum being abroad, the previous exhibition did not pay, as the receipts for admission and sales were both small, the public did not seem inclined to show a practical enthusiasm in the new departure, the members being obliged to pay a good proportion of the expenses out of their own pockets."[14]

Major developments in Chase's life undoubtedly prevented him from contributing any serious effort towards organizing a second show before 1888. In the summer of 1884 Chase returned to Holland. While there, he became preoccupied with painting plein-air landscapes, influenced by contemporary Dutch artists. The following year Chase was re-elected President of the Society of American Artists, a position that demanded a considerable amount of his time. He also traveled abroad that summer, visiting Whistler in London and stopping in Holland before returning home. Several momentous events occupied Chase in 1886, including his marriage to Alice Gerson and his first one-man show, held at the Boston Art Club that winter. In 1887 there was the disastrous sale of ninety-eight of his works at auction, grossing the disappointingly low sum of $10,000. On a more optimistic and personal note, his first child, Alice Dieudonnée, was born that same year.

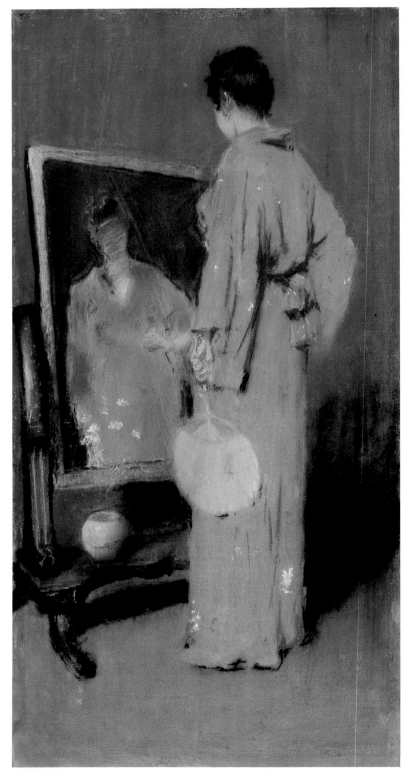

Back of a Nude. c. 1888
Pastel on paper
18 x 13 in (45.7 x 33 cm)
Collection of Mr. and Mrs. Raymond J. Horowitz

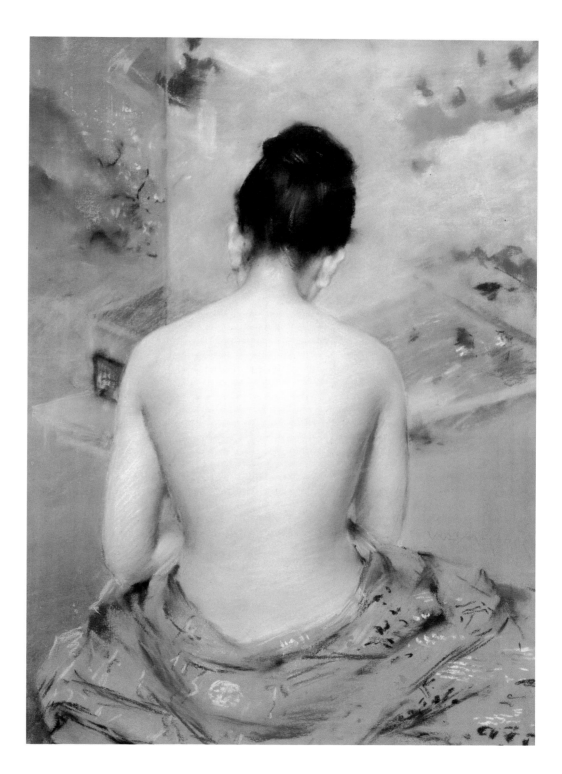

The artists' interest in the pastel medium did not, however, wane between the time the 1884 exhibition closed and the 1888 show opened. In the fall of 1885, Robert Blum and John H. Twachtman (who would be a prominent exhibitor in the second exhibition of the Painters in Pastel) were experimenting with the medium in Venice. Writing to Chase at this time, both artists asked the same question: "What do you think of pastels?"[15] That same fall Chase continued to generate interest in the medium by exhibiting a group of eight of his pastels at the Inter-State Industrial Exposition in Chicago.[16] The following year he went a step further, boldly including twenty-five pastels in his one-man show in Boston — approximately twenty percent of the total exhibition.[17]

The second exhibition of the Society of Painters in Pastel was held at the Wunderlich Gallery, New York, May 7-26, 1888. This time there were sixty-eight works by fifteen artists. Blum, who had sold the most out of the 1884 show, now displaced Chase as the major exhibitor, contributing thirty-one. Chase exhibited six, the second largest number among the original members. Other charter members who contributed to the second show were Beckwith, Palmer, Jones, and Hecker. Among the new artists, John H. Twachtman exhibited the greatest number of works — eleven. The remaining contributions were made by: John La Farge, J. Alden Weir, Lyell Carr, William Coffin, Kenyon Cox, J. Louis Webb, Herbert Denman, and Irving Wiles.[18]

The six pastels submitted by Chase consisted of three landscapes, two portraits, and a female nude.[19] As with the first exhibition, this show received good press coverage. One critic noted that "among its sixty-eight pictures almost all were good, and some were very good..." and called Chase's nude, *Pure,* the most important pastel in the exhibition, commenting on its "delicacy" and its "purity of texture, which pastels alone, and pastels handled in the cleverest way, can achieve."[20] Another critic concurred, praising it as

the most striking in the show: "a masterpiece of technical skill."[21] Apparently, this is exactly what Chase had set out to accomplish. *Pure* was one of a group of nude studies he completed in the late 1880s, depicting the same model in various poses. The series was prompted by a challenge from his fellow artists. Although they acknowledged Chase's versatility as an artist who had demonstrated his skill in depicting a wide range of subject matter, they contended that drawing the female nude was not within his métier. Chase soon proved them wrong. The artist Kenyon Cox reported: "Within a short time some of us have seen a few lovely pastels of the nude female form from his hand. The delicate feeling for color and for values, the masterly handling of the material, the charm of texture in skin or stuffs — these things we were prepared for; but we were not quite prepared for the fine and delicate drawing, the grace of undulating contour, the solid constructive merit which seemed to us a new element in his work."[22] In executing this series of pastels, Chase in effect also answered the challenge of many critics who had been suspicious of his direct means of painting and thought him incapable of careful rendering.

The third exhibition of the Painters in Pastel opened April 20, 1889, at 278 Fifth Avenue, formerly the Haseltine Galleries. Commenting on the organization of the show, Beckwith noted in his diary: "I went down to see the pastels which open today at the Gallery on 5th Ave. Blum, Chase and Twachtman have to do all the work now. I ran the first one, which was enough."[23] Although no catalogue has been located for this show, certain details can be ascertained by examining contemporary reviews of it. The exhibition was described as relatively small, corroborating a diary entry by Beckwith. It consisted of the work of twenty-two artists (eleven members, and an equal number of invited guests). Twachtman and Chase dominated the show, with the former exhibiting eleven works and the latter nine.[24] Among the other artists mentioned were: Beckwith and J. Alden Weir, with two works apiece; and John La Farge and Walter Palmer, each of whom contributed a single work. Robert Blum also participated, but the number of works he showed is not recorded.[25] It was noted that by this point the little coterie of artists had managed to attract a respectable following, although Beckwith complained that "the poor pastel is on its last legs, no one goes there except students and artists."[26]

Particular traits noted in the works shown were attributed to the pastel medium: brilliant colors, facile execution and impressionistic treatment. Although some were criticized as being too highly finished, this comment was directed only at works by non-members.

The following spring (1890) the Painters in Pastel staged their fourth and apparently last exhibition, which was held at the Wunderlich Gallery from May first to the twenty-fourth. Again, no catalogue has been discovered; what is known about the exhibition has been gleaned from contemporary accounts.[27] It consisted of eighty-nine works, the largest of their exhibitions. Among the artists represented were: Beckwith, Twachtman, Weir, Walter Palmer, Childe Hassam, Irving Wiles, Francis Day, Theodore Robinson, Benoni Irwin, Cecilia Beaux, Edith Sackett, Louis Bronberg, Rosina Emmet Sherwood, Maria Brooks, Henry Oliver Walker, Charles Warren Eaton, Carleton Chapman, Robert Reid, and Chase. Robert Blum, who had been one of the Society's key figures, was busy preparing for his trip to Japan later that spring and was not represented.[28] Several works by Chase were given special mention, including his portrait *Mr. J. Henry Harper,* which had been awarded the place of honor in the show.[29] Others listed were: *Little Miss H.,* referred to as a child with "a serious infantile expression and a Japanese doll, the rounded back of whose bald head was a triumph of technic," and *Afternoon by the Sea.*[30] Several more were described, including a "black haired model in a Japanese robe and holding a pink fan contemplating herself in a mirror,"[31] but no titles were cited. A "pastel dinner" celebrating the success of the show was held on April twelfth at a place called Martin's, evidently also chosen for previous celebrations.[32]

Why the Society of Painters in Pastel apparently never exhibited again as a group is open to conjecture. It is obvious that by the time of their fourth show in 1890 they had been successful in achieving their initial goal of placing the pastel medium on a par with oil painting. It is also clear that by their final exhibition the use of pastels by serious artists was widespread — as evidenced by the number of new contributors to that show. By this time, they had even gained the interest and acceptance of the general public. Although Chase continued to work in this medium, he no longer needed such a forum. Subsequent pastels were not executed to prove a point, but for his own personal enjoyment and that of others. Although he completed fewer pastels after 1890, their quality and complexity equals those of the 1880s and, in some instances, surpasses them.

The summer of 1890, after the closing of the last exhibition of the Painters in Pastel, Chase visited eastern Long Island at the invitation of several summer residents, who wanted him to establish a summer school of art where students could learn to paint in the open air. Impressed with the flat expansive terrain and the ever-changing sky, which undoubtedly reminded him of Holland, Chase agreed. The following year the Shinnecock Summer School of Art was founded; it continued until 1902. During this period, Chase produced some of his most successful pastels in and around his summer home in Shinnecock Hills, including *Hall at Shinnecock*, depicting his wife and two of his young daughters in the main hall of their home, and *In the Studio, (Interior: Young Woman Standing at Table)* in which he presents a woman examining prints in his adjoining studio.[33]

It is interesting to note that although Chase was an influential teacher who taught classes during the entire course of his mature career, there is no evidence that he gave lessons in pastel painting. Instead, he reserved this medium for his own experimentation and personal delight.

Chase's work in pastels has been compared to the work of Giuseppe De Nittis, an Italian-born artist who moved to Paris, where he became a friend of Degas and exhibited with the French Impressionists.[34] In 1881 a major exhibition of his pastels was held at the Cercle de la Place Vendôme.

It is possible that while he was visiting Paris that year, Chase saw this exhibition, which received a great deal of critical attention. At some point, Chase also acquired a small painting by De Nittis. Undoubtedly Chase responded to the genteel nature of the artist's subject matter, as well as the refined treatment of his pastels. Chase adopted De Nittis' practice of carrying out his pastels to a degree of finish equal to that of his oil paintings. This was a very different approach from that of artists like James Abbott McNeill Whistler and John H. Twachtman, who treated their pastels as if they were drawings, generally leaving a good deal of the surface undeveloped. Inspired by the large size of De Nittis' pastels, Chase too worked on an unusually grand scale at times. The impact of ambitious works such as *Still Life (Brass and Glass)* and *The White Rose (Miss Jessup)* contrasts with that of the more intimate pastels of artists such as Whistler and Twachtman.[35]

Chase's work in pastel reflects a self-confidence based on a boundless respect for the medium itself. He is seen at the height of his artistic powers in his pastel paintings; they are of a consistently high quality and testify to his total mastery of the technique.

■

Still Life (Brass and Glass). **c. 1888**

Pastel on paper
27 x 37 in (68.6 x 94.0 cm)
Collection of Mr. and Mrs. George J. Arden

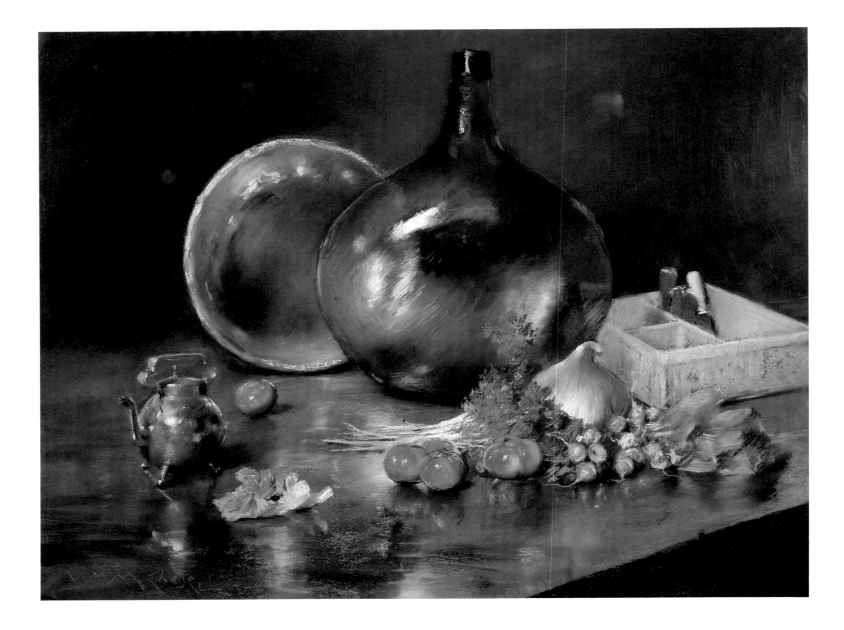

In the Studio (Virginia Gerson). **c. 1884**
Pastel on paper laid down on linen
39 x 22$\frac{1}{2}$ in (99.1 x 57.2 cm)
Hirschl & Adler Galleries, Inc., New York

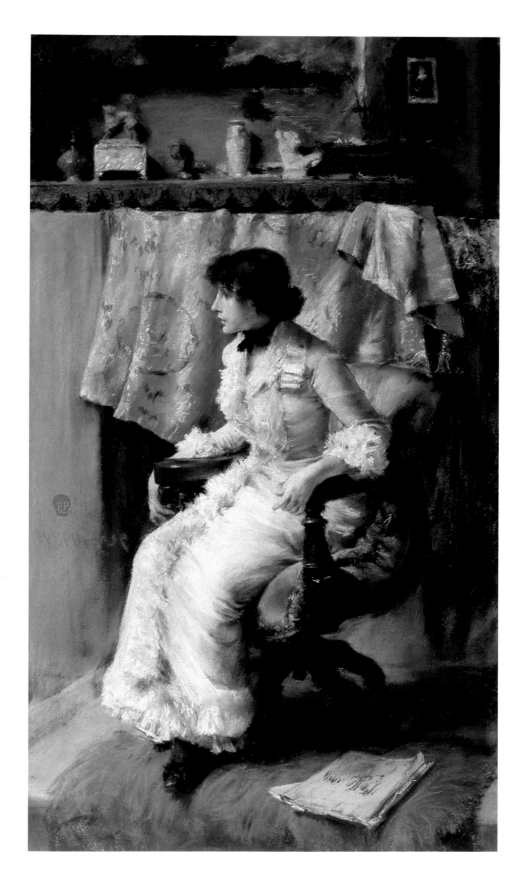

Hall at Shinnecock. 1893
Pastel on canvas
32 x 41 in (81.3 x 104.1 cm)
Private Collection

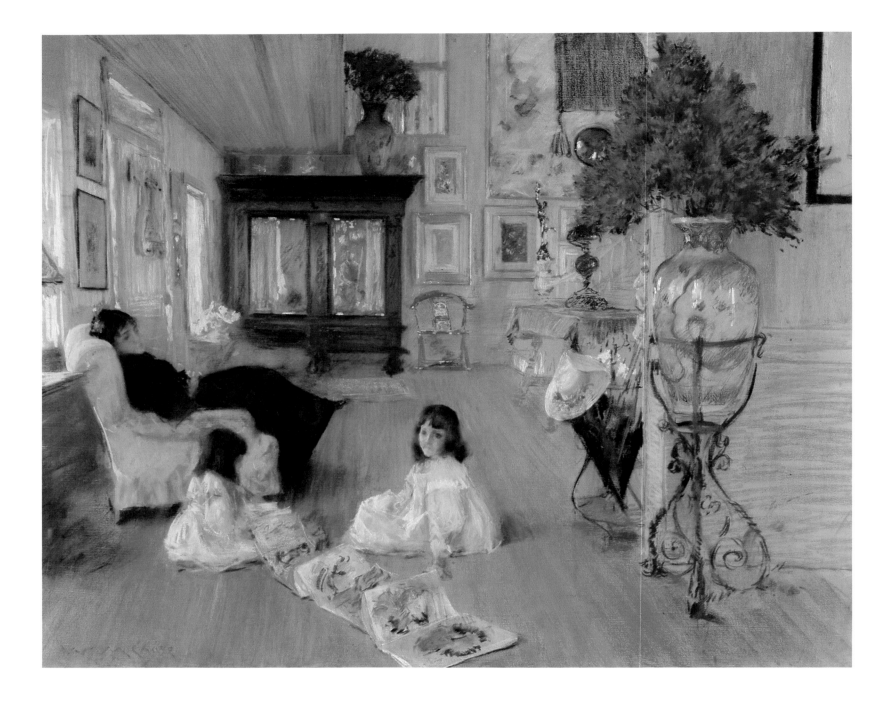

Afternoon in the Park. c. 1890
Pastel on canvas
19 x 15³/₈ in (48.3 x 39.0 cm)
Private Collection

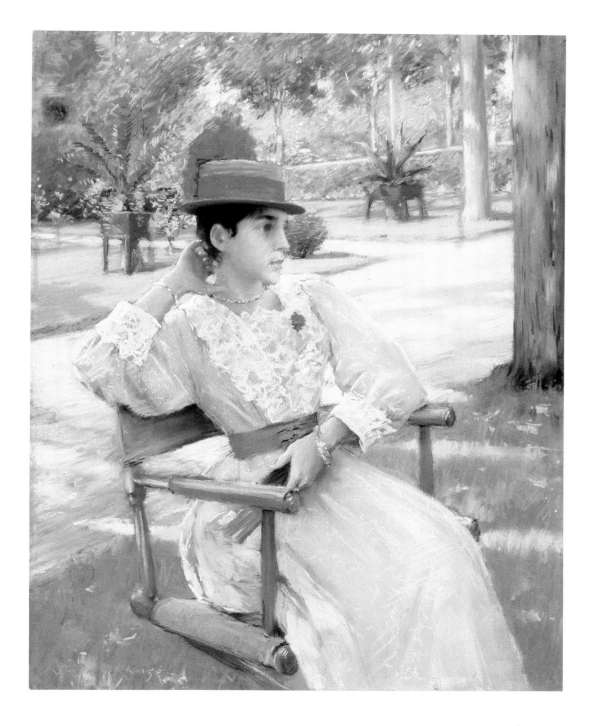

Gravesend Bay. c. 1888
Pastel on canvas
20 x 30 in (50.8 x 76.2 cm)
Manoogian Collection

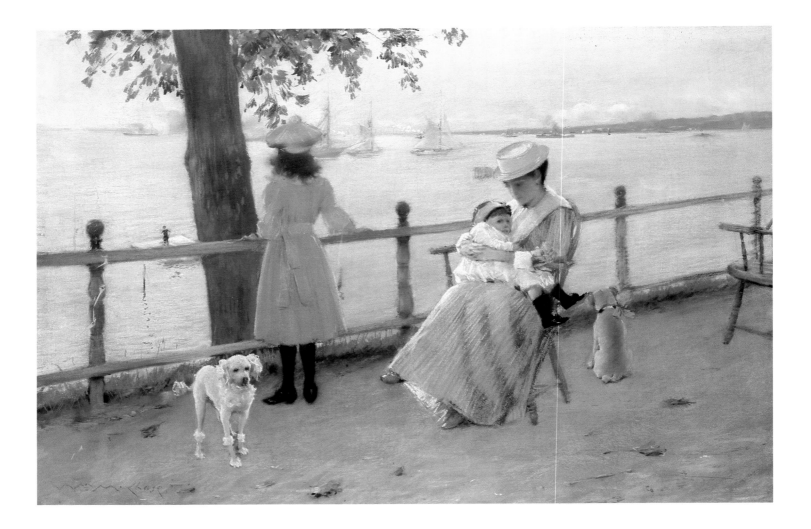

Chase and Whistler

Chase and Whistler, c. 1885.
The William Merritt Chase Archives,
The Parrish Art Museum, Southampton, New York.

During William Merritt Chase's summer trip to Europe in 1884, he saw a painting that greatly impressed him, *Portrait of Miss Alexander* by James Abbott McNeill Whistler, which inspired him to visit the American expatriate painter in London.[1] Filled with enthusiasm, Chase prepared for the visit. Then, recalling what he had heard about Whistler's eccentricities, Chase had second thoughts about how he might be received if he arrived unannounced and without a proper introduction. He therefore changed his plans and traveled once again to Madrid, where he paid homage to another artist he admired, Velasquez. While in Madrid, Chase continued to think of Whistler's painting, later recalling, "'that picture haunted me; it seemed to me the only thing I had seen which was worthy to be hung alongside those of Velasquez.'"[2] He even wrote a letter to Whistler expressing this sentiment; but unsure of how the unpredictable artist would react to this praise, Chase destroyed the note. Such an accolade would have been a special tribute from Chase, who considered Velasquez the "most modern" of the old masters. He also attributed a special quality to Velasquez' paintings, "something so elusive and subtle...that it sets at defiance our power to rightly describe it." Chase asserted "Velasquez, with the independence of true genius, struck out for himself, and casting aside the dogmas and formulae of the schools of his day, painted after his own good fashion, and with such results that we to-day are lost in amazement that one particular genius should so far have excelled and advanced before his age." He also maintained that "no living painter could produce work more pleasing to the eye of the modern critic,"[3] allowing only one exception — James Abbott McNeill Whistler.

In retrospect, Chase's comparison may seem a bit extravagant, but considering his great admiration for Whistler, this exaggeration is understandable. There is no question that Whistler himself had a high regard for Velasquez and was indebted to him for his own artistic development. Like Velasquez, Whistler was a painter whose artistic statement was considered by Chase and others to be unacademic, "absolutely original and thoroughly distinctive." Chase also praised Whistler's art for being an "unaffected expression of his convictions and impressions of the world about him...."[4] Later in life when Chase was asked to compare these two artists, he explained: "'They are utterly different in technique, but alike in their great sympathies for nature.'" He also declared that "'if Velasquez lived he would grasp Whistler by the hand.'"[5] One might wonder

what Whistler's response to this grand gesture would have been: when another admirer of Whistler's told him that he and Velasquez were the two greatest painters in the world, Whistler curtly responded, "'Why drag in Velasquez?'"[6]

It wasn't until the summer of 1885 that Chase actually got to meet Whistler in London. Still apprehensive about how he would be received, Chase arrived armed with a letter of introduction. Writing years later about this momentous encounter, he recalled: "I rapped and waited. Most callers waited at Whistler's door in those days, and few were admitted. Suddenly the door was opened, guardedly, however, and a dapper little man appeared on the threshold and eyed me keenly. 'You're Chase,' said he quickly, 'are you not?' My carefully prepared words took sudden flight, and left me standing in utter confusion. 'Yes,' I said guiltily. 'How did you know?' 'Oh, the boys have told me about you. Come in.' He tossed the proffered letter, unopened, upon a chair, linked his arm affectionately within mine, and led the way to his studio. Our *camaraderie* began at once. For some reason he dubbed me 'colonel', and in a moment we were chatting like old friends."[7]

This amiable encounter marked the beginning of a lively but short-lived friendship. It was natural that the two artists should take an immediate liking to each other. Both were talented and witty, and had common interests, such as their admiration for Velasquez. They were both anti-academic, although Whistler was more vehemently so; most importantly, Chase revered Whistler's work. Originally, Chase had planned to stay in London for only a brief time — the main purpose of his European trip had been to study the work of Velasquez. In a letter to Alice Gerson, Chase reported that his plans had changed and that the trip to Madrid would be delayed.[8] He was enjoying his stay in London and was delighted by his new companion. He stayed at the Metropole, a hotel that had just opened; Chase considered it the finest hotel in London. "'I know of nothing so fine at home,'" he told Alice. "'All the great swells come here, a great many Americans among them.'"[9] Describing his new friend Whistler, Chase reported, "'He's the most amusing fellow I have ever met.'"[10]

Still eager to get on to Madrid, Chase informed Whistler of his intention to leave London. Whistler responded: "'Don't hurry...there are many of my paintings here which you ought to see.'"[11] They then visited an exhibition of his work on Bond Street, and Whistler urged Chase to see other paintings of his in private homes — many of which would no longer admit the quarrelsome artist. At first Chase was entertained by their daily meetings, commenting: "Few hosts were ever as charming as Whistler *could* be; few men were as fascinating to know — for a brief time. For a day I was literally overwhelmed with his attentions; for a week and more he was constantly a most agreeable, thoughtful, delightful companion."[12] However, after about two weeks Chase reported that Whistler's hospitality had worn thin, claiming: "It was impossible, I believe, for any man to live long in harmony with him."[13] Once again, he was determined to leave for Madrid, but the clever Whistler cajoled him into staying on in London, suggesting that the two artists paint each other's portraits. Reluctant to stay any longer, but undoubtedly aware of the publicity such a venture would generate upon his return to New York, Chase assented. According to his account of the arrangement, the artists agreed that whoever was "specially in the mood" would paint, while the other artist posed. Chase soon realized his mistake in accepting such terms: "Whistler, I speedily found, was always 'specially in the mood,' and as a consequence I began posing at once and continued to pose. He proved to be a veritable tyrant, painting every day on into the twilight, while my limbs ached with weariness and my head swam dizzily."[14] A month passed and Chase wrote back to Alice Gerson: "'I really begin to feel that I will never get away from here.'" More optimistically, he reported that the two portraits were nearly completed and that he expected to bring them home with him when he returned.[15] Despite the constant demands upon Chase to pose, which allowed him little time to work on his own painting, he managed to complete his portrait of Whistler. However, Whistler's portrait of Chase was apparently never finished.

During the course of the summer, the two artists visited mutual friends in London, among them the American expatriate painter Edwin Austin Abbey. Chase also assisted Whistler with several financial matters, explaining that there was "a steady stream of creditors at the King Street studio in those days."[16] In one instance, Chase arranged for a wealthy American who was visiting London to purchase a set of Whistler's etchings. On another occasion, Chase offered Whistler some money to reclaim his portrait of Carlyle, which was being held as security for a loan. Evidently, Chase hoped that Whistler might then give him the painting in gratitude. Instead, Whistler refused the money, explaining that he would rather wait until he himself could pay off the loan and once again take possession of the work.[17]

The two artists apparently enjoyed their daily repartee at first. In one instance Whistler commented: "'What a lot you'll have to tell about me, Colonel, when you go back!'" Chase responded: "'No...for you've done nothing, said nothing, new. You're the greatest disappointment of my life.'" Whistler rejoined: "'How terrible you are! You are watching me!'"[18] Although Chase was delighted to match wits with Whistler, he admitted that it was rarely possible to have the last word. In fact, Chase eventually grew tired of it all, later claiming that "As my stay in London drew near its end, our quarreling increased, try as I would to avoid it. 'Don't! Don't!' I cried out in desperation one day. 'At least let me carry away a pleasant last impression of you.'" Whistler responded: "'You don't seem to understand....It is commonplace, not to say vulgar, to quarrel with your enemies. Quarrel with your friends...that's the thing to do. Now be good.'"[19]

By the end of the summer, Chase had given up all plans of visiting Madrid; instead, he decided to go to Holland and then to return to the United States. In spite of their constant disagreements, Chase suggested that Whistler accompany him to Holland, to which Whistler replied: "'Perhaps.... What inducements have you?'" "'The old masters,'" Chase responded. Although Whistler agreed that this would be a good reason to go, he demanded further justification. Chase sarcastically replied: "'Our delightful companionship... should we not prolong it?'" As a final incentive, Chase reminded him of the international exhibition that was being held in Antwerp, where they could see new paintings by Bastien-Lepage and Stevens. Ultimately Whistler decided to go, and Chase soon regretted having extended the invitation. Whistler was more boisterous than ever. Upon reaching the exhibition, he asked Chase, "'Where are your Bastiens?'" Chase directed him to Bastien-Lepage's portrait of his brother, then implored Whistler to let him view this painting alone. Infuriated by this request, Whistler fired back: "'What's this? You ask me to come over here with you, and then you adopt *this* attitude?'" Chase answered: "'Yes....you have the ability to say in a single word that which I don't care to hear about these pictures.'" Whistler then dragged him before the Bastien-Lepage and hissed "'School!'"[20]

This represented the fine line between the two artists' appreciation of contemporary art. The anti-academic Whistler (who had claimed that the only thing he disliked about Chase was that he was a teacher) objected to the fashionable art of the day, favoring a more independent course. Chase, on the other hand, had a much broader acceptance of what he considered to be fine art. Although he was perceptive enough to appreciate Whistler's own personal genius, this did not preclude his appreciation of certain aspects of less innovative art. One of the things that impressed Chase about the work of the more conservative artists was their technical skill — the one thing he found lacking in Whistler's work. He believed that Whistler's art succeeded only through the artist's diligent work and high ideals and not through technical prowess. Commenting on this "flaw," Chase stated: "Of detail and construction he knew little and cared less. He would produce a great portrait; you might know that, but you could not feel certain that he would get his subject upon his feet."[21]

James Abbott McNeill Whistler. 1885

Oil on canvas
74³/₈ x 36¹/₄ in (188.9 x 92.1 cm)
The Metropolitan Museum of Art,
Bequest of William H. Walker, 1918

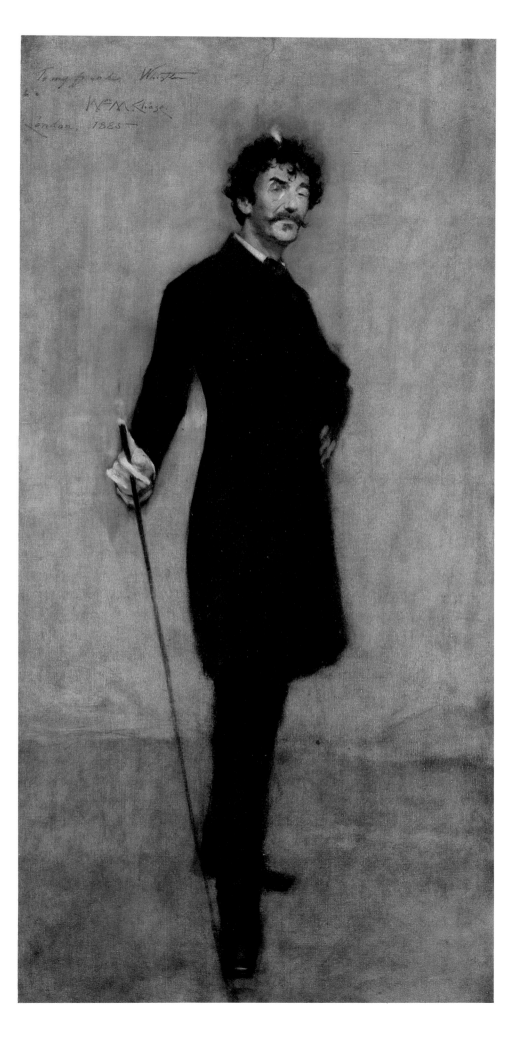

From left: Unidentified man, J.A.M. Whistler, W.M. Chase, and M. Menpes, c. 1885.
The William Merritt Chase Archives,
The Parrish Art Museum, Southampton, New York.

After leaving the exhibition in Antwerp, Chase reported: "The end of a most unhappy day found us in a railway-carriage traveling on to Amsterdam, huddled up in opposite corners, and glaring fiercely at each other."[22] At some point Whistler made a snide remark about Germans. Enraged by this slur against a nationality with which Chase had felt a close kinship since his student days in Munich, he informed Whistler that the next stop was Haarlem and insisted that one of them must leave the train. Characteristically, Whistler responded (in German): "'Yes Colonel...you get out.'"[23] Chase obliged. The next day, after Chase's temper had subsided, he agreed to introduce a group of young artists from Brussels to the controversial Whistler, who was their idol. After keeping the group waiting for half an hour in his Amsterdam hotel, Whistler finally appeared. Chase described what would be his final impression of the artist: "Ah, he came at last with mincing step and monocle set — the dainty, dapper Whistler of Cheyne Walk, Whistler with all his 'gimcracks' on, Whistler on parade, the flippant, enigmatical, cynical, caustic Whistler of the world. And as he stood before his hero-worshippers and heard their murmur of irrepressible adoration, he half averted his face toward me and behind his handkerchief passed me a deliberate, meaning wink!"[24] Although this was the last time the two artists saw each other, they would soon be embroiled in a trans-Atlantic controversy over the portrait of Whistler that Chase had painted that summer.

Later, in an article recalling his time with Whistler, Chase noted that there were two sides to the eccentric artist's personality, "each one of which he made famous....One was the Whistler in public — the fop, the cynic, the brilliant, flippant, vain, and careless idler; the other was Whistler of the studio — the earnest, tireless, somber worker...endlessly striving to add to art the beautiful harmonies, the rare interpretations...his *real self,* which will live in all its glory when the man's eccentricities are utterly forgotten."[25] The great controversy that ensued was based on how Chase decided to portray the "public Whistler," and if, indeed, he had intended this painting to be a full-length caricature of the artist.

Initially Whistler seemed to have no objection to the way Chase had portrayed him, except that he considered the work to be unfinished when Chase left London. In fact, Whistler seemed to enjoy every aspect of Chase's visit and felt somewhat guilty for the discourteous manner in which he had sometimes treated his guest. Shortly after returning to New York, Chase received a letter from Whistler: "'Your stay here was charming for me and it is with self-reproach that I think of the impression of intolerance and disputatiousness you must carry as characteristic of my own gentle self.'"[26] Whistler also requested that Chase delay exhibiting the portrait until he arrived in America himself, at which time it could be completed, along with his companion portrait of Chase. He wrote: "'We must reserve them, screening them from the eye of jealous mortals on both sides of the Atlantic until they burst upon the painters in the swagger of completeness.'"[27] Surely if Whistler had any serious objections to the way Chase had portrayed him, they would have been sharply expressed by this time. Instead, he apparently expected the two works to draw considerable attention and praise when completed and exhibited together, resulting in a great deal of publicity. It is even possible that his claim that Chase's work was not finished was merely a ploy to prevent Chase from jumping the gun and gaining all of the attention by exposing his portrait of Whistler first.

Although Whistler's visit did not materialize that fall, Chase continued to delay exhibiting the portrait for a year. In the meantime, Whistler discovered some disparaging remarks about the painting in the press. He responded by writing to a friend: "In the papers, where naturally I read only of myself, I gather a general impression of offensive aggressiveness, that, coupled with Chase's monstrous lampoon, has prepared me for the tomahawk on landing. How dared he, Chase, to do this wicked thing? — and I who was charming and made him beautiful on canvas — the Masher of the Avenues."[28] The letter was subsequently published in the *New York Tribune* (12 October 1886) — just one month before the portrait of Whistler made its public debut in Chase's first one-man exhibition, held at the Boston Art Club.

Of course, Whistler's comments only drew more attention to the work; critics began to debate the merits of the painting and Chase's intentions in portraying Whistler as he did. In a review of the Boston exhibition one writer described the portrait as the "most noticeable" work in the show, explaining that this was because of the notoriety of the subject, not the quality of the painting. He then condemned Chase's portrayal of the noted artist as "a finical, half-decayed old fop." He also suspected "a spice of malice" on the part of Chase, who he believed had gone beyond portraying Whistler's well-known eccentricities, creating, in effect, a caricature of the artist.[29]

However, neither harsh criticism from the press nor Whistler's own condemnation of the portrait prevented Chase from continuing to exhibit it. During the following decade it was featured in a number of important exhibitions and generated a great deal of publicity for both artists — but at Whistler's expense. In 1887 it was included in Chase's second one-man exhibition, held at Moore's Art Galleries in New York, where it was reported to be the main attraction. On this occasion it was defended by an art critic who claimed that it was not a caricature, but a true likeness: "those who know the eccentric genius will recognize it to be the truth — the harsh truth — neither more nor less."[30] Several writers noted that Chase had chosen to copy Whistler's own style of painting in this work; for some this was part of the farce.

Each time the portrait was exhibited or illustrated, critics had a field day debating its merits and faults; artists took sides on the issue; and the general public delighted in the grand dispute over what was soon considered by many to be a deliberate and scandalous act on the part of Chase. As the painting continued to be exhibited and written about, the stories relating to its inception became more and more embroidered, drifting far from the truth. When the portrait was included in an exhibition of paintings and sculpture by American artists at the Durand-Ruel Galleries in Paris in 1891, the scandal reached an international level. One writer claimed: "There is a story about the creation of this painting which it is fated shall go down to posterity, indissolubly uniting, in the art annals of the fin de siécle, the names of these two illustrious Americans."[31] He then proceeded to tell his own apocryphal version of the circumstances under which the portrait had been painted: "Never in his life, I am told, was Mr. Whistler so astonished as when Mr. Chase, descending upon him at his studio with hardly a word of warning, but with a self possession that, for the time being, quite dominated Mr. Whistler's own, which so rarely fails him, snatched up the latter's palette and brushes, and thrusting the familiar black wand into the palsy-stricken hand of his astonished host, virtually there and then bade him stand and deliver; pushing him into a dark corner like a naughty boy, and then, dancing before him in a frenzy of inspiration, dashed upon the canvas the well known features, the traditional white tuft of hair and the spare figure of the world-renowned denizen of Cheyne Walk."[32] There were even rumors that Chase had stolen the portrait that Whistler had painted of him — a claim Chase flatly and publicly denied.[33]

As Whistler read such nonsense, his temper flared and the controversy ultimately resulted in a permanent break in the artists' friendship. J. Alden Weir, a common friend, tried to appease Whistler, recommending that he ignore such ridiculous statements and assuring him that Chase "who may at times over step himself...has a sincere admiration for you and your art...."[34] Weir also claimed that Chase had assisted him in trying to get The Metropolitan Museum of Art to buy Whistler's *Woman in White.* Weir's daughter, Dorothy Weir Young, recalled another occasion when her father interceded on Chase's behalf: "Once more there must have been an argument about Chase....My last recollection was of our walking down the long passage, with its unwashed gray windows and Whistler standing at the far end

behind us, calling out as a last fling: 'Weir, Weir, you tell Chase that what I have to say to him cannot be said before ladies.'"[35]

Many similar accounts regarding the bad feelings Whistler harbored for Chase followed, ultimately resulting in Whistler's denial of ever having known him. When one American friend of Whistler's declared, "'Why you have a hat like Chase!' Whistler, with a blank stare, replied: 'Chase? Who is Chase?'"[36]

Just what was Chase's intent in portraying Whistler as he did in this painting? Was the portrait intended to be a caricature from the start? Was Chase's mimicking of Whistler's style in this work meant to be a part of a hoax? As a painter to some extent dependent on portrait commissions, Chase was obviously aware of the attention he would receive when a portrait of such a celebrity as Whistler was exhibited in America. It would not be surprising if Chase actually had this in mind when he made arrangements to visit the artist in London. If not, he was quick to grasp the opportunity when it did arise, curtailing his plans to travel to Madrid and putting up with Whistler's antics long enough to complete the portrait. Although eager to display it when he returned to America, Chase patiently awaited Whistler's arrival. Exhibiting the two paintings together could only enhance Chase's own reputation. Why would he risk tainting the notice he would attract for this important portrait by creating a caricature? Why invite the venomous wrath of the portrait's volatile subject? In presenting the "public side" of Whistler with all his "gimcracks," Chase portrayed the image Whistler had so carefully cultivated for his admirers. Certainly no one, least of all Whistler, could object to that. Chase clearly revered Whistler, as evidenced in his letters, lectures, and other public statements.

However, this reverence did not lead Chase, who always took pride in being a realist, to idealize his subject. He painted what he saw. As he often told his students, " 'When the outside is rightly seen, the thing that lies under the surface will be found on your canvas.' "[37] In painting Whistler's portrait, Chase conformed to this principle and revealed the "true" Whistler. More than one photograph shows Whistler with his cane and in a pose very similar to that portrayed by Chase.

Chase predicted at the time he was completing the portrait that it "promises to be the best thing I have done."[38] Whistler himself seemed to have no objection to it until critics began poking fun at it, at his expense. What is surprising is that so many of the critics suspected Chase of creating a caricature of the dandy. After all, he presented Whistler in a dignified pose, as a well-dressed aesthete with a distinguished air. Certainly Chase's image of Whistler is no more foppish than Whistler's own self-portraits. If there was anything ludicrous about the image, it was the inescapable vanity of the subject himself.

The criticism that Chase added insult to injury by painting a caricature of Whistler in a parody of the artist's own style is equally unfounded. It was common practice for Munich-trained artists to paint portraits of their fellow artists in the style of that artist as a way of displaying their technical agility. As Chase had matched wits with Whistler verbally, his portrait of the artist was intended to match what he admired in Whistler's painting, proving that a well-trained painter with a fine understanding of technique could create the same effects achieved by another artist. This portrait, intended as a tribute to a great artist, turned out to be a testimony to Chase's own wit and, ultimately, one of his best-known paintings.

Despite the acrimonious parting of the two artists, Chase continued to speak highly of Whistler and he gave lectures on him regularly, both to his students and to the public. There is no doubt that Chase was in part responsible for generating a great deal of interest in the expatriate's art in this country. When the critic Royal Cortissoz apprised Whistler of these lectures, the latter responded by "quaintly urging" Cortissoz to go after Chase with a "blunderbuss." Although Whistler apparently expected the worst, these talks were actually "full of appreciation"; they did, however, contain "bits of shrewd criticism...."[39]

During his 1903 summer trip abroad, while teaching a class in Holland, Chase learned of Whistler's death. His response to this sad news was: " 'He will be very much missed as an artist.' "[40] As a final tribute to this great painter, Chase and his students arranged for a wreath to be placed on Whistler's coffin.

The controversy over Chase's portrait outlived both artists, however. In 1917, the year after Chase's death, it was announced that his portrait of Whistler was to be donated to The Metropolitan Museum of Art. Joseph Pennell, Whistler's great friend and supporter, objected vehemently and publicly, protesting "the indiscriminate dumping of art and artless works on our galleries." Although Pennell granted that Chase was a "remarkable" artist, he complained that "the remarkable thing about the portrait is its badness from every point of view." He referred to it as "more of a travesty than Barnard's Lincoln" — harsh criticism indeed.[41] Finally, he appealed to the trustees of the Museum and to the public to join in his protest, hoping to persuade the Museum to refuse the portrait, which he denounced as "vile as art and abominable as a portrait."[42] Despite this bitter protest, Chase's portrait of James Abbott McNeill Whistler was accepted by The Metropolitan Museum of Art, where it remains, and is to this day one of the artist's most popular paintings.

■

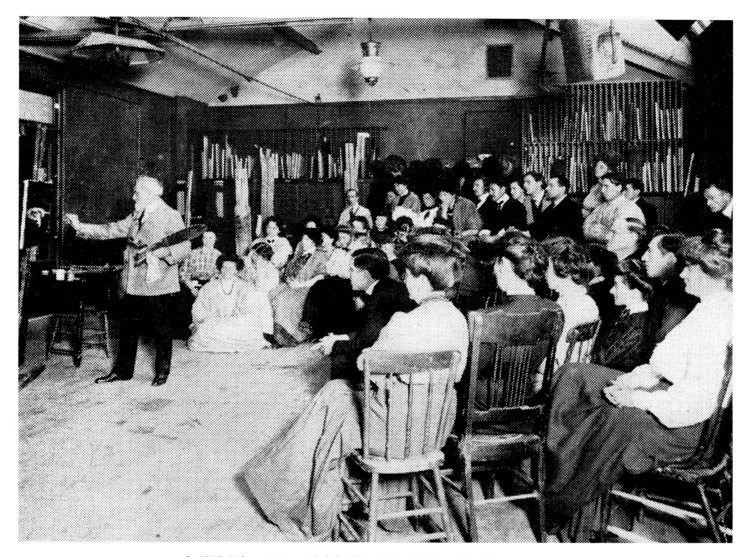

In 1949, *Life* magazine titled this illustration "William Merritt Chase, ruler of the art world in 1900, holds his students enthralled as he dashes off [a] still life in one of his frequent painting demonstrations." The painting on the easel is reproduced on page 168. (Copied from "Guy Pène Du Bois," *Life*, 20 June 1949, p. 66. Photo: Brown Brothers.)

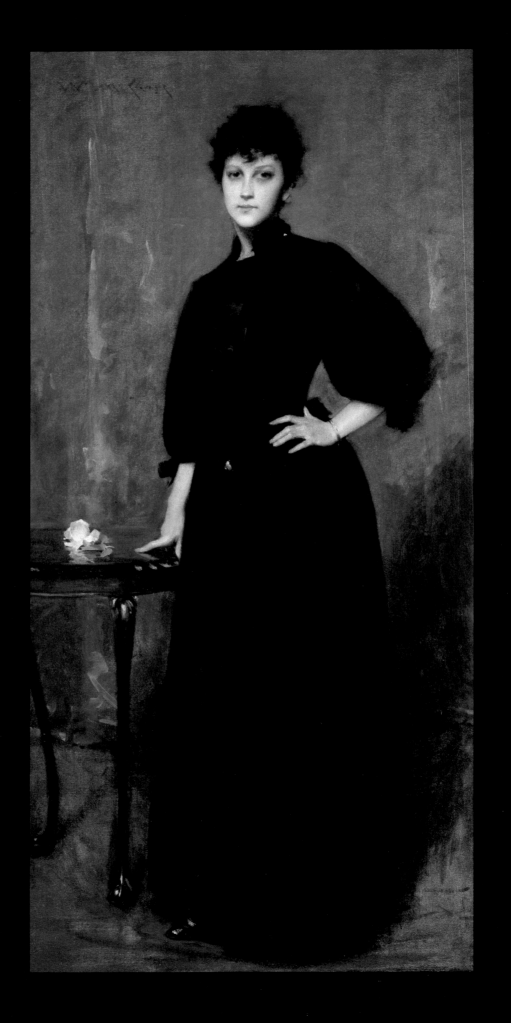

III
The Most Magnificent Profession

10
William Merritt Chase the Teacher

Methods and Philosophy

Art Schools in New York City

The Pennsylvania Academy
of the Fine Arts

A School in the Sands

Summer Classes Abroad
and at Home

A Beloved Mentor and Guide

Portrait of Mrs. C. (Lady in Black;
Portrait of a Lady in Black). **1888**

Oil on canvas
74 x 36 in (188.0 x 91.4 cm)
The Metropolitan Museum of Art,
Gift of Mrs. William M. Chase, 1891

A Bit of the Terrace (By the Lake—
Central Park; Lakeside; Early Morning Stroll). **c. 1890**
Oil on canvas
20³/₄ x 24¹/₂ in (52.7 x 62.2 cm)
Private Collection

William Merritt Chase the Teacher
Methods and Philosophy

Before Whistler and Chase had their major altercation, Whistler had only one objection to his fellow artist: Chase was a teacher. "'You're just like all these others — this vulgar crowd,'" Whistler complained.[1] Other artists also criticized Chase for devoting so much of his time to teaching, a pursuit some thought would have an ill effect on his individual expression. In response to such accusations, Chase, who was proud of his profession as a teacher, countered, "'The association with my pupils, most of them young people, has, I may say, kept me always young in my work, and my interest in painting fresh and ever renewed. The analysis of my pupil's work and the incidental formulating of correct principles, keep me artistically speaking, healthy and my point of view clear.'"[2] He considered teaching a way of making a decent living without having to make the compromises he believed many artists had to make in their work in order to live more comfortably. He warned his students that "'if you as Art students or as artists, paint with the idea of truckling to possible buyers...you degrade the art and yourself. If you paint with the desire of pleasing the vulgar taste, of tickling the fancy of the ignorant, if your aim is to produce what will sell, I beg of you to put up your canvas and brushes and leave them forever.'"[3]

He strongly advised his pupils to become teachers and benefit by their association with others. Chase also seemed to think of teaching as an obligation. "'Far from regarding this work as a waste of energy,'" he stated, "'I consider the office of teacher to be one of the highest honor and I am doing what I can to help those who come after me to tread the path which I have pursued for many years.'"[4] He explained that all who were involved in art would benefit, concluding, "'It is good for the teacher and good for the pupil to repeat the creed.'"[5]

Through his positive attitude about his career as an artist, which he called "the most magnificent profession that the world knows,"

Chase did much to elevate the profession to a degree of social acceptance and even dignity.[6] He transmitted this to his students, and in 1890 reminded them that such acceptance, which might then be taken for granted, did not exist at the time he was a young painter: "A few years ago, it was an alarming thought that there might be a son or a daughter in the family who might become an artist — I have had some experience in that myself...."[7] By the turn of the century, however, conditions had changed considerably in America; the nation was experiencing a cultural renascence, and Chase was a leader in the movement. Guy Pène Du Bois, an artist who studied under Chase, noted "Chase's role in society was of tremendous value to American art. He was filled with the importance of the artist and could defend him with clipped, witty, biting sentences, [and] could even make him acceptable to men convinced that art was an effeminate pastime, the last resort of incompetents. The dullest financiers treated him with respect. Some may even have shivered a little, seeing him approach."[8]

Chase impressed all he encountered; he had great self-confidence and a pride in himself and his profession that bordered on conceit. Unabashedly he admitted, "'They say I am conceited. I don't deny it. I believe in myself and I must.'"[9] This self-respect was just one trait that contributed to his reputation, both as an artist and as a teacher. The very way he dressed and his high style of living reinforced the image he had created as a successful and dignified personage, worthy of attention. He was described as not only a fine artist, but a gentleman of great refinement. "'His neatness in personal apparel is one of his chief characteristics,'" one student observed. "'He never appears before his classes that he is not perfectly groomed and looking as though he had just stepped from a band-box. He always wears a fresh carnation in the button hole of his coat, which offsets the wide black string attached to his nose-glasses, making a characteristic color note. A Beau Brummel with the vitality of ten men...'"[10]

Chase was a charismatic individual: forceful, inspiring, articulate, and entertaining — the perfect teacher. One student described him as "an electric spark shooting his words like darts at you."[11] Another explained that "the reason Chase was 'the real thing' as a teacher was, first, because he knew well how to impart clearly the expression of his own art; and, secondly, because he was just 'plain' kind...and he knew when and how to encourage."[12]

Chase took a personal interest in the development and success of each of his students: he sometimes provided tuition for those who could not afford it, and purchased their paintings and hung them in his studio beside those of the best-known painters of the day. He also saw that his pupils' works got into important exhibitions; he was even criticized for using his influence towards this end. In a review of an exhibition of the Society of American Artists, one writer complained that Chase's work was "conspicuously prominent; and where he is not found, room seems to have been made for work of his numerous pupils."[13]

On a regular basis Chase gave critiques of his students' works, for their benefit and that of the class. These critiques were generally of an encouraging and constructive nature, but when he felt it necessary, as in the case of "some laggard student, whom he consider[ed] to be taking up art as a mere pastime," Chase could be harsh.[14] One of his students surmised, "What if one of the girls did come to the verge of tears on occasion — was it not the best of tonics for new endeavors, a bringing in the aftermath, a might[y] resolve to do better?" The same student recalled one of his own "crits" in which a portrait he had painted was described by Chase as looking like some sort of boiled vegetable.[15] And in another instance, "before one — a weakly executed study of a pale water and sky — he remarked: 'that reminds me of nothing so much as skimmed milk!'"[16]

Although terse, colorful, and sometimes devastating, Chase's comments were never intended to be discouraging. In fact, his students considered them to be quite the opposite; in the words of one, "his criticisms were severe but with an added enthusiasm that would leave you with the thought of next grabbing a huge canvas and really doing something."[17] Whatever their tenor, his critiques were always animated, witty, and effective, providing constant entertainment for all who witnessed them. As Pène Du Bois observed, they "possessed something of his painting quality.

They were made to benefit the many rather than the individual."[18] Actually, the individual was always Chase's foremost concern. Addressing the parents of a group of his students, Chase advised them to refrain from commenting on the work of their children, to leave the criticism up to the instructor. He assured them that he took a special interest in the character of each of his pupils and considered their particular needs: "We have the interest of the student more at heart than you may suppose — I have under my charge seventy pupils, and I think I know the character or tendencies of each student...."[19] He also assumed a paternal role with his students, referring to himself as "the father of more art children than any other living man...." His concern even extended beyond their period of study with him: "It is one of my consolations in life that wherever I go I see my children, and some of them really care to see me. Do you know why? I know. It is because I am keenly in sympathy with every effort they make."[20]

Obviously, Chase considered painting a labor of love, and he expected his students to approach their work with a similar attitude, advising them, "'Self entertainment is what I most hope to bring about. Play with your paint, be happy over it, sing at your work.'"[21] When they became disheartened he came to their support: "'Don't make the mistake I used to make, and think that because your work isn't as good as the day before, or the week before, or even the month before that you are losing ground. It is probable that you are *not* at all, and some time you will suddenly realize that you have made a great gain.'"[22] He cautioned his pupils against painting out of a sense of duty: "'Run away from a study if it does not suit you.'"[23] It was Chase's philosophy that when an artist enjoyed painting, this would be conveyed to the viewer, ensuring a positive response.

For Chase, enjoyment did not preclude serious work. "I want to say something to the art students who are inclined to think that we come here just to have a good time," Chase informed his students at the beginning of one of his school sessions. "I assure you, it is for *serious work* that we meet in these studios. Because work is made easy is no reason that there should be less application or less real effort to make the most of your opportunities."[24] Charles Hawthorne, one of his students who went on to become an important

artist and teacher in his own right, remarked that Chase had patience with any "honest effort in paint," but that he would not tolerate "sham" and "charlatan" efforts.[25] However, Chase had little difficulty in eliciting a sincere endeavor on the part of his pupils, who he claimed generally had a strong desire to become "'real painters, with ambition to excel, but, above all, with ambition to do work of permanent value.'"[26] After all, he had provided them with the means and inspiration to achieve their goal as artists. He informed them: "Your opportunity to leave a record is wonderful and rare; and I plead with you students who have entered the profession to see to it that you leave a record of having been here; to leave a record that you have been on this Earth. There are millions and billions of people who die and are not missed, who leave no record."[27]

Chase constantly instructed his pupils to study other pictures: paintings in exhibitions, recent work in art magazines, reproductions of great paintings, and even the work of other students. His New York students were reminded of the great advantage they had living in a city where so much fine art could be seen first hand. For those outside major cities, he recommended "'get magazines, all you can. Do not read the matter, study the reproductions. Get catalogues of exhibitions. Eat them up. Don't deplore your situation. Be happy — do your best.'"[28] The purpose of this study was stimulation, not critical analysis. Criticism was reserved for art teachers; it was part of how they developed the skills of young artists. Everyone else, especially art students, should view art strictly for pleasure and inspiration. Rather than standing before a work and considering what was wrong with it, Chase told his pupils to single out that work which most impressed them and then concentrate on it exclusively. "Drink it in! Drink it in!! Drink it in!!!"[29] Objecting to those who went to museums and stood before paintings complaining when there were so many others that they might enjoy, Chase said, "I have thought if ever I had a voice in the matter of erecting a great museum I would have carved deeply in stone over the door, 'These works are for your pleasure, not for your criticism.'"[30]

Chase urged his students to avoid specializing in subject matter. Recalling his own student days, he noted that he had been worried about entering Piloty's studio without having done so. He soon realized that it was not necessary, however, and for those who chose to follow such a limited course Chase felt sorry, claiming to "pity the man who thinks of nothing but cattle, who dreams about cattle and can think of nothing else."[31] Chase also objected to anyone who criticized a painting based solely on the artist's choice of subject: "We hear too much of subject, subject, subject."[32] He asserted that the importance of a work of art is in *how* it is painted, not in what is depicted. In fact, Chase believed that a true artist could find beauty in that which does not obviously suggest it: "'There is still all too much of the idea that the beauty and importance of a picture has some relation with the beauty and importance of its subject....I cannot say too often or too strongly that this notion is absolutely false. The value of a work of art depends simply and solely on the height of inspiration, on the greatness of soul, of the man who produced it.'"[33] He also vehemently condemned those artists who chose to idealize their subjects and who insisted that a painting had to tell a story, have a moral, or be poetic. On the contrary, Chase declared, "'People talk about poetical subjects in art...there are no such things. The only poetry in art is the way the artist applies his pigments to the canvas. A yellow dog with a tin can tied to his tail would have been enough inspiration for a masterpiece by a consummate genius like Velasquez. Nothing is vulgar except the vulgarian; some artists are capable of painting the crucifixion in the same way they would copy a cabbage; others can make a sublime achievement of a glue-pot and a pair of spectacles.'" For his students, he recommended simple subjects, explaining that "'If one can paint a fence-rail well, it is far better than an unsuccessful attempt at the most sublime scenery....'"[34] Commenting on the sentimental paintings that dominated the Victorian era (among which were some of his own early works), Chase proclaimed that they were a thing of the past; and he unequivocally stated his point of view on narrative painting: "The story-telling picture...is an absolute impossibility, the picture depends for its interest alone on the story. Imagine how impossible!"[35] Overall, he considered the "literary" in art to be an affectation and a disadvantage to the "'frank, courageous study of nature.'"[36]

Chase believed there were several stages in the development of an individual style of painting. A student should first study fine art and emulate it. He assured his pupils that they would not lose anything by absorbing all that they could from the works of others artists — it was perfectly safe. After all, as students they certainly could not lose their originality, since they had not yet developed an independent statement. In the next stage, the student should take advice from his teacher but not depend too much on him. Chase explained, "The pupil for whom I have the greatest hope is not the one who blindly listens to my criticisms and says 'Yes, yes,' to everything...[but] the one who does not agree with me in everything [and] has some ideas of his own about how a thing should be done."[37] In working out their own form of expression, the final stage, Chase told his students to develop a style based on the best elements they could derive from the work of other artists and then paint in a new and refreshing way. He maintained, "Originality is found in the greatest composite which you can bring together," adding, "'be in an absorbent frame of mind. Take the best from everything.'"[38] He cited John Singer Sargent as a perfect example of an artist who had done so. Suspicious of those artists who claimed to be uninfluenced by art of the past or present, Chase held that "'absolute originality in art can only be found in a man who has been locked in a dark room from baby-hood. He knows nothing of distance. He reaches out his hand to take an apple that is fifty feet away from him and he jumps three feet, stepping over a crack in the floor. Since we are dependent on others, let us frankly and openly take in all that we can....The man who does that with judgment will produce an original picture that will have value.'"[39] Although Chase encouraged his students to emulate another artist whose work they respected, he insisted that they not work slavishly in the manner of any *one* artist. In reprimanding a pupil of his who succumbed to mere imitation, Chase told him, "'You have taken Monet as your example, and have determined to see through his spectacles and adopt his style. Now, Monet's style is all very well for Monet; but I prefer that you should see without spectacles, and truthfully record what you see. You cannot make me believe that the colour was really like that, or that you thought it was. This is a recipe

performance, begun at the top, and carried down to the bottom of the canvas. Never show anything like it again.'"[40] His students were expected to go before nature and paint the "truth." Chase explained: "The truth of a picture is its art integrity, its character, its distinction from the vagrant, the barren, the sensational, the false glare of art."[41] Capturing the truth was not, however, enough; he maintained the most truthful painting could also be the most boring if it lacked "feeling." He continued: "The artist's interpretation of his own feeling in a picture is perhaps the nearest definition of what is also a necessary quality in it — illusion."[42] "Illusion" was achieved through a creative process of self-expression; however, Chase warned against placing self-expression above truth. A staunch realist, Chase also insisted there were many ways of seeing a thing yet depicting it truthfully. He encouraged his students to experiment: "'Try to paint the unusual; never mind if it does not meet the approval of the masses. Always remember that it is the man who paints the unusual who educates the public.'"[43] As a means of achieving this goal, Chase taught his pupils to approach nature from new vantage points, and he offered prizes for the most imaginative of these compositions. Experimentation was the key word: "'There is no order or method for the true artist. He works from inspiration. It is the only way to do great work.'"[44]

While Chase believed that a formal course of study was necessary for an art student to learn the skills required for expressing him- or herself, he also stressed the importance of independence and individuality, encouraging his students to leave school once they had achieved these skills. In fact, he asserted that too many students suffered from over-schooling, producing work of consummate skill, but no personal character. He informed his

Meditation. c. 1885-86

Pastel on canvas
26½ x 20¼ in (67.3 x 51.4 cm)
Collection of Herbert M. and Beverly Gelfand

Lilliputian Boat-Lake—Central Park
(Lilliputian Boats in the Park;
Central Park). **c. 1890**

Oil on canvas
16 x 24 in (40.6 x 61.0 cm)
Private Collection

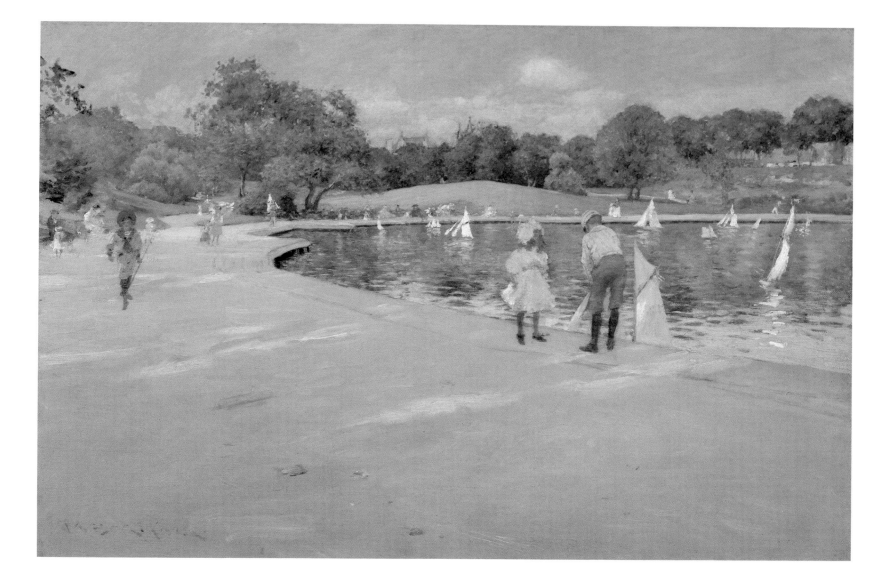

Lady in Pink. c. 1886
Oil on canvas
69½ x 39½ in (176.5 x 100.3 cm)
Private Collection

own students that "the bright genius of more than one promising art-worker has flickered and gone out in the walls of the art academy, by reason of misapplied ambition to conform his method and his ideals to those of his preceptor."[45] Chase told a story about Whistler to illustrate the dangers of this pitfall: "Two former students of mine entered his school, and when questioned by Whistler as to their previous teacher gave my name. 'Ah,' said he graciously, 'you could not have done better.' A third subject replied that he had no teacher at all. 'H-m-m,' said Whistler, loudly, '*you really* could not have done better.' "[46] Although Chase's viewpoint on this issue was less radical, he agreed with its basic philosophy: "I do not decry art-schooling, but I am, above all things, an advocate of independence and individuality," he maintained. "I think that unless the student brings an intelligent mind into his daily routine of academic training, he is irretrievably ruined, and the individual or personal character of his work (the charm of all work!) is crushed out of him forever."[47]

Although Chase had devoted six years to his own academic studies in Munich, in retrospect he believed that such a long period of formal training was unnecessary. In fact, he thought that this training should take no more than three years. He asserted that "the great question is when to *stop* — when to cast aside the leading strings of school training and try to walk alone."[48] He recalled that when he returned to America the first thing he did was try to forget what he had learned, and he advised his pupils to do likewise when they left school: "Now shake off the influence of the school as quickly as you can. Cultivate individuality. Strive to express your own environment according to your own lights, in your own way." He claimed he had actually "driven" young artists out of school for their own good, stating "the school is necessary, of course, but it ceases to be necessary, or useful, or anything but detrimental to the student after it has given him the mechanical facility, the technique."[49]

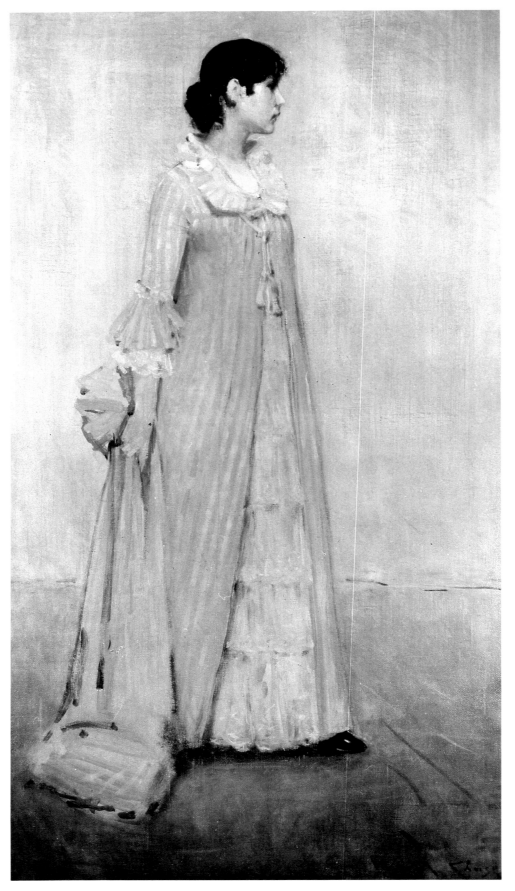

Young Girl with Flowers. c. 1885
Oil on canvas
23 x 13½ in (58.4 x 34.3 cm)
Collection of Mr. and Mrs. Jules Kay

In choosing a school, Chase recommended that a student's first concerns should be determining its aim and considering just what it had to offer the prospective student. He added, "you must do for yourself — you may be guided, but you must think all matters out yourself."[50] During the course of his career as a teacher, which spanned a period of nearly forty years, Chase taught classes at most of the major art academies in America.[51] He founded his own school in New York, the Chase School of Art, and this country's first important summer art school, the Shinnecock Summer School of Art, located on eastern Long Island. He also offered private instruction in his various studios, and for ten years conducted summer classes in Europe. His last summer class, held in 1914, was located at Carmel-by-the-Sea, California. Chase instructed thousands of students, probably more than any other American artist of his day, and the range of his influence was amazingly broad, having an important effect on the succeeding generation. All who studied with him, even modernists such as Georgia O'Keeffe, have expressed their indebtedness to Chase as a teacher — especially for the technical skills they developed under his guidance and instruction.

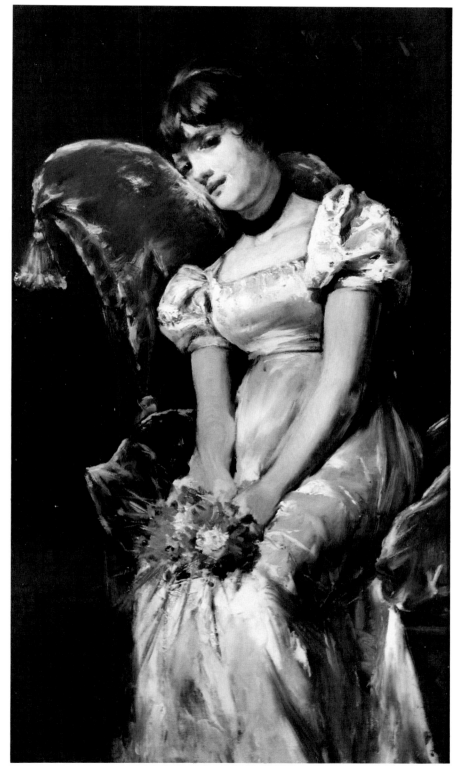

Mrs. Meigs at the Piano Organ. c. 1883
Oil on canvas
18⅝ x 25¹⁵⁄₁₆ in (47.3 x 65.9 cm)
Private Collection

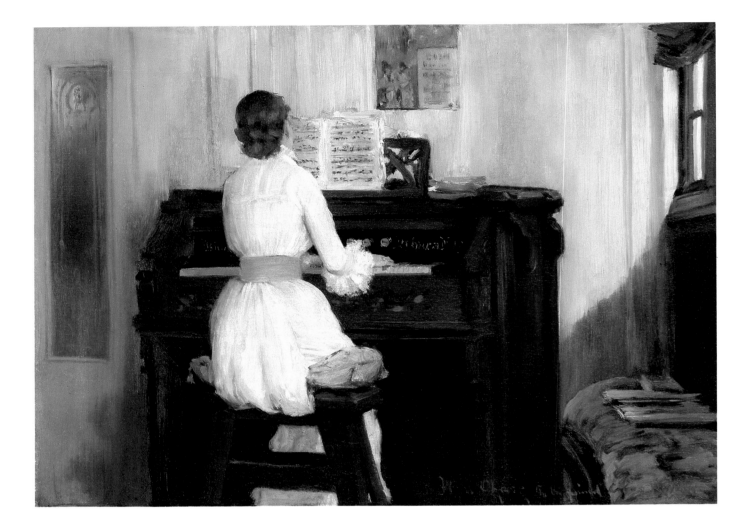

Art Schools in New York City

William Merritt Chase's teaching career began in 1878 at the Art Students' League in New York, a school with which he would be associated for a quarter of a century. [52] At the time he joined the League, it was a fledgling institution with financial difficulties. Calling for aid for the League, a writer for *The New York Times* appealed to affluent Americans to endow such worthy cultural institutions. [53] Chase, who believed that the League's financial difficulties were typical of many art organizations in America, concurred: "It is an extraordinary fact that this is the only country which does not support art-students as it should. We are most in need of it, more than any other nation in the world at the present." [54]

Chase's first position at the League was as the instructor of drawing and painting, replacing his friend Walter Shirlaw, who moved on to teach the composition class. This arrangement received favorable comment in the press: "The League thus loses nothing and gains the services of one of the most thoroughly trained and vigorous of the painters whose work has within a year or two excited so much remark and interest here." With equal enthusiasm, the same writer described the League as being at the forefront of this country's "aesthetic awakening." [55] Another reported that "Mr. Chase and Mr. Shirlaw, two enthusiasts, induct the classes in painting from the model with the enthusiasm of youth and conviction; it is expected that they will turn out many a Franz Hals from among the lively crowd of American disciples." [56] Vitality marked the character of the school — a vitality brought to it by bold and energetic instructors like Chase.

With the exception of one year, 1886, Chase taught at the League continuously until 1896, making an important contribution to the school during its period of greatest growth. When it was founded in 1877, its initial enrollment was seventy pupils; by 1883 enrollment had increased to over 400. In a report published in 1882, William St. John Harper, the League's president, attributed the ever-growing popularity of the school to its teachers, noting that "at no time...have our instructors been more earnest and efficient." [57] Harper commended teachers like Chase who helped create a cosmopolitan atmosphere by bringing in their copies of old master paintings and reproductions of other major works of art. The

school's physical plant improved dramatically over the course of Chase's tenure; after moving several times during the 1880s, it settled in the building of the American Fine Arts Society on West Fifty-seventh Street in 1892, and remains there today. Chase's painting classes met on the fifth floor of this building. Natural light was provided by skylights ranging in size from twenty-five to forty feet square — a more perfect setting for the teaching of art could not have been imagined.

Chase also taught occasionally at the school of the Brooklyn Art Association, first in 1887 and again beginning in 1891, when the school was reorganized, continuing through 1895. [58] This school, located at 204 Montague Street, was modeled after the Art Students' League and included among its initial instructors three of the League's teachers: Chase, Shirlaw, and Benjamin Fitz. From 1891 to 1895 Chase taught a class in painting, sometimes concentrating on still life and at other times on portraiture. In the minutes of the school for April 27, 1896, it was recorded that "William Merritt Chase, instructor of the Life and Portrait Classes, has been obliged to give up his work in the School on account of his European trip and that his place has been temporarily taken by Mr. George Reevs." [59] Chase's departure from the school, however, turned out to be permanent. In fact, he even resigned his position at the Art Students' League, and his reasons were soon clear: he opened his own school in New York — the Chase School of Art — and accepted a post at the Pennsylvania Academy of the Fine Arts in Philadelphia. [60]

Before Chase returned from Europe in 1896 there had been rumors, undoubtedly based on Chase's own comments, that he intended to establish his own school of art abroad, in either Spain or Holland. He had been discouraged by the dismal results of an auction of his paintings held that January, and claimed that American artists had to become expatriates to be successful in their own country. Reflecting on the poor response his paintings had received, he stated, "The financial prizes in...[art] are very few and extremely uncertain. Much of the very best work that is done

Mother's Love (Mrs. Chase and Cosy). **c. 1895**

Oil on canvas
55¼ x 26¼ in (140.3 x 66.7 cm)
Sheldon Memorial Art Gallery, University of
Nebraska-Lincoln, F. M. Hall Collection

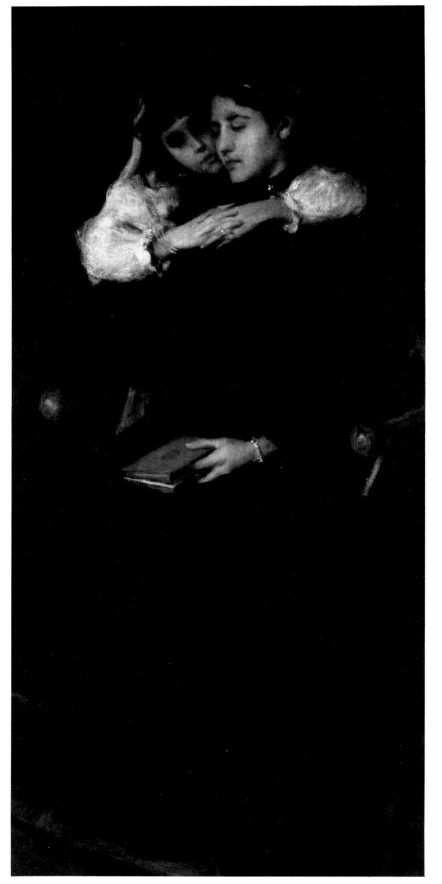

is never appreciated and receives no acknowledgement."[61] Although his art was not properly appreciated by the general public, there was no question that his popularity as a teacher was unsurpassed in this country. Wherever he taught he attracted a large and dedicated following. When he finally did open his own school, in New York at Fifty-seventh Street and Sixth Avenue rather than in Europe,[62] it was an immediate success. In 1898, two years after its founding, Chase turned over the administrative details to Douglas John Connah so that he could devote his full efforts to teaching. Under Connah's direction the school was reorganized and renamed the New York School of Art. Although the school no longer bore his name, Chase remained its dominant personality until 1907.

Tuition fees were reported to be the same as those of the Art Students' League, but as one writer observed, "Those familiar with the methods of that famous organization will perceive...that only in the matter of tuition fees will there be any similarity between the Chase School and the Art Students' League."[63] From the very beginning the local press predicted the popularity of the new school and listed several reasons for its ultimate success: there would be no qualification tests for admission, and anyone familiar with the elements of drawing would be eligible for the painting class. Drawing and color were to be taught simultaneously. In contrast to the traditional course of study, in which beginning students would be instructed in drawing from plaster casts, those at Chase's school would start working immediately from life. Drawing from casts would be reserved for more advanced students, who would also be offered a special evening class designed to encourage "originality and artistic treatment." In this class, based on one Chase had observed in Madrid, students were permitted to work in any medium — a "new departure in art study."[64]

As an inducement to attract students, monthly prizes including monetary awards, free tuition, and at times Chase's own demonstration paintings were offered for the best work completed in each class. In the second year of the school another impressive award was added — a scholarship

to the Académie Julian in Paris, which was presented by its manager, Rudolph Julian. [65] The Chase School of Art was actually described as being like "'Old Julians', though not on the whole as boisterous, as truly Bohemian — or at any rate as blue with smoke — but there was the skylight, the student paintings on the walls, and a general grey green tone in surroundings that made for harmony — and gave a little sense of atmospheric mystery withal." [66] As always, one of Chase's prime concerns in creating such an atmosphere was to provide an inspiring setting in which his students could develop. Regularly scheduled exhibitions made an important contribution to the character of the school. On the last Saturday of each month there were student shows. Chase's own work and that of other instructors was also displayed in the classrooms. A natural extension of Chase's emphasis on the importance of an artistic setting was the establishment in 1904 of a course in "Interior Architecture and Decoration," which was described as being the first practical course of its kind to be offered. [67]

As with any part of Chase's teaching career, there are numerous reminiscences from the School's students that attest to his dynamic approach to teaching. One student, F. Usher De Voll, recalled enthusiastically: "There was an all pervading quiet and seriousness as the students worked on in watchful waiting of the master's arrival. A brisk step — the door flew open — and there entered the dignified, forceful but cheery personality of William M. Chase, a personality in the presence of which we at once felt inspiring influence — the influence of an energetically purposeful life, as truly exemplified in his art, so sincere, so robust — a noble example of 'Art is the expression of man's joy in his work.'" [68] Chase's painting demonstrations, called "Red Letter Days" by De Voll, were memorable events. [69] Another student at the school, Guy Pène Du Bois, recollected:

Once or twice a year [Chase] would, in three hours, finish a life size, full-length figure in the presence of the assembled school. These occasions were holidays. In the attitude of a fencer, Chase attacked the large canvas furiously. Beard and moustache on the qui vive, *he seemed to pirouette with the grace of a ballet dancer, the excitement of a dervish. His brush-marks seemed infallible as, dragged in one place, staccato in another, they flew over the canvas. Once in a sitting he would cry "Ouch!" He could make mistakes, and though on each occasion it was only one, it was enough to prove that he was human. The show he put on had been perfected by practice. It was as accurately timed as a performance by Grock, the most classic of the European clowns.* [70]

Such demonstrations were referred to as "a treat — a feast of 'art repartee' full of the spirit of 'vive l'art l'Americain' — full of valuable advice and encouragement and incentive to do good work." [71]

Chase also gave regular lectures on a broad range of artistic topics. Pène Du Bois, who credited Chase with introducing Velasquez and El Greco to America, described Chase's acquaintance with art as being "as wide as his enthusiasm was enormous....He could upon occasion defend Bouguereau on pure painting grounds and show, when driven by inner necessity, broad brushwork in a Meissonier miniature." [72]

The early years of the school were marked by a certain genteel character, associated with Chase's own manner and his carefully cultivated image as an artist-gentleman, which served as a model for others. This refinement was noticeable both in the artistic setting of the school and in the choice of its instructors. Among the first teachers at the school were Chase's friends J. Carroll Beckwith, Frank Vincent DuMond, and F. Luis Mora, as well as Chase's former student, Irving R. Wiles — all known for their elegant manner of painting. Illustrators with similar artistic sentiments, for example Albert Wenzell and Arthur Keller, were also selected for the staff. Reflecting on the atmosphere created by the school's instructors, Guy Pène Du Bois commented on their "Europeanized" attire and manners. He described Chase as being "dressed in accordance with his doctrine....His flat-brimmed top hat, cutaway, gold-ringed cravat, spats, quick nervous manners were known in New York, Philadelphia, the country over." [73]

In contrast to Chase the *"grand maitre"* was Robert Henri, who began teaching at the school during the 1902-03 term. Henri, described by Pène Du Bois as "tall, six feet at least, dressed carelessly, the head slightly Mongolian" preached "art for life's sake," an attitude directly opposed to Chase's philosophy of "art for art's sake." [74] As for technique, Pène Du Bois claimed that "Henri knew or in any case taught very little of the technic of painting" and that with Henri "elegance was thrown out of all the vocabularies." [75] Why was such an artist, whose approach was diametrically opposed to that of Chase, hired to teach at the school? Evidently Chase responded favorably to Henri's art, which, in spite of their philosophical differences, was similar in its bold vigorous style to Chase's own manner of painting. As early as 1897, Chase had acknowledged the younger artist's talent by borrowing a group of Henri's paintings for an exhibition in New York; later, in 1902, Chase praised one of Henri's paintings, calling it a "'corker.'" [76] Initially Chase must have believed that Henri's teaching would be compatible with the goals of the school, but he soon learned otherwise. As Pène Du Bois later recalled, "Henri set the class in an uproar. Completely overturned the apple cart: displaced art by life, discarded technic, broke the prevailing gods as easily as brittle porcelain. The talk was uncompromising, the approach unsubtle, the result pandemonium." [77] It was not long before Henri's class became the "seat of sedition" among the young artists. Pène Du Bois claimed that "if Robert Henri was young in spirit, his students were easily younger still. They rode this American bull of his with hilarious energy. They were adamant and even violent critics of what Mr. Hearst's Mayor Hylan called 'art artists.'" [78] The once sedate school became the battleground of opposing ideologies. In one instance police reserves even had to be called in to the New York School of Art to settle a brutal fight between Henri's students and a group from the Art Students' League. [79]

By 1907 the complexion of the school had changed so dramatically under Henri's influence that Chase decided to leave the institution he had founded eleven years earlier and return to the Art Students' League, where he taught for the next five years. Chase's break with the school that once bore his name created a sensation. He explained his departure by stating: "'I have warned the

98 **The Mirror. c. 1883**
Oil on canvas
32½ x 17⅝ in (82.6 x 44.8 cm)
Private Collection

Hattie. c. 1886
Oil on canvas
64¾ x 38 in (164.5 x 96.5 cm)
Collection of Mr. and Mrs. Richard J. Schwartz

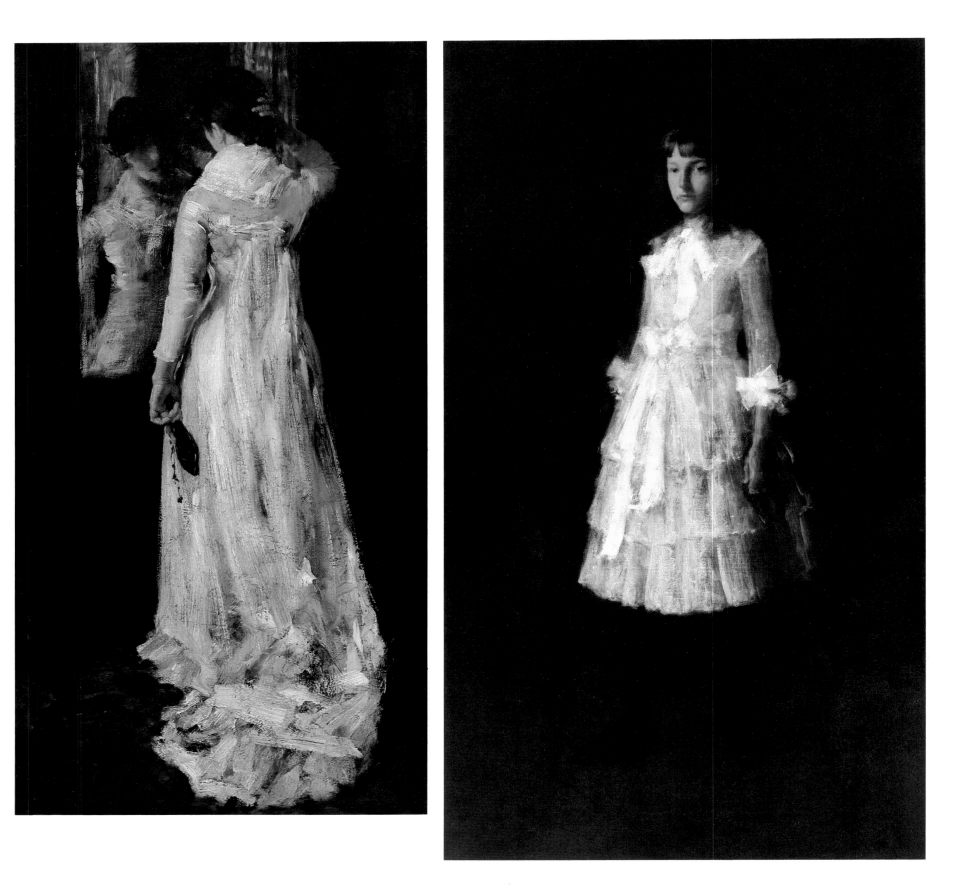

Portrait of a Lady. c. 1890
Oil on canvas
34 x 20¼ in (86.4 x 51.4 cm)
Collection of Dr. Philip M. Laborde

students…that there was danger in mistaking violence for strength.…'"[80] Henri attributed Chase's departure to simple jealousy: "'It appears that Chase is very bitter about the way the students of the school have flocked to my classes.'"[81] When asked about Henri at the time, Chase rebutted, "'I have nothing to say about Mr. Henri.…His influence was not like my own upon the pupils. Art is draughtsmanship.'" After crediting "the valuable work" Chase had done for art students in this country, Henri countered: "'If my ideas are revolutionary, I can only point to my following as the best proof that they have found acceptance.'"[82]

The final rupture in their relationship, and Chase's ultimate reason for leaving the school, was undoubtedly related to Henri's feud with the National Academy of Design, of which Chase was by this time an established member. In 1906 Henri was elected an academician and served on the jury for the annual exhibition.[83] The following spring he was asked to serve on this jury once again. This time he became enraged with other members of the jury, who repeatedly rejected the work of the more progressive artists, including a number of Henri's close friends and students. He was further embittered by the jury's unenthusiastic response to two of his own paintings, one of which was demoted from the first to the second category. Reacting to this indignity he withdrew them. As the conflict between the conservatives and the progressives worsened, there were rumors that Henri might start a secessionist movement. At a meeting held in Henri's studio on April 4, 1907, he and five other artists — George Luks, Arthur B. Davies, William Glackens, John Sloan, and Ernest Lawson — discussed the possibility of a secessionist exhibition. A decision to go ahead was made, and with the addition of Everett Shinn and Maurice Prendergast, the Eight was formed; their landmark exhibition was held the following February.

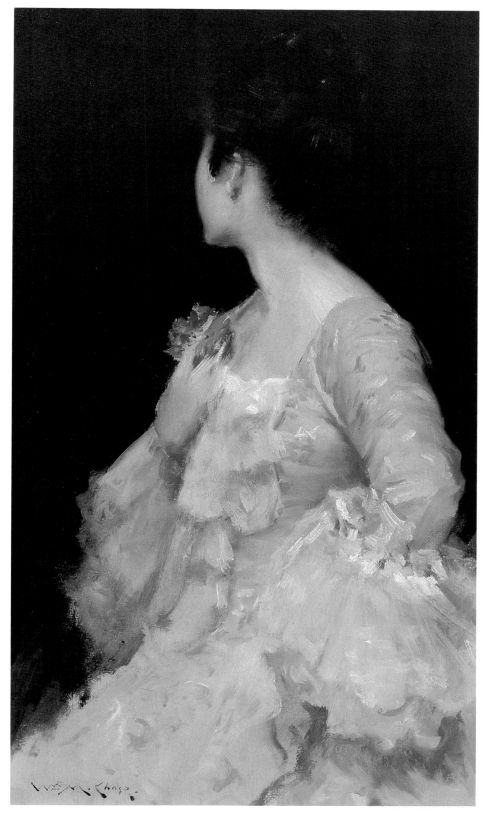

Portrait of a Woman. c. 1888

Oil on canvas
26 x 21½ in (66.0 x 54.61 cm)
Snite Museum of Art, University of Notre Dame

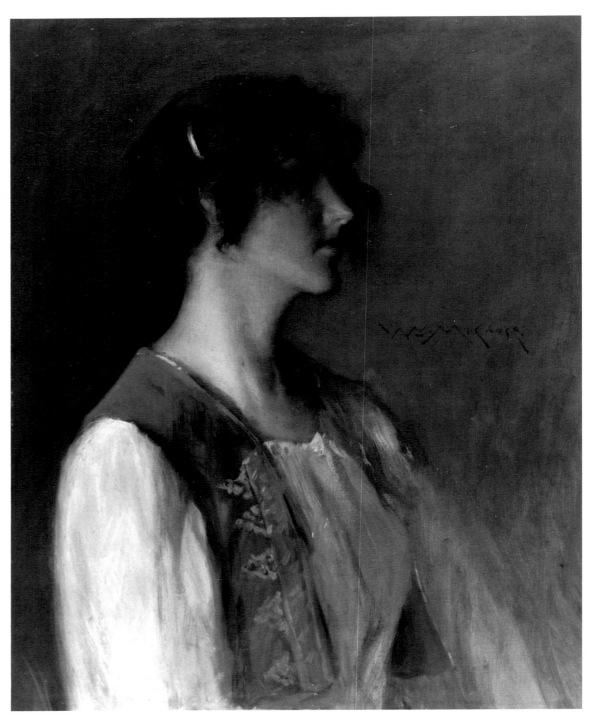

The deteriorating relationship between Chase and Henri was no doubt exacerbated by their competition for portrait commissions. That year Henri had to give up his Bryant Park studio since he was not receiving enough such commissions to maintain it. Chase, on the other hand, was at the height of his popularity as a portraitist, attracting an impressive number of commissions from all over the country. In the Pennsylvania Academy's annual exhibition of 1907 alone, Chase included five portraits; and at the National Academy's show for that year he featured one of his many portraits of college presidents — *J.M. Taylor, D.D., President of Vassar College.* [84] In defense of Henri's situation at this time John Sloan explained, "'He won't do the five o'clock tea drinking that is necessary for the portrait work in this country today.'" [85] This petulant statement was undoubtedly directed at Chase and other successful portrait painters.

Upon Chase's abrupt departure from the New York School of Art, Henri predicted that there would be a "'desperate fight to knock out'" the school, but he maintained that if the business end were handled properly, his reputation as a teacher would ensure its continuing prosperity. [86] Within a year, however, the school was unable to pay Henri's salary, so he resigned. The school's director, Douglas John Connah, reported a very different reason for Henri's departure, claiming that it was prompted by his waning influence on the students. As a last-ditch effort to revive the school, two of Chase's former students, Charles Hawthorne and Eugene Paul Ullman, were hired to replace Henri. However, without a major figure to attract the enrollment necessary for its survival, the school declared bankruptcy the following year.

Seven years after his resignation from the New York School of Art, Chase still harbored bad feelings for Henri and his associates, objecting to the lowly types of subjects they chose to paint and the dreary nature of their work. In a lecture he gave to his summer class in California in 1914 Chase contrasted them to the Impressionists: "'A certain group of painters in New York paint the gruesome. They go to the wretched part of the city and paint the worst people. They have the nickname of the "Depressionists."'" [87]

Memories (Woman in White). **c. 1886**
Oil on canvas
51 x 36½ in (129.5 x 92.7 cm)
Munson-Williams-Proctor Institute, Utica, New York

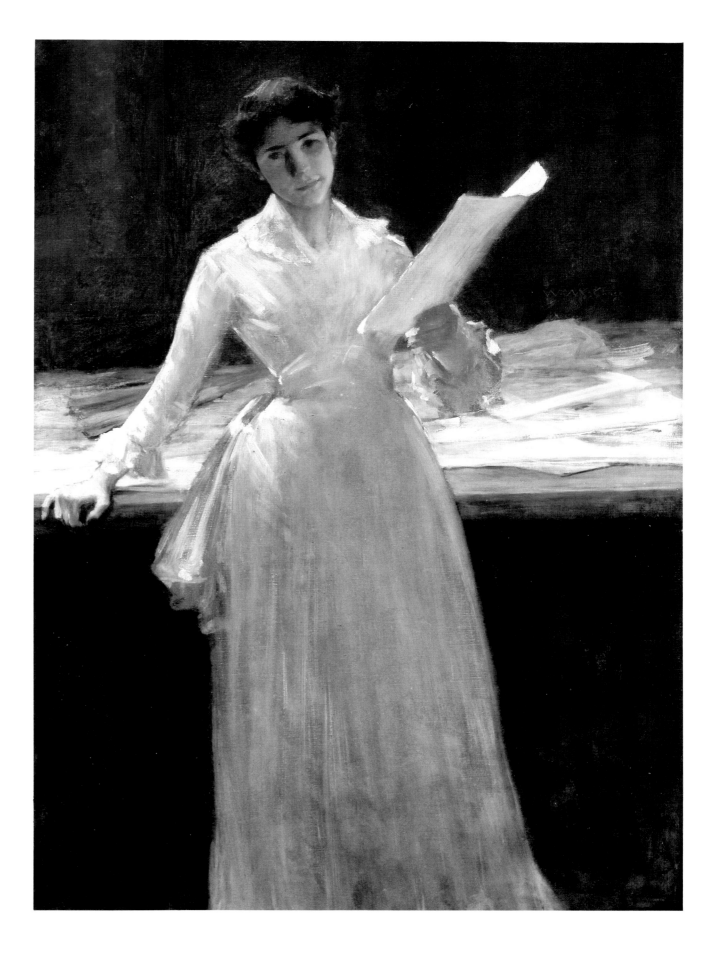

Portrait of a Lady in Pink (Lady in Pink;
Portrait of [Mrs.] Leslie Cotton). **c. 1888-89**

Oil on canvas
70½ x 40¼ in (179.1 x 102.2 cm)
Museum of Art, Rhode Island School of Design,
Gift of Isaac C. Bates

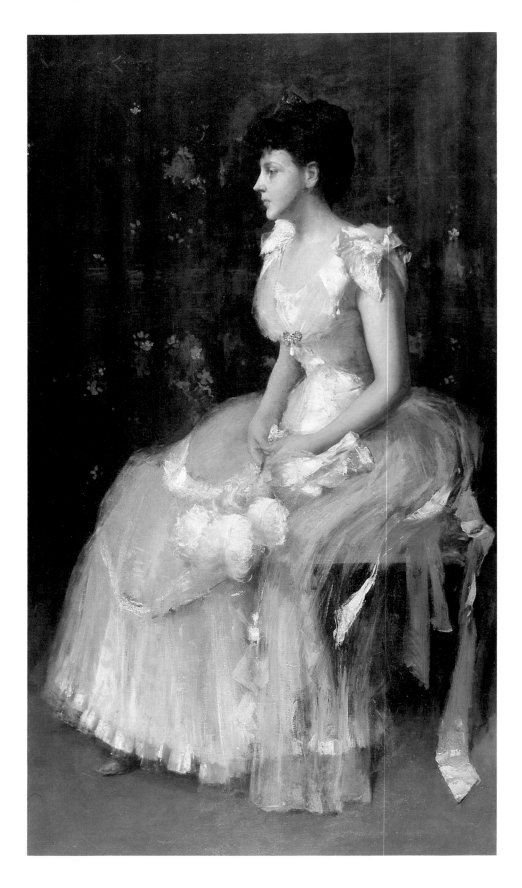

Portrait of Miss E. (Portrait of Lydia
Field Emmet; Lydia Field Emmet). c. 1892
Oil on canvas
71⅞ x 36¼ in (182.6 x 92.1 cm)
The Brooklyn Museum, Gift of the Artist

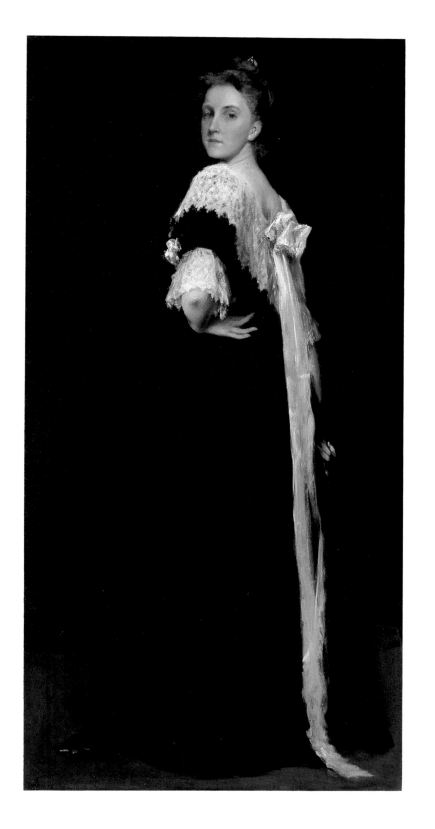

Lydia Field Emmet. 1900
Oil on canvas
24 x 20 in (61.0 x 50.8 cm)
Private Collection

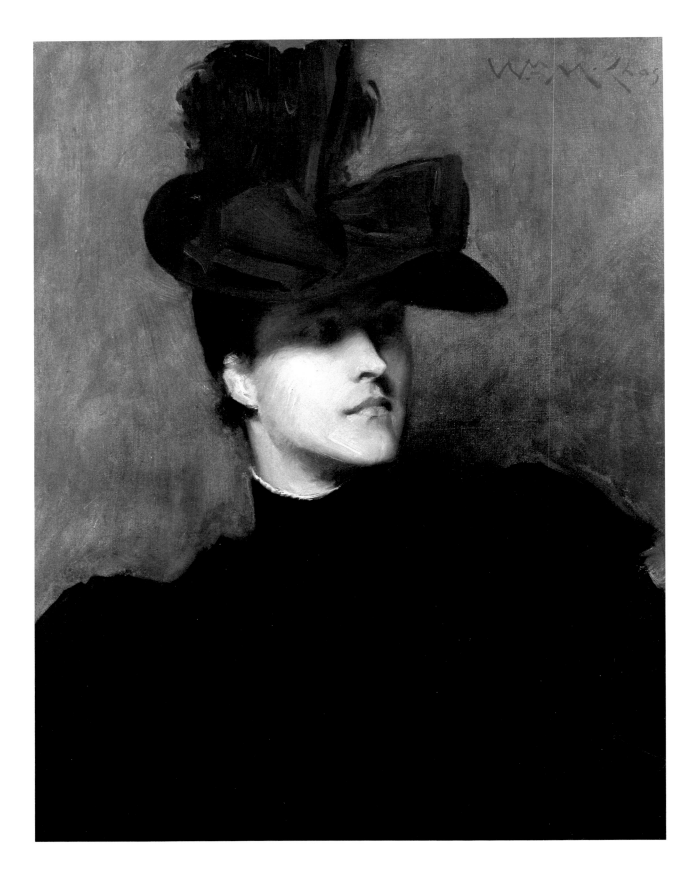

The Pennsylvania Academy of the Fine Arts

By the time William Merritt Chase was appointed to the faculty of the Pennsylvania Academy of the Fine Arts in 1896, Thomas Eakins, the Academy's most influential teacher, had been gone for ten years. A controversial incident had resulted in his resignation. The crisis involved Eakins' removal of the loin-cloth of a male model in the women's class in order to demonstrate the function of the pelvis. After his departure, a more conventional approach to teaching was re-established with the appointment of Thomas Hovenden, who taught there from 1886 to 1888. The use of photography as an aid to teaching was discontinued; the dissecting class was phased out; and drawing from the antique cast received new emphasis. [88]

The decade following Eakins' departure from the Pennsylvania Academy was a difficult period for the institution as it redefined its teaching principles and sought a permanent replacement for Eakins. In 1896 Joseph De Camp, one of several instructors who had been hired, left the school, and Harrison Morris, the Academy's Managing Director, was forced to fill the vacant position. It is clear that Morris believed that there was one artist who had the ability to pick up where Eakins had left off a decade earlier: William Merritt Chase. Evidently Morris was impressed by the paintings Chase exhibited at the Academy's annual exhibitions, particularly after 1892, when he began exhibiting there on a regular basis, contributing an average of five paintings a year. [89] Two years later, Chase was amply represented by seventeen paintings, practically a small one-man show in itself. Among these was his masterwork, *Portrait of Mrs. C.*, more popularly known today as *Lady with a White Shawl*, which was described as "stately, dignified, aristocratic in pose, superb in reserved color...a delicious picture...." [90] Morris was especially impressed by this work, and following the exhibition, it was purchased for the Academy's collection. [91]

By 1896 Morris was determined to secure Chase's services as an instructor for the school.

That summer he traveled to the eastern end of Long Island to meet with Chase at Shinnecock Hills. [92] A statement in the press shortly afterwards announced Morris' success, stating that Chase would "assume charge of the [Academy's] life classes for both men and women and will also organize an advanced class in still life painting, a branch of art in which he excels." [93] Morris was particularly pleased with the situation, explaining, "If we could not have Eakins, the legitimate (perhaps according to the Directors, illegitimate) master for Philadelphia, then here was the ideal choice, and so it eventually proved through the years to come." [94] As expected, Chase was an instant success, especially with the students. According to Morris: "The class adored him, naturally. He was the soul of gentleness and kindness. Each student was to him a personal charge of whom he was proud when his guidance was intelligently received; and even the dullest cannot fail to remember that rare contact with so loveable and gifted a master." [95]

Formerly described as the "chief attraction" at the Art Students' League, Chase had an equal appeal at the Pennsylvania Academy of the Fine Arts, where he was reappointed to his post for the following thirteen years. His classes proved to be so popular the first year that when his services were requested again in 1897, he volunteered to teach an additional class, preferably a portrait class, if the school would increase his wages 100 dollars a month. [96]

Early in his tenure at the Pennsylvania Academy, in 1897, Chase took a leave of absence to attend a major exhibition of his work at The Art Institute of Chicago, from November 23 to December 26, and to teach that school's life class along with his friend Frank Duveneck. The show was described as embracing "every variety of the painter's art so far as style, color, technic and diversity of subject are concerned." [97] Chase's painting methods were also reported to the public enthusiastically: "To watch Mr. Chase while he paints a portrait is to forget paint and brush and palette...and for the time being we feel that art is the great triumph of mind over matter." In all, his visit, hailed with great fanfare in the local press, was said to have "instilled new life and vigor into the art interests of the West." [98]

Chicago's gain was Philadelphia's loss, however, and Chase's students at the Pennsylvania Academy complained bitterly about his absence.

Dissatisfied with Chase's replacement, members of the women's special painting class demanded a refund of five dollars each. Even before his Chicago sojourn, Chase had occasionally failed to meet his classes, and he was reprimanded by the chairman of the school in January 1898. Chase responded with a letter of apology, and promised to be more conscientious in the future. Despite these problems, Chase's popularity continued to grow, and by 1906 his portrait class had become so crowded that he was asked to teach more frequently. Although still bounding with energy at fifty-seven, Chase did not want to increase his teaching load in Philadelphia; he agreed to remain for the next two years but refused to teach additional classes.

During his tenure at the Pennsylvania Academy, Chase arranged for his students to make regular trips to New York, where he gave them guided tours of important museums and galleries in order to develop their views on art. During one visit to The Metropolitan Museum of Art, Chase and his class were observed by a young art student, Walter Pach, who was copying a work by Jean-Baptiste-Edouard Detaille, which happened to hang alongside Edouard Manet's painting *The Boy With the Sword*. As Chase addressed his students on Manet's work, Pach was compelled to listen to what was said about this painting, which he had dismissed as empty and uninteresting the few times he even bothered to look at it. When Chase began to praise the Manet painting Pach became suspicious of this gentleman in "modish" attire as being "a person who made his society manner take the place of knowledge of art." Pach was dumbfounded when Chase proclaimed: "'And don't you see that this and the other Manet are the only pictures here that could hang with the Old Masters, while this (pointing to my Detaille) and everything else in the room are just so much claptrap?'" [99] Astounded by this bold statement, Pach was determined to get the name of this "preceptor" and his school association, intending to write to the head of this school and express his indignation. One can imagine his chagrin upon learning that the art teacher was the renowned William Merritt Chase, and the school, the Pennsylvania Academy of the Fine Arts. When Pach later became one of Chase's students he began to see things differently. Ironically, he even went on

The Golden Lady. 1896
Oil on canvas
40⅝ x 32¾ in (103.2 x 83.2 cm)
The Parrish Art Museum, Southampton, New York,
Littlejohn Collection

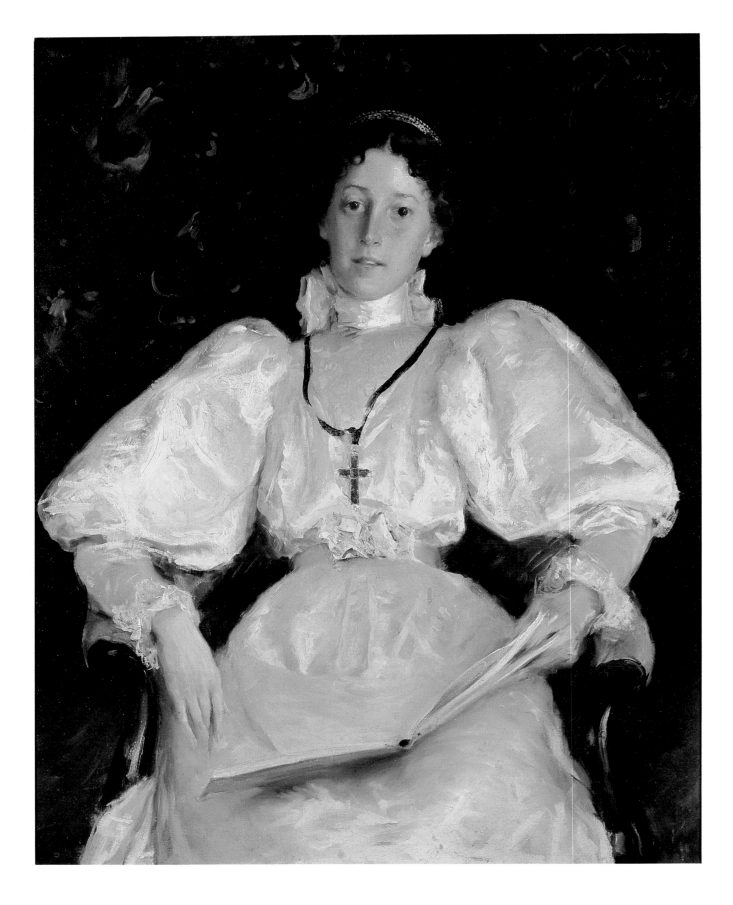

The Red Sash (Portrait of the Artist's
Daughter). **c. 1895**
Oil on canvas
$32^3/_8$ x $25^5/_8$ in (82.2 x 65.1 cm)
Hirshhorn Museum and Sculpture Garden,
Smithsonian Institution

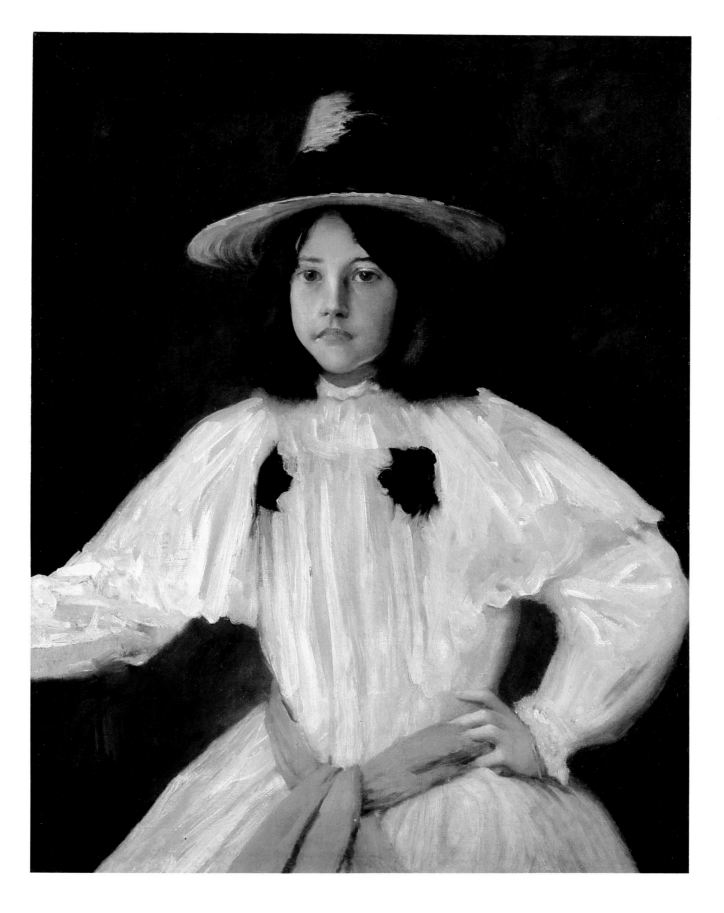

Mrs. Chase as the Señorita. c. 1890

Watercolor on composition board
16½ x 10¾ in (41.9 x 27.3 cm) (sight)
Albrecht Art Museum, St. Joseph, Missouri,
Gift of Mrs. J. Wesley McAffree

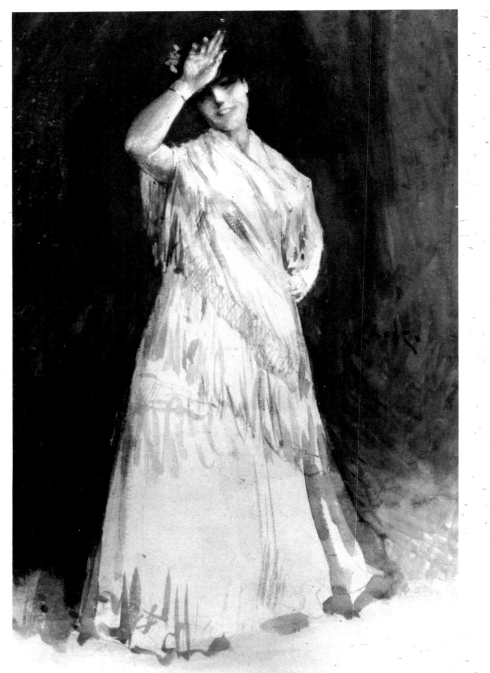

to become an avant-garde artist and a supporter of the modernist movement in America, ultimately surpassing Chase in his radical views on art and artists.

Among Chase's students at the Pennsylvania Academy were several who became modernists — Charles Demuth, Arthur B. Carles, Morton Schamberg, Charles Sheeler, and James Daugherty. In recalling their early days at the Academy under Chase's guidance, most of these artists have expressed their indebtedness to their teacher, especially for his infectious enthusiasm about art and his vital approach to painting. "'How exciting this all was!'" Sheeler reminisced. "'What a waste of time, the hours required for sleep when one could be painting around the clock! The excitement caused by the gleam of light on brass or copper was in our blood.'"[100] During the spring, Chase took Sheeler and other students to the countryside just outside of Philadelphia to practice landscape painting in the open air; Sheeler recalled that "'since our panels were small and what we required of a picture was very slight we often returned at the end of the day with quite a harvest....'"[101] James Daugherty, who described Chase as an artist with an "immense capacity for inspiring enthusiasm," particularly admired his demonstrations of "dazzling brushwork." Daugherty added: "His dashing image remains with me a fond recollection."[102] As the work of these progressive artists began to reflect more radical tendencies however, Chase became disturbed. Daugherty recalled that "the budding school of Paris enraged him. When Sheeler, Schamberg and Pach deserted to the enemy he utterly repudiated them."[103] Arthur B. Carles claimed that at one point Chase wanted to expell him from the Academy's classes because he "'was going through a green period....Yes, green bodies, Everything green, like corpses. It worried the old man sick.'"[104]

It is ironic that Chase provided these young artists with the technique, encouragement, and inspiration they needed to become major modernist painters of the next generation, since he was unable to accept their radical stance. Most of his students at the Academy actually followed a more conservative and accepted course, dominating the next era in numbers — if not in importance.

109 **A Spanish Girl** (Portrait of Mrs. William Merritt Chase in a Spanish Shawl). **c. 1886**
Oil on canvas
27 x 15½ in (68.6 x 39.4 cm)
Collection of R. Philip Hanes, Jr.

The Tamborine Girl (A Madrid Dancing Girl; Mrs. Chase as a Spanish Dancer). **c. 1886**
Oil on canvas
65 x 30 in (165.1 x 76.2 cm)
Montclair Art Museum, Montclair, New Jersey,
Gift of Friends of the Museum, 1962

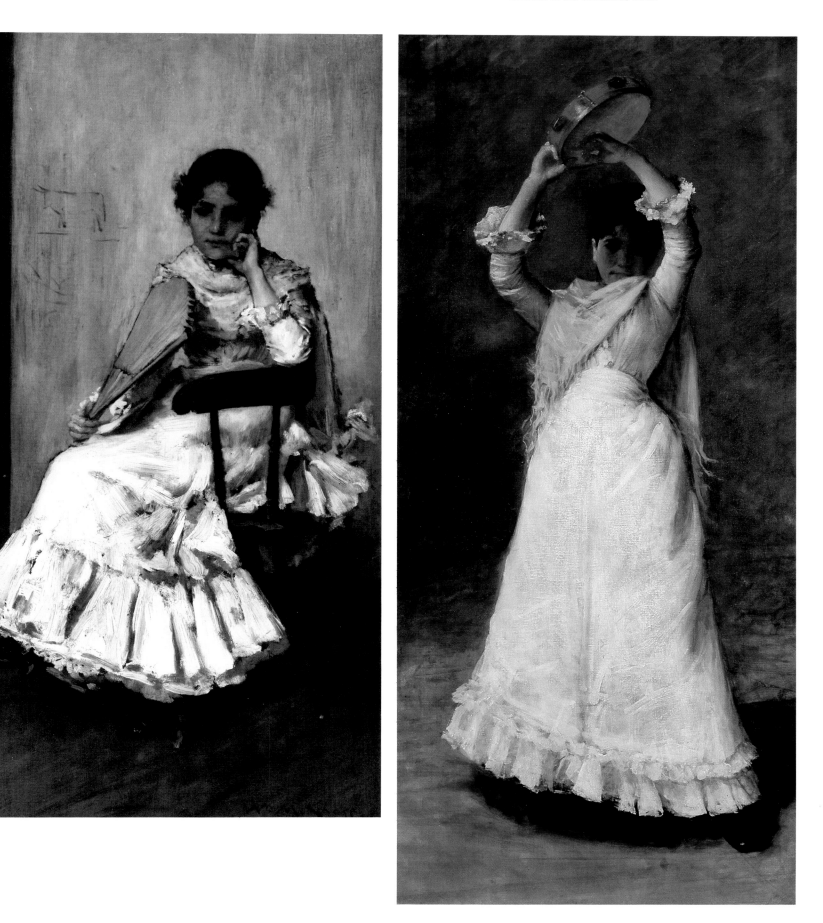

Girl in White. c. 1898-1901

Oil on canvas
84½ x 40½ in (214.6 x 102.9 cm)
Collection of the Akron Art Museum,
Bequest of Edwin C. Shaw

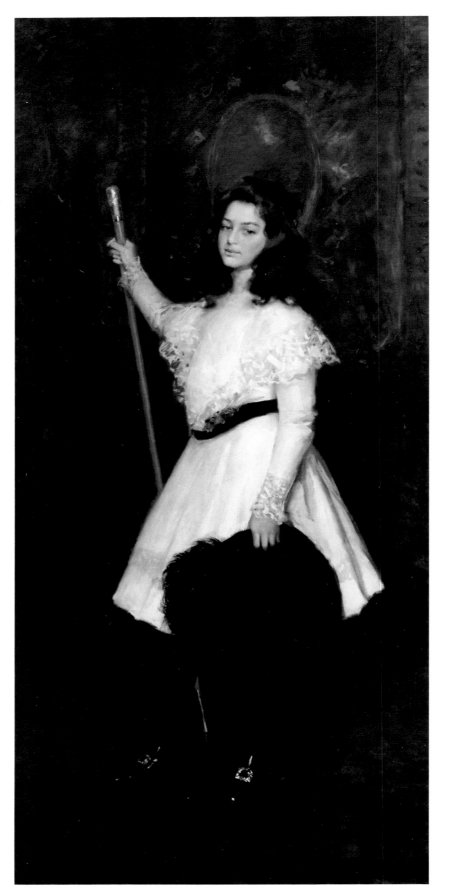

Chase taught long enough in Philadelphia to establish himself there, making "quantities" of friends and procuring numerous portrait commissions. In order to receive his sitters properly, Chase rented a studio which he decorated "with the luxuries of taste and color he had picked up here and there, at auction or in the little old shops he knew how to discover."[105] The city of Philadelphia even allowed him the use of a public school where he might offer free classes for students unable to pay for their instruction.[106]

Later, however, Chase was to become embroiled in political controversies. In 1901, when Morris requested funding from the city for the Academy, the amount of $7,500 was allotted with the condition that two artists, Harrington Fitzgerald and Albert Rosenthal, be appointed members of the Academy's Board of Governors. Opposing such political interference by Mayor Samuel Ashbridge, Morris derided the artistic capabilities of the two artists in question. This stand aggravated the issue and prompted a response in the press, which attacked Chase, as well as the Academy: "Every thoughtful person knows that the Academy has ignored our Philadelphia artists, has sunk into the mire of Impressionism. . . ."[107] In support of his friend Morris, Chase replied, "'The institution couldn't be better conducted, and if Philadelphia artists were dissatisfied they would make a concerted protest.'"[108] This "call to arms" must have been especially annoying coming from an "outsider" such as Chase. Morris stood his ground, stating that he would refuse to accept the money if the ordinance demanding that the two artists be appointed to the Board was attached. Ultimately, a solution was reached and the Academy received its funding without adding the two artists to its board. In another dispute, Chase was reported to have had "spasms" and to have been "convulsed with rage" over Harrington Fitzgerald's appointment to the Municipal Art Jury.[109] Again, Chase questioned the qualifications of this political appointee, claiming that the only honor ever accorded this artist was one he bestowed upon himself. Furthermore, he announced that he would not serve on this jury with Fitzgerald, even though he had never been

My Daughter, Alice. 1898-99
Oil on canvas
22½ x 18¼ in (57.3 x 46.4 cm)
Collection of Mr. and Mrs. Louis L. Silver

asked to join, an oversight which undoubtedly annoyed him. When Chase appealed to his fellow artists to take the same stand, the local press launched a venomous attack against him, referring to his portraits as "inferior" and once again attributing "a wild impressionism that cannot be called true Art" to his teaching.[110]

In 1909, when Chase finally did leave the Pennsylvania Academy, the local press rejoiced over his departure. In an article entitled "Chase Deposed," it is clear that one of the major objections to Chase was that he was not a Philadelphian, but an intruder who had no personal feeling for the city or its inhabitants. The article began with the statement, "The king is dead, long live the king," and went on to praise Chase's replacement — Thomas Anshutz, who was described as "a Philadelphian heart and soul." It concluded with the proclamation: "THIS GREAT CITY SHOULD HONOR AND ENCOURAGE ITS OWN ART TALENT." [111] The Philadelphia-trained artist John Sloan was delighted by this news and noted in his diary, "Hear that Chase has retired from the schools of the Penn. Academy of the Fine Arts. Anshutz is now the head instructor — good!"[112]

In spite of such criticism Chase remained active in Philadelphia. He continued to maintain a studio there, and later opened his own school. As late as 1913 Chase supervised a class of about a dozen students on the top floor of the Shippen School. The tuition was two dollars a month and models, including the well-known Madame Belmont, posed daily. There was no drawing from the cast since Chase believed that working from life was more interesting. Naturally, still life painting was encouraged, and the requisite number of kettles, pots, bowls, jugs, and plates was available. As might be expected, the setting was described as being "quite bohemian," with lanterns and drapery decorations. The walls were filled from floor to ceiling with paintings of a wide array of subjects. In short, the school was described as being "like the old atelier of tradition."[113]

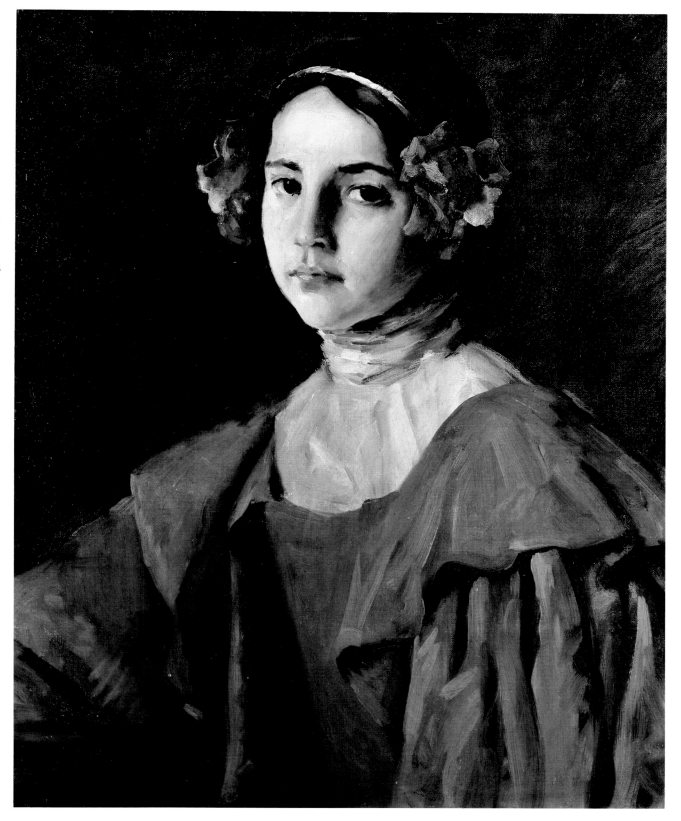

In the Studio. c. 1892
Oil on canvas
29 x 23½ in (73.7 x 59.7 cm)
Collection of Mr. and Mrs. Arthur G. Altschul

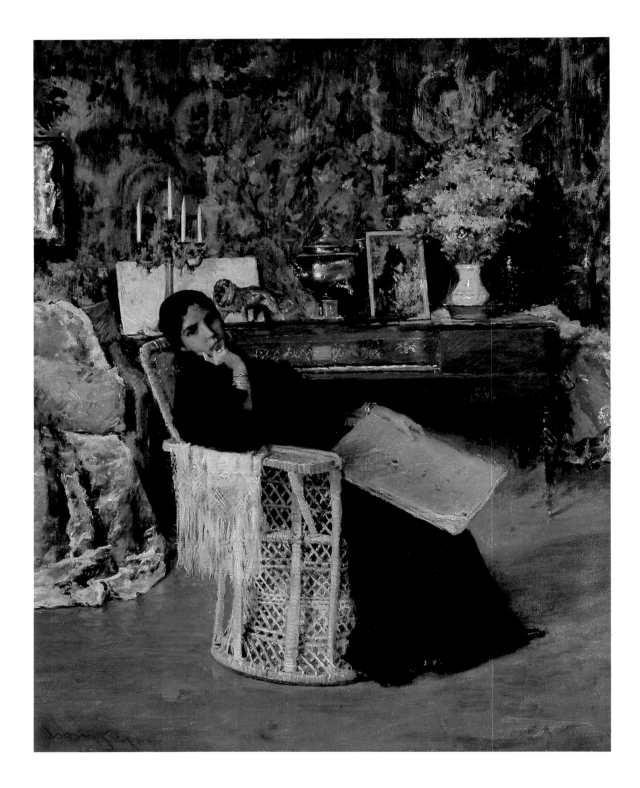

Did You Speak to Me? c. 1897
Oil on canvas
35 x 40 in (88.9 x 101.6 cm)
The Butler Institute of American Art,
Youngstown, Ohio

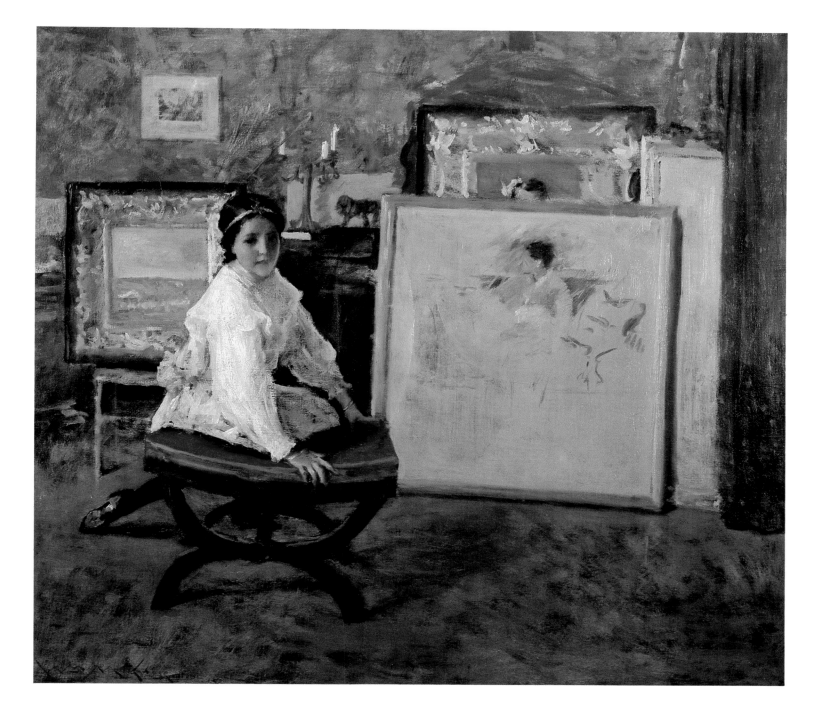

Portrait of Mrs. C. (Portrait of Mrs. Chase). c. 1892

Oil on canvas
72 x 48 in (182.9 x 121.9 cm)

Museum of Art, Carnegie Institute, Pittsburgh,
Purchase, 1909

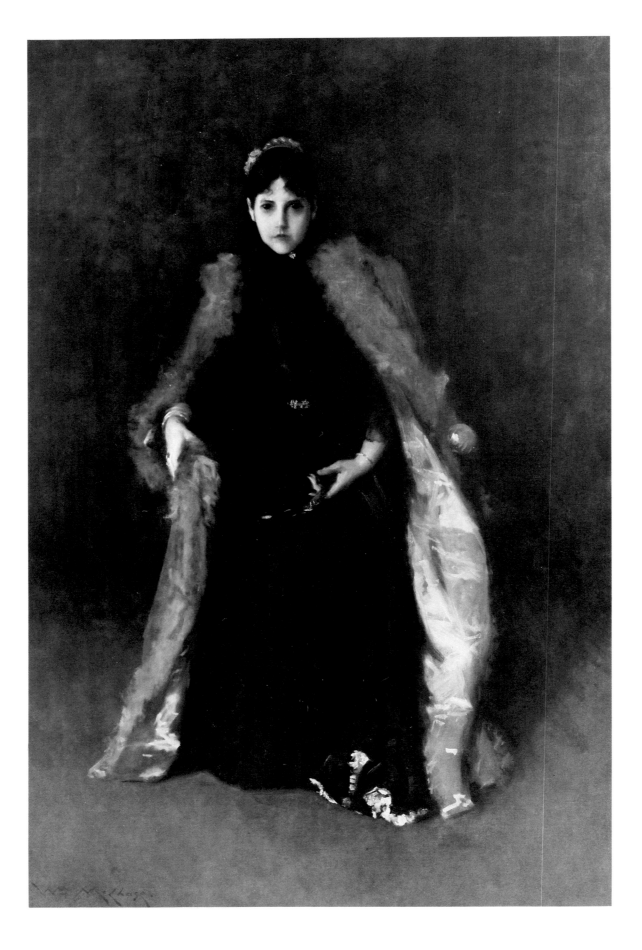

Portrait of a Woman. c. 1895
Oil on canvas
72 x 36 in (182.9 x 91.4 cm)
The Detroit Institute of Arts,
Gift of Henry Munroe Campbell

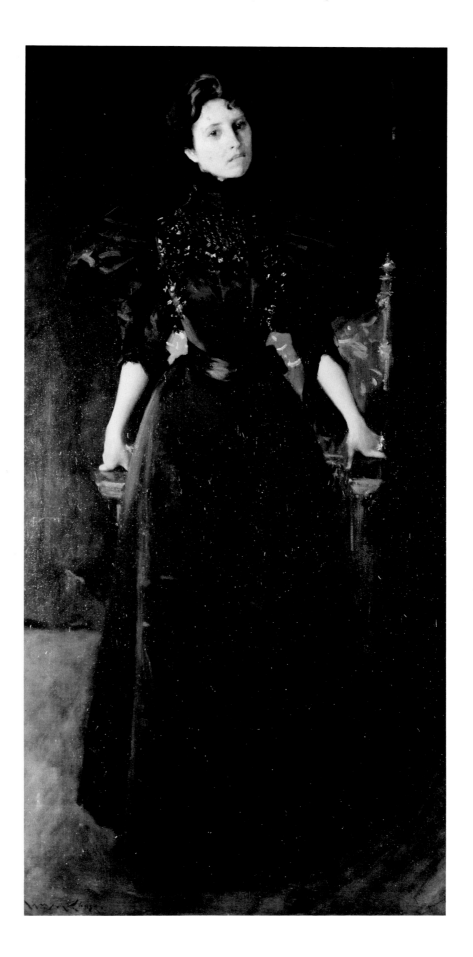

Portrait of Miss F. DeForest (A Lady in
Brown; Young Girl). **c. 1898**

Oil on canvas
20³/₈ x 16¹/₄ in (51.8 x 41.3 cm)
Richard York Gallery

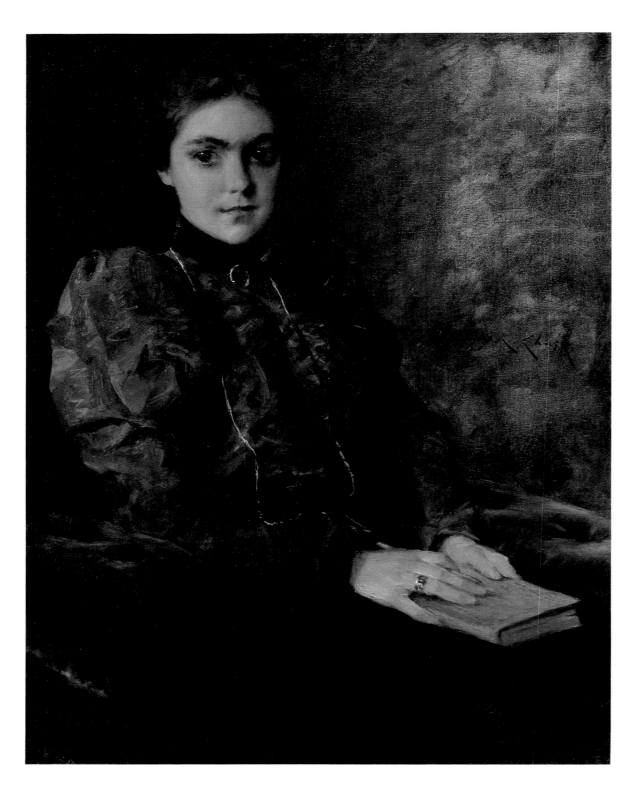

Portrait of the Artist's Daughter (Dorothy). **c. 1897**
Oil on canvas
35¹/₂ x 25¹/₂ in (90.2 x 64.8 cm)
Collection of Mr. and Mrs. Haig Tashjian

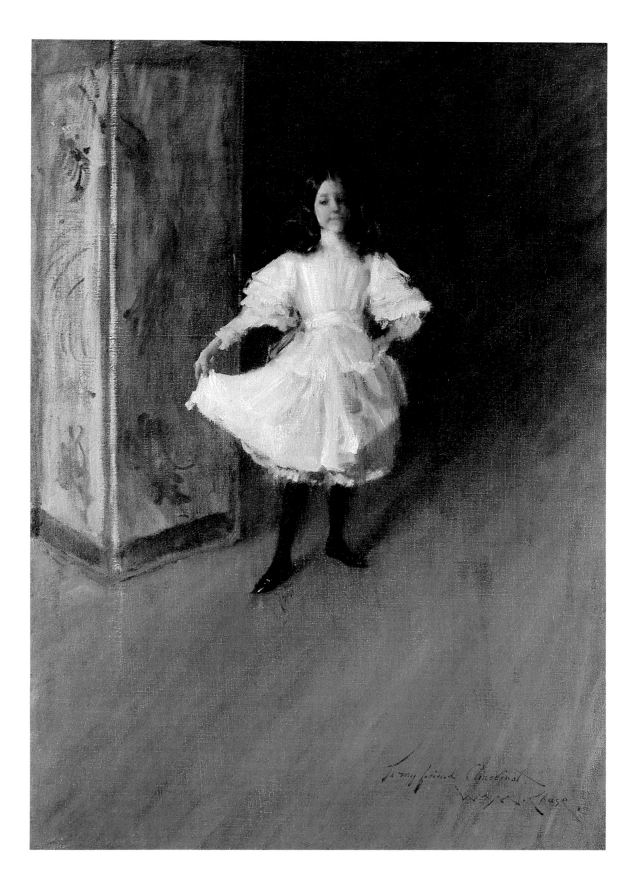

Young Girl in Black (Artist's Daughter
Alice in Mother's Dress). **c. 1899**

Oil on canvas
60$\frac{1}{8}$ x 36$\frac{3}{16}$ in (152.7 x 91.9 cm)
Hirshhorn Museum and Sculpture Garden,
Smithsonian Institution

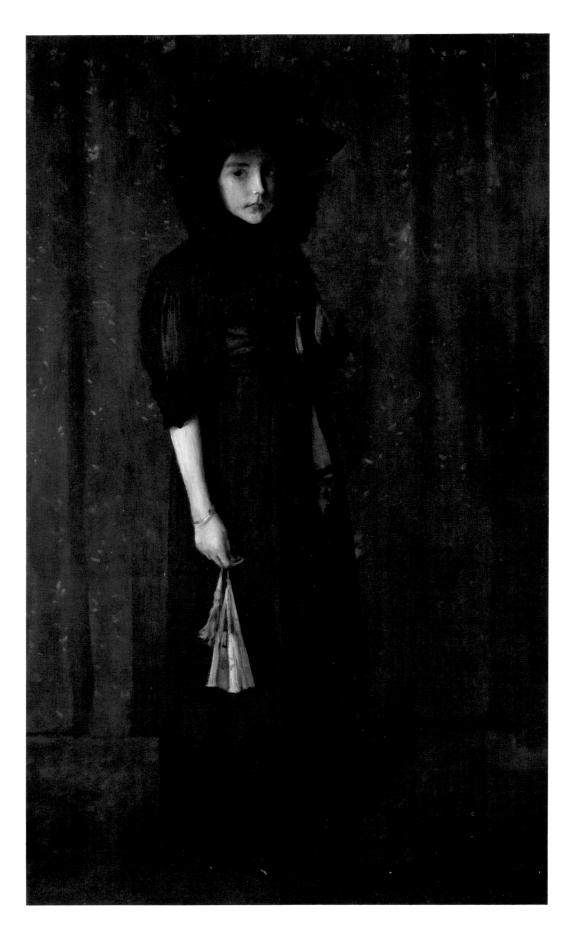

Head of a Girl (The Artist's Daughter). **c. 1899**
Oil on canvas
19$\frac{1}{2}$ x 15 in (49.5 x 38.1 cm)
North Carolina Museum of Art, Raleigh

The Bayberry Bush (Chase Homestead:
Shinnecock Hills; Shinnecock Hills). **c. 1895**

Oil on canvas
25¹/₂ x 33¹/₈ in (64.8 x 84.1 cm)
The Parrish Art Museum, Southampton, New York,
Littlejohn Collection

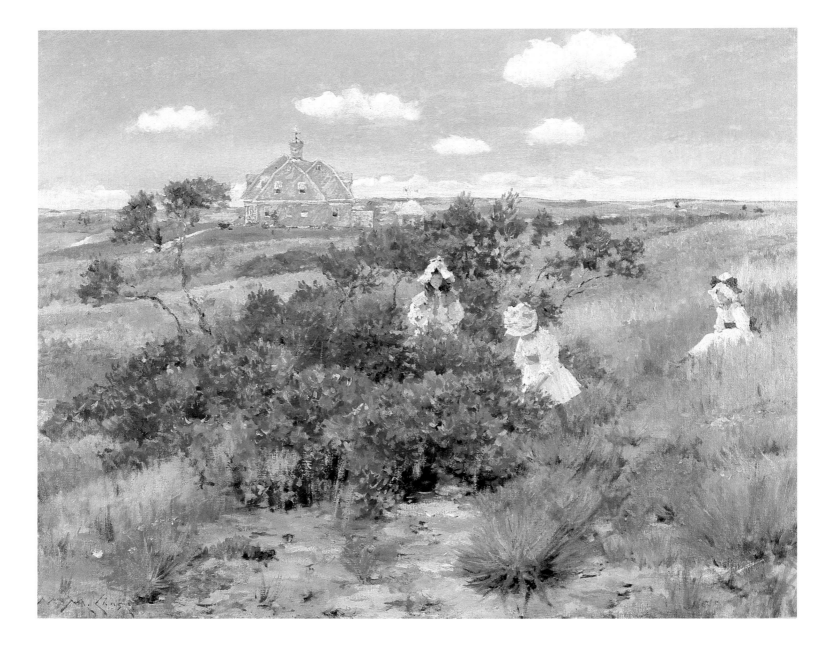

A School in the Sands

During the summer months, when art schools in the cities were closed, Chase traveled to the countryside to paint. At first, in the late 1870s and 1880s, he had reserved this time for his own work, painting landscapes directly out-of-doors. In 1891, however, he founded the Shinnecock Summer School of Art, located on the eastern end of Long Island near the Village of Southampton, and taught summer classes there on a regular basis through the summer of 1902. Initially the school, which was the first major summer art school of its kind in the country, served as an extension of his city classes,[114] but it soon attracted students from all parts of the United States, as well as from Canada. These students shared a common goal: to learn the principles of plein-air painting under Chase's guidance. The result of their efforts was a distinctive style of painting — bright, cheerful, and spontaneous, described by contemporary critics as "impressionistic." Rockwell Kent, who studied at the school, explained that their painting was, in part, a reaction to the "messy, tobacco-fingered Barbizon school, and the 'greenery yallery Grosvenor Gallery' stuff. . . ."[115] In contrast, Chase and his pupils at Shinnecock Hills were interested in capturing fleeting impressions of the landscape, swiftly painted and filled with bright sunlight.

The genesis of the Shinnecock Summer School of Art has been attributed to the foresight of one woman, Mrs. William Hoyt, and the support of a number of wealthy patrons.[116] Mrs. Hoyt, a summer resident of the area and an amateur painter who had traveled extensively in Europe, understood the principles of plein-air painting and realized the potential provided by the ever-changing atmospheric conditions of eastern Long Island. When she invited Chase to Southampton

Cyanotype of the Chase Homestead, Shinnecock Hills, Long Island.
The William Merritt Chase Archives,
The Parrish Art Museum, Southampton, New York.

in 1890, her purpose was two-fold: to familiarize him with the area's possibilities, and to convince him to direct a formal summer school of art where American art students could learn to paint outdoors in their own country.

Chase was, of course, a natural choice for the school's director and chief instructor. In the mid-1880s he had painted outdoors in Holland and successfully exhibited these works in the United States; and in the late 1880s he had applied the precepts of European plein-air painting to American subjects, creating a series of beautiful park scenes in and around New York. His ability as a teacher had been demonstrated by the great popularity of his classes at the Art Students' League and the Brooklyn Art School. Furthermore, he was at ease with the wealthy and socially prominent patrons who could provide the school's financial backing.

During the 1890s, Southampton gained recognition as a fashionable summer colony, proclaimed by the local press as "a summer resort for New Yorkers. . .not far behind Newport."[117] Its refined nature was a perfect setting for Chase, and nearby Shinnecock Hills promised to be equally attractive from an artistic point of view. Undoubtedly Chase also responded to the similarities of Long Island's terrain and atmosphere to those of Holland; he immediately accepted Mrs. Hoyt's offer to direct this "school in the sands." All that was needed was the land for the school and the funding. The land was supplied by several summer residents — Mrs. Hoyt, Mrs. Henry Kirke Porter and Samuel L. Parrish — and financial support was provided by a number of wealthy patrons, including: Mrs. August Belmont, Mrs. Andrew Carnegie, Mrs. William Kissan Vanderbilt, Mrs. Astor, and Mrs. Whitney.[118] The school's executive committee was comprised of Chase; the three local residents who had given the land for the school; three women artists, Rosina Emmet Sherwood, Mrs. Candace Wheeler, and her daughter Dora Wheeler Keith; and Judge Henry E. Howland.

The school building was completed in 1891, and the first classes were held that summer. Although enrollment was not limited to female students, it was expected that many young women from Chase's classes in New York would attend.

The Potato Patch (Garden, Shinnecock). **c. 1893**
Watercolor on paper
11³/₄ x 15³/₄ in (29.9 x 40.0 cm)
Private Collection

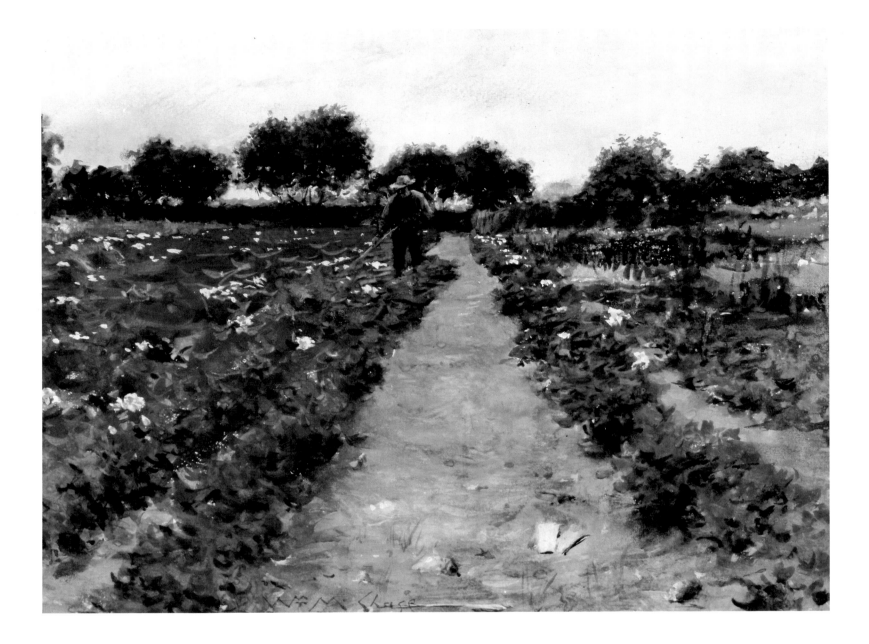

Shinnecock Indian Girl. c. 1892
Oil on canvas
16⅛ x 12¼ in (41 x 31 cm)
Private Collection

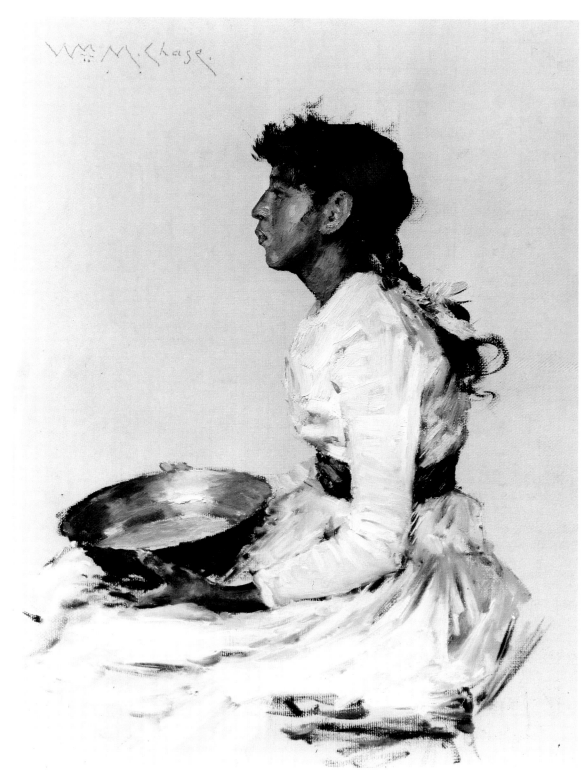

Among the female artists active at the school were
Ellen Emmet Rand, Lydia Field Emmet, Emily
Nichols Hatch, Louise Lyons Heustis, and Annie
Traquair Lang. "Shinnecock Hills...blossomed
every summer with feminine talent," observed one
writer.[119] The school was never devoted exclusively
to the instruction of women, however. The male
art students at Shinnecock Hills included
Rockwell Kent, Howard Chandler Christy, Charles
Hawthorne, Joseph Stella, and the brothers
Reynolds and Gifford Beal.[120]

The school building and surrounding cottages,
built as student housing for about 150 students,
came to be known as the "Art Village." This
complex was described as "a unique little
settlement, nestling among the hills...comprised
of twelve or fifteen low built, shingle sided
cottages, a large log studio and a restaurant."[121]
There was also the "Art Club," a large house
donated by one of the promoters of the school as
an accommodation for women students.[122] This
house was the site of most of the social affairs —
fancy dress balls, "witch parties," and other festive
activities. The school building itself contained a
large room where criticisms were held, a studio for
indoor painting on rainy days, and a supply shop
where the students could obtain their materials.

Chase's summer residence, completed in 1892,
was designed by the firm of McKim, Meade &
White. Its location, approximately three miles west
of the Art Village, was selected because it was near
enough to the school for easy access, and yet far
enough away to ensure Chase's privacy. There he
used his free time to paint some of his finest
paintings. The interior of his home can be seen in
such works as *Hall at Shinnecock*, which depicts
the large central hall of the house, and *In the
Studio (Interior: Young Woman Standing at
Table)*.[123] While still part of the house, the studio
was deliberately set off on the western end to allow
Chase to work uninterrupted by family matters. In
addition to these rooms, there was a dining area
off the central hall and numerous small bedrooms
on the second floor. The third floor was used as
servants' quarters. The setting of the house, which
can be seen in paintings such as *Idle Hours*
and *The Bayberry Bush*, was described in a
contemporary account as being "surrounded by
bay, sweet fern and vivid patches of butterfly-
weed...its nearest neighbor off on a distant hilltop.
On one side lies the ocean in vista, on the other
Peconic Bay....Its place is decorative rather than
intimate."[124]

Shinnecock Landscape. c. 1895
Oil on canvas
35 x 40 in (88.9 x 101.6 cm)
Private Collection

Shinnecock Hills, with its "glorious atmospheric effects," was considered by artists and critics alike to be superbly suited for plein-air painting. "Not only are the hills the most delightful place in the world, but...no greater profusion of material can be found anywhere to delight the eye of an artist," one writer declared.[125] Local farmers, who did not share this writer's view, were reported to be amused and surprised by the interest the artists had in their land. Considering the dunes nearly worthless, they suspected that "'them city folks must be clean daft to come way down here to live!'"[126] As the Art Village expanded, however, local landowners were only too pleased to accept $250 for an acre of land that they considered to be worth only $2.50 — "if the city folks were 'fools enough to pay it.'"[127] They were even more baffled by the art students who had infiltrated their lives, finding beauty in such mundane things as water pumps, cabbage fields, and split-rail fences. Chase was stumped by one bewildered farmer who asked him frankly, "What is it you find worth painting down here?"[128]

Not far from the Art Village was the Shinnecock Indian Reservation, originally off limits for the art students as well as other local residents. The gregarious Chase, however, somehow managed to befriend the Indians and soon gained permission for his students to paint on their land. In fact, a number of Indians even agreed to model for the artist and his students; and one beautiful young girl, Romaine, was immortalized in Chase's portrait *Shinnecock Indian Girl*.[129] Chase showed his sincere interest in the welfare of the Indians, and on one occasion he even donated a painting to be sold at auction for their benefit.[130] He also chose a Shinnecock Indian word, *"Neamaug,"* for his daughter Hazel's middle name. "Neamaug," meaning "between the waters," aptly described her place of birth: the Chase summer homestead set in the hills between Shinnecock and Peconic Bays.

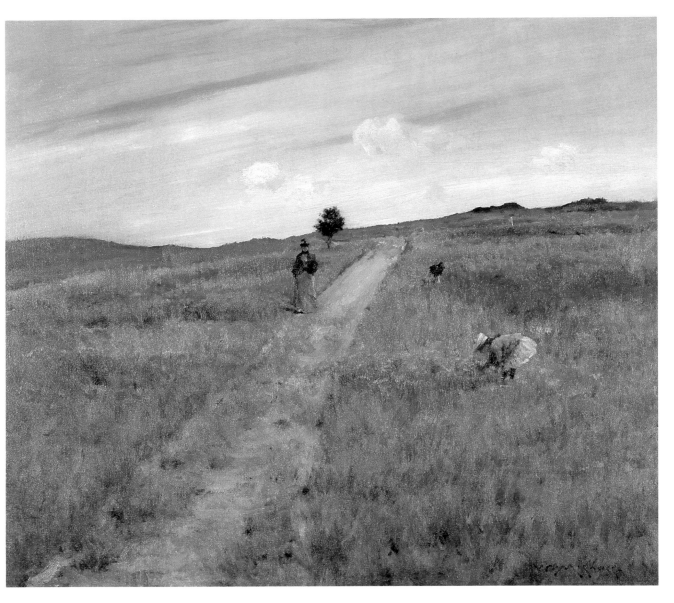

Rest by the Wayside (Rest by the Roadside). **c. 1898**
Oil on plywood panel
25$\frac{1}{2}$ x 20$\frac{1}{4}$ in (64.8 x 51.4 cm)
Ball State University Art Gallery, Muncie, Indiana.
Permanent loan from the Frank C. Ball Collection.
Ball Brothers Foundation

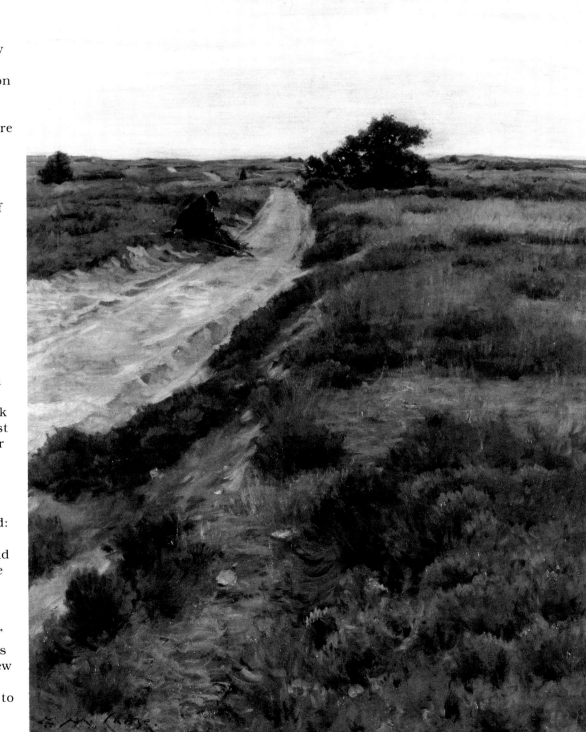

The daily activities of the school varied somewhat from year to year, as did its auxiliary staff. An 1894 account provides a general picture of the school's daily operations: "Early on Monday all the sketches that have been made during the week are brought to the studio and arranged upon a large two-sided easel, which was built for the purpose. About 10 o'clock Mr. Chase arrives and the students take their seats on camp stools before him. While he is criticising the sketches on one side of the easel the other is being filled, and so on, until all have been submitted."[131] As many as 200 studies were reviewed by Chase in a single morning, often taking as long as three-and-a-half hours, but no one seemed to grow tired during these lengthy sessions. After the critiques Chase would remain at the school studio to answer questions which the students wrote on slips of paper and dropped in a box. The rest of the afternoon and the following day were devoted entirely to outdoor critiques, during which time Chase would pass from one easel to the next, providing helpful advice and encouragement. Some of his comments have been recorded by Reynolds Beal: "'Open your sky more and paint a tree that a bird could fly through.'...'How much light there is in everything out-of-doors! Just look out of that window and note that even the darkest spot of that clump of trees is many shades lighter than the sash of the window.'"[132] When harsh words were necessary, Chase used them: "'Too much "chic", Miss W — , it's very dangerous however charming. "Chic" never yet made up for poor work.'" At other times he was more reserved: "'I never expected to see you paint as well as this when you came into the class — you did such bad work. I will tell you now, though I would not have breathed it before.'"[133]

For the remainder of the week the students painted on their own, preparing studies for Chase's next formal critique. At times "queering" contests were also held. The purpose of these was to get the students to look at their subjects in new and fresh ways, and to prevent them from developing formulas. Each student was directed to imagine the most unlikely presentation of their subject and then to paint it in that manner. The most successful attempt was rewarded by one of Chase's own sketches.

Chase, who believed his students were in general a hard-working lot, never worried about them slacking off no matter how tempting this might have been in a summer colony. The recollections of several students testify to their

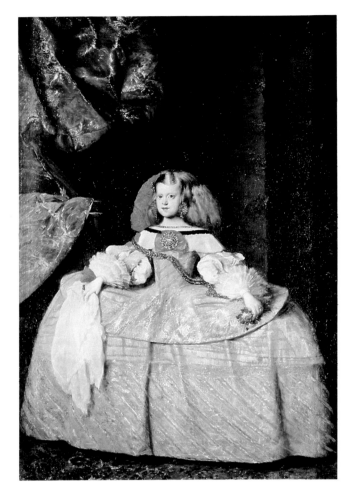

Diego Rodriquez de Silva Velasquez
The Infanta Margarita. c. 1664-65
Oil on canvas
80-5/8 x 57-7/8 in (205 x 147 cm)
The Prado, Madrid

diligent work. "When I was painting with Chase out at Shinnecock, in his summer school, I used to make three sketches a day," Howard Chandler Christy recalled. "They thought I did too much. Well, I simply had to work."[134] Rockwell Kent described his diligence in equally vivid terms: "No student at Shinnecock can ever have devoted himself to his work with greater energy. All of every morning and of every afteroon I would be out of doors, my easel set up in some field or grove or barnyard. All day I'd paint."[135] Of course there was some relief from this daily routine. Kent also noted in his autobiography such events as cake-walks, charades and German plays. Concerts and dances were organized, with Kate Budd and the Emmet sisters — Lydia Field Emmet, Ellen Emmet Rand and Rosina Emmet Sherwood — playing an important role in such social affairs. There were also "tableaux" in which Chase, members of his family, and students would pose in full costume with props in imitation of famous paintings. Among the most popular of these were the memorable poses of Mrs. Chase as Dagnan-Bouveret's *Madonna* and Helen Chase as Velasquez' *The Infanta Margarita.*[136]

Local residents occasionally shared in the excitement at the Art Village. Chase admitted the public to his own studio from time to time; and once a month he would deliver a lecture on art. At times his weekly criticisms were held on Saturdays and were open to the general public, who found them to be quite entertaining — evidently at the expense of more than one student's utter humiliation. "This was as good as a bull-fight to the cottagers and the loungers from the hotels," recalled one. "The patrons were out in full force to patronize and gave parties at little expense and with great gusto to their friends, inviting all they cared to invite to attend the morning criticisms.

Carriages and even motors were at the door, the 'nobility' with their lorgnettes ready, the students all sitting on little camp stools before a large revolving easel...until hundreds of daubs had met their fate."[137] Another student complained: "Isn't it perfectly heartless for them to come here and ogle through their lorgnettes and put on the airs of connoisseurs and laugh when Mr. Chase says cutting things. I'd like to kill them all."[138] Finally, things got out of hand and Chase was forced to remind the local gentry that his critiques were indeed for his students' benefit and not for entertainment, although there is no indication that outsiders were ever banned.

At the end of each summer at Shinnecock Hills there was a special exhibition featuring the best student works of the season. "No other summer class in America could have made such a showing, as probably no other master has such a following among his pupils of so many trained artists," asserted one of the participants. "There was no attempt to display saleable pictures, such as from subject or treatment would be likely to please the popular taste, or catch the eye of a purchaser. It was all honest *student* work, made with the idea of progress, and not of result...one-third of the canvases appeared under the title 'sketch,' another third as 'studies,' and of the small remainder, which alone their makers seemed to consider worthy of any name, the titles chosen seemed almost affectedly unattractive, and to purposely avoid the story-telling interest or any startling originality."[139] In a sense these exhibitions were teaching shows, designed to display technical achievement and development as well as truly finished paintings. After closing at Shinnecock Hills, the exhibitions were sometimes circulated to New York, Philadelphia, and Pittsburgh.

Although the Shinnecock Summer School of Art gained momentum with each passing year, Chase decided to discontinue his classes there after the summer of 1902; in their place, in 1903, he began to offer summer classes abroad.[140] Explaining this change, Chase stated: "'There are [now] other excellent schools for Summer work over here, which can be used by men and women who do not wish to go abroad; some at Cape Cod, another at Old Lyme, Connecticut. The National Academy and the Society of American Artists have

**An Infanta, A Souvenir of Velasquez
(Helen Velasquez Chase). 1899**

Oil on canvas
30½ x 24⅛ in (77.5 x 61.3 cm)
Private Collection, Courtesy of Newhouse Galleries

Summer schools of art in different quarters; the Pennsylvania Academy of Art also.'"[141] In contrast to these summer classes in America, his European tours offered students a chance to see great works of art in the major galleries of the Continent. Chase claimed that such exposure "'widens their horizons, brings them in contact with leading masters of the day, affords them the equivalent of the old system of Wanderjahre, which was a necessary course for apprentices to the useful studies and arts before they could set up as masters. They had to wander from their own towns and their own country sometimes, in order to learn what was old fashioned in their teaching, what was good enough to be preserved. I fancy that pupils who have been abroad under such auspices learn neither to overrate nor to underrate foreign examples, neither to think that America holds all that is worth while, nor to imagine that residence in Europe alone will make artists of them.'"[142]

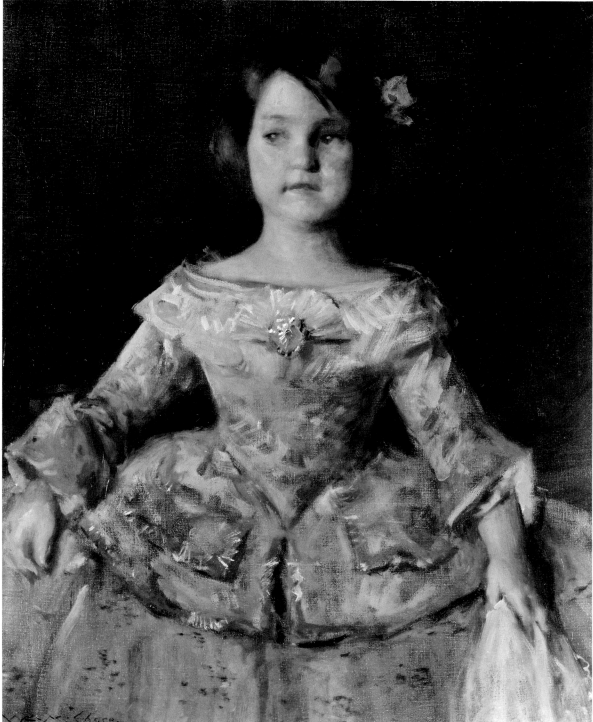

Helen Chase posing in costume, c. 1899.
The William Merritt Chase Archives,
The Parrish Art Museum, Southampton, New York.

Swollen Stream at Shinnecock. c. 1895
Oil on canvas
44⅛ x 46 in (112.1 x 116.8 cm)
Private Collection

Near the Beach, Shinnecock. c. 1895
Oil on canvas
41 x 59 in (104.4 x 149.9 cm)
The Toledo Museum of Art, Gift of Arthur J. Secor

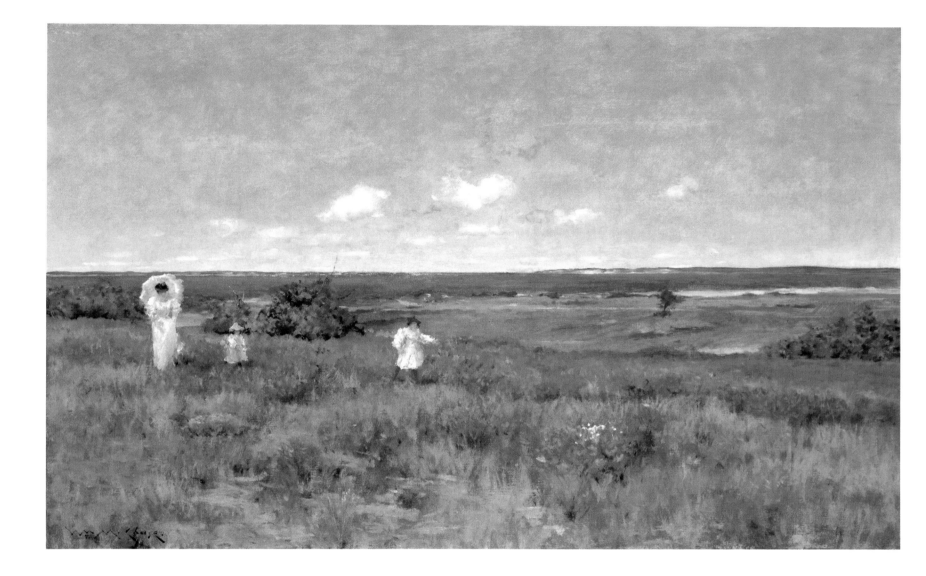

Children on the Beach. 1894
Oil on board
12⅝ x 16 in (32.1 x 40.6 cm)
Private Collection

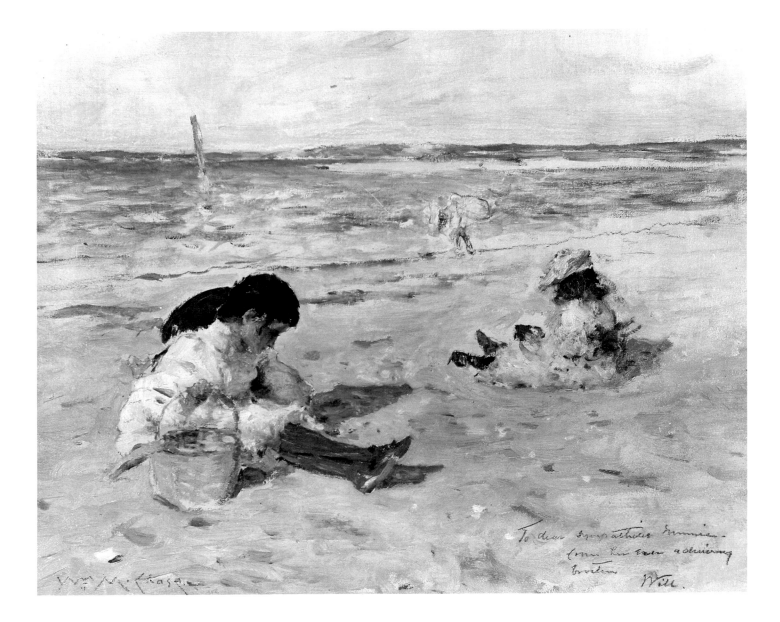

Landscape, Shinnecock, Long Island. c. 1896

Oil on wood panel
11⅞ x 16⅛ in (30.3 x 40.9 cm)
The Art Museum, Princeton University,
Gift of Francis A. Comstock

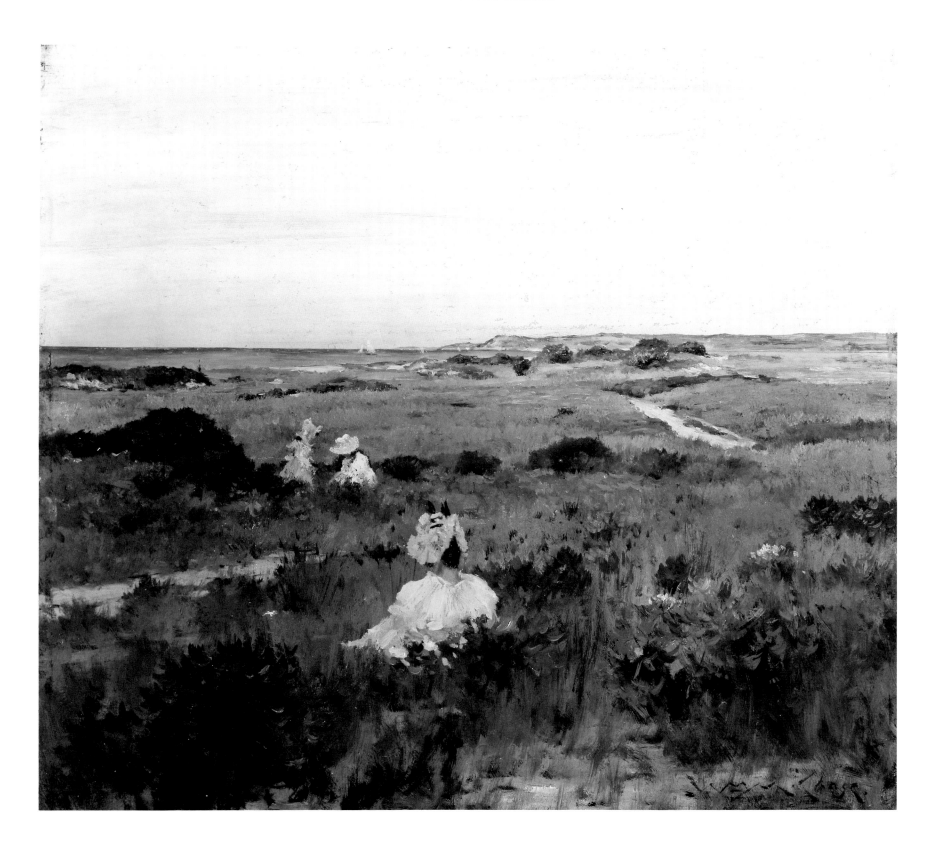

Over the Hills and Far Away (Landscape). c. 1897

Oil on canvas
25³/₄ x 32³/₄ in (65.4 x 83.2 cm)
Henry Art Gallery, University of Washington,
Horace C. Henry Collection

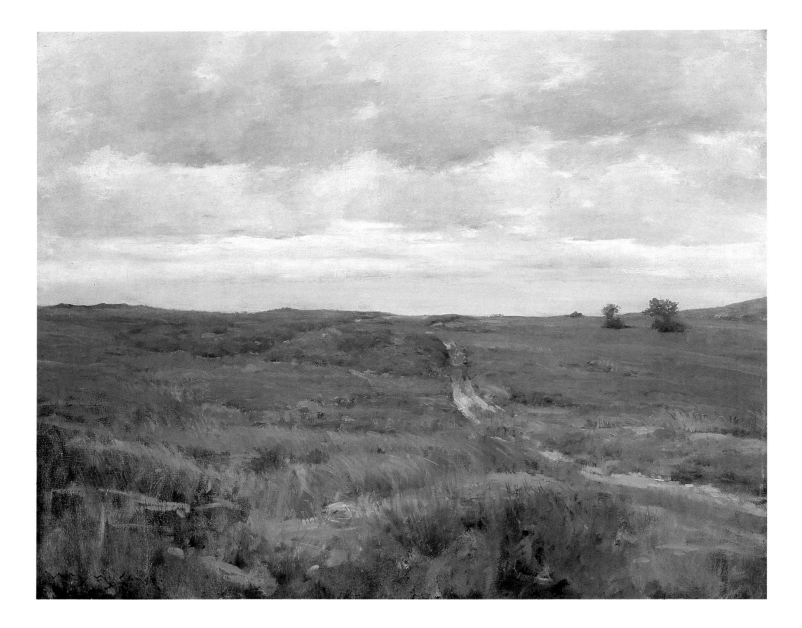

Portrait Sketch (Girl in a Middy Blouse). **1902**
Oil on canvas
24 x 18⅛ in (61.0 x 46.0 cm)
Milwaukee Art Museum Collection, Gift of Frida Gugler

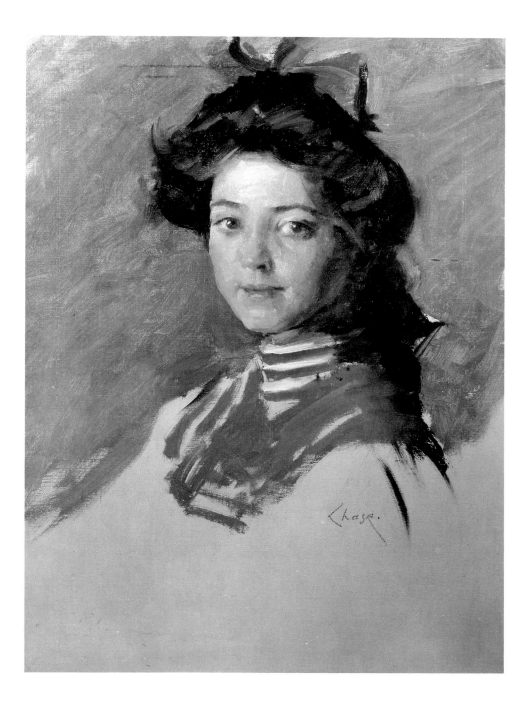

A Florentine Villa. c. 1907-09

Oil on canvas
15½ x 22¼ in (39.4 x 56.5 cm)
Private Collection

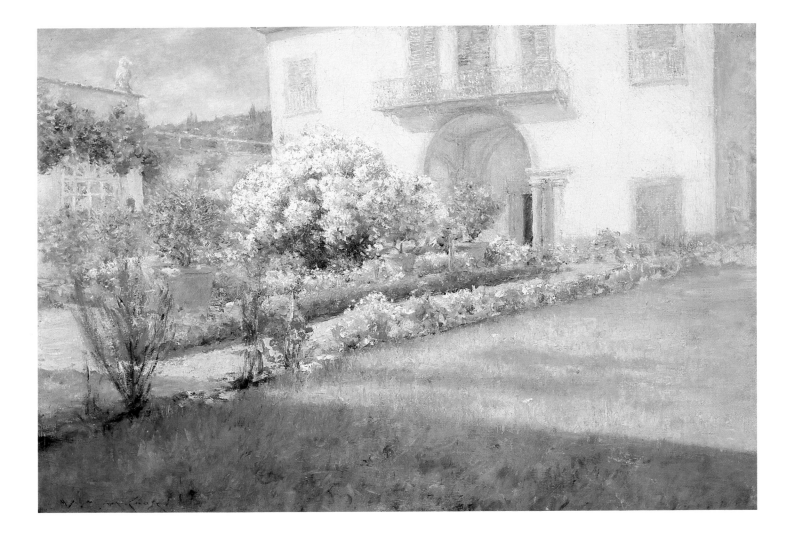

Summer Classes Abroad and at Home

When Chase began teaching his summer classes at Shinnecock Hills, he was determined to create a school of art that was truly American. "Many people say that we have no school of art in America; but I do not agree with them," he proclaimed to his students. "The studies of our Shinnecock School which cover these walls to-night are representative of American art. There is no staining, no tinting, but here is American painting which will produce good results. Let me urge you to strive to prove that our American art is a vital thing."[143] By 1903, with this mission accomplished, Chase took on a new challenge. Instead of striving for national pride in the art of this country, Chase was now concerned that Americans would become overconfident and lose sight of their art's relationship to Europe. His European tours, conducted almost every summer between 1903 and 1913, were intended to provide aspiring young artists with a broader perspective. During his years at Shinnecock Hills, he had managed to visit Europe only once, in 1896. Although still vital at the age of fifty-four, Chase probably thought that he might not have many years ahead to share his enthusiasm for the great art treasures of Europe with his devoted pupils. Undoubtedly he also yearned to see these paintings himself, and to renew old bonds with artist-friends abroad.

As early as 1896 Chase had envisioned establishing an American school of painting abroad. "'I am going to establish at Madrid a school of painting — an American School,'" he announced. "'Such a venture would have been laughed at a comparatively short time ago. Today, however, I have not only assurances of plenty of American pupils, but pupils are also coming in numbers from Paris and Munich, the greatest art centers today in Europe. Our school at Madrid is to be like the school at Athens, and I have not the slightest doubt of its success.'"[144] Originally Chase intended to spend two or three months a year teaching in Madrid.[145] His students would devote half of each day to copying paintings by Velasquez, and the remainder of the day working from the model outdoors. The format of this school was to be based on the plan of the Académie Julian in Paris; and the "most talented men available" were to assist Chase in making his school a "permanent institution."[146] That spring he departed for Madrid

with his class, his wife, and two of their daughters, Alice Dieudonnée and Dorothy Bremond. The "school" was reported to be a great success, and plans were soon announced for a second session the following year. However, Chase's new teaching affiliations in the States demanded so much of his time that he postponed his plans to develop a formal American school of painting in Europe for a number of years. Finally, with the termination of his summer classes at Shinnecock Hills in 1902, Chase was free to conduct informal summer classes abroad, a modification of his earlier scheme.

In 1903 the first of these classes was held in Holland. An enticing program was outlined in an announcement by C.P. Townsley, Jr., the class manager. Holland's picturesque landscape was described as "flat and low-lying, intersected by numerous canals and dotted with wind-mills...." Also mentioned were the country's fine art galleries, "filled with the choicest works of the old Dutch masters, seen here as they can be seen nowhere else in the world."[147] The class itself was based in Haarlem, the birthplace of Frans Hals, where the students could study his masterpieces first-hand. As with Chase's earlier European class in Madrid, the students' time was divided between copying the works of the old masters and painting out-of-doors. Frequent visits to the art galleries of Amsterdam and neighboring cities were scheduled, and two days of each week were devoted to Chase's critiques. The class, limited to forty pupils, lasted two months, beginning at the end of June. The total cost, including round-trip steamship tickets, rail fare, tuition, and "excellent" hotel accomodations, ranged from $296 to $386, depending on the type of cabin desired aboard ship.[148]

Chase embarked early, traveling to London, Paris, and Munich before settling in Haarlem for the summer months. In London he visited the artists John Lavery and Frank Brangwyn; and in Paris he saw the artist Alexander Harrison and the art dealer Mr. Knoedler.[149] He also attended the Paris Salon exhibition, which he described as having "'only a few really good pictures.'"[150]

Returning to Munich for the first time since his student days, Chase was warmly welcomed by old friends. "'I went to call on some of my artist friends today, found Prof. Dietz and Prof. Dietrich in their studios and enjoyed a very pleasant call,'" he wrote home.[151] While there he also called on the American expatriate Carl Marr and the German painter Fritz von Uhde, and visited the home and studio of Franz von Lenbach, where he admired the paintings of Arnold Böcklin. In contrast to this tranquil setting was the home of the German symbolist Franz von Stuck, where Chase, horrified by its bizarre decorative scheme, declared: "'How terrible to have to live in such a place!'"[152] Chase also saw several exhibitions, including the Munich Secession show, which he rated as "'very good.'"[153] In Munich, Chase was joined by two of his former pupils, Henry Rittenberg and Eugene Paul Ullman, who accompanied him to several other exhibitions of contemporary art. Chase then took Rittenberg to the home of his mentor, Karl von Piloty, who had died in 1886. There they saw one of the portraits of Piloty's children that Chase had painted in his student days. He also showed Rittenberg a small section of one of Piloty's major historical compositions that he had worked on. Before going on to Holland, the three artists traveled to Vienna and Berlin, where they saw paintings by Hals, Rembrandt, and Velasquez. While in Berlin, they also visited an exhibition of contemporary art, where Chase was represented by a painting of his daughter Alice Dieudonnée.[154]

Near the end of his travels in Germany, Chase wrote his wife, "'I am getting almost an indigestion of pictures...and will be glad when I can get to work.'" The next day he finally arrived in Haarlem and prepared to receive his students with a gala party celebrating their arrival and the Fourth of July: "'Early in the morning I had them put out a large American flag. Mr. Townsley went to Rotterdam to meet the party. I had sent to Amsterdam for flags and must say the room looked very pretty. He got a small picture of Washington and one of Roosevelt. I had flowers and music, a small American flag at each place made especially at Amsterdam...funny looking things.'"[155]

As in Germany, Chase was warmly received in Holland by artist-friends whom he had first met in the early 1880s. Among those he visited was Hendrik Willem Mesdag, who was honored that Chase had traveled so far to enable his American students to study the work of Dutch artists

Mesdag, an inveterate collector, invited Chase and his students to view his extensive collection. In The Hague, the group also called on Jozef Israëls at his studio. Chase reported home: "'We found Mr. Israels a very charming little man. (He does not stand as high as my shoulder.) The students were all delighted with the man and his pictures.'"[156] The remainder of the day was devoted to visiting the museums and searching out collectables in the local marketplace.[157]

Chase considered this summer class a great success. He declared upon his return to America: *The class of art students I took to Holland last year settled the question how best to spend the Summer, or, say two or three months of the Summer. The combination of travel, art museums, and work turned out all that I expected, for each in its way helps the other, and the stimulus is constant. The mere change of surroundings to a novel environment enlivens a pupil, and when he gets down to work the fact that he is in a foreign land, where foreign artists are liable at any time to call and see what he is doing, exerts a lively effect on his ambition. Then he sees from time to time the pictures of modern men and the old masters. Being with friends and fellow-workers, he does not get lonely and discouraged, as the solitary art student often does when first he goes abroad. It is really a lark, and yet hard work, as good a mixture as any one need expect.*[158]

In 1904 Chase decided to make London the location for his next summer class. "'I believe it is best to change the scene each year,'" he explained. "'While last summer we enjoyed that quaint, immaculate old Dutch town and painted the same scenery that found favor with Ruysdael, Hobbema, Hals, and Rembrandt, and while we had close to hand the incomparable pictures of the old Dutchmen at Amsterdam and Haarlem, this year we took London by storm.'"[159] He especially wanted his students to see the masterworks in the city's museums and galleries, commenting: "'In the National Gallery the old masters have been

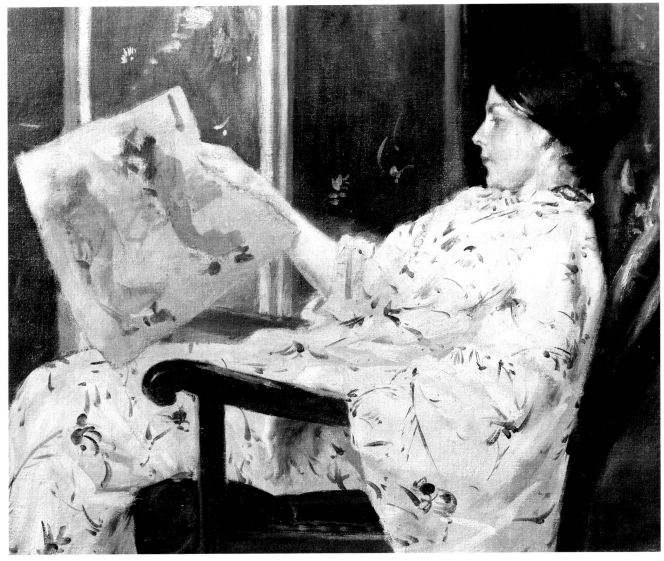

arranged chronologically, so that one can take a certain art period, and on one day study that period by itself, leaving another for a second visit.'" For Chase the Wallace Collection supplied "'just what London formerly lacked, the completest and finest set of works by Corot and the Barbizon landscapists, for instance, not to speak of other French work. You can imagine how stimulating to students it is to see masterpieces by the leading spirits of modern schools, pictures that establish standards.'"[160]

On June fourteenth, the class of forty pupils departed for Rotterdam, where they were met by Chase's representative and brought by boat to London.[161] The weekly schedule was similar to the one established in Holland the previous summer: the students copied paintings in museum collections under Chase's supervision, and devoted an equal amount of time to painting landscape and figure studies out-of-doors. On rainy days, indoor sketching took place in a large studio in St. John's Wood that had been procured for the class. Two days of each week Chase provided criticisms or accompanied the class on trips to art galleries. Monday morning critiques were followed by short talks on art by Chase, and during the course of the summer, Chase also delivered two special evening lectures.

There were also visits to exhibitions at the Royal Academy and the New Gallery, as well as to the studios of such prominent artists living in London as Sir Lawrence Alma-Tadema and Frank Brangwyn. The American expatriate artists who opened their studios to the class included John Singer Sargent, George Henry Boughton and Sir James Jebusa Shannon. Chase later commented on their hospitality: "'I never knew such kindness. Men of long-established reknown...came to see us and invited us to their studios. The painters over there certainly live in great style. They were very sympathetic, and left nothing undone to make the students feel that England is a second home.'"[162]

Several prizes were awarded during the summer, including the George B. Whitney Prize of $100 for the best study painted during the season.[163] Also offered was a one-year scholarship to the New York School of Art, given to the student whose overall work was considered to be of the highest caliber. Two demonstration sketches by Chase were awarded to students whose paintings displayed "the best selected motives."[164]

One student from the class, Charles Sheeler, later recalled with enthusiasm his response to the great works of art they saw that summer, particularly the paintings by the Spanish masters Velasquez and Goya. He was equally inspired by the Dutch masters, later recounting: "'Then there was Hals who, with all that Chase had said about him, claimed the right of way. Brilliancy to the nth degree — and those blacks! They have seldom been equaled and never surpassed.'"[165] Commenting on the effect of the trip Sheeler later reported, "'We went home at concert pitch, determined to outdo Hals and possibly to improve upon him.'" He then admitted: "'I do not recall that this was ever accomplished.'"[166]

Chase had no trouble deciding where to hold his next class. Having covered Holland and England, he planned to move on to Spain: "'In Madrid, or near Madrid, my agent may be able to find just what we want, and then we shall have a chance to study the Spanish and Netherlandish schools at the Prado...and perhaps make the acquaintance of some of the living Spanish artists....'"[167] In May of 1905, Chase confirmed these plans: "'Oh yes — fifty scholars whom I shall meet this time in Madrid. Summer's the time for the Spaniards, for then they enjoy themselves baking in the sun. I expect to revel in Velasquez this summer — not forgetting Greco, Goya, and a few more, eh?'" Although Chase expressed some concern over the language barrier, he was undaunted by this minor obstacle. "'But you know what Spaniards are — hospitality itself — and that grand air! By Jove!'" he exclaimed. "'I don't think there is any nation in Europe can approach it!'"[168] Although Chase observed that "ordinary" American tourists were not always regarded "with the most favorable eyes" in European countries, artists were generally well received, as "'art is a kind of passport, and I am always amazed at the sympathy and kindness which meet us as soon as people learn who we are and what we are about.'"[169]

In Madrid, the students could study the Prado's strong holdings of Velasquez, Murillo, Goya and El Greco. Charles Sheeler, again a member of the class, recalled a moment in the great corridor of the Prado, when Chase, viewing the "long line" of works by El Greco, declared: "'Look at him! Magnificent painter!'" He then qualified this statement by cautioning his students to avoid looking at El Greco's manner of drawing. Chase's warning, Sheeler explained, was not intended as a condemnation of the Spanish master's draughtsmanship, but rather a means of directing his students to El Greco's very special approach to painting. According to Sheeler, this advice reflected Chase's own "'particular interest in painting as such. That was an end in itself. It didn't matter what it was if it was brilliantly painted.'"[170]

Chase's students were also introduced to contemporary Spanish art, such as the work of Joaquin Sorolla y Bastida, whose work they saw at his house and studio. Although the artist was out of town, the class was warmly received by his brother-in-law, who provided a tour of the house filled not only with Sorolla's broadly painted and sun-filled compositions but also with paintings by other artists.[171]

As in the past, Chase's students were expected to devote a portion of their time to painting landscapes and figure studies in the open air. Chase himself was particularly interested in the distinctively Spanish types — peasants whom he described as "'a splendid, solid, well set up lot of men,'" yet he painted very few contemporary subjects on this trip.[172] Instead, he devoted most of his time to copying the works of the old masters at the Prado. The few portraits he did paint, such as *Spanish Gypsy*, were probably demonstration pieces for his class.[173]

In 1906, instead of conducting a summer class, Chase made a short trip to Europe on his own. "'I was over for only a few weeks. I was hard worked during the Winter, so I didn't take any classes abroad this year; I wanted a rest — and I had it. I made no effort to go to any special places — just took things very easy,'" he later explained.[174] In spite of this claim, Chase covered a considerable amount of ground in a short time. His first stop was London, where he visited his friend John Singer Sargent, whom he described as being "'very busy with portrait work.'"[175] From London Chase proceeded to Paris and then on to Leyden before returning home. His reactions to the exhibitions he saw in each city were mixed. The high point of the trip was an exhibition of Belgian paintings at London's Guildhall where Chase was particularly

impressed by the work of two artists: Henri de Braekeleer and Alfred Stevens.[176] The first he described as a Belgian painter who was "utterly unknown" in London at the time and whose work was "superb." Stevens was, of course, well known to Chase, who purchased four of his paintings from the show. Chase was also pleased by a major show of paintings by Sorolla which he saw in Paris,[177] but he was disappointed by the Rembrandt Celebration which he had made a special trip to see in Leyden.[178] After returning to New York, Chase spent some time resting at his summer home in Shinnecock Hills.[179]

The following summer, 1907, Chase reinstituted his summer classes abroad with a trip to Italy. Its plan differed considerably from those of previous years, with more of an emphasis on art history and appreciation. Louis G. Monte and Walter Pach were employed as managers and lecturers for the tour.[180] The entire trip, which began in Boston on June seventh, lasted for approximately three months and included visits to no fewer than seventeen places. In Rome the students visited the Forum, the Colosseum, the Capitoline Museum, the Vatican and its museum, the Sistine Chapel, Hadrian's Tomb, and the Pantheon. Sights in Siena included the Cathedral and the Baptistery; and in Milan they visited the Cathedral, the Palazzo di Brera and the Biblioteca Ambrosiana. In Venice the itinerary included the Doge's Palace, San Marco, the Academy, the Scuola di San Rocco and San Giorgio degli Schiavoni. On August twenty-fourth the group crossed the Adriatic Sea to visit Trieste. They then proceeded by steamer to Fiume to view additional Roman antiquities before moving on to Palermo. The actual painting class took place in Florence, where the students stayed for two months studying the paintings in the Pitti Palace and the Uffizi Gallery. As always, they were expected to paint landscapes and figure studies in the outdoors, and a studio was provided for indoor sketching on rainy days.

It was during this summer that Chase acquired his villa in Florence on the far side of the Arno. Chase met two American artists while in Florence — George de Forest Brush and Julius Rolshoven, the latter of whom entertained Chase and his students in his villa just outside of the city.[181]

Evidently Chase did not hold any formal summer classes in Europe in 1908 or 1909.[182] He did, however, visit Italy in both of these years. While there in 1908, he painted a self-portrait commissioned by the Uffizi Gallery for its famous collection of self-portraits. His friend and biographer Katherine Metcalf Roof, who was visiting Florence at the time, later commented on Chase's "unaffected pleasure" at receiving this great honor and his overwhelming enthusiasm for his villa.[183]

In 1910 Chase resumed his European classes, scheduled to be held — quite naturally — in Florence.[184] Although somewhat less ambitious in scope than the tour conducted three years earlier, the itinerary for this trip was still impressive. The forty students left New York in early June and traveled to Naples, Capri, Rome, Siena, and finally to Florence, where they were met by Chase at the end of the month. The session, scheduled to last for two months, followed the format established in previous sessions.

During this summer, Chase also invited his students to his lovely Villa Silli. At least one, Annie Traquair Lang, painted several views of it, both indoors and out. A written account of the villa was published in an article written later that year:
His Italian residence is the old Villa Silli, not far from the beautiful and famous Villa occupied by Mr. Acton. It is most picturesque, dating back to 1400, and when Mr. Chase bought it it was furnished in part with antique objects corresponding to its age. To these he has added. The stone walls of the villa are four feet in thickness, and half way up to the second floor is a secret door giving on a flight of stone stairs that leads to the top of the house. This was for refuge in case of war, and the stairs are only wide enough to afford passage to one person. If that person were an enemy he could be scalded with boiling water thrown from above....

All the floors of the villa are of glazed clay, and are painted in beautiful colors. The visitor on entering finds himself in a room 40 feet deep by 30 wide, the ceiling in white and gold, and depending from it a large crystal chandelier. The effect is enhanced by an arch at the end of the room which opens into the garden.[185]

The villa was located half-an-hour's ride up a mountain and offered a panoramic view. The orangery, olive grove, pomegranate trees, and beautiful old cypress trees around the villa have all been recorded in Chase's paintings. One of the "glories" of the villa, and also the subject of several of his paintings, was a large oleander bush, "over eight feet high and when in bloom making a gorgeous bouquet of pink near the house."[186]

It was a festive summer for Chase and his friends in Florence. Among those present were Chase's colleagues, the painters J. Carroll Beckwith and Irving R. Wiles, as well as Mrs. Beckwith and Wiles' daughter Gladys. Some of the activities of the summer months were recorded by Beckwith in his diary, which provides an amusing perspective on Chase and the personalities involved. By the time Beckwith arrived on July thirteenth, Chase had already been conducting his summer painting class for two weeks. Unfamiliar with the city, Beckwith was escorted around by Chase, who pointed out such necessary services as the bank and the art supply store. The group of friends met frequently during the summer months, often dining together. On one occasion, unknown to Chase, Beckwith invited the American artist Kenyon Cox to join them. Apparently he and Chase were not on good terms at the time, and Beckwith was concerned that Chase would decline the invitation if he knew that Cox would be present. Afterwards, Beckwith wrote in his diary: "Did not dare tell Chase that Kenyon was coming. My gracious. What a hopeless egotist Cox is — I scarcely even knew any one in the past 30 odd years that had any liking for him....Our dinner was so pretty that it was a shame to waste it on such an intellectual bore as Kenyon."[187] On another occasion, criticizing Chase's rather haphazard manner of acquiring "artistic" objects, Beckwith noted: "He is singularly devoid of discrimination. Anything that is antique goes with him. I fear he is gathering a lot of rubbish."[188] The following day Beckwith visited Chase's Villa Silli, which had been restored recently and was described by him as being "perfectly beautiful." "Chase had not yet got enough things to spoil it," according to Beckwith. At this time, the villa, which Chase apparently had leased for the past two summers, was being offered for sale. Beckwith, who was "charmed" by the place,

The Blue Kimono (Girl in Blue Kimono). **c. 1888**
Oil on canvas
57 x 44½ in (144.8 x 113.0 cm)
The Parrish Art Museum, Southampton, New York,
Littlejohn Collection

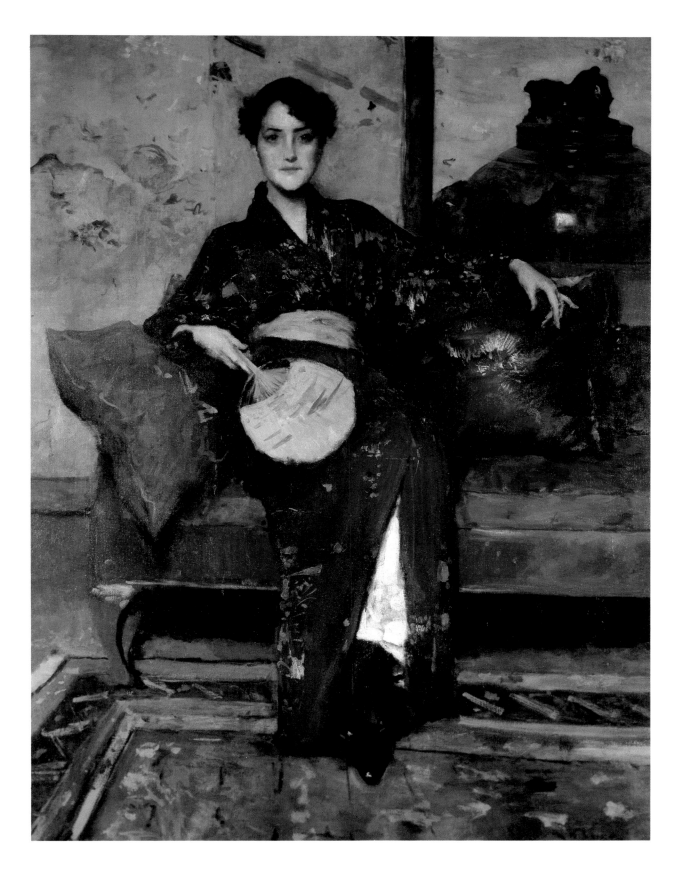

encouraged his friend to purchase it. "I urged Chase to do it. He is part a dealer already in antiquities why not combine houses?" he wrote.[189] Chase soon purchased the villa and became involved with the expatriate colony in Florence.[190] That same summer he met Charles Loeser, whom Beckwith described as "a curious, interesting person. His taste runs to the Early Sienese school and Matisse, a very poor impressionist painter."[191] Chase's reaction to Loeser and his modern paintings was more severe. When Chase was invited to view the collection, which also included works by Cézanne, he returned "boiling over." Chase described their encounter to Walter Pach, telling how he had advised Loeser to "'Sell the stuff now while you can still get some money for it. You won't if you wait long. People won't ever take to your Cézanne in any numbers.'" Chase was infuriated by Loeser's response: "'He just twiddled that little mustache of his and said in his confounded way, "Well, I never did think he'd be popular with the mahsses." I ought to have taken my hat and walked out of the place. Do you know what he meant by "the Mahsses"? He — meant — me!'"[192]

During the summer of 1911 Chase traveled alone, stopping off in London and Paris before going to Florence to teach his summer class.[193] Although no specifics are known about this class, one can assume that it was similar to those held in previous years. On the other hand, details relating to the summer class Chase conducted in Bruges in 1912 have been well documented. The announcement released early that year noted two inducements for serious art students to visit Belgium: the works of the great Flemish masters available for study in Bruges, as well as in nearby Brussels, Antwerp, and Ghent; and the quaint charm of the surrounding countryside "with its picturesque streets and low-gabled houses...canals, bridges, churches, its ancient city gates, its open-air markets, and the innumerable lace-makers working before their doors...an endless variety of subjects for sketches." If this were not enough to tempt

students to give up summer vacation plans in order to study painting abroad, the announcement included the following reminder about Bruges: "It lies near the sea-coast, with its numerous bathing resorts...."[194] For the more serious student, Antwerp offered an art museum, a cathedral, and the Musée Plantin. The format of the course was basically the same as in previous years. This time, however, *Arts and Decoration* offered to pay for all of the expenses of the art student who was able to sell the greatest number of subscriptions to their magazine.

Chase departed from New York early with his wife and son Roland Dana, stopping in London and Paris before meeting the class in Bruges in late June.[195] Among the students who attended the Chase summer class in Bruges in 1912 were Sarah Noble Ives, Patricia Gay, Esther M. Groome, and Harriet Blackstone, the last of whom recorded the class' daily activities.[196] By the time Blackstone arrived the majority of the class had preceded her to the Pension Redlich-Knight on the Rue du Vieux Sac, which she described as "a rare old home which was built some five hundred years ago for one of the famous Counts of Flanders." The setting itself was reported to be "picturesque" and "very paintable," with an old garden where the students had their breakfast and where they painted from a model each afternoon, "stopping at five o'clock for a cup of tea and a chat."[197] Between the time they finished breakfast and the time they started painting in the afternoon, the students would scatter about the city making sketches or finding suitable subjects for future studies. On Monday mornings the class met in the large dining room of the pension, which was converted to a studio once a week for Chase's criticisms. "On criticism days," Blackstone recalled, "the conversation naturally is teeming with Mr. Chase's talk, and it would delight your soul to see how every word he utters is hung on to and taken in....He seems to have a passion for imparting what he has learned in his many years of experience." Monday critiques were followed by Chase's talks on art concerning "the method of painting of some great master; some pictures we have seen; gallery visited together, or some gallery far away; always interspersed with most delightful reminiscences...."[198] Wednesdays and Saturdays were "brass market days" when students could shop for studio accessories. Blackstone found Saturday's market to be particularly enticing,

tempting "beyond endurance, not only the students but Mr. Chase himself. Indeed, Mr. Chase has 'fallen' many times...." She noted that Friday was "fish market day in the Catholic community," and on two such Fridays Chase painted demonstration pieces for the class, choosing as his subject, most appropriately, fish still lifes.[199] Like many other Chase students, Blackstone recorded numerous anecdotes about her teacher. Among the social activities she noted that summer was a "mask fête attended by Chase and his pupils in full costume. Chase showed up as the "Duke of Indiana," decked out in formal evening attire and sporting the many ribbons and medals he had been awarded over the years. Other types who attended included a "Spanish cavalier, the 'Lady from the Orient,' and an Egyptian outfit." As a prize for the best costume, Chase offered to paint the winner's portrait; this honor went to "Belle Lathrope."[200]

A detailed account of one of Chase's painting demonstrations that summer was given by W.H. Fox, who happened to be on hand while Chase was painting the major work, *Still Life: Fish*, now in the Brooklyn Museum:

On a table in a corner of the studio lay a group of fish, fresh that morning from the Bruges market, wet and glistening. A monster of the skate kind, a large cod, and some North Sea herring lay together in artistic juxtaposition, and formed a composition which Mr. Chase intended to paint. The canvas had been prepared with a surface of silvery white and blue tones somewhat resembling the prevailing color of the fish. Over this the painter put in a background of a reddish-green tone. A small spot of brilliant white shone on one of the fish. Mr. Chase had put on the canvas the highest light and then rubbed the darkest tone into the picture. "Between these two tones," said he "is my gamut. I must not allow any of the intermediate tones in the picture to reach either of these extremes no matter what the light or the shadow on it may be." As the painter proceeded, intelligible form began to arrange itself from space, the swirls and strokes of the brush drawing in with the pigment the masses and the details of the work with a certitude and firmness of touch only possible in a master.[201]

View of Fiesole. 1907

Oil on panel
11¾ x 16 in (29.9 x 40.6 cm)
Smith College Museum of Art, Northampton,
Massachusetts, Purchased 1952

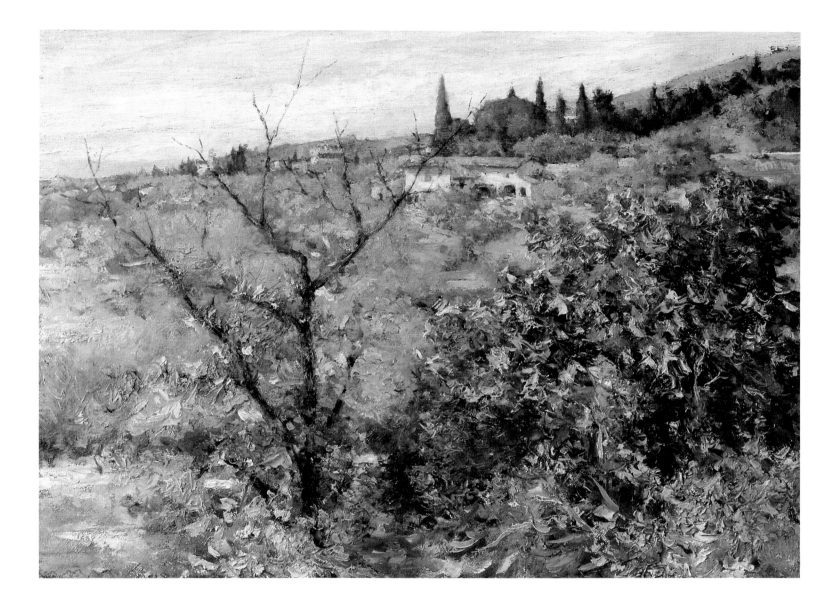

Fox reported that Chase worked on the painting for four hours "with feverish energy," sprinkling ice water on the fish from time to time to keep them fresh. "When he threw down his brushes at noon, the picture was so far advanced that it might very properly have then been exhibited."[202] Chase also painted several portraits this summer, and still life paintings other than fish.[203]

The summer of 1913 Chase held what would be his last summer class abroad. By this time he had given up all his teaching posts in America and art students were reminded in the brochure for the summer class that this would be "practically the only opportunity afforded of studying under Mr. Chase...."[204] The class, which was to be held in Venice, was limited to thirty. Its itinerary, described as "an ideal summer vacation for art lovers," was similar to that of the summer class he held in Italy three years earlier. The group left New York in late May and stopped at Madeira, Gibraltar, and Genoa before arriving in Naples on June eighth. Five days were spent in Naples and its environs. The group then traveled on to Rome for a stay of ten days and stopped in Siena for a day on their way to Florence. After five days in Florence, they left for the final destination, Venice, where they stayed for seven weeks, studying the paintings of the Renaissance masters and sketching either outdoors or in a studio. Once again, a scholarship was offered by *Arts and Decoration.*

As in years past, Chase departed from New York early, this time accompanied by his wife and daughter Dorothy, who traveled with him as far as Paris. Chase continued on alone, meeting the class in Venice.[205]

While in Venice he visited with several artists, including the American expatriate Julius Rolshoven and Emma Ciardi, an Italian artist whose work Chase praised highly. He also visited the widow of Mariano Fortuny y Carbó, an artist admired by Chase and his colleagues for his brilliant brushwork and technical skill. Inspired by the studio effects and paintings he encountered

in Madame Fortuny's small palace, Chase wrote his wife: "'I feel a fresh spell of enthusiasm after seeing such things.'"[206] This was not, however, a productive summer for Chase's own work. He had difficulty locating a studio, complained of the constant bad weather, and objected to the crowds he encountered at the Lido. He did find suitable subjects, however, claiming "'there is always something to paint here.'" He sketched from his balcony and expressed a special interest in painting fish still lifes. After completing one for his class as a demonstration piece, Chase reported, "'The students now want to paint still life the rest of the time while here.'"[207]

The following spring Chase made a short trip to London, but conducted no classes in Europe.[208] Instead, he returned home and in June left for California, where he was to hold what would be his last summer class.[209] The class, held at Carmel-by-the-Sea, was sponsored by the Arts and Crafts Club of Carmel, founded in 1905, and which had been offering summer classes since 1910.[210] Soon after he arrived, Chase found a place to stay in Del Monte, a short distance from Carmel; he also obtained a studio in nearby Monterey. The organization of the class was much like those he had held at Shinnecock Hills. "Board criticisms" were scheduled for Monday mornings, as usual, and the rest of the week was devoted to painting outdoors.

It appears to have been a productive summer for Chase, who completed a wide variety of paintings. In several letters to his wife he mentioned that he was busy painting and expected to get a lot done. Aside from a number of demonstration pieces, Chase painted several fish still lifes, small landscapes of Monterey, and a portrait of Channel Pickering Townsley (the manager of the class).[211] It was also at this time that Chase painted *The Flame,* the last of his kimono pictures, a series begun in the 1880s.[212] He was especially delighted with the monotypes he was producing. Chase had experimented with this type of "painterly print" as early as the 1880s. By 1914, he had discovered that he could get a good impression by using a common clothes wringer to transfer the image from the plate on which it was painted to a sheet of paper. As he completed these monotypes, created for his own personal pleasure

and that of his family and friends, Chase sent them back home. Despite the great amount of time Chase devoted to his work, he managed to set some aside for leisurely activities, including a "Rodero."[213] He also mentioned playing billiards and attending a stag party given in his honor.

When the season came to a close in mid-September, Chase left for New York, traveling by way of the Grand Canyon, a route reported to be neither of his choosing nor to his liking: "When Chase heard that two of his friends intended to stop off there he was scornful. Why did they wish to see that freak of nature?"[214] An opponent of the romantic Hudson River School and their grandiose compositions that often depicted the natural wonders of America, Chase preferred simpler aspects of nature for his own landscape paintings. Although suitably impressed by the splendor of the Canyon, he apparently never painted this subject; nor did he show any real interest in Western art as such.

Reverie: A Portrait of a Woman. c. 1890-95

Monotype on paper
19½ x 15¾ in (49.5 x 40.0 cm)

Metropolitan Museum of Art, Purchase, Louis V. Bell,
William E. Dodge, and Fletcher Funds, Murray Rafsky Gift,
and funds from various donors, 1974

John Singer Sargent
William M. Chase. 1902
Oil on canvas
61-1/2 x 41-3/8 in (156.2 x 105.1 cm)
Metropolitan Museum of Art,
Gift of Pupils of Mr. Chase, 1905

A Beloved Mentor and Guide

It seems fitting that Chase's last formal art class was held in America. During his lifetime, Chase had fought the battle for American art — developing what he considered to be a distinctly American statement in his own work and that of his students. By offering his summer tours to Europe, he also placed American art in perspective for the next generation of artists. Beyond a doubt he was the most popular American art teacher of the day, teaching more students than any other artist in this country. The many and varied tributes made by his dedicated students remain as a testimony to this important contribution. The range of his influence was amazingly broad, affecting both traditional artists and modernists. In describing Chase, his students have consistently presented an image of a kind man who was gregarious, entertaining, and generous to a fault; a fine teacher who was dynamic and inspiring; and a master of technique who could easily convey his love of art and his knowledge of painting in a vital and effective way. Georgia O'Keeffe, who studied with Chase at the Art Students' League, recalled with great enthusiasm that "when he entered the building a rustle seemed to flow from the ground floor to the top that 'Chase has arrived!'" Although O'Keeffe ultimately chose a very different direction and became one of this country's foremost modernist painters, she remained indebted to Chase for his early encouragement, stating, "I think that Chase as a personality encouraged individuality and gave a sense of style and freedom to his students."[215] Guy Pène Du Bois summed up his feelings for Chase in the following way: "The entire New York world of painting was dominated by William Merritt Chase, a glittering personality with a pointed gray beard and a handlebar mustache, who preached art for art's sake — to the devil with reality and all its vulgar interruptions."[216] And Gifford Beal declared, "to see him paint was a revelation."[217]

A more tangible tribute was undertaken in 1902 when a group of students at the New York School of Art commissioned John Singer Sargent to paint a commemorative portrait of Chase.[218]

That summer, accompanied by his friend Harrison Morris, Chase traveled to London, where the portrait was to be painted. Despite the fact that they arrived at midnight, Chase arose early the next morning to prepare for this momentous event. When Morris went downstairs to join his friend, he found Chase in formal attire, "the perfect model of fashion," dressed for his sitting "in all his glorious apparel, including the white carnation in the buttonhole of his frock coat, the eyeglasses on the broad silken leash, the spats, the tuft of the silk handkerchief peeping from his pocket, the white silk necktie clasped with the matchless emerald...." Responding to this sight, Morris told Chase: "'Sargent won't paint you that way. It ought to be a little pietà, with a student in adoration at each side.'"[219] As it turned out, Sargent *did not* want to paint Chase in formal garb as a dandy; nor did he want to create an icon (as wryly suggested by Morris); instead he wanted to portray Chase as an artist and insisted that his friend pose in his "old blue studio coat," palette and paint brushes in hand. When the portrait was completed it was shipped to America, where it was widely exhibited and then given to The Metropolitan Museum in 1905 and credited "Gift of Pupils of Mr. Chase."[220] As Doreen Burke has pointed out, this was a most appropriate gesture on the part of Chase's students, who had often visited the museum with him and listened to his lectures on various paintings in its collection.[221]

There were at least two other formal tributes made by Chase's students, memorials delayed by American involvement in World War I. The first was an exhibition of works of art by former students of Chase's Shinnecock Summer School of Art mounted in 1922. Appropriately the show was held in Southampton. The foreword of the simple catalogue acknowledged Chase's "great work" for American art and his "unfailing inspiration and generous help as a Master."[222]

Another tribute took place in 1924, the presentation of a bronze bust of Chase to New York University.[223] W. Francklyn Paris, the originator of this project, initially thought he would approach Chase's fellow artists for contributions to pay for the bust, but on second thought he decided to restrict the donations to Chase's pupils, explaining "it came to me that in addition to being a great painter, Chase was a great teacher, probably the greatest teacher of painting America has as yet produced, and it occurred to me, knowing the character of the relations which always existed between this lovable and beloved mentor and guide and his pupils, that a much finer tribute would be paid him, if the bust which I proposed to enshrine here were presented by his pupils instead of by his confrères and fellow-artists."[224] Nearly 100 former students contributed to this memorial fund.[225] The formal presentation of the bust was made by Irving Wiles: "On behalf of the Committee, I take great pleasure in presenting to New York University, this memorial to William Merritt Chase, erected by his pupils, to be an everlasting tribute to his fame as a teacher and guide and consecrated to his memory for his great kindness as a friend to all of us."[226]

■

IV
A Leading Spirit in American Art

11

An International Style

12

The Ten American Painters

13

A Typical American Artist

14

The Last Years

Sunlight and Shadow. 1884
Oil on canvas
65¼ x 76½ in (165.6 x 194.3 cm)
The Joslyn Art Museum, Omaha, Nebraska

Ring Toss. c. 1896
Oil on canvas
40³⁄₈ x 35¹⁄₈ in (102.6 x 89.2 cm)
Private Collection

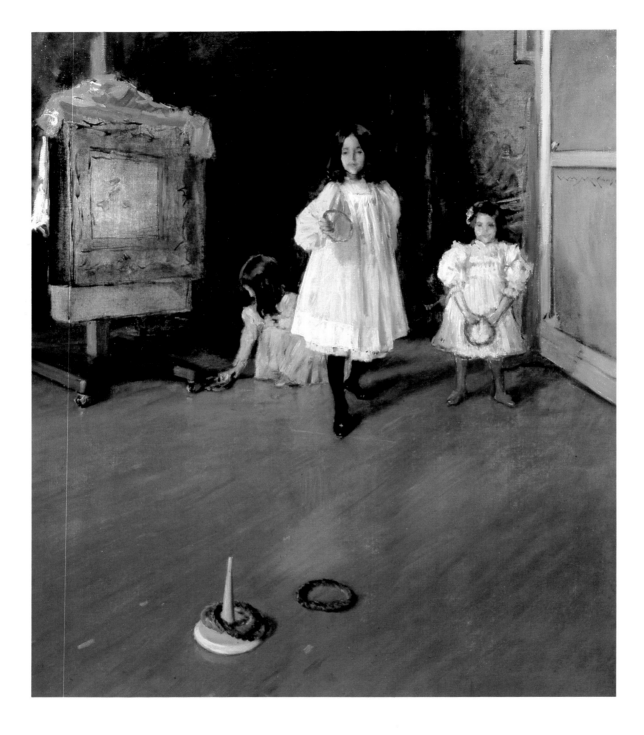

An International Style

When William Merritt Chase returned to New York in 1878, he was considered to be radical — at the forefront of the modern movement associated with the Society of American Artists. As early as 1880, the Society's exhibitions were deemed to be the most advanced in the country, the American equivalent of progressive trends abroad. One writer reported that "the shorthand of art is exhibited in paying displays at the Grosvenor Gallery in London, at the expositions of the 'impressionists' in Paris, and with the Society of American Artists in New York...."[1] The same writer explained that these artists had common aims and stressed the importance of capturing their first impressions, achieving a fresh, unlabored look in their work. He then cautioned: "The error of the young 'impressionists' is apt to be that they are too easily satisfied with work in the expressive and preparatory stage. Their work is a much finer thing than dull commonplace academic work; but they should not forget it is not nature — at least not the whole of nature. Nature never displays the paint stroke by which she gets an effect of color."[2]

Chase was one of the few Americans who actually exhibited in independent shows in Europe. In 1884, he was invited to show his work with "*Les Vingt*" *(Les XX)* in Brussels, who had joined together to promote modern art in Belgium through international exhibitions and their publication *L'Art Moderne.* Other Americans who were included in their exhibition of 1884 were John Singer Sargent and James Abbott McNeill Whistler. Two years later, when Chase exhibited with this group again, works by Monet, Renoir and Redon were included, clearly demonstrating the progressive nature of this group.[3] It is significant that Chase's work was thought to be so advanced at the time — and included in such progressive shows.

When critics of the period commented on the "impressionistic" nature of Chase's paintings, they were referring to his slashing, summary brushstrokes and his ability to capture a fleeting moment.[4] These traits were the result of his training in Munich and his admiration for old masters such as Velasquez and Hals; also associated with this heritage was the dark, somber palette he used in the 1870s. In a review of the Society of American Artists' exhibition of 1879, one critic responded to this aspect of Chase's work, describing the entry, *Landscape*, as "a thoroughly bad picture...crude in color — black, brown and muddy...the whole wanting in elements of beauty."[5] Two years later, when Chase's portrait of Frank Duveneck, *The Smoker,* won an honorable mention at the Paris Salon, it was praised by the Belgian Impressionist Alfred Stevens, who, however, criticized the painting's dark, somber tonality. "Why do you try to make your canvases look as if they had been painted by the old masters?" he asked.[6] Soon afterwards, Chase took this criticism to heart. While not forsaking the free, rapid brushwork of his Munich days, he began to develop a fresher and brighter palette, most clearly evidenced in his landscape paintings of the 1880s. The impetus to this change came during the early 1880s in Holland, where he took up plein-air painting. By the mid-eighties, the "black, brown and muddy" palette referred to in the 1879 review was a thing of the past — Chase's paintings were now filled with the light of the outdoors. While abroad in 1884, Chase spent time painting in Antwerp, where he was spotted by the American painter F. Hopkinson Smith in "a narrow sort of lane which led up to a courtyard near a house that looked as if Rubens might have lived in it. There in the full sunlight, back to me, with a cap on his head, five-foot canvas in front of him, stood Chase laying in his background with mighty sweeps of his brush. I called out, 'You May-Jane,' and Chase, without losing a sweep or turning his head, and with an extra brush in his mouth, shouted back, 'Come in offen de wet grass!' So I knew he was all right and I left him with no more words."[7]

While on the same trip abroad in 1884, Chase visited his friend Robert Blum, and painted *Sunlight and Shadow,* which depicts Blum sitting in a garden. This delicate painting, with its pastel-like colors, shows the adjustments Chase was making in his palette, perhaps inspired by his exposure to the works of the French Impressionists and their precursors, such as Eugène Louis Boudin, whose work Chase greatly admired.

Chase had been thoroughly familiar with Manet's work as early as 1881, and this interest probably led him to see works by the other French Impressionists shortly afterwards. In any event, he had the opportunity of seeing a broad array of

their paintings in April of 1886, when the American Art Association hosted a major exhibition, organized by Durand-Ruel, in New York. The exhibit was comprised of approximately 300 works of art, including seventeen by Manet, twenty-three by Degas, thirty-eight by Renoir, forty-eight by Monet, forty-two by Pissaro, fifteen by Sisley, and three by Seurat. The exhibition was so popular that it was extended and went to the National Academy of Design, where it was supplemented by an additional twenty-one works borrowed from American collections.[8]

Later that year, from November eighteenth to December fourth, Chase was given his first major one-man show at the Boston Art Club. This comprehensive exhibition included 138 works of art — paintings, drawings, watercolors, and an impressive number of pastels. Among those listed in the catalogue were several designated as "studies," "sketches," and even "unfinished" paintings. His inclusion of paintings of this nature in an important exhibition confirms that Chase believed such simple and freely painted sketches were indeed works of art worthy of public attention. The exhibition was well received, and several critics commented on the "impressionistic" nature of Chase's work. One declared the show to be "the sensation of the month in art circles." He claimed that "it is upon just such work as this that we can safely base our hopes for art in America."[9] Another writer referred to the show as "a varied exposition of artistic impressionism..." and noted that "nearly all of Mr. Chase's landscapes look as if he seized upon his impression at its first inception, leaving out whatever would mar its artistic vividness."[10] In an otherwise laudatory review, the free, spontaneous nature of Chase's work was commented on in this fashion: "The only argument brought against Mr. Chase is that he does not sufficiently 'carry out' his pictures." However, he then conceded "there may be a fair difference of opinion on that point." This writer concluded that any artist could "rest his reputation" on three works alone: "his wonderful pastel of a woman in white, the large Holland scene, and his picture of a young woman in a blue plush upholstered chair."[11] The works referred to are most probably *The White Rose (Miss Jessup), Sunlight and Shadow,* and *Interior of the Artist's Studio (The Tenth Street Studio)*.

Commenting on these reactions to his paintings, Chase later recounted this incident: "It was in Boston, in the gallery where my pictures hung, when a gentleman came towards me... 'Mr. Chase, will you please explain to me this new way you have of painting?...I mean this broad kind of slap-dash.' I said... 'I will...assure you that it is not new, but quite old....'"[12] Chase then likened his approach to that of Velasquez, explaining: "We have a mistaken idea of what finish is — I firmly believe that if Velasquez were here to-day — he might be considered a very clever artist, who rarely, if ever, finished a picture or study."[13] It is significant that Chase attributed his impressionistic approach to Velasquez (whose work the French Impressionists also admired) rather than his French contemporaries. It is clear, however, that by this point he was directly indebted to these artists in his painting of contemporary subject matter and the use of certain compositional devices such as the use of dramatic diagonals and cropped images.

A series of impressionistic park scenes begun in 1886 reflect these influences. Among his loveliest works, they were well received at the time by artists and critics alike. The artist Kenyon Cox attributed a distinctly "American quality" to these paintings, which he referred to as "little jewels." To Cox they represented "new proof, if proof were wanted, that it is not subjects that are lacking in this country, but eyes to see them with. Let no artist again complain of lack of material when such things as these are to be seen at his very door...." He concluded, "They are far and away the best things Mr. Chase has yet done, and are altogether charming."[14] In a similar vein, critic Charles De Kay considered these works mature statements that proved Chase had been "slowly won away from entangling alliances with his masters in Paris and Munich....He has discovered Central Park."[15] Although Chase was credited with discovering the artistic beauty of America's city parks, the inspiration to paint these scenes was likely foreign — the most probable source being Sargent's earlier views of the Luxembourg Gardens in Paris.

Chase's reasons for choosing to depict this country's parks were, in part, due to circumstance. With his marriage in 1886 and the subsequent births of his nine children, Chase was faced with the responsibility of a family.

He discontinued his regular summer trips abroad, and turned instead to his immediate surroundings for subjects. In general he found the sights in the city dismal and uninspiring, claiming: "The sky scraping monsters have smothered quite out of existence as objects of beauty many of the mighty old landmarks of this city....Art feeds itself upon the daily influence of its surroundings and this being the case it is fortunate that, at this time transportation is made easy...."[16] The parks were an exception, where, during the late 1880s, Chase found relief from his urban environs — at least most of the time. On one occasion, while visiting Central Park, he was disturbed by an amateur painter who apparently was equally inspired by the beauty of the park's setting. At first Chase offered some constructive criticism of her "most unpromising piece of work...executed in clashing colors." After realizing that the woman had not understood a word he had said, Chase lost all patience and spoke more plainly: "'What I mean, madam, is that...if it looks like that in the Park *I* don't want to go there.'"[17]

To understand the degree to which Chase accepted Impressionism and the effect that it had on the development of his own style of painting, as well as his teaching, several factors should be considered: the types of paintings Chase selected for his own extensive collection; his comments on the works of other artists; and his specific statements about Impressionism. The eclectic Chase drew inspiration from many sources, and his collection of paintings by other artists reflects the broad range of his taste. Any analysis of Chase's collecting and the degree to which the paintings he chose illuminate his interests and how they affected his own artistic development should be undertaken with caution. Although Chase appears to have led an extravagant life, in truth his means were actually quite limited compared to the great collectors of the day. Apparently he was unable to acquire the work of several artists whom he clearly respected, for example, John Singer Sargent and Mary Cassatt.[18] Nonetheless, certain generalizations can be made from an analysis of the works he did obtain. As might be expected, Chase was most attracted to bravura brushwork, and the spontaneously executed paintings in his collection reflect this. In terms of still life painters, it is clear that the artist he most admired was Antoine Vollon (represented by twenty paintings, half of which were still lifes).

Sketch—Children Playing Parlor Croquet. c. 1888
Oil on canvas
31¼ x 34¼ in (79.4 x 87.0 cm)
Collection of Mr. and Mrs. Joseph H. Davenport, Jr.

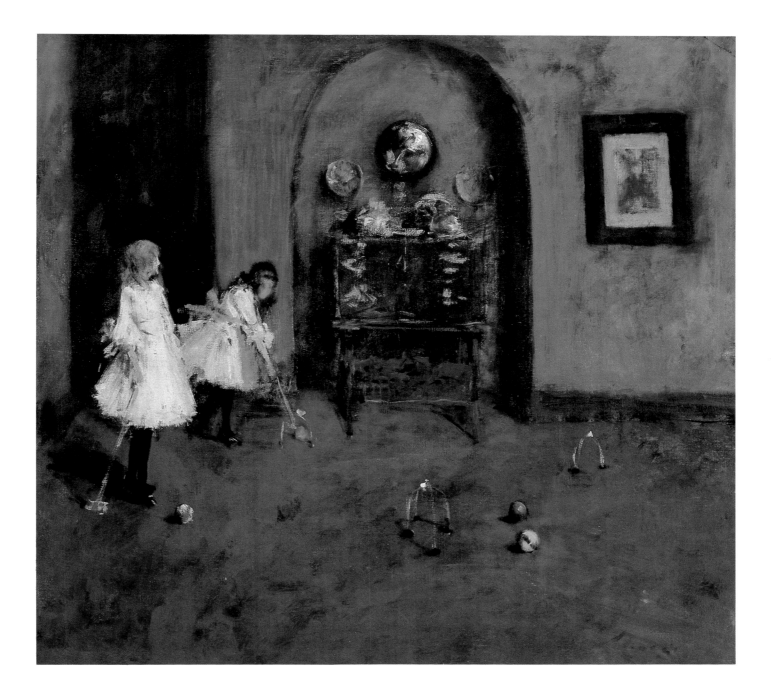

Hide and Seek. 1888

Oil on canvas
27¹/₂ x 36 in (69.9 x 91.4 cm)
The Phillips Collection, Washington, D.C.

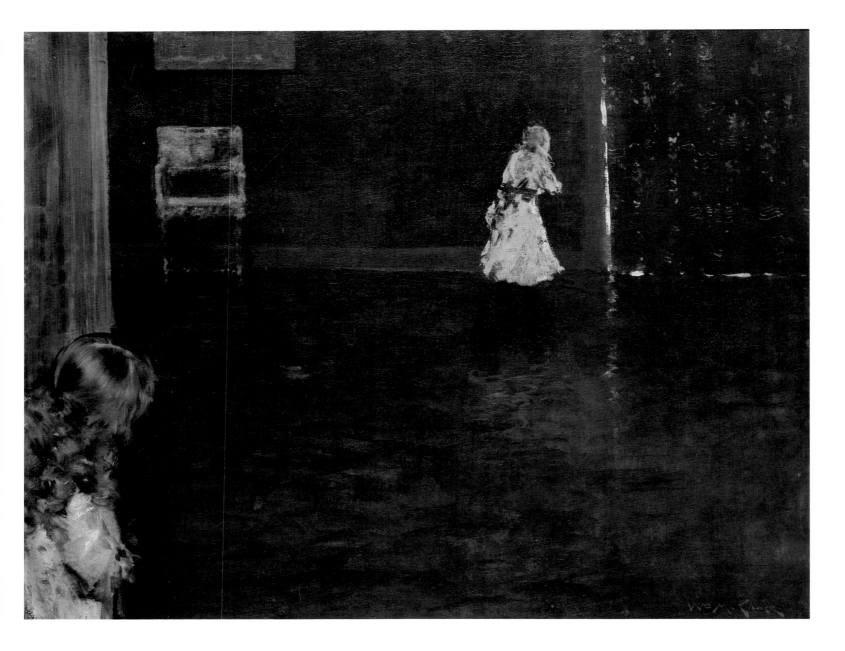

For the Little One
(Hall at Shinnecock). c. 1896

Oil on canvas
40⅛ x 35 in (101.9 x 88.9 cm)
The Metropolitan Museum of Art, Amelia
B. Lazarus Fund, by exchange, 1917

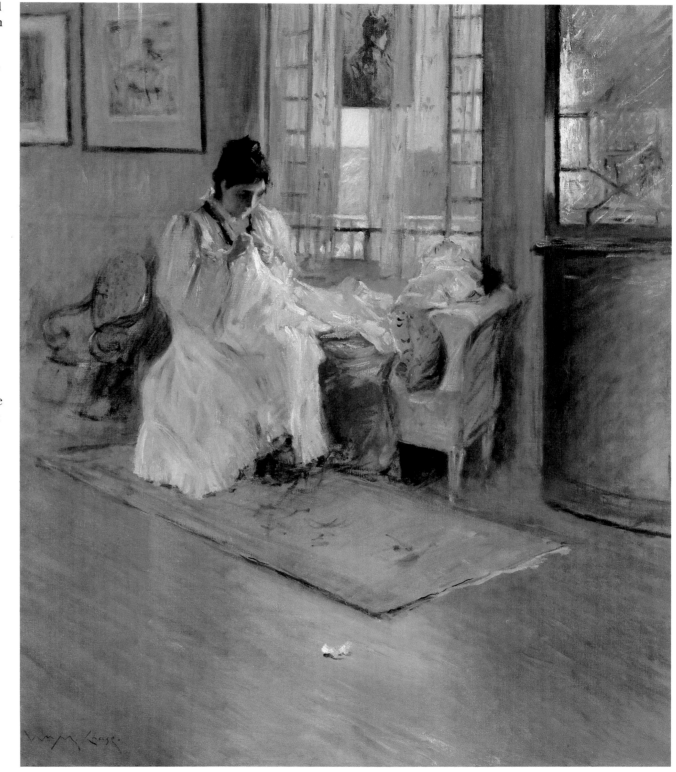

The portraits and figure studies that Chase owned evidence his favor for fashionable portraitists such as Giovanni Boldini, Paul Helleu, John Lavery, James Joseph Jacques Tissot and Antonio Mancini. Alfred Stevens, whom Chase particularly respected, was represented by nine paintings. Other favorites included Augustin Théodule Ribot and Ferdinand Roybet. He was also especially partial to landscapes by the so-called pre-Impressionists such as Eugène Boudin and the Dutch plein-air painters Johan Barthold Jongkind, Anton Mauve, Johannes Berardus Blommers and Hendrick Willem Mesdag.[19]

Since we cannot rely solely on the works of art Chase collected as an indication of his preferences, it is also important to consider Chase's own statements and the opinions of his contemporaries. Undoubtedly John Singer Sargent and James Abbott McNeill Whistler were the artists he most admired. In fact, in Chase's portraits one can easily recognize the influence of both of these painters, varying in degree from work to work, and of course never overshadowing Chase's own personal expression. In one critic's opinion, Chase's portraits were "not as subtle as Whistler, not as rugged as Sargent, he seems more normal than either." The same writer claimed that Chase's portraits "did not exhibit his mental experience as much as [they] might have done, but the sightseer took satisfaction in the solid underpinning of the Chase figures compared to Whistler's and the quiet harmony of the Chase tone compared to Sargent's."[20] In developing his own statement (described variously as being "sane," "sober," and "normal" when compared to the work of Whistler, Sargent and the Impressionists), Chase created a strong and harmonious — if somewhat less daring — expression.

Chase referred to Sargent as "the greatest portrait painter in the world"[21] and praised him as being "a brilliant example of the great artist in whom there is no intermission between the head and the hand."[22] According to Walter Pach, Chase's admiration for Sargent was two-fold: he especially respected his "technical adroitness" and he admired Sargent's material success and glamorous lifestyle.[23] In comparing the two artists' works, one contemporary critic ranked Chase "next to Sargent among our portrait painters" but claimed that Chase was not as "brilliant." On the other hand, he credited Chase's portraits as having "sober qualities" that gave his figures a definite presence. He also attributed to his work a certain "dignity," which he considered to be a good influence on American art, an influence that would be transmitted to the next generation of American artists through Chase's teaching. "Many of the younger portrait painters who to-day follow Sargent very closely, received their fundamental instruction from Chase," he noted. The same writer identified the major strength of Chase's work as being his "keen sense of construction," with each stroke of paint serving a specific function in building up volume in a "masterful manner."[24]

Second only to Sargent in Chase's estimation was Whistler. Like Whistler, Chase was especially concerned with creating an "ensemble." This effect is most clearly seen in his subtly painted interiors, such as *For the Little One*, and *Hide and Seek*,[25] but it is also noticeable in other works, including his landscapes. In describing his approach to landscape painting Chase stated: "'You must not ask me what color I should use for such an object or in such a place; I do not know till I have tried it and noted its relation to some other tint, or rather if it keeps the same relation and produces on my canvas something of the harmony I see in nature.'"[26] This aesthetic unity can be seen in the coastal scenes Chase painted in the 1880s, for example, *The East River.*[27] To a lesser degree, it is apparent even in his Shinnecock landscapes painted in the 1890s, such as *The Bayberry Bush*, in which Chase utilized a limited tonal scale, accented with touches of bright color.

Chase's teaching methods also reflect his concern for tonal harmony: "'Tonality is perhaps the masterful maturity of technique, impressing more definitely than any other quality the beauty, the very best of ideal, Nature, — in art.'"[28] To

achieve this effect, he advised his pupils to "have the colors on the palette graded from white to black; half represents light, and half shadow. After a while one ceases to think of it as paint, but only as light and shade, and one's brain and hand will be so in unison that the right color is picked up instantly and the sketch grows quickly — spontaneously — and one leaves it with regret."[29] Chase also advised his students to avoid stark whites and pure black; "It so happens that pure black rarely occurs. Dark holes have air in them that removes the tone from pure black, that accounted for on canvas has a tremendous value."[30] This comment reflects Chase's understanding of this Impressionist concept.

Among the Impressionists whose works he collected were Edouard Manet, Berthe Morisot, Guiseppe De Nittis and Eva Gonzales.[31] He also respected the work of Degas, Cassatt, and to a certain extent, Monet. According to Walter Pach, Chase "could even stand Renoir, in the earlier works of that painter."[32] On numerous occasions Chase acknowledged the achievements of these artists; but he also had some reservations about their work. At first he thought Impressionism to be a passing fad, but eventually regarded it more seriously. Although he never considered himself an Impressionist, under their influence Chase's work of the late 1880s and the 1890s began to change. He adopted certain Impressionist techniques and taught them as well. His palette became brighter, especially in his pastels; his brushstrokes became shorter, breaking up the surface of his work; and his concern for capturing the first impression of his subjects became even more pronounced. "'Never finish anything. Every picture completes itself in the process of doing,'"[33] he told his students. "'Say just enough to convey the impression forcibly....'"[34] Like the Impressionists, Chase was especially successful in capturing a fleeting instant. Responding to Chase's candid depictions of leisurely life in the parks in and about New York City, one critic referred to him as a "human camera."[35] Another described Chase as "quick beyond most contemporaries to catch a subject at the right moment."[36] In an amusing anecdote about Chase, his own daughter was quoted as saying, "Papa, come quickly; here is a cloud posing for you!"[37]

Chase recognized the luminosity the Impressionists were able to convey in their paintings, but he objected to their means of achieving it. He criticized them for being "'more scientific than artistic in their aims....'"[38] He did concede that never "in the history of art was open-air, light and air, attempted or done as well as it is today...", and cited the work of Monet as proof of this.[39] Although Chase praised Monet for his courage in doing what he believed despite harsh criticism, he objected to Monet's mindless disciples who merely found a superficial formula in the French artist's way of painting. One summer Chase found that a number of his own pupils had been adversely influenced by the work of Monet, whose paintings (along with those of the other Impressionists) were being shown in New York and other cities with growing frequency. He became increasingly impatient with the "lurid patches of yellow and blue" that began to dominate his students' paintings, and confronted one of the perpetrators of these studies: "'And it was as yellow as that?' he asked. 'Oh yes, Mr. Chase. Really it was. The sun was right on it you know, and it was very yellow.' The pupil babbled on, imagining that she was being very convincing. 'Hm,' was Chase's reply, after another glance. 'And September not here yet! Give the goldenrod a chance, madam. Give the goldenrod a chance.'"[40]

Chase also reminded his own pupils "'it is not only the light picture that succeeds. Impressionism with the high-keyed picture gave us some things that have come to stay, light, air, space — of which the old painters knew less. But the high-keyed picture is not the only one. You are to avoid recipes. There are no recipes. Not objecting to light pictures, I tell you that the dark, the black picture, in quiet tone is just as satisfactory....'"[41] And, in his work at Shinnecock Hills, Chase set an example by painting tonal interiors utilizing deep rich color, as in his painting *Reflection*, as well as sun-filled landscapes like *At The Seaside.*[42]

From the instruction Chase gave his students at Shinnecock Hills, it is clear that he understood certain techniques of the Impressionists. He explained to his students that the Impressionists used short brushstrokes "'to convey the idea that air vibrates and that we can see through it like a screen....'"[43] Although Chase realized the effect that could be achieved by breaking up the surface of a painting, he purposefully avoided "little dabs of color," and advised his students to do likewise.[44]

Reflection (Reflections). c. 1893
Oil on canvas
25 x 18 in (63.5 x 45.7 cm)
Collection of Mr. and Mrs. Raymond J. Horowitz

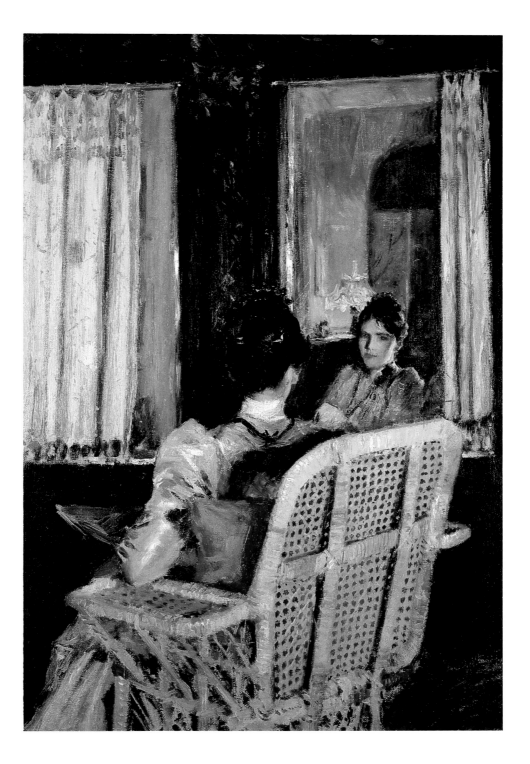

At the Seaside. c. 1892

Oil on canvas
20 x 34 in (50.8 x 86.4 cm)
The Metropolitan Museum of Art,
Bequest of Miss Adelaide Milton de Groot, 1967

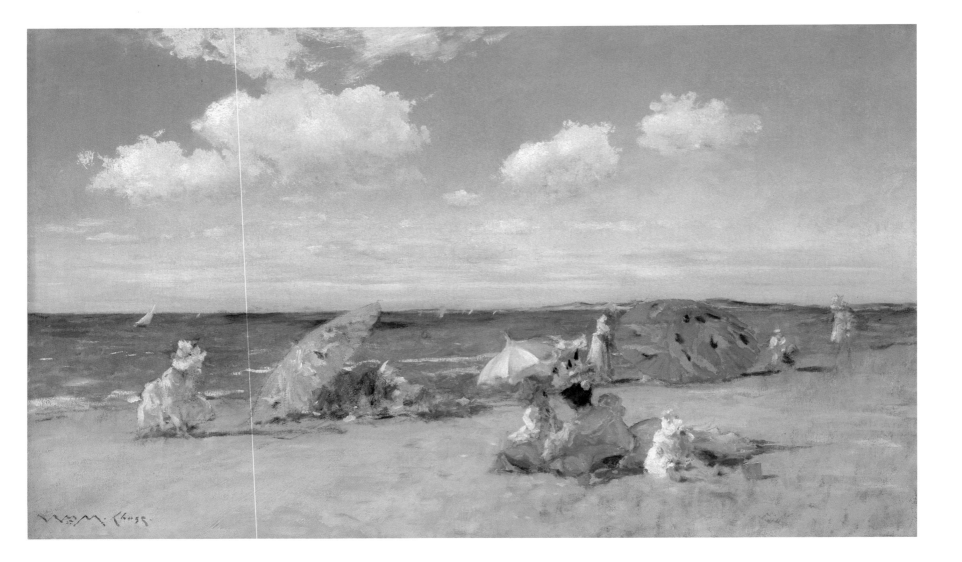

Mother and Child in a Park. 1889
Pen and ink on paper
7⅞ x 8½ in (20.0 x 21.6 cm) (sight)
Private Collection

An Impressionist technique Chase adopted without reservation was the use of cropped images to create a sense of immediacy. In fact, at one point he even cut down some of his earlier paintings, apparently in an attempt to achieve this effect. In a similar vein, he urged his students to always have on hand a number of different size mats and frames to place over their works "'to see if any part can be advantageously cut off.'"[45]

Another aspect of Chase's work that can be traced to the Impressionists is the use of certain compositional devices similar to those used by Edgar Degas and Guissepe De Nittis. For example, Chase favored dramatic perspective lines that draw the viewer immediately into the work — an effect which is heightened by the use of a broad open foreground.[46]

In spite of the fact that Chase never considered himself to be an "Impressionist," a term that was too limiting for his diverse oeuvre, his paintings were hung alongside their works in exhibitions and even acquired by some of the same American collectors. At one point H.O. Havemeyer owned Chase's painting *Flowers*, and the Potter Palmers owned at least five of his works: two paintings, *On the Lake* and *Boat House, Prospect Park*, and three pastels, *Study of Flesh Color and Gold, Grey Day*, and *Peonies*.[47]

In recent years, Chase's work has been grouped with that of a number of his contemporaries under the term "American Impressionism." Although Chase would not have classified himself as such, his work does relate directly to that of the artists falling in this category. In fact, many of them were his friends, whose paintings were generously represented in his collection. Chase owned at least six works by Ernest Lawson and five by John H. Twachtman; other Americans associated with this group whose work he collected include: J. Carroll Beckwith, Robert Blum, Thomas Wilmer Dewing, Walter Griffin, Charles Hawthorne, Alfred H. Maurer, Theodore Robinson, J. Alden Weir and Guy Wiggins. In varying degrees all of these American artists were influenced by the French Impressionists, as well as by each other. This movement reached its height of importance in America in the 1890s, at which point a group of artists formed "The Ten," an independent organization of painters united by a common purpose and a shared aesthetic.

Terrace at the Mall, Central Park. c. 1890

Oil on panel
11½ x 16½ in (29.2 x 41.9 cm)
Collection of Richard M. Scaife

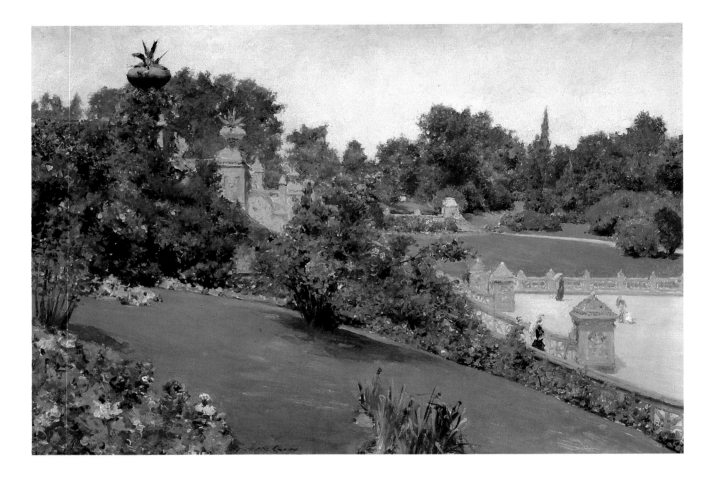

Boat House, Prospect Park (Boats on a
Lake; Boats on the Lake, Prospect Park). **c. 1887**
Oil on board
10¼ x 16 in (26.0 x 40.6 cm)
Collection of Meg Newhouse

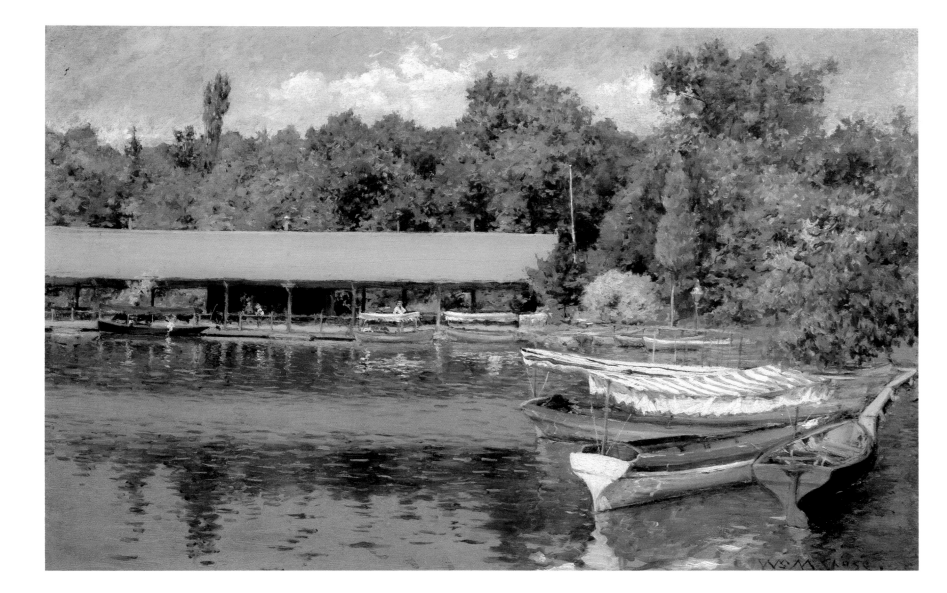

Shell Beach at Shinnecock. c. 1892

Oil on canvas
18 x 26 in (45.7 x 66.0 cm)
Thomas Gilcrease Institute of American
History and Art, Tulsa, Oklahoma

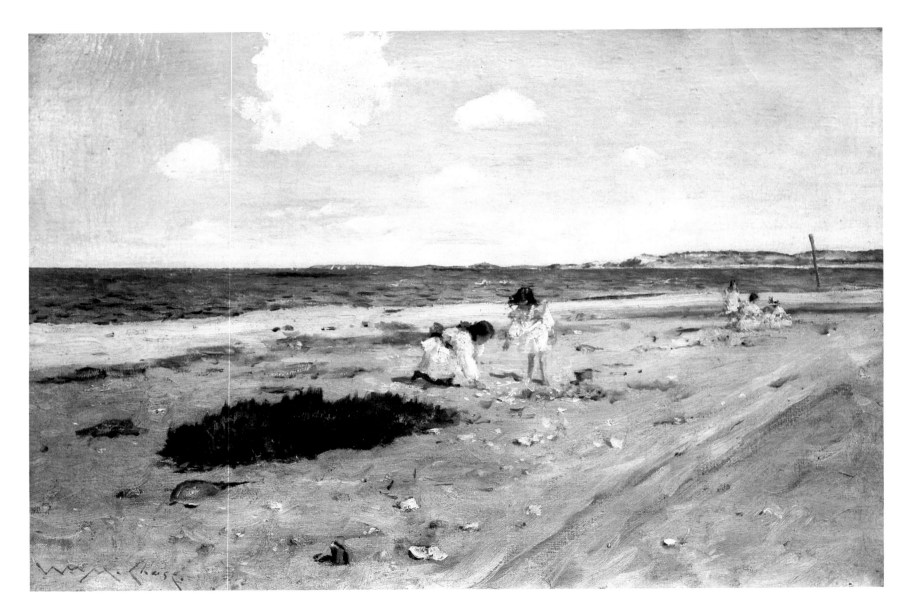

A Sunny Day at Shinnecock Bay. c. 1892
Oil on panel
18³/₈ x 22⁷/₈ in (46.7 x 58.1 cm)
Private Collection

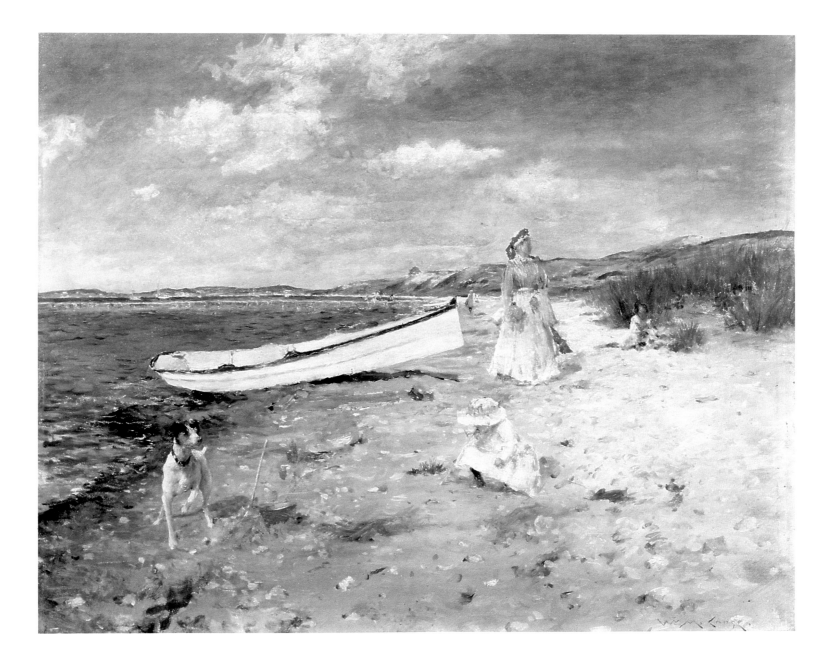

Self Portrait (Portrait of the Artist). **1915-16**
Oil on canvas
52½ x 63½ in (133.4 x 161.3 cm)
Art Association of Richmond

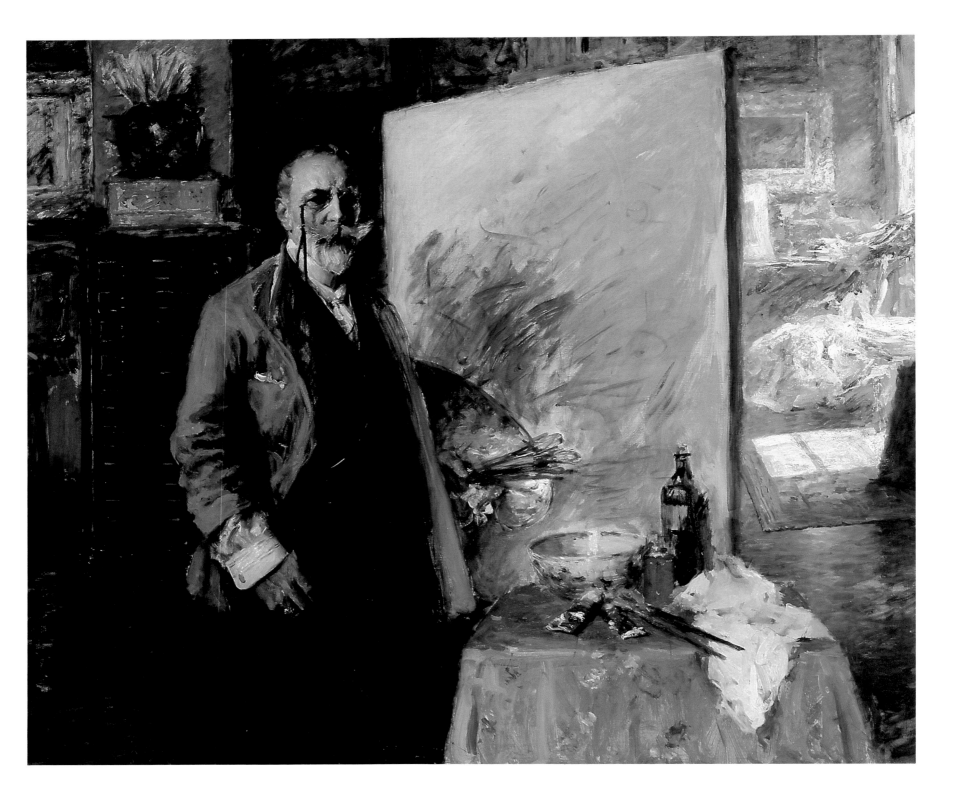

The Ten American Painters

In December of 1897, a group of artists banded together and seceded from the Society of American Artists. The original group consisted of Frank Benson, Joseph De Camp, Thomas W. Dewing, Childe Hassam, Willard Metcalf, Robert Reid, Edward Simmons, Edmund Tarbell, John H. Twachtman, and J. Alden Weir. These artists, who are now sometimes considered to be the core group of American Impressionists, had no radical reasons for seceding, nor was their work especially progressive or out of line with what was being shown at the Society. Instead, they left for more personal reasons — to exhibit their paintings more harmoniously. Their organization was intended to be an informal one with no by-laws, juries, or officers. *The New York Times* reported: "It is not the intention of these gentlemen to organize a rival society, or indeed, to form any organization at all, Mr. Weir said last evening. He said that the seceding artists grew dissatisfied with their membership in a large body which is governed by form and tradition, and having sympathetic tastes in a certain direction in art, they had withdrawn from the Society of American Artists to work together in accordances with those tastes." Weir claimed that the group opposed the "barbaric idea" of large exhibitions, and "following the Japanese view," intended to organize small shows limited to the best three or four paintings by each member artist.[1] Responding to the broad array of styles and the uneven quality of the paintings that were being selected for the exhibitions of the Society at the time, Simmons commented: "We left the society as a protest, not believing that an art show should be like a child's bouquet — all higgledy-piggledy with all the flowers that can be picked."[2] Tarbell objected to the lack of distinguished artists on the Society's jury of awards, and De Camp attacked the "rising tide of commercialism" in the Society's shows. One member of The Ten was even quoted as referring to the Society of American Artists as the "Society of Mediocrity."[3]

Contemporary press accounts provided additional reasons for the formation of The Ten. According to one, they believed that the Society's exhibitions no longer represented progressive art in America, which had been its original objective, but was instead concerned with exhibiting art that would sell.[4] In a similar vein, another report noted: "The reason which the seceders give for their action, in their formal letter addressed to the president and members of the Society of American Artists, is that it is apparently impossible to maintain a high standard of art when, as in the case of the Society, it is imperatively necessary to attract the general public to exhibitions in order to meet expenses." He also stated it would be a "deplorable event" if this secession would cripple the Society and put an end to such comprehensive exhibitions. However, he doubted that this would come about since there was still a sufficient number of fine artists who remained with the Society to assure the continuation of the organization — Chase was one of them.[5]

Since Chase's work was obviously compatible with that of the original members of The Ten, one might wonder why he did not join the group in the beginning. Undoubtedly his bond with the Society of American Artists was so strong at the time The Ten seceded that it would have been unthinkable for him to be associated with their cause. He was one of the Society's most forceful spokesmen and served as its president for a total of eleven years. Also, just two years before The Ten withdrew, Chase had been awarded the Society's prestigious Shaw Prize for his painting *A Friendly Call.*[6] He remained a loyal member to the end, joining The Ten only when he knew that end was imminent, in 1905.

It is apparent, above and beyond the 1897 secession of The Ten, that the Society of American Artists' exhibitions in the nineties had been affected by the vying for position of various factions within its ranks. Whichever faction dominated the jury and hanging committee determined the type of exhibition for that year and selected who would receive the awards. In 1896, the artists who were to break away from the Society and form The Ten dominated the jury and the hanging committee — and won the coveted awards.[7] In total, the show was considered "encouraging in every way."[8] The next year, however, the complexion of the show changed dramatically. Apparently in 1897 a new faction took charge; the exhibition was more conservative than in previous years, and the prizes were

awarded to two moderate artists: Bruce Crane, a tonalist painter, and George Willoughby Maynard, whose work was academic and decorative in nature. In fact, only four of The Ten were represented in the show at all.[9] Undoubtedly their secession was related to this change.

Several artists, though not members of the group, were sympathetic with the action of The Ten. Two, Winslow Homer and Abbott Handerson Thayer, had actually been invited to join. Homer declined the invitation, explaining that he had already planned to retire at the end of the season.[10] Thayer originally agreed to become a member, but changed his mind because of his committment to the Society of American Artists and because he felt that his limited output would not be adequate to assure him of having a sufficient number of works available for The Ten's annual shows.[11] J. Carroll Beckwith shared The Ten's dissatisfaction with the way in which the Society was being run. As early as 1890, he complained about "the Monet gang back from Europe with everything pale lilac and yellow."[12] It was not that he objected to Impressionism, but rather that he disapproved of any one style dominating the Society's shows, depending upon who did the jurying each year. In April of 1898 he noted in his diary: "I am much disgusted with the Society. It is an organization vacillating from one fad to another and each spring [a different] crowd rules it. The 10 who have seceded did quite right."[13]

The resignation of The Ten was, however, criticized in the press. One critic objected to all the attention they were receiving for their action, calling it a "little 'tempest in a teapot.'" He explained that the founding of the Society of American Artists was indeed a major development in American art history, the "birth of a new school as well as a movement in American art." In contrast he claimed that "the seceders, to use a perhaps vulgar simile, are not setting up another circus, but simply a side show." He then predicted that their move would eventually lead to a similar break within their own ranks, proving the absurdity of such fractures.[14] Sadakichi Hartmann was even more vehemently opposed to The Ten's secession, writing that they had "made the vain attempt to divide Manhattan art into three factions." He concluded that the group had nothing to say that could not have been said just as well on the walls of the Academy or the Society.[15]

As it turned out there were no radical intentions behind the group's break. In fact, seven of the ten members continued exhibiting their paintings at the National Academy of Design. In 1898 — the year of The Ten's first exhibition — half of them displayed their works at the Academy's yearly show: Benson; Hassam, Reid, Twachtman, and Weir. Tarbell resumed showing his paintings at the Academy's annual exhibitions in 1899, although on an irregular basis, and Hassam and Weir participated in their shows almost every year.

If these artists objected so adamantly to the nature of the Society's exhibitions, why did they then continue to exhibit their paintings at the even more conservative Academy? It is clear that from the start their major objection was indeed an aesthetic one; they wanted their own works to be seen at their best, next to compatible paintings and in a complimentary setting. What they were seeking was an alternate exhibition space for a select group of artists who shared a common aesthetic, not a separate organization that would compete with either the Society of American Artists or the National Academy of Design. They were able to accomplish their objective in their own exhibitions, and for many of them it was possible to do so without having to sacrifice the opportunity of showing their work with another organization as well. In his autobiography *From Seven to Seventy,* Simmons explained the original intent of the group: "The first few years we divided the wall into equal spaces and drew lots for them, each man having the right to use it as he saw fit, hanging one picture or a number of pictures. . . ." However, he wrote that this procedure was soon abandoned since artists with small paintings objected to having their works placed next to his own large mural paintings. Ultimately the artists agreed to leave the hanging of the show up to the dealer, the result being: "He placed those which sold the best in the choice parts of the room. . . ."[16] This was an ironic outcome for a group of artists whose major concern was an aesthetic one and whose main objection to the exhibitions at the Society was their commercial aspect. In fact, Simmons claimed that The Ten were actually accused of having formed with just such a commercial interest in mind; however, he flatly denied this.[17] Regardless of their original intent, it is obvious that by joining together and exhibiting their work as a group at Durand-Ruel's gallery, which was by this time doing quite well with the French Impressionists, The Ten would then be more closely associated with these artists — and

thus, more successful. Their annual exhibitions held between 1898 and 1918 were, in fact, successful and well received by the press.

In 1902 John H. Twachtman died. The Ten did not fill the vacancy until 1905, when Chase was invited to join the group. "I like to keep good company. I am therefore glad to be one of the members of 'Ten,'" Chase responded.[18] Several weeks later, a notice was released in *The New York Times:* "The Society of Ten American Painters has filled its ranks again by the election of Mr. William M. Chase and gives thereby notice that it has a function to exercise in the world of art and has no intention to disband or grow ever less by the gradual dropping off of its members."[19] By the time Chase was invited to join The Ten in 1905, however, things had changed considerably, allowing Chase to accept the invitation without any controversy.

In fact, several articles released at this time discussed the possibility of unifying New York's three major art organizations: the Society of American Artists, the National Academy of Design, and The Ten. The two older organizations had steadily been growing closer together, with many important artists becoming members of both. The same year Chase was asked to join The Ten, his friend Frederick Dielman, who was president of the National Academy of Design, was elected a member of the Society of American Artists. Commenting on the situation one writer asked, "What [could be] more graceful, what more in sympathy with these piping days of peace than the election of the President of the Academy to membership in the Society?" The same writer interpreted Chase's election to membership in The Ten and his immediate installation as its leading figure as further evidence of reconciliation: "The fact is, that as these artists grow older they regard this separation into different camps more and more in the nature of youthful vagaries hardly warranted by the actual state of things, extravagances upon which, they now look back with a tolerant smile."[20]

A Friendly Call. 1895

Oil on canvas
30¼ x 48¼ in (76.8 x 122.5 cm)
National Gallery of Art, Washington,
Chester Dale Collection, 1943

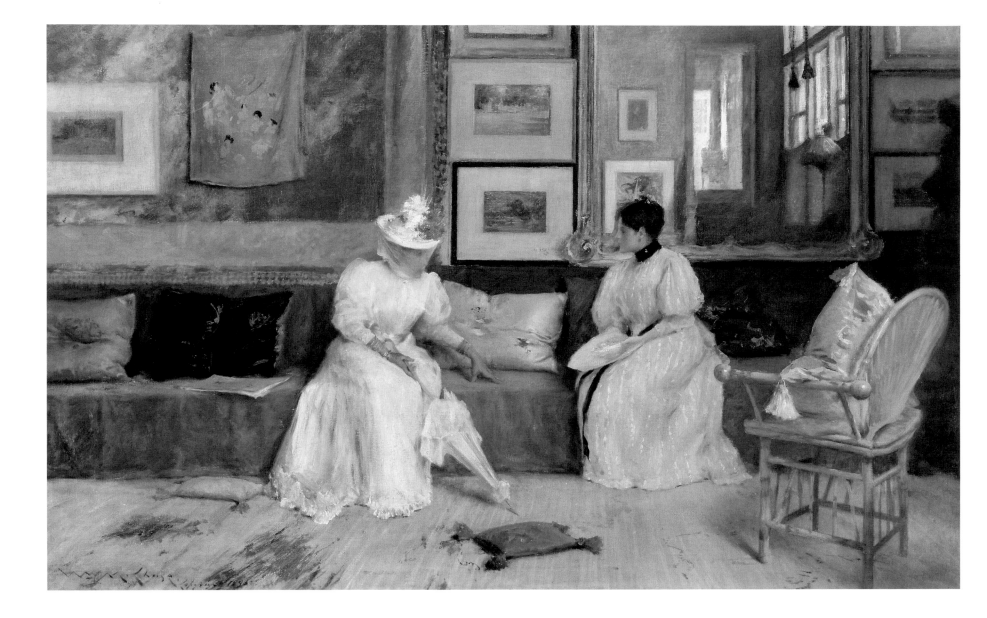

Still Life, Fish. 1912

Oil on canvas
$32\frac{1}{8}$ x $39\frac{9}{16}$ in (81.6 x 100.5 cm)
The Brooklyn Museum, New York,
John B. Woodward Memorial Fund

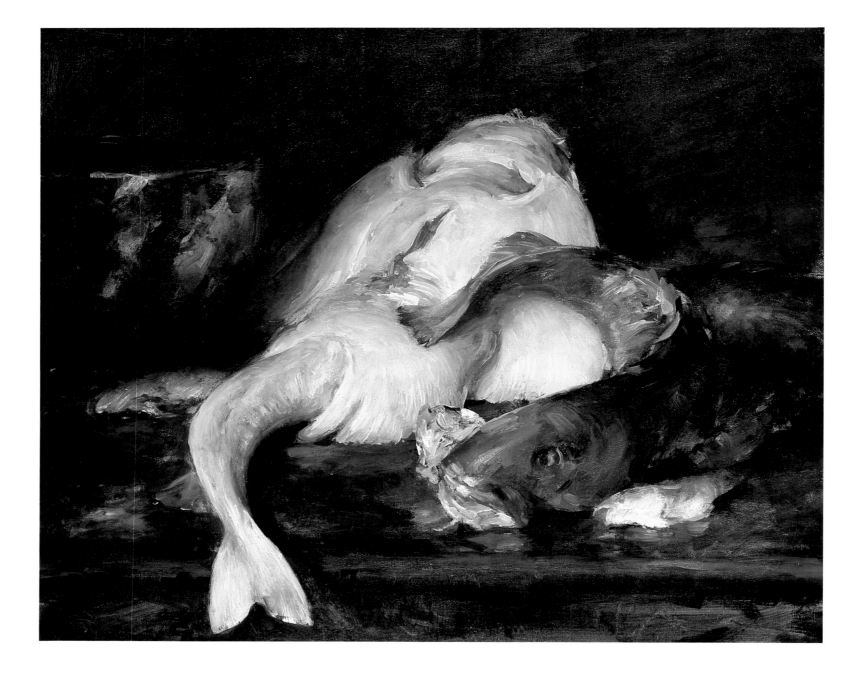

The Big Brass Bowl. c. 1898

Oil on canvas
35 x 40 in (88.9 x 101.2 cm)
Trina, Inc., Fall River, Massachusetts

To some extent, Chase's invitation to join The Ten might be considered a political gesture, similar to the election of Dielman to the Society of American Artists: a means of blending the three groups in preparation for an eventual merger. Chase would have been a natural choice for this purpose, being a prominent member of both the Society and the Academy. Shortly after becoming a member of The Ten, Chase was confronted by a reporter: "What do you think of these rumors of consolidation going about these days?...This talk of Academy and Society and Ten Painters uniting to form one body?" The ever-diplomatic Chase responded, "I think that there has been so much babble and foolishness about the disunion and hard feeling among sets of artists that the public has been led to believe we are all backbiting and quarreling. Therefore the sooner we show how exaggerated all this gossip is the better; we can do so by meeting and agreeing that the time is past for a lot of small separate organizations."[21] That time was not far off — at least for the Society of American Artists and the National Academy, which merged the following year, 1906. At this time three members of The Ten were elected academicians — Hassam, Tarbell, and Reid.[22] Nevertheless, The Ten chose to continue exhibiting as a separate entity, while participating in the annual shows of the National Academy of Design.

It is interesting to review just what types of paintings Chase contributed to The Ten's annual exhibitions and how they were received by the press. By 1906, the year he first exhibited with them, Chase's subjects were primarily portraits and fish still lifes — hardly what one would consider in line with the refined aesthetics of The Ten. If members of this group had objected to their paintings being overwhelmed by Simmons' murals, one can only wonder how they felt about having their delicate pictures placed alongside Chase's large fish paintings. One critic observed that, compared to the others', Chase's paintings were the most realistic, "particularly in the pictures of fish and of pots and pans and onions...." Rather than reacting to what some might consider unattractive, or even objectionable, subject matter, this writer responded to the

Fish Still Life. c. 1900
Oil on canvas
20 x 24½ in (50.8 x 62.2 cm)
Private Collection

technical beauty of these works, proclaiming: "Mr. Chase's paintings of onions and fish...make you see the beauty that is onions and fish for the first time. And as that may be a revelation, it should be worthwhile." He went on to describe the fish still lifes as an "institution."[23] By this time, 1913, they were: every major museum in the country had either acquired one, or would soon. Although pleased with the recognition he received for painting these works, Chase was concerned that he might be remembered solely as a painter of dead fish.

In addition to the still life paintings, Chase contributed several landscapes, spontaneous studies of friends and family, and a good number of portraits. Although boldly and freely executed, many of the latter were merely "society portraits," which were most successful when the subjects were beautiful young women, as in his *Portrait of Miss Frances V. Earle.*[24] The landscapes he displayed were predominately ones painted on his summer trips to Italy. These were sometimes criticized for their strong color, which appeared garish to some.

The Ten's show of 1915 included two paintings by Chase, a still life and *Self Portrait (Portrait of the Artist).*[25] In reviewing the exhibition one critic claimed that Chase easily dominated the show "with a large and remarkably true and vivid *Self Portrait*...and a remarkably fine still life study of *Fish.*" He praised the *Self Portrait* saying: "It is not an exaggeration to say that the portrait is probably the best thing the artist ever did. It is certainly better than that of Chase himself by Sargent, which is saying a good deal." In reference to the *Fish,* he concluded that "the painter has long since painted such subjects and in them he has reached such a degree of sheer virtuosity that they might be worthy of Chardin or Vollon."[26] Later that year Chase died. It is ironic that in his last showing with The Ten, he inadvertently presented this image — a portrait of himself alongside the subject he feared he would be known for best.

The remaining members of The Ten continued exhibiting together for two more years. Their last show, which might be considered something of a retrospective, was held at the Corcoran Gallery of Art, 1918-1919. Commenting on the casual nature of the group and its ultimate demise, Simmons stated: "The Ten American Painters was started quite by accident, and when the too-human elements began to enter, it died a natural death."[27]

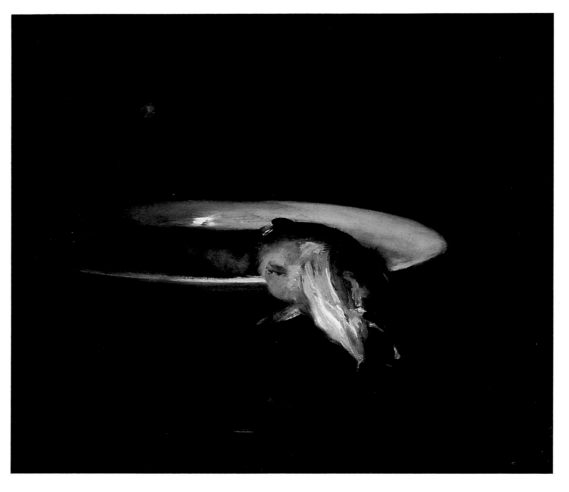

Portrait of Miss Frances V. Earle (Miss Earle). **c. 1905**
Oil on canvas
60 x 36 in (152.4 x 91.4 cm)
Collection of Dr. and Mrs. John J. McDonough

Portrait of a Lady in White (Emily Clark). c. 1893
Oil on canvas
40 x 29 in (101.6 x 73.7 cm)
Collection of Mr. and Mrs. Meredith Long

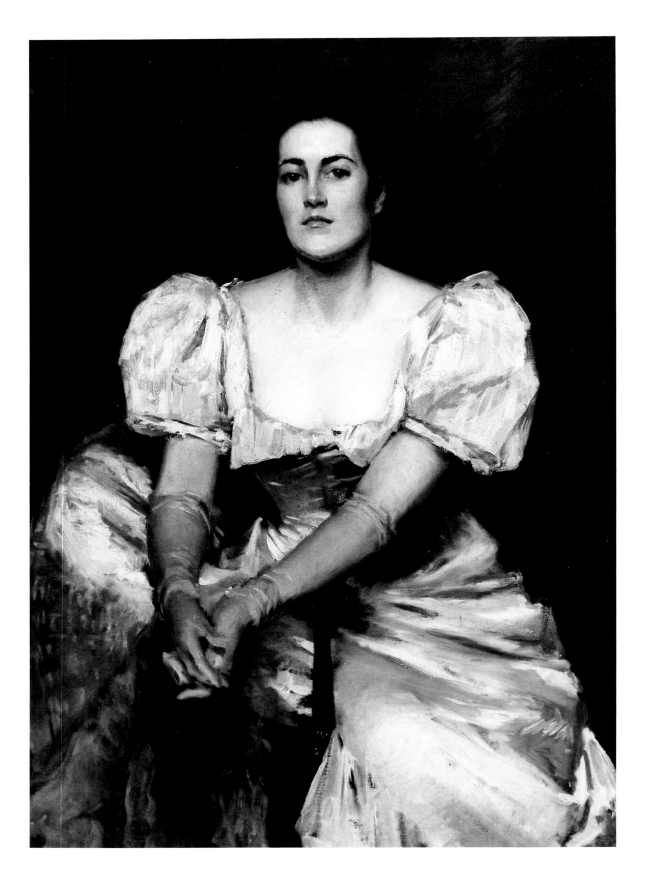

A Typical American Artist

Nationalistic spirit has prompted many critics and historians of American art to identify specific traits as being indigenous to our art of the past and to use these as criteria for determining the quality of specific works. A great deal of effort has been spent in attempts to establish a national identity for the art of our country, based on a somewhat arbitrary system of contrasting "archetypal" figures such as Thomas Eakins, Winslow Homer, and Albert Pinkham Ryder with American expatriates such as James Abbott McNeill Whistler, John Singer Sargent and Mary Cassatt. There are, however, many other important artists who fall somewhere between these two categories; and those who are more difficult to categorize are only lately gaining the recognition they deserve. William Merritt Chase is the quintessential example: he was trained abroad, spent much of his time abroad, and remained *au courant* with European artistic developments — but he worked in his native land. His art and that of others of his generation reflect diverse influences, both American and European, and have been described as eclectic. Unfortunately this word has carried a negative connotation, implying that these artists had little, if anything, original to say in their art. Obviously none of our native artists developed their work in a vacuum. America's earliest, even the most naive, artists often based their work on European prints; and even those held to be the "most American" were influenced by European art. Measuring the degree to which each was influenced by European art can be a tricky matter; and using this measure as a basis for determining quality is certainly a mistake. In the past, artists like Chase have suffered from this type of evaluation. Obviously Chase was intimate with many European artists, whose work had a definite influence on his own. He was the first to admit that he borrowed from many — but only the best — to develop a highly personal, composite style of painting. His philosophy was: "Originality is found in the greatest composite which you can bring together."[1]

In addition to considering the obvious European influences on Chase's art, it should be noted that in his own time critics often described what they believed to be distinctively American characteristics in his painting. However, his contribution to the development of an American artistic identity extends well beyond the presence of any such specific traits in his own work. The fact that he was the most influential American art teacher of his day has long been recognized. He was also one of the staunchest advocates of American art, and he deserves much credit for the general public gaining faith in their native artists. Therefore, in an attempt to set the record straight, it is important to re-examine Chase's attitudes towards America, his contribution to the development of American art, and those qualities in his own composite style of painting that were considered to be especially American by his contemporaries.

The patriotic spirit of William Merritt Chase, born and reared in the mid-West during the time of the Civil War, is undeniable. Although he found life in the Navy incompatible with his temperament, his pride in his country never diminished.[2] He realized that it was necessary to travel abroad to receive a finished and proper education in art, and like many other aspiring young Americans, he went to Europe to complete his training. There he remained for six years, finishing his course of study at the Royal Academy in Munich in 1878, at which point he turned down a teaching post offered him there (and its assurance of success) in order to return home. He was optimistic — an attitude inspired, in part, by his professor Karl von Piloty. From the time of his return to New York until the day of his death, Chase devoted his life to promoting a greater appreciation and understanding of art in this country. In fact, when he died he was described as "a splendid rallying point in the fifty years that he was a creative personality in America, whether he was home or abroad; for, despite his boulevard attire and air, he was American to the core and knew his time and influenced it as few other artist-teachers in a period that was the most formative and most pregnant half-century that the country had ever known."[3]

Upon his arrival in New York, Chase enthusiastically seized the opportunities at hand: he acquired the most desirable studio in the city, he assumed an important teaching post at the most advanced school, and he became an active and vital spokesman for American art in general.

Portrait of Miss Dora Wheeler. 1883

Oil on canvas
62½ x 65¼ in (158.8 x 165.7 cm)

The Cleveland Museum of Art,
Gift of Mrs. Boudinot Keith
in memory of Mr. and Mrs. J. H. Wade

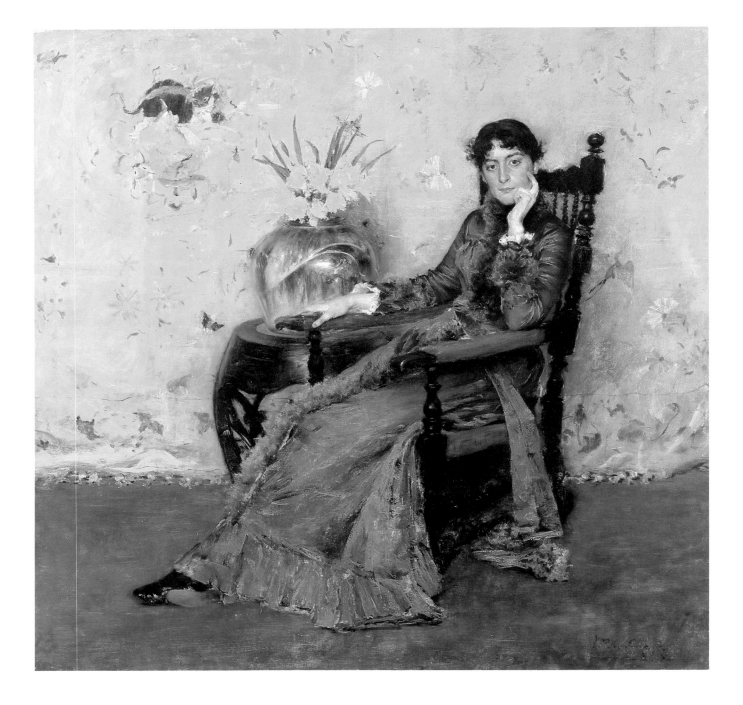

Portrait of Mrs. C. (Lady With a White Shawl). 1893

Oil on canvas
75 x 52 in (190.5 x 132.1 cm)
Collection of the Pennsylvania Academy
of the Fine Arts, Temple Fund Purchase, 1895

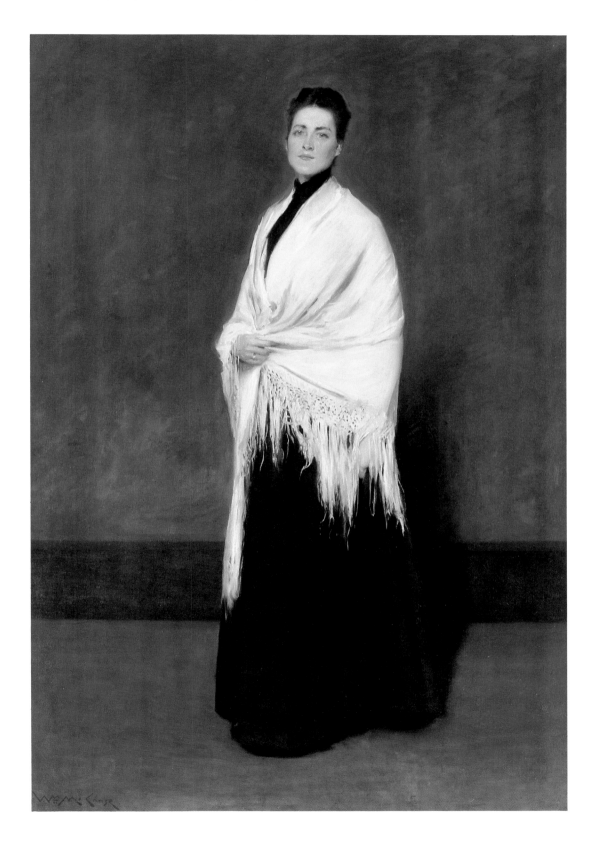

Although encouraged by both Piloty's prophecy of a great school of art arising in this country and his own immediate success in New York, Chase soon recognized one obstacle that would plague him for most of his life: his compatriots' lack of appreciation for art, and, even worse, their lack of interest in American art. In 1866 one critic had complained: "The American people do not well understand, nor much care for, the arts that have to do with visible beauty. To beauty itself they are not indifferent. Beauty as it exists in nature is probably of as much concern to the Americans as a nation, as to most other nations. But they do not readily respond to the appeals of beauty as seen in art. And for the theory and practice of art that deals with beauty they care very little."[4] The same writer declared that there were no art critics, no class of true connoisseurs and few art students. Such were the conditions in America when Chase left to study abroad. Obviously, by the time he returned things had changed: there were respected art critics, fine opportunities for artistic studies — with many aspiring youths taking advantage of them — and important art collections in the making. Still, there was much to be done. Referring to conditions in America at this time, Auguste Rodin has been quoted as saying, "'America has had a Renaissance, but America doesn't know it.'"[5] Chase was at the forefront of the movement to get Americans to realize the advances that had been made in the art of their country — and to support further progress. It was crucial for America's cultural development; and more specifically it was critical for his own survival, as well as that of his fellow artists. Appealing to those who collected the work of foreign artists while ignoring native talent, a contemporary critic with views similar to Chase declared "let those who run down the Art of their country, expend their money on foreign pictures, and smile at the bickering of cliques and parties, assert their patriotism by contributing to endow the schools that will promote tolerance and breadth of culture."[6]

Commenting on the lack of support for the growing number of art students in America,

another critic claimed that American art students received more encouragement elsewhere than at home. The same was true for mature American artists, many of whom remained abroad for this very reason. As late as 1890, Chase declared that "many of our deserving painters have not, and do not, receive the support which they are entitled to...."[7] A contemporary writer corroborated this point of view: "Americans stay in Europe because they find appreciation and reward." He also noted "they fritter themselves away on European subjects and strive after a European style because the demand is for these and these are paid for."[8] To some extent even Chase succumbed by necessity to this pressure, providing the public with a requisite number of European subjects. Responding to the situation, a critic said of Chase's Holland scenes: "the best, [is] one from Scheveningen, showing a beach and dune the very counterpart of East Hampton, where so far as we know no one ever found a subject for a landscape....But probably there are twenty Americans ready to buy a bit of Scheveningen for one that will look twice at a corner of East Hampton,"[9] an ironic comparison since fourteen years later Chase would found a school of landscape painting very near East Hampton. There were times when Chase had grave doubts about his decision to remain in America. The most serious test, and perhaps the most disheartening moment of his career, was the disastrous auction of the contents of his Tenth Street Studio in 1896, described by one writer as a "sad affair."[10] He reported that there appeared to be more interest in the studio decorations than in Chase's own paintings, and that in response to this insult the artist intended to abandon this country and join the contingent of Americans abroad. Although Chase did indeed spend the spring in Spain, that summer he returned to New York with renewed vigor and determination, prepared to resume the battle for the recognition of American art and to prove to his countrymen that their artists were as talented and capable as those in Europe.

As late as 1907 Chase reported that two art dealers had approached him only a few years earlier and said that if he would do his work abroad and send it back to them, they would pay him more than double what he received for his paintings done in America.[11] In a lecture he later gave in Bridgeport, Connecticut, Chase told of his response: "'I believed there is room for missionary work in art in the United States and I have stayed

here. It has been a sacrifice however, for across the water I could find the atmosphere for which I have worked these many years.'" The local newspaper reported that his tenacious spirit "called forth applause."[12]

Without denying the genius of artists such as Whistler, Sargent, and Cassatt, there is no doubt that the preference for things European affected them favorably, as it did less well-known expatriates such as Daniel Ridgeway Knight, Edwin Austin Abbey, and George Henry Boughton, all of whom were extremely popular artists in their day. Several contemporary critics considered Chase's own choice to return to America and make it his permanent home a brave gesture — as well as a patriotic one — with one claiming: "Whistler disowned us and made a joke of the city of Lowell, his birthplace; Abbey accepted a Knighthood, but the *New York Evening Post* finds it pleasant to think of...William M. Chase...as 'belonging wholly to America.'"[13] Another held Chase's patrotism to be his most attractive trait and praised "his belief in American art, which has remained unshaken ever since he gave up the Munich professorship to cast his fortunes with his fellow-countrymen."[14]

Chase preached his doctrine of the importance of American art to anyone who would listen, but did admit that once when he visited a major international exposition in Paris he was at first afraid to cross the threshold of the American section, fearing that he would find nothing but imitations. Instead he was pleasantly surprised: "'I faced paintings that were fresh, striking, and distinctive. Let those who still harbor the thought that art in this country is yet in its infancy, bear in mind that at this exposition in a foreign land, and a land where they know something about art at its best, the exhibitors from the United States won two more medals than those from any other country represented there.'"[15]

It was only late in his life that Chase came to believe that Americans had finally begun to realize the value of their own art. He proclaimed: "We Americans can feel justly proud of the showing our men and women have made, are making in the art world, and I do not make an exaggerated statement when I assert that there are no better. The people of this country have begun to set aside their unjust prejudice to American art, and are now placing examples of our best artists in their collections. Our artists are also employed for the first time in doing important mural decorations, all of which is proving entirely satisfactory to all concerned."[16]

Analyzing Chase's art and identifying characteristics that might be considered "typically American" is a complex task. His style of painting, although possessing certain aspects that may be considered as such, is cosmopolitan in nature — a complex adaptation of bits and pieces borrowed from innumerable American and European artists, and covering a wide spectrum of schools of art, past and present. In defense of his eclectic style he said that "the most original painters are those who have stolen here a little and there a little from everyone. When they arrive at the level of the masters they have sought to imitate, they will find they can do so much better work themselves that they can't help being original."[17] To identify the multiple influences on Chase's art one would have to discuss each work individually, since they vary from work to work. One critic observed of Chase's painting *Sunlight and Shadow* that "you seem to see a composite giant at work, a Tissot-Stevens-Whistler-Chase...." However, he also noted the very special quality that Chase himself brought to it: "Anywhere within the frame a vandal could hack out some canvas and it would be a bit of beautiful paint."[18] Chase's unique success in combining the influences of various artists to achieve an original effect was noted by critic Royal Cortissoz: "Chase's versatility consisted in assimilating with extraordinary aplomb something of the technical spirit of one artist after another — Leibl, Fortuny, Alfred Stevens, Boldini — and he did it with so infectious a gusto that no one could ever dream of charging him with plagiarism."[19]

Chase was not the only artist working in this eclectic style, which might be referred to as an international style of painting, one utilized by artists in both America and in Europe and propagated to a great extent by the many international expositions of the day. Chase was just one of the most clever and able, and thus attracted the greatest attention. Addressing the cosmopolitan nature of this art, Chase remarked, "What is happening may not be acceptable to many patriotic people, but it is inevitable and will gladly be accepted by those who keep in touch with the time, and that is, that Art has become international. The best of art today belongs to all countries combined and localization has been entirely done away with. It means a higher aim and a higher standard for all. Annual International Exhibitions are now held in every great city of the world and it is on these occasions that the artists of the world get their professional placing."[20]

A contemporary critic considered this kind of painting well suited to America, and even referred to it as the country's "national style." After all, America's character is a complex blending of the cultures of other countries (mainly European); therefore, its art should reflect a similar blending of artistic styles. He claimed that "the national style, so far as there can be any American style, is a composite, blending indistinguishably the influences of old and new schools of painting." Based on this premise, he found Chase to be "a typical American artist." The same critic found that even though largely based on European sources, the American manifestation of this broader, international style was "sane, unsentimental, truthful and unpretentious."[21] Referring to similar characteristics, another critic reported: "It was this essential honesty and clear-headedness that made the art of Chase hold its own whatever were the fashions of the hour, many of which he introduced...and the directness of his canvases sacrificed nothing to an infantile and pretended simplicity...."[22]

In discussing Chase's portraits, one writer credited him — along with Sargent — with capturing a characteristically American element: "the nervousness, crispness, intensity of American life."[23] "We are a new people in a new country," declared Chase. "Watch the crowds along Picadilly or the Champs Elysees — you spot the Americans among them almost as easily as if they wore our flag in their buttonholes. It means that already a new type has appeared, the offspring, as we know,

of European stock, but which no longer resembles it."[24] Not only was Chase able to distinguish how Americans differed in their looks, mannerisms and personalities when compared to their European counterparts, he was also able to portray these differences. A fine example of his work in which he has successfully captured the distinctively American type of woman is his *Portrait of Miss Dora Wheeler,* which attracted the attention of a German critic when it was exhibited in Munich. After referring to Chase as a "full blooded American," he went on to describe Miss Wheeler as being "as genuine an American as ever was, handsome moreover, and interesting also, though apparently gifted with more cleverness than feeling. The way in which she fixes her piercing look on you without herself betraying anything, puts you in mind of a sphinx."[25] It is interesting to have this view of American womanhood from a European of the period. A similarly penetrating image of a direct, "American" woman can be found in Chase's painting *The Blue Kimono (Girl in Blue Kimono).*[26]

Chase himself was also aware of having painted what he considered to be a typically American beauty. He said of Emily Clark, the subject of his *Portrait of Mrs. C (Lady with a White Shawl)* and the model for several of his other paintings:[27] "As she arose gracefully and stood smiling before me I knew at once that fortune had sent me the very subject I had long hoped to find — a perfect type of American womanhood."[28] Chase described her special attributes as being "a clear-cut, classic face with splendid profile — a steadfast expression of sweetness, loveliness, womanliness, and, above all else, dignity and simplicity...."[29] A writer of the period observed "it is the fine humanity of it — the eternal womanly — that catches the fancy. It is the portrait of a sensitive, refined American woman — in a way the ideal of a type that every American has seen or at some time has known about."[30]

Park Scene. c. 1885-86

Oil on canvas
13⅝ x 19⅝ in (34.6 x 49.9 cm)
The Art Institute of Chicago, Gift of Dr. John J. Ireland

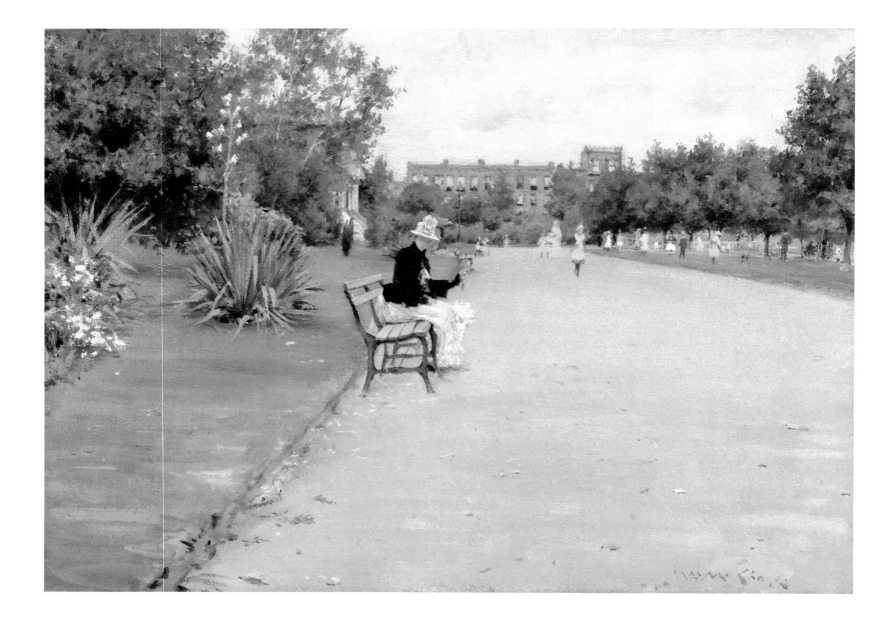

Chase believed that the distinctive traits of each nationality could be captured only by artists painting their own countrymen. He allowed only two exceptions: Van Dyck and Sargent.[31] Chase's belief corresponds to Jozef Israëls' philosophy regarding landscape painting. "'I doubt if any artist can paint well in any country but his own...,'" Israëls stated in an 1895 interview, and went on to ask, "'Why do Americans come to Holland to paint pictures? Is there nothing to paint in America?...I think that American artists will paint better pictures when they are content with the subject matter they have at home.'"[32] Chase, who had traveled to Holland in the early 1880s in search of picturesque subject matter, soon learned this for himself. By the mid-eighties he found inspiration in his own country, reporting, "'there are charming bits in Central Park and Prospect Park, Brooklyn....Along the docks and wharves there is every bit as good material as that on the banks of the Thames, which the English artists have made immortal.'"[33] One critic maintained that the paintings inspired by these newly discovered places were as "picturesque" as anything painted in Holland or Normandy. The same critic recommended that other American artists follow Chase's example rather than keeping their eyes "hermetically sealed" while in their own country.[34] Yet another writer criticized those American artists who "leave the picturesque at home while they rush around the globe in search of it."[35] Apparently these simple scenes painted in Brooklyn and New York brought Chase some of the acclaim he deserved. Moreover, they were considered to be especially American in character. Responding to them, Kenyon Cox declared: "Let the public cease complaining of the un-American quality of American art...."[36] In these unpretentious scenes of everyday life in the city's parks, Chase was able to achieve a careful balance between figures and landscape, a refined and unsentimental statement that elevated genre painting in America to a new height.

As early as 1866, a writer whose comments seem to prefigure these paintings complained of the sublime treatment of nature in the work of artists associated with the Hudson River School: "The artists...must speak a language understood by the people, and deal with things cared for by the people, — with real things." Although he conceded that when there were strange effects of light or color in nature they should be painted as such, he also believed "the everyday effects must be painted too. In a few years every person who has by nature any love for beauty should be made familiar with good representations on canvas of all the more ordinary aspects of nature — the look of ordinary midday sunlight on grass, of the shadows at the same time and place, or still water....In every kind of art, truth to nature is an imperative law."[37] When Chase's park scenes were first exhibited two decades later, they were praised by a critic with a similar attitude: "Indeed, why should not these exquisite scenes of Central Park find their way from the artist's easel to the walls of citizens' as easily as pictures of Niagara, or views taken in Lutetia Parislorum? Few cities can boast so beautiful a park as New York."[38] It is evident from this review and others that Chase's park scenes were to a certain extent considered to be patriotic; in them the natural beauty of America is as proudly rendered as in the paintings of the Hudson River School, although the subject and manner differ greatly. In contrast to the grand, romantic vistas of the Hudson River School, which focus on the dramatic aspects of nature and its overwhelming effect on mankind, Chase's paintings provide a more intimate and familiar view of everyday life in America. They are glimpses of settings shaped and designed by man, for the pleasure of a new breed of American, a prosperous and genteel class with plenty of leisure time. America had changed since the height of the Hudson River School's popularity in the preceding decades; Chase's park scenes reflected this change. He presented subjects that people cared about, and could easily identify with — and in a beautiful and refined manner.

With this series of paintings, Chase attained a mature statement. He had abandoned the old master style he learned in Munich and turned to contemporary subject matter presented in a modern and refreshing style. Explaining the dramatic change in his work, Chase stated:

"'modern conditions and trends of thought demand modern art for their expression.'" He also said that "'the greatest historian is he who paints the things of his own time.'"[39] This became his new course, first in his park and dockside pictures and a decade later in scenes painted at Shinnecock Hills, Long Island. The fact that he succeeded in this course was noted by a contemporary writer: "He is emphatically of his day and an interpreter of his day in art...."[40] Chase could hardly be more American in his choice of subject matter, drawn from his immediate surroundings and painted in a simple, candid way. In his life, he was a typically prosperous American of the leisure class, and in his painting he captured the essence of his era. As one contemporary writer predicted: "Chase will be a superb figure of ancient history for the contemplation of students in the thirtieth century; he is so much of his own time that he will doubtless last for all time."[41]

■

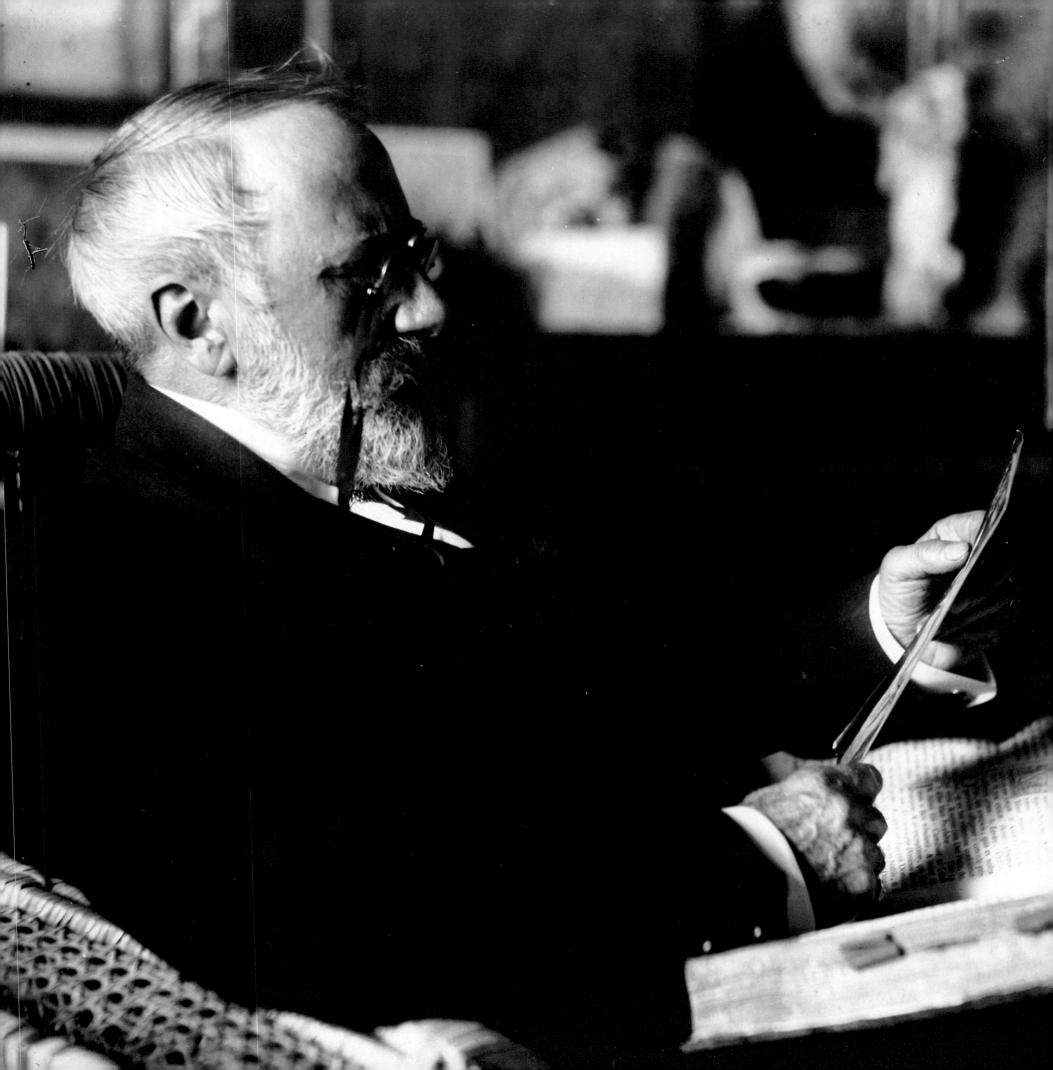

The Last Years

William Merritt Chase, c. 1907.
The William Merritt Chase Archives,
The Parrish Art Museum, Southampton, New York.

Commenting on the identity William Merritt Chase so successfully cultivated, one writer noted in 1915: "Naturally, the Chase legend was created by Chase. His vivacity, his delight in astonishing with staccato paradoxes, his hat, his cravat, his beard, his eyeglasses, are survivals of the romantic Whistler days."[1] In truth, this role of the successful gentleman-artist was assumed by Chase long before his association with Whistler. It was an image that Chase adopted upon his return from his studies abroad, and one he maintained throughout his life. Reactions to it varied over the years. Walter Pach explained that Chase had initially cultivated it as "a reaction against the look of both the dominant business class of the nineteenth century and the bohemian class of the Romantic Period."[2] As late as 1891, Chase's style of dress was still considered "modern," "neat and gentlemanly," and atypical attire for an artist.[3] By the beginning of the twentieth century, however, the very appearance that had assisted him in gaining the attention and distinction he sought began to work against Chase. Some associated a certain aloofness with this look; others considered it old fashioned. In comparing Chase to Robert Henri, the artist Rockwell Kent said Chase looked like a "dinner guest of kings" while Henri appeared to be "a man of the people."[4] By 1916, the last year of his life, Chase's appearance evoked the past — an image which was beginning to be associated with his art as well.

During the first two decades of the twentieth century, the culmination of his career, Chase received more honors and awards than ever before, with gold medals presented to him at the Exposition Universelle, Paris (1900); the Pan-American Exposition, Buffalo (1901); the South Carolina Interstate and West Indian Exposition, Charleston (1901); the Universal Exposition, St. Louis (1904); and the International Fine Arts Exposition, Buenos Aires (1910). Other important awards included the First Corcoran Prize,

Corcoran Gallery of Art, Washington, D.C. (1905) and the Proctor Portrait Prize, Winter Exhibition, National Academy of Design, New York (1912).[5] International recognition included the Uffizi commission in 1907; he was made a Knight of the Order of St. Michael of Bavaria in 1908; and in 1913 Chase's painting *Dorothy and Her Sister* was purchased by the Luxembourg Palace, Paris.[6] Chase was given a gallery of his own at the Panama-Pacific Exposition in San Francisco in 1915, and in 1916 he received an honorary degree from New York University.[7] Many of these honors and awards, received so late in his career, were to some extent intended to credit Chase's general contribution to art and the consistently high quality of his own art, rather than for any specific achievement. Certainly his art had not reached a higher level of excellence at this late date — just a greater degree of acceptance. During this period Chase was given one-man shows in nearly every important city in the country, including: Philadelphia, Boston, Cincinnati, Indianapolis, Buffalo, Cleveland, Detroit, Toledo, and New York. It is ironic that at the same time Chase was receiving such accolades his art was already beginning to be criticized as being outmoded. By the first decade of this century Chase had clearly gained the attention of the general public that had failed to support him in earlier years — but he had fallen out of step with modern developments in art. All of his life he had managed to adjust to new trends in art without ever slavishly adopting any one prevailing style; but with the advent of modern art, so-called, Chase became inflexible. He considered modernism to be "untruthful," "charlatanry," diametrically opposed to everything he stood for and had fought for in establishing truthful ideals for American art. And he was as vocal in his opposition to this new movement as he had been in promoting his own radical cause as a young man in the 1870s. He was especially harsh in his criticism of the major figures associated with Cubism, Futurism, and Fauvism. Walter Pach, who accompanied Chase on several visits to Europe, and who was sympathetic to the modern movement, recalled an incident in Paris when "Mr. Chase once gave a groan of dismay as we stood together looking at a Picasso drawing in the window of Sagot's shop in the Rue Lafitte." Pach believed that this was the first work by Picasso that Chase had ever seen; and although it was a fairly conventional drawing from Picasso's Blue Period, Chase had become by this point "suspicious of every newcomer."[8] Pach continued:

"The real trouble came when Mr. Chase discovered Cézanne, the year after that artist's death. He came to Florence in a rage over the perversity of Paris — that was actually buying paintings by the 'idiot,' as he called the — to him — utterly unknown man."[9] While in Italy, Chase discovered Charles Loeser's collection of Cézanne's work, and, as recounted earlier, returned to his own villa "boiling over."

On numerous occasions Chase spoke out against modernist developments in Europe. Although he admitted that "'the Paris salons recorded a decided decadence in painting...there was too much of a sweet prettiness — too much of the sweet pink in color,'" he did not consider "modern" art a viable alternative, explaining: "'I try to keep myself receptive and catholic; I know that if all pictures were on the same plan they would become very tiresome. But I cannot abide charlatanism and I hate a liar. This "new" business seems to me utter charlatanism and not honest. I know Matisse. He is a man of strong artistic intelligence. When he does what he is doing now I am convinced that he is indulging in charlatanry. It is assumed that he thought: "Well, I will make a little commotion somehow." Perhaps he now believes in it. You know they say a man repeating a lie often enough comes finally to believe his own deception.'"[10] On another occasion, Chase referred to Matisse's followers as "'chiefly students who realized, as did their leader, that they were not artists.'"[11]

In a debate on modernism sponsored by the Contemporary Club at the Bellevue-Stratford Hotel in Philadelphia, Chase and Kenyon Cox confronted the progressive art critic Frederick James Gregg. "William M. Chase paid his respects to 'Messieurs les ennemis,' in much the same vein [as Cox], his extempore remarks upon the 'Futurists' causing considerable merriment,"

reported one writer. In his talk, Chase called the selling of Futurist paintings a "gold brick swindle" and "a misdemeanor worse than obtaining money under false pretenses." Once again, he labeled Matisse a "charlatan," and he finished the talk by reading an appreciation of Matisse's work written by Gertrude Stein "that convulsed the audience with the insane composition of it somewhat in the style of 'The House That Jack Built.'"[12] The *Ledger* described this reading as "the gem of the evening," the piece being written "in a strange jargon quite as queer as the pictures." The paper went on to quote part of what Chase read and his own opinion of it: "'"He is doing what he had been doing; he was certain then that he was a great one, for he was doing what he was doing and was a great one when he was doing what he was doing"'...the audience roared. For five minutes Mr. Chase read. Then he folded the paper and with evident disgust asked whether art was served by such 'stuff.' Then he declared that true art could only thrive through work and high ideals."[13]

On another occasion, while visiting an exhibition that included modern art, Chase was confronted by an enthusiast of the movement who beseeched him: "'Is it not remarkable, Mr. Chase?'...'Yes,' the great painter...replied, 'remarkable indeed, if, after all, you young fellows should be right and we old fellows, from Rembrandt down should have been all wrong.'"[14]

Shortly after Chase's death, critics actually commented on certain abstract qualities in his paintings, traits which were not intended by Chase to be seen in this way. By the 1930s some critics even credited Chase for having paved the way for modern art in this country: "The present generation of artists owes him a debt for showing the way to modern pictorial technique, and he should be remembered as a famous artist and educator."[15] This is an ironic tribute considering Chase's obvious disdain for modern art; in fact, it was as a teacher that he was most vehemently opposed to it. In 1916 J. Carroll Beckwith stated in a letter to Chase that there was "one thing we have both stood for shoulder to shoulder all these many years, and that is, the teaching and carrying on of our profession according to the principles of the past as it had come down to us from our masters and those who went before them. I am sure that you have been as astonished as I have, at the strange gods that have been set up to be worshipped by some of our younger confreres."[16]

This letter was prompted by a report he had received of Chase's vocal opposition to a speech delivered by Willard Huntington Wright, one of the major proponents of modernism in America — a man referred to by Beckwith as "that exponent of rot." Wright in turn regarded artists like Chase and Beckwith as "minor academic painters...who view art through the eyes of the past."[17]

Chase considered modernist principles of art contrary to those he valued as an artist and as a teacher, claiming, "It is a serious matter when students are told that they must not know anything in art." Analyzing this philosophy, Chase contended, "I have tried in vain to find out what the aim of it all is, and the nearest I have succeeded in coming to any kind of a conclusion is that any indication in a work of art that the producer of that work has had any training was proof of his failure, either in ancient or modern times. In other words the student is told that he must get out of school."[18] Obviously Chase, who had devoted a major portion of his life to teaching and promoting better opportunities for art students in America, could not accept such a philosophy — one that had begun to affect his own pupils. In a talk given at The Metropolitan Museum, Chase described its effects: "Nowadays there is so much of fractiousness and 'vision'; the microbe has come and many students have got the disease. I call it 'the kinks.' I have had students with them, and I say to them: 'If you want the kinks taken out of yourself you go up to the Museum and see something there, and get yourself into condition for going to bed comfortably.'"[19]

Many of Chase's best students actually drifted away from him at this time, abandoning him for the modern camp. Although he probably didn't realize it, Chase had in truth inadvertently helped spawn modernism, by arming them with a good training in technique (something that he had thought modernists shunned), and providing them with inspiration and encouragement during their formative years. Virtually all those pupils who went on to become prominent avant-garde artists have credited Chase with important contributions to their development. Georgia O'Keeffe stated: "I think that Chase as a personality encouraged individuality and gave a

sense of style and freedom to his students...I thought that he was a very good teacher. I had no desire to follow him, but he taught me a good deal."[20] Joseph Stella was another aspiring artist encouraged by Chase. At one time, responding to a painting Stella had just completed, Chase proclaimed: "'Manet couldn't have done it any better.'"[21] Charles Sheeler described his early mentor as having a "tremendous enthusiasm for painting" which was infectious. Sheeler also claimed: "He was an inspiring teacher, very inspiring...You begrudged the time that you had to sleep because you weren't able to paint during that time."[22]

Chase's bitter reaction to modernism can be attributed, for the most part, to the fact that it was diametrically opposed to his principles of art and art instruction; but those closest to him have also identified more personal reasons. As early as 1910, Chase was intentionally slighted by Henri and his circle when they did not invite him to exhibit in the Independent Exhibition they formed that year. Chase's former student and friend Walter Pach had suggested that Chase, along with J. Alden Weir and Childe Hassam, be invited to exhibit in the show, but John Sloan bitterly objected and wrote in his diary: "I opposed this violently, but finally agreed that they might be informed of the Ex. but not *asked* to exhibit."[23] Ultimately, Sloan convinced the others to ban Chase from the exhibition which is now considered a precursor of the famous Armory Show held in 1913. The Armory Show represented the first comprehensive exhibition of modern art in this country, and, as might well be expected, Chase was not asked to participate. Again, this was a deliberate slight, prompted more by political reasons than by his style of painting. Many of his former students and colleagues were represented in the exhibition: J. Frank Currier, who had never progressed beyond the style which he had developed in Munich in the 1870s and who by this time had been dead for four years; Leon Dabo, a follower of Whistler; Charles Harold Davis, a conservative Tonalist painter; and the American Impressionists Gaines Ruger Donoho, Philip Hale, Childe Hassam, Theodore Robinson, John H. Twachtman, and J. Alden Weir. Commenting on the exclusion of Chase's work by the organizers, Jerome Myers recounted seeing Chase at the exhibition: "More interesting to me than all this mob, the millionaires and the celebrities and all the Grade B people, was the figure of William M. Chase, with his immaculate high hat and his Sargentesque appearance — an artist whose work was not included in the exhibition and who had every right to feel the indignity of having been slighted. Although the later selection of artists had gone out of the hands of our original group, nevertheless I for one felt the injustice keenly."[24] Incidentally, Chase had assisted many of the young artists in the exhibition, including Jerome Myers, by being among the first to purchase their early paintings. [25]

Walter Pach theorized that Chase was against modernism because "he felt he was being classed with the very people he had revolted against: the professors at Munich, or 'the buckeye' painters of America to whom he had been the *enfant terrible* on his return home."[26] Resenting this miscategorization, Chase reacted by condemning the progressive art of those who relegated his own art to the conservative past, and by denying the importance of the movement. Although in the last year of his life Chase admitted that modernism had a "tremendous following," he predicted " 'In spite of this I do not think there is any occasion for alarm. This kind of thing is exhausting itself. I might go so far as to say it has already exhausted itself.'"[27] Although this was a gross miscalculation on his part, there are those who respected him for his conviction, and holding on to his ideals — ideals that were equally valid, just different.

Although Chase was at the pinnacle of his career in the first two decades of the twentieth century, his artistic statement was tenuously balanced somewhere between the poetic ideals of the nineteenth century and the more rigorous intellectual interests of twentieth-century modernism. Both camps found fault with his art: the "old school" criticized the lack of a spiritual quality, mainly stemming from his choice to depict common, everyday subjects. [28] Those with more modern leanings attacked him for his technical prowess, claiming that he used his skills to create a facile statement, devoid of any serious thought or intellectual content. What many of his contemporaries failed to understand, or at least to accept, was that Chase never aspired to such ideals. He considered himself a realist, attempting to paint whatever was before him in a truthful, interesting and artistic manner. This was the premise of his art; this is what he set out to achieve; and this is what he accomplished. Despite any criticism from either camp, Chase attained a considerable measure of success and prosperity in the last two decades of his life. He was acknowledged as a versatile artist able to treat just about any subject with equal skill. He concentrated his efforts mainly on two subjects, portraits and still life compositions, which at this time, had eclipsed the landscape paintings that had been so popular in the 1880s and 1890s. He also continued painting interiors with marked success. Commenting on the quality of the late examples of this theme, one writer declared: "Whether it is in the sumptuous splendor of a Venetian palace, shaded from the summer sun, or just a perspective of rooms, in which one would like to live, the charm of a Chase Interior is immediate. It is more than a trick of cool light on reflecting surfaces, mahogany table-tops and hard-wood floors. It is a hint of once familiar moments long forgotten, a sentiment for the quiet dignity of a patrician home."[29] If Chase did not reach the heights of poetry considered so important by many of his contemporaries, he was clearly successful in conveying dignified sentiment in these interior scenes as well as in his portraits.

By the beginning of the twentieth century, Chase was undoubtedly the most sought-after portrait painter in America after his friend John Singer Sargent, who had the added distinction of being the painter of British society. Both artists had developed a successful formula using bold, vital, summary brushstrokes to create lush, brilliant, and attractive images. Never compromising reality by altering a sitter's features, Chase was able to achieve this by focusing on the dignified aspects of their character while paying

equal attention to the decorative quality of the sitter's adornments and setting; this was, of course, most true in his portraits of women. So concerned with creating an "ensemble," Chase was at times criticized for treating portraiture as if it were still life painting. One critic noted "a certain externality in some of his work as a portrait painter; for though many of his portraits are excellent, there are others where he seems to have treated his sitters as bits of still-life to be brilliantly reproduced, but with no more attachment to their personalities than if they were brass pots or Kennebec salmon."[30] Chase was not terribly interested in probing deep psychological aspects of his sitters' personalities; instead he chose to portray their positive aspects, an important factor in his success as a portraitist. Those who gave him commissions were not interested in seeing any troubled side of their personalities recorded for posterity; they were interested in being portrayed as pleasant people — and this was the aspect that Chase sought out in their characters, with varying success.

Although he derived an important part of his income from these commissions, Chase received his greatest acclaim for his still life paintings of fish, praised by critics and sought after by American museums. Virtually all the critics singled out these paintings for special accolades. When one of these fish still lifes was exhibited at the National Academy of Design in 1909, it was reported: "William M. Chase once more had a still life of *Fish,* that he paints with such authority, and which have long since been remarked by his brother painters as among the best of the *nature morte* performances of modern men. It really seems quite incredible that such verisimilitude can be reached with paint on canvas. Yet Mr. Chase dashes in with enthusiastic energy and apparently, *premier coup,* evolves the brilliant pictures of dead fish, pots and brasses in a really masterful manner."[31] In these paintings, Chase took great pride in demonstrating his consummate skill as a technician, able to capture convincingly and seemingly without effort the special qualities of various textures through the manipulation of his materials.

This ability was credited by some to be his greatest asset as an artist. As one critic noted: "His skill is very great, and he has employed it in entirely worthy provinces of effort, always making

the most of his talent. He belongs to that class of painters who through their own sheer enjoyment of their work, the joy of creation, produce a like turn of gusto in their constituency, by the contagion of their pleasurable emotion, and while not sounding the depths of human experience, or contributing to the psychologists' knowledge of human nature, are just simply what old Chardin said he aimed to be — a good workman!"[32] Another critic, claiming that Chase rarely aspired to anything of high distinction, contended that as "a 'painter' he was a consummate success — as a mere craftsman."[33] By the time of Chase's death in 1916, he was both condemned and praised for the same traits: clever brushwork; technical virtuosity; consummate skill; versatility; elegance; vitality; and flair. Those who found fault claimed that Chase wasted these gifts by using them to demonstrate his ability as a painter rather than to create art on a higher moral plane. Those who praised him recognized these traits as indications of his great talent — a talent carefully nurtured through hard work and study, and enhanced by his sheer love of art. No one questioned his ability as a "painter"; he was acknowledged to be the greatest "painter" of his day in America — a distinction Chase certainly would have been proud to claim. However, he was also an "artist," who devoted his entire life to seeking out what he thought artistic and beautiful. In the simplest of objects or the most ordinary of people, he was able to find something of beauty, and through his skill as a painter he was able to convey this to others. Realizing Chase's artistic goals and achievements, one astute critic noted shortly after his death: "So far as we know, Chase never painted a decoration, nor desired to do so; never told a story in paint, rarely chose any subject that anybody else might not have seen. His superiority was merely to see it more clearly. In the lucidity with which he accepted these limitations he was eminently of his generation."[34] In his many portraits, landscapes,

interiors — and even his still life paintings — Chase has preserved for posterity a record of the affluent and carefree generation to which he belonged. The peaceful character of this period changed dramatically during the last decade of the artist's life, and came to an end shortly after his death when America entered World War I.

The sequence of events leading up to Chase's death and the events immediately following it are somewhat vague. Evidently he was ill for some months before he actually died — of what was reported to be cirrhosis of the liver. On October 21, 1916, it was noted in the press that Chase had been seriously ill for several months.[35] Annie Traquair Lang, a former student and his devoted friend, informed another friend that Chase had been slowly wasting away — dropping from 160 pounds to 100 — and suffering "almost continuously." She recalled that at one point his family had sent him off to Atlantic City in hopes that he might regain his strength at the seashore: "Waveringly he gathered a few sketching materials together and I helped him tie the bundle. 'Shall you try to paint?' I asked. 'Yes,' he said, 'perhaps I can forget this pain if I work — probably on the beach I shall see many charming notes — there is nothing like painting, Annie!'" Recalling this last encounter with Chase, Lang stated: "I insisted on carrying his package which was really heavy. He protested in his usual gallant manner....At 16th Street and Irving Place he stopped and said that I must not go farther....So I bid Mr. Chase 'au revoir' there on the corner. He took his package and walked away — I looked back at him and I saw that his hat had blown off. It rolled rapidly for almost a block. He looked so frail — I shall never forget how he looked then, with his bare head and careful slow step!"[36]

By October Chase had returned to his New York home at 234 East Fifteenth Street, and on October twenty-first the press reported an improvement in his health.[37] However, on October twenty-fifth it was noted that his illness had again "taken a serious turn," and later that day Chase died.[38] His death was announced in *The New York Times* the following day, and on October twenty-seventh a formal obituary appeared, stating: "He did not outlive his usefulness. He never reached senility. It is not to be doubted that it was his will

to die before his skill had left him, while the memory of his latest pictures was still fresh."[39] Three days after his death, an announcement stating that Chase had already been buried in Greenwood Cemetery in Brooklyn was released; Karl Reiland of St. George's Episcopal Church officiated the services.[40]

Some were surprised by the abruptness of the burial. One was Annie Lang, who wrote in a letter that it had been arranged "secretly and in a manner to *deceive*. Mrs. Chase had hurried him to his grave within less than a day and a half from the moment he died, and not a recognition of him, not a tribute, not an expression from the hundreds and thousands who loved him was allowed! Think of it! Not a flower, not a ceremonial! Not even his *own* family — I mean his mother, two sisters and their family were near him. They live in *Brooklyn*. They knew no more of his funeral than I did — until it was over....One of the country's biggest *builders* is gone — and it has hardly caused a *ripple* in the calm surface of our complacent existence. But there are *hearts* that *truly mourn*! Nothing can change that! His spirit will live always among those who *knew*, understood, and loved him accordingly." Although it is impossible to know the exact circumstances of Chase's final days or of his death and interment — which Lang called "mysterious" — it is quite possible that the proud Chase and his family did not allow visitors to the sickbed because they wanted his many friends and admirers to remember him as the vital and dynamic personality he had been rather than the frail and weak man he had become. Also, all his life his family generously shared him with the public, artists, students, critics, and other admirers; perhaps Mrs. Chase wanted the final days of her husband's life to be private and quiet, undisturbed by the fanfare and publicity associated with his cosmopolitan life. As might be expected, however, his death did not go unnoticed. Although not presented at a memorial service, the tributes were many.

Artists, former students, critics, and other associates all paid tribute to their beloved friend.

In responding to the initial announcement of Chase's death, J. Carroll Beckwith noted in his diary: "It was a great blow for altho I have seen little of him these past years, from '78 when we came home together on the Red Star Steamer Switzerland until he was married, we were very intimate. He and Blum and I were always together....He was a fine artist and both generous and square — It has made me blue all day."[41] Following this very personal reaction, Beckwith wrote a formal letter of tribute to *The New York Times* that was published on October 29, 1916. Lamenting the fact that Chase had still not received due credit for his important contributions to American art, Beckwith questioned, "Why is it that the mass of our people are so slow in their just valuation of their gifted countrymen?"[42]

Nevertheless, Chase's contribution was acknowledged by many who had an appreciation of American art. Summing up Chase's greatest accomplishment, Frank Alvah Parsons stated: "Perhaps the greatest thing to mark the life of this otherwise great man was the fact that out of an accumulation of almost unthinkable, inartistic appreciation in this country, William M. Chase espoused the cause of art and worked at first almost alone for [its] propagation and maturity. In fact, he may also be said to be the father of the great art movement which is at present sweeping the country in hundreds of manifestations other than that of painting."[43] In another article Chase was heralded as "the ablest painter of face values that America has yet produced....He was an ornament in all company, a true citizen of the world."[44] His death was mourned in cities throughout America, especially in those where he had conducted art classes. In Philadelphia, where he had never been completely accepted during his lifetime, it was reported in the *Philadelphia Bulletin* that Chase's death "caused the deepest regret in art circles here, where he was long identified with the Pennsylvania Academy of the Fine Arts as a teacher and friend of all aspiring young artists."[45] Another tribute was written by the critic and noted collector Duncan Phillips, who was later an important patron of modernist American artists such as Arthur Dove and John Marin, but whose catholic taste led him to purchase Chase's charming painting *Hide and Seek*. Commenting on Chase's key position as an

avant-garde artist in his early years, Phillips stated: "Time was when William M. Chase was regarded by his fellow countrymen as a radical artist....Today, they call Chase reactionary, they who fight sham battles, brandishing paper pistols. And yet the position where he held his own against all comers marks the battle front of forty years ago, where the victory was won which made possible the present and the future of American painting."[46] In a similar vein, the artist Gifford Beal, a former student of Chase's, maintained: "New art movements come and go, each decade heralds a new artistic god, but the generations give their big men to the great tradition of painting. When the story of American art is finally told, Chase's name will be high on the list of the great."[47]

It has taken most of the seventy years since his death for that perspective to finally be acheived and for William Merritt Chase to begin receiving the credit due for his truly important contribution to the art of this country, both in his own art, and in his promotion of American art.

■

Self Portrait (Self Portrait with Hat). **c. 1911**

Monotype on paper
7³/₄ x 5⁷/₈ in (19.7 x 14.9 cm)
Private Collection

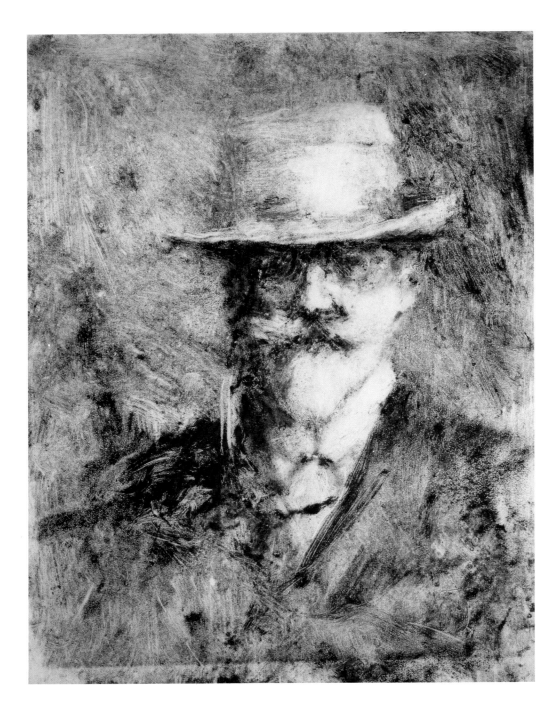

1849
William Merritt Chase born in Williamsburg, Indiana, November, 1.

1861
Family moves to Indianapolis.

1867
Begins artistic training with Barton S. Hays.

1869
Goes to New York, studies at National Academy of Design with Lemuel E. Wilmarth.

1871
Moves to St. Louis, supports himself by painting still lifes.

1872
Fall, backed by St. Louis patrons, embarks for Munich and begins studies at Royal Academy under Alexander von Wagner.

1873
Befriends Frank Duveneck and other compatriots; starts apprentice series; wins medal for work (also next two years).

1874
Begins working under Karl von Piloty at the Academy; begins sending works back to important exhibits in America about this time.

1877
Commission from Piloty marks turning point in career.

1878
Spends time in Venice with Duveneck and Twachtman; returns to Munich, turns down teaching position at Royal Academy; leaves for New York City; begins teaching at newly formed Art Students' League (through 1896); joins Society of American Artists and other art organizations.

1880
Meets Alice Gerson, whom he later marries; elected president of Society of American Artists.

1881
First visit to eastern Long Island with Tile Club; travels to Europe, spends two months in Spain; honorable mention, Paris Salon.

1882
Summer trip to Europe; discussion of organization devoted to pastel painting initiated.

1884
Exhibits in first show of Society of Painters in Pastel (again in 1888, 1889, 1890); exhibits with *Les Vingt* in Brussels.

1885
Summer, meets J. A. M. Whistler in London, paints his portrait; again elected president Society of American Artists, serves ten years.

1886
Marries Alice Gerson; first one-man exhibition, Boston Art Club; begins painting park and coastal scenes in and about New York.

1887
First one-man exhibition in New York—auction sales poor; teaches at Brooklyn Art Association; birth of first child.

1888
Begins painting kimono series about this time; executes numerous pastels.

1889
Medal, Exposition Universelle, Paris.

1890
Elected Academician, National Academy of Design; paints in Central Park around this time; visits Southampton, Long Island, to discuss founding school there.

1891
Founds Shinnecock Summer School of Art near Southampton, begins summering there (through 1902) and painting landscapes in surrounding area; second unsuccessful auction of works; begins teaching again at Brooklyn Art Association.

1896
Disastrous auction of works and studio contents; stops teaching at Art Students' League and in Brooklyn; takes first summer class to Europe, to Madrid; upon return founds Chase School of Art in New York and begins teaching at Pennsylvania Academy of the Fine Arts, Philadelphia.

1897
One-man exhibition at The Art Institute of Chicago; serves as guest instructor there.

1898
Chase School becomes New York School of Art, Chase remains as head instructor.

1902
Last summer class at Shinnecock School; travels to London where his portrait is painted by John Singer Sargent.

1903
First of series of European summer classes, in Haarlem, Holland.

1904
Summer class in London.

1905
Joins Ten American Painters; summer class in Madrid.

1906
Short trip to Europe in summer.

1907
Leaves New York School of Art, resumes teaching at Art Students' League; summer class in Florence; acquires villa there.

1908
Trip to Florence; paints self portrait for Uffizi Gallery; elected member of National Academy of Arts and Letters.

1909
Ceases teaching at Pennsylvania Academy; visits Florence.

1910
Summer class in Florence; large retrospective at National Arts Club, New York.

1911
Summer class in Florence; last year teaching at Arts Students' League.

1912
Summer class in Bruges.

1913
Last summer class in Europe, in Venice.

1914
Last summer class held at Carmel-by-the-Sea, California; makes numerous monotypes.

1915
Has own gallery at Panama-Pacific Exposition, San Francisco.

1916
Honorary degree from New York University; traveling one-man show seen in Detroit and Toledo; health failing, summers in Atlantic City to convalesce; dies in New York home on October 25.

Chapter 1

1. Later renamed Ninevah, Williamsburg was founded in Johnson County, in the southern part of the state, around 1822. Its early industries included leather manufacturing, cabinetmaking, and wagon and carriage building (*History of Johnson County, Indiana* (Chicago: Brant & Fuller, 1888), p. 555).

2. Unless otherwise noted, biographical information about Chase's early years is drawn from the article "W.M. Chase, the Noted Artist, Five of Whose Pictures Are at Herron Institute, is Living Proof That Good Does Come Out of Brown County," *Indianapolis News,* 15 December 1906, p. 14. This article is based on reminiscences gathered from local residents and an interview with Chase conducted by Benjamin Northrup, "Great Artist's Struggle," *Indianapolis News,* 14 January 1899, p. 9. Siblings Charles, Hattie, and Carrie were named in an interview with Mr. and Mrs. Robert S. Chase, 5 April 1983).

3. John D. Barnhart and Donald F. Carmony, *Indiana From Frontier to Industrial Commonwealth* (New York: Lewis Historical Publishing Co., 1954), vol. 2, p. 159.

4. George S. Cottman, *Centennial History and Handbook of Indiana* (Indianapolis: Max R. Hyman, 1915), p. 135.

5. *History of Johnson County,* p. 197.

6. "W.M. Chase, the Noted Artist."

7. Barnhart and Carmony, *Indiana,* vol. 1, p. 419; DeWitt C. Goodrich and Charles R. Tuttle, *An Illustrated History of the State of Indiana* (Indianapolis: Richard S. Peale & Co., 1875), p. 89.

8. Northrup, "Great Artist's Struggle."

9. John Herron Art Museum, *Chase Centennial Exhibition,* exh. cat., text by Wilbur D. Peat (Indianapolis, 1949), unpaginated.

10. J. Walker McSpadden, *Famous Painters of America* (New York: Thomas Y. Crowell, 1907), pp. 329-30.

11. "Janitor Brother Tells How Chance Aided W.M. Chase," *Indianapolis Star,* 25 March 1917.

12. Northrup, "Great Artist's Struggle." Peat identified Chase's first teacher as Barton S. Hays (*Chase Centennial*), correcting Katherine Metcalf Roof, who gave his name as "Benjamin Hayes" (*The Life and Art of William Merritt Chase,* (1917; New York: Hacker Art Books, 1975), p. 13). For information on Hays, see Wilbur D. Peat, *Pioneer Painters of Indiana,* (Indianapolis: Art Association of Indianapolis, 1954), pp. 167-69, 232.

13. Northrup, "Great Artist's Struggle." Abraham David Milgrome discusses the discrepancies in various sources regarding when Chase studied with Hays: "Chase's biographer, Katherine Metcalf Roof, says that he went to the National Academy in New York in 1869 and stayed until 1871 when he joined his family in St. Louis. Roof, *Chase,* 24. However, Frank Howell, a classmate of Chase's in Indianapolis, noted in his diary that on October 21, 1870, he saw Chase's studio sign on the Y.M.C.A. building in St. Louis. Frank Howell, 'Recalls Early Days of William M. Chase,' *Indianapolis News,* December 5, 1916, 11. Wilbur D. Peat, basing himself partly on Howell's account, gives 1866 as Chase's first period with his teacher Barton S. Hays in Indianapolis and noted that he came back to Hays from the National Academy in 1869. Peat, *Pioneer Painters,* 178" (Abraham David Milgrome, "The Art of William Merritt Chase" (Ph.D. diss., University of Pittsburgh, 1969), pp. 147-48).

14. Peat, *Chase Centennial.*

15. Northrup, "Great Artist's Struggle."

16. Peat, *Chase Centennial.*

17. "The Picture That First Helped Me to Success," *The New York Times,* 28 January 1912, Section 5, p. 5.

18. S.G.W. Benjamin, *Our American Artists* (Boston: D. Lothrop & Company, 1879), pp. 62-63.

19. *Complete Descriptive Muster Roll of the Crew of the U.S. Ship Portsmouth,* 21 August 1867, Military Archives, Washington, D.C.

20. Private collection, courtesy of the Birmingham Museum of Art, Birmingham, Alabama. Although this work may have been painted in New York in the fall of 1869, its style clearly reflects Chase's training in the Midwest, and predates any serious influence from his studies at the National Academy of Design.

21. Roof, *Chase,* p. 22.

Chapter 2

1. Katherine Metcalf Roof, *The Life and Art of William Merritt Chase* (1917; New York: Hacker Art Books, 1975), p. 14. Chase's regard for Cox is recorded in Mary Quick Burnet's description of a later visit he made to Cox's studio. By that time, Chase had become a renowned artist and Cox was regarded as a "regional" painter. Chase, however, recognized Cox's talent, and claimed that if he had continued his studies abroad, Cox would have been "one of the most celebrated artists of this country" (Mary Quick Burnet, *Art and Artists of Indiana* (New York: The Century Company, 1921), pp. 87-88).

2. Northrup, "Great Artist's Struggle," *Indianapolis News,* 14 January 1899, p. 9. For information on Eaton, see Wilbur D. Peat, *Pioneer Painters of Indiana* (Indianapolis: Art Association of Indianapolis, 1954), pp. 159; 160-62; 174; 230.

3. Roof, *Chase,* p. 20. Among the other studio buildings described by Roof were the University Building on Washington Square, and the Tenth Street Studio Building at 51 West Tenth Street, referred to as "the strong-hold of the Hudson River School" (Ibid., pp. 20-21). Its occupants included Albert Bierstadt, Homer Dodge Martin, Sanford R. Gifford, and John George Brown, to name just a few (artist's addresses obtained from Maria Naylor, ed., *The National Academy of Design Exhibition Record, 1861-1900,* 2 vols. (New York: Kennedy Galleries, 1973), *passim.*).

4. Louis Comfort Tiffany, Lemuel Wiles, Alexander Helwig Wyant, William Hart, Alfred Cornelius Howland, John Frederick Kensett, Arthur Fitzwilliam Tait, and George Smillie all had studios in the Y.M.C.A. Building at this time (Naylor, *National Academy of Design, passim.*).

5. Apparently Chase was close to Eaton, who painted a sensitive portrait of him in 1870 (illustrated in Roof, *Chase,* opposite p. 18). Eaton's studio was a popular gathering place, where Chase met artists Edwin Austin Abbey and James Kelly as well as the playwright Bret Harte and the actress Sarah Jewett (Roof, *Chase,* p. 19).

6. "Talk on Art by William M. Chase," *The Art Interchange* 39 (December 1897), p. 126.

7. Naylor, *National Academy of Design.* The present locations of these paintings are unknown. The "W.F. Macy" credited with lending Chase's *Portrait* might be a misprint for W.S. Macy, William Starbuck Macy, a friend and fellow student of Chase's.

8. *Still Life with Fruit,* The Parrish Art Museum, Southampton, New York; *Still Life with Fruit and Pitcher,* private collection, Courtesy Sotheby's, New York.

9. William H. Gerdts, *Painters of Humble Truth: Masterpieces of American Still Life, 1801-1939* (Columbia, Missouri: Philbrook Art Center and University of Missouri Press, 1981), pp. 97-98.

10. Gerdts in a letter to the author, dated 6 December 1982.

11. Northrup, "Great Artist's Struggle."

12. "Janitor Brother Tells How Chance Aided W.M. Chase," *Indianapolis Star,* 25 March 1917, provides location and last names of artist residents. Gould & Aldrich's 1872 St. Louis City Directory lists Chase and Pattison at 414 Olive.

13. "Janitor Brother."

14. Ibid.

15. Northrup, "Great Artist's Struggle."

16. Roof, *Chase,* p. 25; Thomas B. Brumbaugh, in "William Merritt Chase Reports to St. Louis from Munich: A Correspondence," (*The Bulletin* of the Missouri Historical Society 15, no. 2 (January 1959), p. 124) cites a letter from Chase that mentions William Jones in this context.

17. "Janitor Brother."

18. Abraham David Milgrome, "The Art of William Merritt Chase" (Ph.D. diss., University of Pittsburgh, 1969), cites Nikolas Pevsner, *Academies of Art, Past and Present* (New York, 1940), pp. 210-15.

19. Roof, *Chase,* pp. 30-31.

Chapter 3

1. Much of the information about the artists working in Munich during this period is drawn from two sources: The Brooklyn Museum, *Triumph of Realism, An Exhibition of European and American Paintings, 1850-1910*, exh. cat., text by Axel von Saldern (Brooklyn, 1967); and E.B. Crocker Gallery, *Munich and American Realism in the 19th Century*, exh. cat., text by Michael Quick and Eberhard Ruhmer (Sacramento, 1978).

2. S.G.W. Benjamin, "Contemporary Art in Germany," *Harper's New Monthly Magazine* 55 (1877), p. 4.

3. Ibid.

4. See Rodolphe Marggraff, *Catalogue des Tableaux de l'ancienne Pinacothèque royale de Munich, avec notices biographiques et des annotations tant historiques que critiques* (Munich: 1800).

5. William Merritt Chase, "Address Given at The Metropolitan Museum of Art, New York City, January 15, 1916 — 8 p.m." cit. A. Milgrome, *The Art of William Merritt Chase* (Ph.D. diss., University of Pittsburgh, 1969), p. 107.

6. Ibid.

7. Katherine Metcalf Roof, *The Life and Art of William Merritt Chase* (1917; New York: Hacker Art Books, 1975), pp. 328-29.

8. Charles Caffin, *Story of American Painting* (New York: Frederick A. Stokes, 1907), p. 110.

9. Chase to Coale, 12 June 1873, copy in possession of the author.

10. Von Saldern, *Triumph of Realism*, p. 28. *Frau Gedon*, Bayerische Staatsgemäldesammlungen, Munich.

11. Quick, *Munich and American Realism*, p. 21 points out the influence of *Kokotte* on Chase. *Kokotte (Die junge Pariserin)*, Wallraf-Richartz-Museum, Cologne; *Portrait of a Woman*, Wadsworth Atheneum, Hartford, Connecticut; *Coquette*, New York art market, 1970.

12. Art Institute of Chicago.

13. Von Saldern, *Triumph of Realism*, p. 33.

14. Katherine Metcalf Roof, "William Merritt Chase: The Man and The Artist," *The Century Magazine* 93 (April 1917), p. 834.

15. Quick and Ruhmer, *Munich and American Realism*, p. 22. See this catalogue for an in-depth discussion of the activities of American artists in Munich around this time.

16. Roof, *Chase*, p. 28.

17. *Hugo von Habermann*, Nelson Gallery — Atkins Museum, Kansas City (reproduced in Akron Art Museum, *William Merritt Chase: Portraits*, exh. cat., text by Carolyn K. Carr (Akron, 1982), p. 9); *The Artist Eduard Grutzner*, collection of Rudolf Neumeister, Munich.

18. According to Roof (*Chase*, p. 41), *The Smoker* was destroyed by fire. An etching by Wilhelm Unger after the painting is reproduced in The Parrish Art Museum, *William Merritt Chase in the Company of Friends*, exh. cat., text by Ronald G. Pisano, (Southampton, New York, 1979), p. 38.

19. Cincinnati Art Museum.

20. Addison Gallery of American Art, Phillips Academy, Andover, Massachusetts (reproduced in Akron, *William Merritt Chase: Portraits*, p. 8).

21. Chase's painting, *Unexpected Intrusion* — now known as *Turkish Page* — is in the collection of the Cincinnati Art Museum. Duveneck's, *The Turkish Page*, is in the collection of The Pennsylvania Academy of the Fine Arts, Philadelphia.

22. Josephine W. Duveneck, *Frank Duveneck: Painter — Teacher* (San Francisco: John Howell Books, 1970), p. 63.

23. *Duveneck Painting the Turkish Page*, Cincinnati Art Museum.

24. Thomas B. Brumbaugh, "William Merritt Chase Reports to St. Louis from Munich: A Correspondence," *The Bulletin* of the Missouri Historical Society 15, no. 2 (January 1959), p. 121.

25. Ibid., p. 122.

26. Ibid., p. 124.

27. Benjamin Northrup, "Great Artist's Struggle," *Indianapolis News* 14 January 1899, p. 9.

28. Collection of the Union League Club, New York. M.G. van Rennselaer was later to call *Ready for the Ride* "the most interesting picture of the year" ("William Merritt Chase — Second and Concluding Article," *American Art Review* 2 (February 1881), p. 135).

29. Northrup, "Great Artist's Struggle."

30. Medals listed in Roof, *Chase*, p. 330.

31. *The Dowager*, collection of Lewis B. Williams (reproduced in Akron, *William Merritt Chase: Portraits*, p. 10); *Keying Up — The Court Jester*, The Pennsylvania Academy of the Fine Arts.

32. Northrup, "Great Artist's Struggle."

33. Ishmael, "Through the New York Studios," *The Illustrated American* 5, no. 52 (14 February 1891), p. 618.

34. Both versions, collection of Mr. and Mrs. Larry Thompson.

35. Northrup, "Great Artist's Struggle."

36. Dorothy Weir Young, *The Life and Letters of J. Alden Weir* (New Haven: Yale University Press, 1960), p. 117.

37. Roof, *Chase*, p. 51.

38. Ibid., p. 45.

39. *Monkeying with Literature*, Yale University Art Gallery, New Haven, Connecticut; *A Fishmarket in Venice (The Yield of the Waters)*, The Detroit Institute of Arts.

40. *In the Baptistery of St. Marks*, present location unknown; *The Antiquary Shop*, The Brooklyn Museum.

41. Collection of Mr. and Mrs. Jerome Westheimer.

42. Roof, *Chase*, p. 51.

43. Ibid., p. 52. A full account of this celebration is found on pp. 51-53.

Chapter 4

1. "Chase's Americanism," *Literary Digest* 53 (11 November 1916), p. 1250.

2. "William M. Chase," *Fine Arts Journal* 34 (November 1916), unpaginated.

3. Lillian M.C. Randall, ed., *The Diary of George A. Lucas, An American Art Agent in Paris, 1857-1909*, 2 vols. (Princeton: Princeton University Press, 1979); and Madeleine Beaufort, Herbert Kleinfield, and Jeanne Welcher, eds., *The Diaries: 1871-1882 of Samuel P. Avery, Art Dealer* (New York: Arno Press, 1979).

4. Earl Shinn, ed., *The Art Treasures of America*, 3 vols. (Philadelphia: Gebbie & Barrie, 1879-1881).

5. "Nationality in Art," *The New York Times*, 28 November 1878, p. 4.

6. "American and Foreign Art," *The New York Times*, 9 November 1879, p. 4.

7. W.C. Brownell, "The Younger Painters of America," *Scribner's Monthly* 20, no. 1 (May 1880), p. 2.

8. "The Meaning of American Art," *The New York Times*, 12 December 1878, p. 4.

9. Ibid.

10. Much of the information on nineteenth-century American collectors is derived from an article by Albert Boime, "America's Purchasing Power and the Evolution of European Art in the Late Nineteenth Century," in *Salons, Galleries, Museums and Their Influence in the Development of 19th and 20th Century Art* (Bologna: Cooperativa Libraria Universitaria, 1979), pp. 123-39.

11. Marchal E. Landgren, *Years of Art: The Story of the Art Students League of New York* (New York: Robert M. McBride & Co., 1940), p. 31.

12. Landgren, *Years of Art*, p. 20. The discussion of the history of the Art Students' League is based on this text.

13. Ibid., p. 26.

14. The rule alloting academicians eight feet "on the line" was rescinded shortly after it was passed, but the damage had been done (National Collection of Fine Arts, Smithsonian Institution, *Academy: The Academic Tradition in American Art*, exh. cat., text by Lois Marie Fink and Joshua C. Taylor, (Washington, D.C., 1975), p. 80).

15. Mrs. Gilder also showed support of the new movement by serving as vice president of the Art Students' League in 1879 (Landgren, *Years of Art*, p. 24).

16. Rosamond Gilder, ed., *The Letters of Richard Watson Gilder* (Boston and New York: Houghton Mifflin Co., 1916), p. 89.

17. "Society of American Artists," *The American Art Review* 1 (1880), p. 258.

18. Ibid.

19. Will H. Low, *A Painter's Progress* (New York: Charles Scribner's Sons, 1910), p. 215.

20. J.M.T., "The American Artists' Exhibition," *The Art Amateur* 11, no. 2 (July 1884), p. 30.

21. "Eastman Johnson bought one study of an old woman by Chase for $500, and thought like a master," wrote John Ferguson Weir to Julian Alden Weir in a letter dated 20 November 1876 (Dorothy Weir Young, *The Life and Letters of J. Alden Weir* (New Haven: Yale University Press, 1960), p. 114).

22. *Broken Jug*, The Baltimore Museum of Art. Katherine Metcalf Roof gives the information about Miller in *The Life and Art of William Merritt Chase* (1917; New York: Hacker Art Books, 1975), p. 54.

23. "Art Notes," *The New York Times*, 23 May 1877, p. 4.

24. *Flower Girl*, Private Collection.

25. "Chase's Court Jester," *The Art Journal* 4 (1878), p. 257.

26. Ibid., p. 258.

27. M.G. van Rennselaer, "William Merritt Chase — Second and Concluding Article," *American Art Review* 2 (February 1881), p. 135.

Chapter 4 continued

28. Avery had visited Munich several times in the 1870s, where he met with Karl von Piloty, and likely discussed art with the American students, including Chase. Perhaps it was this association that prompted Avery to make this uncharacteristic purchase (Beaufort et. al., *Diaries of Samuel P. Avery*, 11 August 1875, p. 328; 29 June 1878, p. 480; 24 July 1878, p. 526).

29. James Carroll Beckwith, *Diary*, 31 December 1878, National Academy of Design, New York.

30. Ibid., 11 September 1878.

31. Ibid.

32. Landgren, *Years of Art*, p. 31.

33. Roof provides the most complete description of the Art Club's activities: "Doctor Miller was president. Beckwith, Shirlaw, Dielman, Saint Gaudens, Frank Millet, Reinhart, F.S. Church, and Swain Gifford were among its members. It met at The Studio, a chop-house on Sixth Avenue, where many of the artists dined quite regularly....During its five years of existence the club held exhibitions of work by its members, and collected funds to send an exhibit of American painters to the International Exhibition at Munich in 1883, an enterprise in which Chase was especially interested" (*Chase*, p. 57).

34. M. G. van Rensselaer, "William M. Chase — First Article," *American Art Review* 2 (January 1881), pp. 93-94.

35. Roof, *Chase*, p. 56.

36. Information about the Tenth Street Studio can be found in Young, Weir, f.n., p. 201; "An Artist's Collection," *The Collector* 2, (1892), p. 32; and in Nicolas Cikovsky, Jr., "William Merritt Chase's Tenth Street Studio," *Archives of American Art Journal* 16, no. 2 (1976), pp. 2-14. According to exhibition records of the National Academy of Design, artists who lived at 51 West 10th Street at the time that Chase moved in were: William Beard, J.G. Brown, J.W. Casilear, F.E. Church, M.F.H. de Haas, John L. Fitch, S.R. Gifford, Seymour Guy, George Henry Hall, E.L. Henry, Winslow Homer, R.W. Hubbard, Albert Insley, John La Farge, Thomas Le Clear, Joseph Lyman, Homer D. Martin, George Herbert McCord, Jervis McEntee, J.C. Nicoll, Walter Palmer, Ernest Parton, F. Schuchardt, George Shelton, A. Cary Smith, Kruseman Van Elten, W. Whittredge, and T.W. Wood. These records indicate that in 1879 Church, La Farge, and others moved out, while Oscar R. Coast, Lockwood de Forest, William F. de Haas, Henry Farrer, John H. Hicks, William Page, Arthur Parton, L.E. Wilmarth, and George Yewell gave the Tenth Street Studio building as their address (Maria Naylor, ed., *The National Academy of Design Exhibition Record, 1861-1900*, 2 vols. (New York: Kennedy Galleries, 1973), *passim.*).

37. John Moran, "Studio Life in New York," *The Art Journal* 5, (1879), pp. 344-45.

38. Ishmael, "Through the New York Studios," *The Illustrated American* 5, no. 52 (14 February 1891), p. 619.

39. Elizabeth Champney, *Witch Winnie's Studio* (New York: Dodd, Mead & Co., 1892), p. 18.

40. The preliminary sketch for *The Tenth Street Studio* is reproduced in van Rensselaer, "Second Article," fp. 138. Van Rensselaer indicated that by this time (1881), the painting had been sketched in in black and white. Evidently Chase continued to work on it over time to its present state of completion. The painting is now in the collection of the Museum of Art, Carnegie Institute, Pittsburgh.

41. *Interior of the Artist's Studio, (The Tenth Street Studio)*, 1880, was painted in 1880 and first exhibited in 1881; it was owned by Chase's early patron Samuel M. Dodd. This painting was included in several important exhibitions of the time, among them that of the Society of American Artists in 1881. Several years later it was also featured in Chase's earliest one-man show held at the Boston Art Club (1886) and the following year was shown at Moore's Art Galleries in New York. When displayed at the Society of American Artists' exhibition, the painting received mixed praise. It is now in the collection of the Saint Louis Museum of Art.

42. John Moran, "Artist Life in New York," *The Art Journal* 6 (1880), p. 123.

43. W.A. Cooper, "Artists in Their Studios," *Godey's Magazine* 130, no. 777 (March 1895), p. 296.

44. Beckwith, *Diary*, 1 April; 24 April, 1890. Roof also described the event in detail (*Chase*, pp. 155-58). *Carmencita* is in the collection of The Metropolitan Museum of Art (reproduced in the author's *William Merritt Chase* (New York: Watson-Guptill, 1979), p. 53).

45. The background of the Gerson family and Chase's association with them is described in Roof, *Chase*, pp. 65-75, and in Juanita J. Miller's book *My Father, C.H. Joaquin Miller, Poet* (Oakland: Tooley-Towne, 1941). Additional information about the history of the Gerson family is on file with the author.

46. James Edward Kelly (1855-1933) studied at the National Academy of Design. Early in his career he worked as an illustrator, but in the early 1880s became known for his sculpture. He was one of the founders of the Art Students' League.

47. Joaquin Miller (1839/1841-1913) was an American poet, dramatist and novelist. His real name was Cincinnatus Heine Miller.

48. Their ages are based on Roof's assertion that Chase knew the Gersons for six years before they were married in 1886 (*Chase*, p. 75).

49. Miller, *My Father*, pp. 87-88.

50. The nickname "Toady" was not meant in a derogatory way. It was probably derived from the word's definition of "fawn over" or "plays up to."

51. "Mrs. William M. Chase," *The Daily Graphic*, 17 February 1887.

52. Ibid.

53. Their first son, William Merritt, Jr., born in 1889, lived only two years. According to family members, Mrs. Chase bore thirteen children, of which eight survived.

54. Katherine Metcalf Roof, "William Merritt Chase: The Man and the Artist," *The Century Magazine* 93 (April 1917). p. 839, 840.

55. Ibid, p. 840.

Chapter 5

1. W. MacKay Laffan, "The Tile Club at Work," *Scribner's Monthly* 17, no.33 (January 1879), pp. 3402-03.

2. Ibid., 3401.

3. "It was [Edward] Wimbridge who suggested that the painting of tiles be made the focal point of the group." Dorothy Weir Young identified Wimbridge as an English architect. (Lyman Allan Museum, *Men of the Tile Club*, exh. cat., (New London, 1945), unpaginated).

4. Laffan, "At Work," p. 3403.

5. Ibid., 3404.

6. Ibid., 3405.

7. As pointed out by Roof, "An interesting picture of the Tile Club and of the life of the painters of that period is shown in Hopkinson Smith's novel 'Oliver Horn,' in which the club is described under the name of The Stone Mugs, and...the painter Munson is a fictional presentment of Chase..." (Katherine Metcalf Roof, *The Life and Art of William Merritt Chase* (1917; New York: Hacker Art Books, 1975), p. 383). The book she refers to is F. Hopkinson Smith, *The Fortunes of Oliver Horn* (New York: P.F. Collier & Son, 1902).

8. The members of the Tile Club, their names, and their occupations are found in *Julian Alden Weir, An Appreciation* (New York: The Century Club, 1921), pp. 378-79. Chase's nickname "Briareus" does not appear until the article "The Tile Club Ashore" (1882). Briareus, a descendant of the god Uranus, was a giant with fifty heads and one hundred hands; the name evidently refers to the facility with which Chase painted (See William Sherwood Fox, ed., *Greek and Roman Mythology*, vol. 1 of Louis Herbert Gray, gen. ed., *The Mythology of All Races*, 12 vols. Boston: Marshall Jones Co., 1916).

9. Laffan, "At Work," p. 3409.

10. Ibid.

11. Ibid.

12. W. MacKay Laffan and Edward Strahan [Earl Shinn], "The Tile Club at Play," *Scribner's Monthly* 17, no.34 (February 1879), p. 3471.

13. Ibid., p. 3474.

14. W. MacKay Laffan and Edward Strahan [Earl Shinn], "The Tile Club Afloat," *Scribner's Monthly* 19, no.35 (March 1880). p. 3642.

15. Ibid.

16. Ibid., p. 3644.

17. Ibid., p. 3670.

18. Ibid., p. 3644.

19. Ibid., p. 3650.

20. Ibid.

21. The University of Montana, illustrated in Ibid., p. 3649.

22. Ibid., p. 3656.

23. Ibid., p. 3660.

24. Ibid., p. 3663.

25. Ibid., p. 3647.

26. "The Tile Club at Whitehall," *The New York Times*, 10 July 1879, p. 35.

27. W. MacKay Laffan, "The Tile Club Ashore," *The Century Magazine* 23, no.34 (February 1882), p. 3481.

28. Ibid.

29. Ibid., p. 3482.

30. Ibid.

31. Ibid., p. 3483.

32. The article states that "the scheme reached maturity at the close of June" (Ibid., p. 3483). Chase was most certainly included on this trip, as he is mentioned several times in the text, and several sketches signed "Briareus" are reproduced in the article. He also appears in a sketch by Frederick Dielman entitled *Under the Awning* which is illustrated on p. 3485 (present location unknown). However, J. Carroll Beckwith noted in his diary on 5 June 1881 (National Academy of Design, New York) that he, Chase, and several other artists left for Europe that day. Therefore, Chase could not have been on Long Island during the month of June. The Tile Club trip probably took place earlier, perhaps in late May, rather than in late June as the article states. Judging from the text, the trip was much shorter than their earlier holidays.

33. Ibid., p. 3484.

34. Ibid.

35. Ibid.

36. Ibid., p. 3487.

37. Ibid., p. 3493.

38. Private collection.

39. *The Sea Serpent, as Seen by "Briareus"* is illustrated in Ibid., p. 3488 (present location unknown). Such an imaginary subject is rare in Chase's *oeuvre*.

40. Ibid., p. 3498.

Chapter 6

1. Katherine Metcalf Roof, *The Life and Art of William Merritt Chase* (1917; New York: Hacker Art Books, 1975), p. 93.

2. "The Collector," *The Art Amateur* 40, no. 6 (May 1899), p. 115.

3. James Carroll Beckwith, *Diary*, 5 June 1881, National Academy of Design, New York. Unless otherwise noted, details about this trip are taken from Beckwith's *Diary*, 1881. Roof identified Lawrence as a decorator (*Chase*, p. 93).

4. Beckwith, *Diary*, 9 June 1881.

5. Roof, *Chase*, p. 93. Apparently the panels were later removed and became the possession of one of the owners of the line; their present whereabouts are unknown (Ibid., pp. 93-94). A panel painting entitled *The Critic* (present location unknown) was listed (lot no. 173) in the 1917 estate sale catalogue (American Art Galleries, May 14-17), as having been done aboard the *Belgenland*, and described: "The sketch shows a man in a white jumper with black trousers and black soft hat, which is tilted back, standing with hand in pocket and pipe held before his chin, looking critically to the right, being seen in profile."

6. Beckwith, *Diary*, 23 June 1881.

7. Beckwith's diary entry for 29 June 1881 mentions visiting Sargent. Doreen Bolger Burke discusses the ceiling decoration in *American Paintings in The Metropolitan Museum of Art, Vol. III: Painters Born Between 1846 and 1864* (New York: The Metropolitan Museum of Art, 1980), p. 135. Beckwith also mentions having seen Duveneck, but it is not clear whether they actually saw Duveneck himself or if he is referring to Chase's painting of Duveneck, *The Smoker* (*Diary*, 23 June 1881).

8. Roof, *Chase*, pp. 95-96, cited a section of a letter from Blum to Chase, dated 16 July 1881, and reproduced a sketch from it on p. 335.

9. Roof, *Chase*, p. 96; she also reproduced sketches by Chase, p. 336.

10. "Painters and Their Work," *New York Daily Tribune*, 6 November 1881, p. 5. The identification of these works is uncertain at present.

11. Beckwith, *Diary*, 4 September 1881.

12. Roof, *Chase*, p. 95.

13. William M. Chase, "The Import of Art: An Interview with Walter Pach," *The Outlook* 95 (25 June 1910), p. 442.

14. Roof, *Chase*, p. 94.

15. Dorothy Weir Young, *The Life and Letters of J. Alden Weir* (New Haven: Yale University Press, 1960), p. 145. Weir and Chase embarked for Europe only two days apart — Weir on June second and Chase on June fourth — shortly after the two had returned from their trip to Long Island with the Tile Club. They certainly must have discussed meeting in Paris while working together on Long Island that spring. According to Beckwith's diary, Chase was in Paris ten days before Weir purchased Manet's *Boy with a Sword* from Durand-Ruel on June twenty-seventh, and would have had the chance to see these two works (information about Weir's activities in Paris is taken from a letter from Doreen Bolger Burke to the author, dated 15 November 1982). Although Roof did not document her sources, it is apparent from reading her early biography of Chase that she interviewed those artists mentioned who were living at the time she was compiling her manuscript. Therefore, she likely discussed this matter with Weir.

16. Frances Weitzenhoffer, "First Manet Paintings to Enter an American Museum," *Etrait de la Gazette des Beaux-Arts* (March 1981) pp. 127-28. This article was brought to my attention by Doreen Bolger Burke.

17. Beckwith, *Diary*, 10 September 1881; 17 September 1881.

18. Information about the 1882 trip abroad is taken from C.C. Buel, "Log of an Ocean Studio," *The Century Magazine* 27, no. 3 (January 1884), pp. 356-71, unless otherwise noted.

19. Ibid., p. 356.

20. Ibid.

21. Ibid.

22. Ibid., p. 358.

23. Ibid., p. 369.

24. Ibid., p. 361.

25. Ibid., p. 362.

26. Ibid. Anderson's *Farewell to Sandy Hook* is illustrated on p. 357 (present location unknown).

27. Ibid. Vinton's *"Captain" Was in the Tones of his Voice* is illustrated on p. 361 (present location unknown). Blum's *The Emigrant Model*, New Britain Museum of American Art, New Britain, Connecticut,is illustrated on p. 368.

28. Ibid. Blum's *Flying the Great Kite* is illustrated on p. 367 (present location unknown).

29. Ibid., p. 368.

30. Ibid., p. 369.

31. Ibid. Quartley's *Moonlight Through the Lifting Fog* is illustrated on p. 364 (present location unknown); his *Petrels Following in the Streamer's Wake* is illustrated on p. 370 (present location unknown).

32. Ibid., p. 367.

33. Ibid. Beckwith's *The Comet* is illustrated on p. 362 (present location unknown).

34. Ibid. Chase's *Under a French Sky*, private collection, courtesy Mongerson Gallery, Chicago, is illustrated on p. 359; his *A Mediterranean Memory* is illustrated on p. 366 (present location unknown).

35. Ibid., p. 370. According to Roof, Chase painted a panel of this description in the smoking room of the *S.S. Pennland* on the 1883 trip (*Chase*, p. 108).

36. Buel, "Log," p. 370. These works were exhibited at the Art Students' League later that year, and described in "Art Notes," *The Art Journal* 8 (1882), p. 351, which credits Chase and Beckwith with the clock and barometer decorations, and Blum with painting the ceiling. This article was brought to my attention by Bruce Weber.

37. Buel, "Log," p. 358. According to the article, although Fortuny's biographers gave his birthdate as June eleventh, the "disciple of Fortuny" on this voyage had "private information" that the Spanish artist was born on June ninth. Robert Blum was identified as the "disciple of Fortuny" by Bruce Weber in a letter to the author, dated 16 May 1983.

38. James Carroll Beckwith, *Diary*, 17 June 1882, National Academy of Design, New York. Unless otherwise noted, details about this trip are taken from Beckwith's *Diary*, 1882.

39. This work was destroyed by fire in 1882 according to an article by Montezuma, "My Note Book," *The Art Amateur* 8, no. 2 (January 1883), p. 29.

40. Roof, *Chase*, p. 105. In a letter to his parents, Robert Blum explained that Scribner's planned to publish an article using illustrations by Chase and Blum. This enabled Blum to visit Spain, who would not have been able to afford it otherwise. (Robert Blum to Frederick and Mary Blum, 13 May 1882, Blum family correspondence, courtesy Bruce Weber). The article, "Street Life in Madrid," was written by Susan N. Carter and published in *The Century Magazine* 39, no. 6 (November 1889), pp. 32-41. It is not known why so much time elapsed before publication.

Chapter 6 continued

41. Beckwith, *Diary,* 29 August 1882. Although Chase and Vinton stopped in Paris, it is clear that their main intention was to go on to Holland based on a letter Blum sent to his parents (9 September 1882, Blum family correspence, courtesy Bruce Weber).

42. Roof, *Chase,* p. 107. It is not known if Chase actually met with Boldini.

43. Beckwith, *Diary,* 26 September, 1882.

44. Roof, *Chase,* p. 107.

45. Yale University Art Gallery. This large composition is most likely the painting Chase lent to the Art Association of Indianapolis Loan Exhibition in November 1883 under the title of *Near Madrid,* along with another Spanish subject titled *Sunny Spain* (present location unknown). The paintings were listed in the catalogue as "never before exhibited."

Chapter 7

1. James Carroll Beckwith, *Diary,* 1883, National Academy of Design, New York. Much of the information about Chase's participation on various committees in 1883 is drawn from Beckwith's *Diary* for that year. The Munich Crystal Palace exhibition was held in August 1883, and the American section included work by Chase, Beckwith, Blum, Twachtman, J. Alden Weir, Dora Wheeler, Thomas Eakins, Winslow Homer, S.R. Gifford, and Thomas Cole. Chase exhibited four works: *Portrait of Miss Dora Wheeler, Young Girl Reading* — both of which had been included in the Paris Salon earlier that summer — his portrait of of Frank Duveneck, *The Smoker,* and a drawing entitled *The Spanish Farmer,* probably *A Countryman,* collection of Susan and Herbert Adler, and reproduced in Susan N. Carter's "Street Life in Madrid," *The Century Magazine,* 39, no. 6 (November 1889), p. 35.

2. Beckwith, *Diary,* 2 June 1883.

3. Katherine Metcalf Roof, *The Life and Art of William Merritt Chase* (1917; New York: Hacker Art Books, 1975), p. 108.

4. Ibid.

5. *Portrait of Miss Dora Wheeler,* Cleveland Museum of Art; *Young Girl Reading,* present location unknown.

6. *Spanish Bric-à-Brac Shop,* New York art market, 1983; *Garden of the Orphanage, Haarlem, Holland* probably *Courtyard of a Dutch Orphan Asylum,* Washington University Gallery of Art, Saint Louis, Missouri.

7. *Dutch Orphan,* present location unknown; *Bit of Holland Meadow,* The Parrish Art Museum, Southampton, New York (reproduced in The Parrish Art Museum, *William Merritt Chase in the Company of Friends,* exh. cat., text by Ronald G. Pisano, (Southampton, New York, 1979), p. 45, under the title *A Bit of Green in Holland* [*Landscape*]); *Canal in Holland,* present location unknown; *Dutch Canal,* collection of Diane G. Tanenbaum, M.D. (reproduced in Ibid., p. 44, under the title *Canal Path, Holland*); *North Sea, Holland,* present location unknown.

8. Private collection.

9. "Pastels by William M. Chase," *New York Herald,* 31 December 1883, p. 8.

10. Beckwith, *Diary,* 5 November 1883.

11. Chase's committee membership, and information about objects he and others lent to the exhibition is found in *Catalogue of the Pedestal Fund Art Loan Exhibition* (New York: National Academy of Design, 1883). Other committees included: Coins and Medalic Art; Old Prints; Wood Engravings; Ceramics, Carvings and Furniture; Metal Work; Arms and Armor; Stained Glass; Missals and Old Books; Oriental Art; Musical Instruments; and Aboriginal Art. The "Ladies Committees" covered the following categories: Old China, Miniatures, Fans, Old Jewelery and Silver, Lace, Portfolio, Costume (Antique and National), and Embroidery.

12. Of the objects assembled, the display of Oriental art was singled out at the preview for special praise, as promising to be a "fine exhibit" as well as a "good decorative ensemble" ("For the Bartholdi Pedestal," *New York Herald,* 29 November 1883, p. 6).

13. "Two Art Exhibitions," *New York Herald,* 2 December 1883, p. 6.

14. "For the Bartholdi Pedestal."

15. "Two Art Exhibitions."

16. Ibid.

17. "For the Bartholdi Pedestal."

18. Ibid.

19. "Two Art Exhibitions."

20. "Opening for the Bartholdi Pedestal," *New York Herald,* 4 December 1883, p. 5.

21. Beckwith, *Diary,* 19 December 1883.

22. "The Art Loan Exhibition," *New York Herald,* 31 December 1883, p. 5.

23. *The New York Times,* 24 December 1883, p. 4.

24. "Two Art Exhibitions."

25. "Art News and Comments," *New York Daily Tribune,* 6 January 1884, p. 4. A later article states that a total of $14,000 was raised (Montezuma, "My Note Book," *The Art Amateur* 10, no. 3 (February 1884), p. 58).

Chapter 8

1. Clarence Cook, "The Painters in Pastel — A Noteworthy Little Display," *The Springfield Republican,* 27 June 1888.

2. Montezuma, "My Note Book," *The Art Amateur* 8, no. 2 (January 1883), p. 29; no. 5 (April 1883), p. 101; and no. 3 (February 1884), p. 58.

3. James Carroll Beckwith, *Diary,* 18 January 1884, National Academy of Design, New York. Details of the organization of the Pastel Exhibition are taken from the 1884 *Diary.*

4. Ibid., 25 January 1884. Chase dined with Beckwith, Blum, and Jones (Francis Coates Jones or Hugh Bolton Jones) to discuss final plans for the spring exhibition.

5. The next meeting of the group had to be delayed until February fourteenth since Beckwith and Chase spent the first week of February in Washington, D.C., testifying before a sub-committee of a Congressional Ways and Means Committee on the unfair tariffs placed on the importation of foreign art (Ibid., 4-6 February 1884). Beckwith was president of the Free Art League, and at one point Chase was its vice-president (Ibid., 29 March 1889). The tarriff issue concerned Chase throughout his life. He was quoted as late as 1909 as stating, "You cannot put too strongly my approval of the abolition of the art duty," which apparently was at last imminent ("Many Art Works to be Rushed In," *The New York Times,* 20 June 1909, section 3, p. 2).

6. The exhibition opened a week later than the original date, March sixth, that was agreed on in January (Beckwith, *Diary,* 30 January 1884).

7. Beckwith, *Diary,* 15 March 1884.

8. W.P. Moore Gallery, *Initial Exhibition of Painters in Pastel, March 17-12, 1884,* exh. cat., (New York, 1884). S.G. McCutcheon was active in New York 1878-1883 (Clark Marlor, *A History of the Brooklyn Art Association with an Index of Exhibitions* (New York: James F. Carr, 1970), p. 271).

9. M.G. van Rensselaer, "American Painters in Pastel," *The Century Magazine* (December 1884), p. 205.

10. "The First Exhibition of the American Painters in Pastel," *The Art Journal,* 10 (1884), p. 189.

11. "Art News and Comments," *New York Daily Tribune,* 20 January 1884, p. 4.

12. In 1884 Chase exhibited *Girl in Black; Still Life; Flowers; Oriental Sketch; North Sea, Holland; Dutch Orphan; Bit of Holland Meadows; A Child; Surprise; The Japanese Book; The Dividing Line; Canal in Holland; Portrait; May I Come In; Dutch Canal; In the Studio;* and *Moi?* (Moore Gallery, *Initial Exhibition*).

13. Beckwith went on to say, "Yet I am glad that Blum has met with such success" (*Diary,* 29 March 1884). Blum sold at least four works from this show. (Bruce Weber in a letter to the author, dated 16 May 1983).

14. "Art News and Notes," *The Art Interchange* (3 December 1885), p. 152.

15. Katherine Metcalf Roof, *The Life and Art of William Merritt Chase* (1917; New York: Hacker Art Books, 1975), pp. 147-48.

16. Most of the works exhibited in Chicago had been seen in New York in the 1884 exhibition of the Society of Painters in Pastel.

17. Once again, many of the pastels had been exhibited previously, and although there were approximately fifteen that were being exhibited for the first time, few of them were likely recent works.

18. H. Wunderlich & Co., *Second Exhibition of the Painters in Pastel at the Gallery of Messrs. H. Wunderlich & Co., 868 Broadway, New York, May 7-26, 1888,* exh. cat., (New York, 1888).

19. In 1888 Chase exhibited *My Baby; Shelter House, Prospect Park; Pure; Sunlight and Shadow; A Squatter's Hut, Flatbush;* and *Portrait* (Ibid.).

20. M.G. van Rensselaer, "An Exhibition of Pastels," *The Independent*, 24 May 1888, p. 647. *Pure*, present location unknown.

21. Cook, "The Painters in Pastel."

22. Kenyon Cox, "William M. Chase, Painter," *Harper's New Monthly Magazine* 78 (March 1889), pp. 556-57.

23. Beckwith, *Diary*, 20 April 1889.

24. "The Pastel Exhibition," *The Art Amateur* 21, no. 1 (June 1889), p. 4.

25. Bruce Weber in a letter to the author, dated 16 May 1983.

26. Beckwith, *Diary*, 14 May 1889.

27. "The Pastel Exhibition," *The Art Amateur* 23, no. 1 (June 1890), p. 4. Dates of the show and its contributors are taken from this article.

28. Bruce Weber in conversation with author in May 1983. Beckwith notes in his diary for May eighth that "Blum gave a dinner tonight, it has lasted until 4 of the morning. Blum starts for Japan on Sunday" (*Diary*, 1890).

29. *Mr. J. Henry Harper*, present location unknown.

30. *Little Miss H.*, present location unknown; *Afternoon by the Sea*, present location unknown. The latter was described as large and a work that had been seen before.

31. "The Pastel Exhibition," *The Art Amateur* 23, no. 1 (June 1890), p. 4.

32. Beckwith, *Diary*, 12 April 1890.

33. *Hall at Shinnecock*, private collection; *In the Studio (Interior: Young Woman Standing at Table)*, Hirshhorn Museum and Sculpture Garden, Smithsonian Institution.

34. For more information on De Nittis, see Dianne H. Pilgrim, "The Revival of Pastels in Nineteenth Century America: The Society of Painters in Pastel," *The American Art Journal* 10, no. 2 (November 1978), pp. 43-62.

35. *Still Life (Brass and Glass)*, collection of Mr. and Mrs. George J. Arden; *The White Rose (Miss Jessup)*, Phoenix Art Museum.

Chapter 9

1. Much of the information in this section is based on Chase's account of his summer with Whistler, "The Two Whistlers: Recollections of a Summer with the Great Etcher," *The Century Magazine* 80 (June 1910), pp. 219-26. Katherine Metcalf Roof reproduced this article almost verbatim in her *The Life and Art of William Merritt Chase* ((1917; New York: Hacker Art Books, 1975), chapters 11 and 12 *passim.*), but also chronicled their relationship through Chase's letters to Alice Gerson, and later, Whistler's letters to Chase. Chase noted in his article that he first thought of approaching Whistler on an 1885 trip to London and Madrid, but did not get his courage up to do so until the following year. This is apparently a typographical error, since their meeting in London is firmly documented as occurring in 1885.

Chase's interest in Whistler's art clearly predates his visit. No doubt he would have been familiar with Whistler's reputation during his student years abroad; he certainly would have been aware of the highly publicized trial of Whistler vs. Ruskin in 1878. During that same year, Whistler's work was included in the annual exhibition of the Society of American Artists, and the following year an early self portrait of Whistler was included in an exhibition organized by Chase and his colleagues at the Art Students' League. In the fall of 1881 Whistler's famous painting *Arrangement in Gray and Black: Portrait of the Artist's Mother* was exhibited at the Pennsylvania Academy of the Fine Arts' annual exhibition, and the next year it was featured at the annual showing of the Society of American Artists in New York. Also, as noted earlier, one of Whistler's watercolors was selected by Chase and his committee to be included in the Bartholdi Pedestal Loan Fund Exhibition in 1883. Chase also had the opportunity to see paintings by Whistler that were included in the Paris Salon exhibitions of 1882, 1883, and 1884.

2. J. Walker McSpadden, *Famous Painters of America* (New York: Thomas Y. Crowell & Co., 1907), pp. 337-38.

3. William Merritt Chase, "Velasquez," *Quartier Latin* 1, no. 1 (July 1896), p. 5.

4. Chase, "The Two Whistlers," p. 223.

5. "Some Students' Questions Briefly Answered by Mr. W.M. Chase," *The Art Amateur* 36, no. 3 (March 1897), p. 68.

6. Chase, "The Two Whistlers," p. 223. When Chase questioned Whistler about this remark, Whistler replied, "'You don't suppose I couple myself with Velasquez, do you? I simply wanted to take her down a bit, that's all'" (Ibid.).

7. Ibid., p. 219.

8. Roof, *Chase*, p. 112.

9. Ibid., p. 114.

10. Ibid., p. 112. While in London, Chase also encountered Samuel Dodd, one of the St. Louis patrons who had funded his early studies in Munich, and renewed their friendship (Ibid., pp. 112-14).

11. Chase, "The Two Whistlers," p. 219.

12. Ibid.

13. Ibid.

14. Ibid., p. 220.

15. Roof, *Chase*, p. 114.

16. Chase, "The Two Whistlers," p. 220.

17. Roof, *Chase*, pp. 142-44, reproduced a letter from Whistler regarding this situation, and explained the matter in greater detail.

18. Chase, "The Two Whistlers," p. 220.

19. Ibid., p. 224.

20. Ibid., pp. 224-25.

21. Ibid., p. 223.

22. Ibid., p. 225.

23. Ibid. Although he is not mentioned in Chase's article, Mortimer Menpes apparently accompanied them to Antwerp. He related a different version of the final break, stating that Chase was so upset by Whistler's facetious comments about the exhibition they saw, that "he flew out of the gallery, and went to bed, ill; and there we left him to recover while we went on to Holland" (*Whistler As I Knew Him*, London: Adam and Charles Black, 1904, p. 151).

24. Chase, "The Two Whistlers," p. 226.

25. Ibid., p. 222; 226.

26. Roof, *Chase*, p. 140.

27. Ibid., p. 141.

28. James Abbott McNeill Whistler, *The Gentle Art of Making Enemies*, (9th ed.; London: William Heinemann, 1922), p. 185. Two of Whistler's associates, Joseph Pennell and Mortimer Menpes, mention his portrait of Chase. Pennell described it as "a full-length of Chase, in frock-coat and top hat, a cane held jauntily across his legs" (E.R. and Joseph Pennell, *The Life of James McNeill Whistler* (London and Philadelphia: William Heinemann and J.B. Lippincott Co., 1908), vol. 2, p. 29); Menpes remembers the portrait as "never quite completed, although the Master worked on it for some weeks" (*Whistler* p. 145).

29. T., "A Boston Estimate of a New York Painter," *The Art Interchange* (4 December 1886), p. 179.

30. "The William M. Chase Exhibition," *The Art Amateur* 16, no. 5 (April 1887), p. 100.

31. Montezuma, "My Note Book," *The Art Amateur* 25, no. 3 (August 1891), p. 48.

32. Ibid.

33. "William M. Chase and His Friend Whistler," *The Boston Herald*, 28 March 1911.

34. Dorothy Weir Young, *The Life and Letters of J. Alden Weir* (New Haven: Yale University Press, 1960), p. 204.

35. Ibid., p. 205.

36. Roof, *Chase*, p. 145.

37. Katherine Metcalf Roof, "William Merritt Chase: The Man and the Artist," *The Century Magazine* 93 (April 1917), p. 834.

38. Chase in a letter to Alice Gerson, dated 8 August 1885, Archives of American Art, Smithsonian Institution, Roll P73; also reproduced in Roof, *Chase*, p. 114.

39. Royal Cortissoz, "The Field of Art," *Scribner's Magazine* 81, no. 16 (February 1927), p. 218.

40. Roof, *Chase*, p. 207.

41. "Chase's Portrait of Whistler," *Boston Transcript*, 31 December 1917. George Grey Barnard was commissioned by Charles P. Taft to sculpt a memorial to Lincoln for the city of Cincinnati. Striving for a realistic portrayal, Barnard used a life mask taken of Lincoln in 1860 and as his model a 6' 4" forty-year-old farmer from Kentucky. When the statue was unveiled in early 1917, it created controversy very similar to the reaction caused by Chase's portrait of Whistler. Barnard was accused of "creating a portrait...that showed him as a coarse, imbecile dolt, with oversized hands and feet, and clothes that were excessively baggy and rumpled....The critics interpreted [the expression on Lincoln's face] as vacant stupidity" (Wayne Craven, *Sculpture in America* (New York: Thomas Y. Crowell & Co., 1968), p. 449).

42. "Chase's Portrait."

Chapter 10

1. William M. Chase, "The Two Whistlers — Recollections of a Summer With the Great Etcher," *The Century Magazine* 80 (June 1910), p. 224.

2. W.H. Fox, "Chase on 'Still Life'," *The Brooklyn Museum Quarterly* 1 (January 1915), p. 198.

3. Marietta Minnigerode Andrews, *Memoirs of a Poor Relation* (New York: E.P. Dutton, 1927), p. 396.

4. Fox, "Still Life," p. 198.

5. Ibid.

6. William M. Chase, "Painting," *The American Magazine of Art* 8, no. 2 (December 1916), p. 50.

7. William Merritt Chase, "Address of Mr. William M. Chase Before the Buffalo Fine Arts Academy, January 28, 1890," *The Studio* 5, no. 13 (1 March 1890), pp. 121-22.

8. Guy Pène Du Bois, *Artists Say the Silliest Things* (New York: American Artists Group, Inc., 1940), p. 85.

9. Henrietta Gerwig, *Fifty Famous Painters* (New York: Thomas Y. Crowell & Co., 1926), p. 384.

10. J. Walker McSpadden, *Famous Painters of America* (New York: Thomas Y. Crowell & Co., 1907), p. 344.

11. Charles Hargens, "Notes Just as They Were Written in My Diary," cit. A. Milgrome, *The Art of William Merritt Chase*, Ph.D. diss. (University of Pittsburg, 1969), p. 143.

12. "William Merritt Chase," *The Outlook*, 114 (8 November 1916), p. 538.

13. "Seventh Exhibition of the Society of American Artists," *The Art Interchange* (5 June 1884), p. 136.

14. McSpadden, *Famous Painters*, p. 344.

15. F. Usher De Voll, "Reminiscences of a Student," cit. Milgrome, *Chase*, p. 125.

16. Rosina H. Emmet, "The Shinnecock Hills Art School," *The Art Interchange* 31 (October 1893), p. 89.

17. Hargens, "Notes," p. 144.

18. Pène Du Bois, *Silliest Things*, p. 85.

19. Chase, "Address — Buffalo," p. 122.

20. William M. Chase, "Address Given at The Metropolitan Museum of Art, New York City, January 15 1916 — 8 p.m.," cit. Milgrome, *Chase*, p. 113.

21. Andrews, *Memoirs*, p. 398.

22. "Notes from Talks by William M. Chase: Summer Class, Carmel-By-The-Sea, California, Memoranda from a Student's Note Book," *The American Magazine of Art* 8 (September 1917), p. 438.

23. "A School on the Sands," *The Brooklyn Daily Eagle*, 14 October 1894, p. 9.

24. William Merritt Chase, "Talk on Art by William M. Chase," *The Art Interchange* 39 (December 1897), p. 126.

25. "Address of Charles W. Hawthorne," *Memorial Exercises Attending the Unveiling of a Bust of William Merritt Chase*, New York University, 29 May 1923, p. 9.

26. Walker, *Famous Painters*, p. 351.

27. Chase, "Address — Metropolitan," pp. 122-23.

28. Andrews, *Memoirs*, p. 394.

29. Chase, "Address — Metropolitan," p. 108.

30. William M. Chase, "Painting," *The American Magazine of Art* 8 (December 1916), p. 52.

31. Chase, "Talk on Art," p. 127.

32. Chase, "Address — Buffalo," p. 122.

33. William M. Chase, "The Import of Art: An Interview with Walter Pach," *The Outlook* 95 (25 June 1910), p. 444.

34. Perriton Maxwell, "William Merritt Chase — Artist, Wit and Philosopher," *The Saturday Evening Post* (4 November 1899), p. 347.

35. Chase, "Painting," p. 52. Among examples of Chase's own paintings that reflect such sentiment are *Broken Jug*, c. 1877, and *Portrait of a Lady (Harriet Hubbard Ayer)*, 1880, California Palace of the Legion of Honor, San Francisco. (This portrait was cut down by the artist.)

36. Andrews, *Memoirs*, p. 397.

37. Chase, "Talk on Art," p. 126.

38. Chase, "Address — Metropolitan," p. 116; "Notes from Talks," p. 434.

39. "From a Talk by William M. Chase with Benjamin Northrup of The Mail and Express," *The Art Amateur* 30, no. 3 (February 1894), p. 77.

40. Elizabeth W. Champney, *Witch Winnie at Shinnecock* (New York: Dodd, Mead & Co., 1894), pp. 28-29.

41. William M. Chase, "Artists' Ideals," *The House Beautiful* 23 (February 1908), p. 12.

42. Ibid.

43. "A School on the Sands."

44. "Notes from Talks," p. 437.

45. William M. Chase, "Velasquez," *Quartier Latin* 1, no. 1 (July 1896), p. 4.

46. Chase, "The Two Whistlers," p. 224.

47. Chase, "Velasquez," p. 4.

48. Ibid.

49. William M. Chase, "The Danger of Art Schools," *Metropolitan Magazine*, unidentified clipping, artist's clipping file, Corcoran Gallery of Art, Washington, D.C.

50. Chase, "Address — Buffalo," p. 123.

51. According to listings in the *American Art Annual*, from 1900 to 1906 Chase taught advanced painting in Hartford, Connecticut. Classes were sponsored during these years by the Art Society, and held at the Wadsworth Atheneum. However, Eugene R. Gaddis, archivist at the Wadsworth Atheneum, was unable to provide any information about the Society or Chase's classes in Hartford, as early records are not fully organized at present (Gaddis in a letter to Beverly Rood, dated 3 March 1983, on file with the author).

52. Along with Chase's many school affiliations, private instruction was offered in his various studios, first in his celebrated Tenth Street Studio, acquired in 1878 and maintained until 1896. Among his first private students there were Dora Wheeler [Keith] and Rosina Emmet [Sherwood] (Katherine Metcalf Roof, *The Life and Art of William Merritt Chase*, (1917; New York: Hacker Art Books, 1975), p. 85). Others who received private instruction from Chase there include Irving R. Wiles, Reynolds Beal, Rosalie Gill and Henry G. Thomson — all of whom painted renditions of it.

53. "The Meaning of American Art," *The New York Times*, 12 December 1878, p. 4.

54. Chase, "Address — Buffalo," p. 125.

55. William C. Brownell, "Art Schools of New York," *Scribner's Monthly* 16, no. 6 (October 1878), p. 777; 781.

56. "The Art Students' League," *The Art Amateur* 2, no. 2 (January 1880), p. 24.

57. Marchal E. Landgren, *Years of Art: The Story of the Art Students League* (New York: Robert M. McBride & Co., 1940), p. 35.

58. Clark S. Marlor, *A History of The Brooklyn Art Association with an Index of Exhibitions.* (New York: James F. Carr, 1970), p. 54. Information about The Brooklyn Art Association was taken from this source.

59. Clark S. Marlor in a letter to the author, dated 5 November 1976. Chase's permanent replacement was George De Forest Brush.

60. At this time, Chase occupied for a brief period (1897-98) a studio located at 108 East Twenty-third Street. Since he was so involved in establishing the Chase School of Art, it is unlikely that he offered private instruction in this temporary studio. In 1899 he moved to a studio located at 303 Fifth Avenue, where he remained through 1907, and where he probably resumed teaching privately.

61. "The Reward of Art," *The Art Amateur* 34, no. 5 (April 1896), p. 107.

62. The New York School of Art was located at 57 West 57th Street until 1906, when it moved to 2237 Broadway, at 80th Street.

63. "The Chase School of Art and the Art Students' League," *The Art Amateur* 35, no. 5 (October 1896), p. 91. Tuition for the Chase School was "$8.00 per month, $50.00 per year of 8 months by the half day. $16.00 per month, $100 per year of 8 months by the day, for any of the classes" ("Preliminary Announcement of the Chase School of Art" Archives of American Art, Smithsonian Institution, Roll P73, frame 302).

64. Spencer H. Coon, "The Work of William M. Chase as Artist and Teacher," *Metropolitan Magazine* 5, no. 4 (May 1897), p. 311.

65. "Art School News and Notes," *The Art Amateur* 37, no. 1 (June 1897), p. 144.

66. De Voll, "Reminiscences," p. 125.

67. Frank Alvah Parsons, "Paris Ateliers of the New York School of Fine and Applied Art," (Paris: New York School of Fine and Applied Art, 1930), p. 39.

68. De Voll, "Reminiscences," p. 125.

69. Ibid., p. 127.

70. Pène Du Bois, *Silliest Things*, p. 85.

71. De Voll, "Reminiscences," pp. 126-27.

72. Pène Du Bois, *Silliest Things*, p. 84.

73. Ibid.

74. Ibid., p. 86.

75. Ibid., p. 90; 89.

76. William Innes Homer, *Robert Henri and His Circle* (Ithaca: Cornell University Press, 1969), p. 106.

77. Pène Du Bois, *Silliest Things*, p. 86.

78. Ibid., p. 84; 89.

79. Ibid., p. 89.

80. "Wm. M. Chase Forced Out of New York Art School; Triumph for the 'New Movement' Led by Robert Henri," *New York American*, 20 November 1907, p. 3.

81. Homer, *Henri*, p. 133.

82. "Chase, Nettled, Leaves Art School He Founded," *New York World* (21 November 1907), p. 8.

83. Information on Henri's career is based on Homer, *Henri*, pp. 126-56.

84. Vassar College Art Gallery, Poughkeepsie, New York. At this time Chase reportedly had several studios, including a luxurious space located at 33 Fourth Avenue which he maintained until his death. This studio was fully described in a contemporary account: "The Fourth Avenue Studio was even more spacious than the Tenth Street place. Partitions were taken down until a connecting chain of four rooms remained, two of which were extremely large....Rich draperies, Spanish, Italian, Chinese, and Japanese embroideries were in evidence on all sides. Pictures of his own and of other painters, including a few old masters, stood about or were hung on the walls. Beautiful old furniture, including some rare Spanish pieces, bits of porcelain, brass, copper, Japanese carvings; miscellaneous *objets d'art*, Italian, French, Dutch, Spanish, and Oriental, were set each in the exactly right place for the taste that can enjoy such multitudinous ornament!" (Roof, *Chase*, p. 229). Chase instructed his private pupils in the space on the floor below. There has been some confusion as to when Chase established his Fourth Avenue Studio. Roof stated that this move took place in 1908 (Ibid.), a claim supported by the listing for Chase in the New York City Directory for that year. However, Molly Nesbit has pointed out that an article published in the *New York Evening Post*, 27 April 1907 already mentions Chase's Fourth Avenue Studio ("William Merritt Chase: An Art Atmosphere in New York," class paper, Vassar College, 1973). An article released in 1909 suggests that Chase maintained both studios during this period, with the Fifth Avenue Studio, close to the Waldorf Astoria, being used for "posing his high-rank portrait patrons" (James William Pattison, "William Merritt Chase, N.A." *The House Beautiful* 25 (February 1909), p. 53). Although there is no listing for the Fourth Avenue Studio in the New York City Directory after 1910, Roof stated that Chase taught at this studio through the end of 1915. She claimed that he intentionally kept the listing out of the directory in order to ensure his privacy (*Chase*, p. 229).

85. Homer, *Henri*, p. 126.

86. Ibid., p. 133.

87. "Notes from Talks," p. 437.

88. The history of The Pennsylvania Academy during this period is drawn from The Pennsylvania Academy of the Fine Arts, *In This Academy: The Pennsylvania Academy of the Fine Arts, 1805-1976;* exh. cat., text by Frank Goodyear, Jr., et al. (Philadelphia, 1976), pp. 179-81. (Pennsylvania Academy of the Fine Arts is hereinafter abbreviated "PAFA.")

89. Critical reaction, however, was mixed. In 1892 one critic for the *Philadelphia Evening Item* complained that Chase had "three conspicuously disagreeable full length portraits, with mysterious titles, such as 'Mrs. X — lady in brown,' and 'Mrs. X — lady in black,' and 'Alice.' It would be hard to say which is the worst of the three." Nevertheless, he praised Chase's *Still Life*, as being "decidedly meritorious, and his best contribution ("A Very Fine Exhibition," *The Item,* 14 February 1892. PAFA Scrapbooks, Archives of American Art, Smithsonian Institution, Roll P53, frame 400).

90. Pattison, "William Merritt Chase, N.A.," p. 56.

91. The painting was purchased for the ridiculously low sum of $500. Apparently Chase realized that his ultimate gain in having it represented in the Academy's prestigious collection would far surpass any immediate gain he might obtain by asking for more money. In a telegram to Morris, Chase stated: "I want the Academy to have the portrait, therefore accept offer. Do not make known price" (Archives of American Art, Smithsonian Institution, Roll P73, frame 307).

92. Morris, *Confessions,* p. 69.

93. "Wm. M. Chase's New Field," Unidentified news clipping, Philadelphia, 18 August 1896, copy in possession of the author. On 3 October 1896, it was recorded in the Academy's minutes that William Merritt Chase had been "secured for the position made vacant by Mr. Joseph De Camp, at a salary of Two Hundred and Fifty Dollars per month and railroad expenses, and that he agreed to give two days of his time each week to such instruction as was desired of him" (Minutes, PAFA Committee on Instruction, 3 October, 1896, p. 44, courtesy Doreen Bolger Burke).

94. Morris, *Confessions,* p. 70. Although little has been recorded about Chase's relationship with Thomas Eakins, they appear to have been close friends. Lloyd Goodrich discusses their association in his recent book, *Thomas Eakins* 2 Vols. (Cambridge: Harvard University Press, 1982), and states that after Winslow Homer and John Singer Sargent, Eakins considered Chase to be one of the most important American artists of their day. Chase and Eakins had early contact through their involvement with the Society of American Artists. Later, apparently during the period that Chase was teaching in Philadelphia, Eakins painted a portrait of him (Hirshhorn Museum and Sculpture Garden, Smithsonian Institution). Lloyd Goodrich asserts that at this time, c. 1899, Chase painted Eakins' portrait as well, which he believes was destroyed by Mrs. Eakins in later years. However, no specific reference to this work has yet been uncovered in the literature or in exhibition records. Chase owned at least two paintings by Eakins: *Arcadia,* The Metropolitan Museum of Art, sold in Chase's 1917 estate sale as *Idyl,* and *Sailing,* Philadelphia Museum of Art, which was inscribed "To his friend William M. Chase, Eakins." Goodrich has noted that although the two artists were opposites in every way, they were good friends, and that "according to [Samuel] Murray, Chase was often in Eakins' studio. He was a crack shot with the revolver, as was Eakins. Murray said they rigged up a shooting gallery in the cellar, with an iron sheet to stop the bullets" (Goodrich, *Eakins,* p. 220). However, Murray, who was Eakins' close friend, disliked Chase and claimed that he discouraged prospective patrons from going to Eakins (noted in Phyllis D. Rosenzweig, *The Thomas Eakins Collection of the Hirshhorn Museum and Sculpture Garden,* (Washington: Smithsonian Institution Press, 1977), vol. 2, p. 171).

95. Morris, *Confessions,* p. 93.

96. These and other details relating to Chase's tenure at PAFA are taken from the Committee on Instruction's minutes during that time.

97. Although a contemporary review of Chase's Chicago exhibition claimed that there were seventy-five works in the show, only seventy-one are listed in the catalogue. Another, *Alice* (credited as being donated to the Art Institute by Ernest A. Hamill in 1893) is illustrated but not listed; therefore it is conceivable that there were several works added to the show but not included in the catalogue. The majority of the works were offered for sale, with the exception of five that were lent by the noted Chicago collector Potter Palmer, and one lent by James H. Dole ("William M. Chase, His Life and Work, *Arts for America,* 7, no. 4 (December 1897), p. 197).

98. "His Life and Work," p. 200; 197.

99. Walter Pach, *Queer Thing, Painting* (New York: Harper & Brothers, 1938), pp. 9-10.

100. Constance Rourke, *Charles Sheeler: Artist in the American Tradition* (New York: Harcourt, Brace and Company, 1938), p. 19.

101. Ibid., p. 22.

102. James Daugherty, Interview with author, 14 July 1973.

103. Ibid.

104. Jo Mielziner, "Arthur Carles: The Man Who Paints with Color," *Creative Art Supplement* (February 1928), p. xxxii.

105. Morris, *Confessions,* p. 94. The Philadelphia City Dirctory for 1897 lists a William M. Chase, collector, at 3961 Warren. However, no definite listing for Willliam Merritt Chase appears until ten years later. In 1907 Chase opened a studio in Philadelphia, which was used both for his own work and for private instruction. At first his studio was listed in the Philadelphia City Dirctory as 1001 Bailey Building; the following year it was listed as 1002 Bailey Building, which it remained until 1913. Apparently with his trips to Europe and California in 1914, there was not enough time remaining to justify keeping a Philadelphia studio that year. He did, however, return to Philadelphia in 1915, at which time he opened his last studio in that city at 2769 Ash Building. His studios in Philadelphia were, of course, just intended for part-time use; his residence remained in New York, where he spent most of his time.

106. Roof, *Chase,* pp. 309-10.

107. Riter Fitzgerald, "Academy of the Fine Arts Forty Years Ago!' *The Item,* undated, 1901. PAFA Scrapbooks, Archives of American Art, Smithsonian Institution, Roll P53, frame 501.

108. Riter Fitzgerald, "The Academy Agitated," *The Item,* 19 December 1901, PAFA Scrapbooks, Archives of American Art, Smithsonian Institution, Roll P53, frame 494.

109. "The Unhappy Chase," *The Item,* n.d., artist's clipping file, Corcoran Gallery of Art, Washington, D.C.

110. Ibid.

111. Riter Fitzgerald, "Chase Deposed," *The Item,* 10 September 1909, artist's clipping file, Corcoran Gallery of Art, Washington, D.C.

112. *John Sloan's New York Scene,* ed. Bruce St. John, intro. Helen Farr Sloan (New York: Harper & Row, 1965), 13 September 1909, p. 333.

113. Hargens, "Notes," 20 October 1913, p. 142. Little else is known about this school. It likely served as a studio for the painting of his Philadelphia portrait commissions. A description of it given by this student suggests that it might be the studio interior depicted in a photograph in the William Merritt Chase Archives of The Parrish Art Museum, Southampton, N.Y., which is identified as Chase's Philadelphia studio.

114. " 'The Shinnecock Hills Art School' (a branch of the Brooklyn Art School) held a very interesting exhibition at Sanchez's in W. 23rd St., of the summer work of the pupils of Mr. William M. Chase. This consisted chiefly of sketches, although there were some finished pictures of remarkable technical merit. The practical side of landscape painting is what is chiefly aimed at in this school, and it must be conceded that this is well taught. In nearly all the examples shown one notes a genuine feeling for the facts of nature; the poetry will come later to those who have not mistaken their vocation. Praise must especially be awarded to Mr. Charles F. Naegle and Miss Lydia Field Emmet. Good work was also shown by Miss Elizabeth Strong, Mr. Howard Chandler Christy, Miss Elizabeth Curtis, Mr. Ernest Meyer, Mr. Charles Langley and Mr. Addison T. Millar" (*The Art Amateur* 30, no. 6 (May 1894), p. 172).

115. Rockwell Kent, *It's Me, O Lord,* (New York: Dodd, Mead & Co., 1955), p. 76.

116. Roof, *Chase,* p. 162.

117. *The Southampton Press,* 28 August 1897.

118. *New York World,* 2 February, 1891. Which Mrs. Astor or Mrs. Whitney has not been established.

119. "W.M. Chase," *The Nation* 103, no. 2679 (2 November 1916), p. 428.

120. "Fully one third of the number are professional artists or art students returned from foreign ateliers glad to obtain a little of that frank criticism which one can get in Europe, but which our brothers here, restrained by false ideas of courtesy, are very chary about giving us" (Champney, *Witch Winnie,* p. 13).

121. "A School on the Sands."

122. Samuel Parrish provided the building in which the club was housed, and Mrs. Hoyt apparently screened its residents (John Gilmer Speed, "An Artist's Summer Vacation," *Harper's New Monthly Magazine* 87, no. 517 (June 1893), p. 14). Sometimes referred to as the "Girl's Club," the Art Club "held occasional lectures, exhibitions, and sales, and the building was not held entirely sacred to art, but was opened for the dances, tableaux, concerts, etc., in which the lively young students found relaxation; and not the students alone, for the fashionables of Southampton highly appreciated an invitation to the studio, while the students as a rule resisted the seductions of Southampton merrymaking with a praiseworthy devotion to work" (Champney, *Witch Winnie* pp. 19-20).

123. *In the Studio (Young Woman Standing at Table)* is reproduced in my *William Merritt Chase* (New York: Watson Guptill, 1979), p. 65. The studio is also pictured in *A Friendly Call,* National Gallery of Art, reproduced herein, p. 165.

124. Roof, *Chase,* p. 176. *Idle Hours,* Amon Carter Museum, Fort Worth; *The Bayberry Bush,* The Parrish Art Museum, Southampton, New York.

125. Emmet, "The Shinnecock Hills Art School," p. 89.

126. McSpadden, *Famous Painters,* p. 340.

127. Ibid.

128. Speed, "Summer Vacation," pp. 9-10.

129. Private collection.

130. Roof, *Chase,* p. 187.

131. "A School on the Sands."

132. Reynolds Beal Papers, Archives of American Art, Smithsonian Institution, Roll 286.

133. Cit. Milgrome, *Chase,* p. 140.

134. William B. M'Cormick, "Christy Turns to the Portrait," *International Studio* 76, no. 305 (October 1922), p. 60.

135. Kent, *O Lord,* p. 80.

136. Roof, *Chase,* p. 185.

137. Andrews, *Memoirs,* p. 391.

138. Champney, *At Shinnecock,* p. 26.

139. Ibid., pp. 269-70.

140. After Chase's classes at Shinnecock Hills were discontinued, other artists scheduled summer classes at various spots on Long Island, including Hampton Pines, Bayport, Good Ground, Belle Terre, and Southampton.

141. "Art School's Trip Abroad," *The New York Times,* 4 September 1904, p. 5.

142. Ibid.

143. Chase, "Talk on Art," p. 127.

144. *The Art Amateur* 34, no. 5 (April 1896), p. 108.

145. Coon, "Artist and Teacher," p. 313.

Chapter 10 continued

146. Ibid. Another account reported that a second class would be held in Holland in 1897 ("Here and There," *The Arts*, unidentified clipping, artist's clipping file, Corcoran Gallery of Art, Washington, D.C.).

147. Brochure, "Chase Class in Holland, Summer of 1903," copy in possession of the author. The text in the following pages is written with the assumption that the plans described in such brochures did indeed take place. Additional confirmation of their activities has been noted when available.

148. The group was scheduled to leave New York on June twenty-fourth aboard the Holland-American Line's *Potsdam*, landing at Rotterdam, whence they were escorted to Haarlem. The students were also given the alternatives of leaving for Europe earlier to see the exhibitions at the Paris Salon and the Royal Academy in London or of remaining in Europe after the termination of the class since the steamship tickets could be used any time within a year.

149. Details about this trip are taken from Chase's letters to his wife, recorded in Roof, *Chase*, pp. 190-213. Chase may have met Roland, Edmond, or Charles Knoedler in Paris, who were all active in the gallery's business at the time, but it seems likely that it was Roland, for whom Chase named his second surviving son, Roland Dana, born 1901.

150. Roof, *Chase*, p. 192.

151. Ibid., p. 196.

152. Ibid., p. 200.

153. Ibid., p. 195.

154. This painting was described by Chase as being a picture of his daughter 'Cosy' (Alice Dieudonnée) holding a Japanese book (Roof, *Chase*, p. 202). Although the identity of this work has not yet been established, it is possible that it was Chase's painting *The Japanese Print*, which was included in the Munich Crystal Palace Exhibition of 1905 and is presently in the Neue Pinakothek, Munich. However, the model for this painting has been identified by Roof as Mrs. Chase (Katherine Metcalf Roof, "William Merritt Chase: The Man and the Artist," *The Century Magazine*, 93 (April 1917). p. 833). If Roof is correct, then Chase evidently referred to another painting, which has not yet been located.

155. Roof, *Chase*, p. 203; 204.

156. Ibid., p. 212.

157. During this trip abroad, Chase learned of the deaths of two of his artist friends, Robert Blum and James Abbott McNeill Whistler. Blum's death was reported to him in Paris by Alexander Harrison. The news of this tragic event shocked Chase. In writing to his wife, Chase lamented the loss of his dear friend: "I can't get it out of my head. Was he sick long? Just think of his being no more" (Roof, *Chase*, p. 193). Chase read of Whistler's death in a newspaper while he was conducting his class in Haarlem. In spite of their quarrels, Chase still revered Whistler's work and stated, "He will be very much missed as an artist" (Ibid., p. 207).

158. "Art School's Trip Abroad."

159. Ibid.

160. Ibid.

161. Brochure, "Chase Class in England, Summer of 1904," copy in possession of author. Once again, the class sailed on the *Potsdam*.

162. "Art School's Trip Abroad."

163. This prize was offered by the brother of George B. Whitney (a former pupil of Chase) in his memory. In return, Mr. Whitney's brother was to receive the painting that won the award (brochure, "In England").

164. Ibid.

165. Rourke, *Charles Sheeler*, p. 21.

166. Ibid., pp. 21-22.

167. "Art School's Trip Abroad."

168. " 'Get Together' Says Mr. Chase to Fellow Artists," *The New York Times*, 21 May 1905, p. 3.

169. "Art School's Trip Abroad."

170. Transcript of a recorded interview of Charles Sheeler by Martin Friedman, 18 June 1959, Walker Art Center, Minneapolis.

171. Roof, *Chase*, p. 220.

172. "Get Together."

173. *Spanish Gypsy*, present location unknown.

174. "Interesting Notes About Wm. M. Chase," *The New York Times*, 2 December 1906, p. 4.

175. Ibid.

176. "Works by Flemish and Modern Belgian Painters" included works by Frans Hals and Peter Paul Rubens as well as works by contemporary artists such as Alfred Stevens and James Ensor.

177. Ibid. "Sorolla y Bastida" was held at the Galerie George Petit, Paris, from 12 June to 10 July, and included 483 paintings and 13 drawings.

178. Fêtes de Rembrandt à Leyde" was held 15 July to 15 September. Twenty-five paintings and 100 drawings by Rembrandt were exhibited, along with works by other artists such as Jan Van Goyen and Adrian Van Ostade.

179. "Interesting Notes."

180. Their itinerary is drawn from the brochure "Chase Class in Italy: 1907, Fourth Season in Europe," copy in possession of the author. The class sailed aboard the *Romanic* of the White Star Line and arrived in Naples on June twenty-first.

181. Roof, *Chase*, p. 223-24.

182. According to Roof, Chase did have a group of students in Florence in 1909 (*Chase*, p. 231), but this must have been an informal class because the fifth of his summer classes in Europe was not held until 1910, at which time an announcement was released: "It will be welcome news to many to learn that for the summer of 1910 Mr. Chase has consented to accompany another (his fifth) art class to Europe...." (Brochure, "Chase Class in Italy, 1910 — Fifth Season in Europe," copy in possession of the author).

183. Roof, *Chase*, p. 225. Roof says that Chase was commissioned to paint a self-portrait for the Uffizi in 1908 (*Chase*, pp. 224-25). However, an article published in November of 1907 documents that the commission was received earlier than Roof remembered ("Wm. M. Chase Forced Out of New York Art School," p. 3). The actual painting was likely executed the following year, 1908.

184. Details about the trip are taken from "Fifth Season in Europe." According to this brochure, the group left New York on June second aboard the *Pannonia* of the Cunard Line and arrived in Naples June sixteenth. An unidentified clipping dated April 1910 (in possession of the author) corresponds to this brochure in all details but the ship taken and the arrival date. This article stated that the class would sail aboard the *Cretic* of the White Star Line and arrive in Naples on June twenty-first. Apparently Chase and his wife traveled separately from the class. *The Times* announced that "William M. Chase, the artist, sailed yesterday on the *Mauretania*, accompanied by his wife. He said they sailed to meet Colonel Roosevelt in England by appointment. Their wanderings abroad will take them to Florence, where the artist will take charge of a class of twenty-five pupils" ("Artist Off to Meet Roosevelt," *The New York Times*, 2 June 1910, p. 20). Mrs. Chase must have traveled with her husband for only part of the summer, as there is no mention of her in Beckwith's *Diary*, 1910 (National Academy of Design, New York), which chronicles his visit to Florence that summer and mentions Chase several times.

185. Gustav Kobbe, "The Artist of Many Studios," *The New York Herald*, 20 November 1910, Magazine Section, p. 11.

186. Ibid.

187. Beckwith, *Diary*, 2 August 1910.

188. Ibid., 12 August 1910. Beckwith stated "Then I met Case at the cafe...." Since no other "Case" is mentioned in this section of the diary and the description fits Chase's passion for collecting this must refer to Chase.

189. Ibid., 13 August 1910.

190. Beckwith noted in his diary "Chase came to the studio this morning. He has signed the papers for the purchase of the villa here..." (31 August 1910). Kobbe ("Many Studios, 20 November 1910") stated "Mr. William M. Chase early last summer bought a villa in Florence," which would also refer to the summer of 1910. However, as previously noted, Roof mistakenly claimed that Chase bought the villa in the summer of 1907, the year before she was invited to visit it. Chase probably only leased the villa during this period, purchasing it in the summer of 1910, when it was offered for sale.

191. Beckwith, *Diary*, 4 September 1910.

192. Pach, *Queer Thing, Painting*, p. 37.

193. Roof, *Chase*, p. 238. Information about the trip is found in Roof, pp. 237-38.

194. Brochure, "The Chase Art Class in Belgium, Season of 1912," copy in possession of the author. The class of forty pupils left New York in early June, aboard the *Vaderland* of the Red Star Line. They arrived in Antwerp on June eighteenth, where they stayed three days before moving on to Brussels, finally arriving in Bruges on the twenty-fourth.

195. Information about Chase's travels before he joined the class is taken from Roof, *Chase*, pp. 238-39.

196. "The Painter's Bruges," Harriet Blackstone Papers, Archives of American Art, Smithsonian Institution, Roll 1617.

197. Ibid., frames 1147-51.

198. Ibid., frames 1153-54.

199. Ibid., frames 1157-58.

200. Ibid, frames 1158-60.

201. Fox, "Still Life," p. 199.

202. Ibid., p. 200.

203. *Belgian Melon*, The Parrish Art Museum, Southampton, New York; *Just Onions*, Los Angeles County Museum of Art.

204. Brochure, "The Chase Art Class in Italy, 1913 — Eighth Season in Europe," copy in possession of the author. Details about the class are taken from this brochure. They left New York on May twenty-fourth abouard the Cunard Line steamship *Ivernia*.

205. Roof, *Chase*, p. 240. Details of this trip are drawn from Chase's letters, in Roof, pp. 240-44.

206. Ibid., p. 243.

207. Ibid., p. 242; 243.

208. Ibid., p. 246.

209. Ibid., p. 247. Details of this trip are drawn from Chase's letters, in Roof, pp. 247-50.

210. Eunice T. Gray, "The Chase School of Art at Carmel-by-The-Sea, California," *Art and Progress* 6, no. 4 (February 1915), p. 120. Information about the class is taken from this article.

211. Present location unknown.

212. Philbrook Art Center, Tulsa, Oklahoma.

213. Roof, *Chase*, p. 247.

214. Ibid., p. 250.

215. O'Keeffe in letters to the author, dated 18 August 1972 and 18 September 1972.

216. "Guy Pène Du Bois," *Life* Magazine, 20 June 1949, p. 66.

217. Gifford Beal, "Chase — The Teacher," *Scribner's Magazine* 61 (February 1917), p. 257.

218. The history of this commission is discussed in detail in Doreen Bolger Burke, *American Paintings in The Metropolitan Museum of Art, Vol. III: A Catalogue of Works by Artists Born between 1846 and 1864*, Kathleen Luhrs, ed., (New York: The Metropolitan Museum of Art, 1980), pp. 257-60.

219. Morris, *Confessions*, pp. 73-4. The story of the sitting is based on Morris, although he mistakenly said that it occurred in 1898.

220. Before the work was formally presented to The Metropolitan Museum of Art it was exhibited at M. Knoedler & Company in New York in 1902, as a benefit to raise the funds to pay Sargent for it.

221. Burke, *American Paintings*, p. 258.

222. Forty-two artists in addition to Chase were reprsented in the show, including Charles Hawthorne, Rockwell Kent, Edmund Greacen, Reynolds and Gifford Beal, Lydia Field Emmet, Ellen Emmet Rand, Henry Rittenberg and Eugene Paul Ullman. ("Tribute to William M. Chase," Memorial Hall, Southampton, L.I., 17 August to 5 September 1922.)

223. The bust was executed by Chase's former student Albin Polasek. New York University had already honored Chase by bestowing an honorary degree upon him in 1916.

224. W. Francklyn Paris, "William M. Chase," *Personalities in Art* (New York: Architectural Forum, 1930), pp. 107-08.

225. Among the nearly 100 former Chase students who contributed were Wayman Adams, Howard Chandler Christy, Eugene Paul Ullman, Lydia Field Emmet, Lilian Wescott Hale, Rosina Emmet Sherwood, Donna Schuster, and Elizabeth Sparhawk Jones.

226. "Address of Irving R. Wiles," *Memorial Exercises*, p. 11.

Chapter 11

1. "Art for Artists," *The Art Amateur* 2, no. 5 (April 1880), p. 90.

2. Ibid.

3. William H. Gerdts, *American Impressionism* (Seattle: Henry Art Gallery, University of Washington, 1980), p. 11.

4. See Ibid., pp. 27-31, for an in-depth discussion of the way the terms "impressionistic" and "impressionism" were used by artists and critics at the time.

5. J.F.B.W. "Society of American Artists," *The Aldine — The Art Journal of America* 9, no. 9 (1879), p. 278.

6. Katherine Metcalf Roof, *The Life and Art of William Merritt Chase* (1917; New York: Hacker Art Books, 1975), p. 95.

7. *Julian Alden Weir: An Appreciation of His Life and Works* (New York: The Century Club, 1921), pp. 86-87.

8. Gerdts, *American Impressionism*, p. 29. The show was entitled "Works in Oil and Pastel by the Impressionists of Paris," and the catalogue included an introduction by Theodore Duret (National Academy of Design Special Exhibition, American Art Association, 1886). The Academy rented the large gallery to the American Art Association for one month, beginning May 21, for $1300 (National Academy of Design Minutes, 10 May 1886).

9. "The Chase Exhibition," *American Art Illustrator* (December 1886), p. 99.

10. T., "A Boston Estimate of a New York Painter," *The Art Interchange* 17, no. 12 (4 December 1886), p. 179.

11. "The Chase Exhibition." "'The large Holland scene'" referred to here is likely *Sunlight and Shadow*, The Joslyn Art Museum, Omaha, Nebraska. Although the title *Sunlight and Shadow* was used for this work in the Chase estate sale catalogue, 1917, it is unlikely that it was exhibited under this title during Chase's lifetime. Establishing this work's original title has been complicated by the fact that an egg tempera painting exhibited under the title *A Summer Afternoon in Holland* and fully described in contemporary accounts clearly matches this work in every respect but its medium (see the review of the American Watercolor Society exhibition of 1886, *The New York Commercial*, artist's clipping file, New York Public Library). Yet, conservation work performed on *Sunlight and Shadow* in 1975 by Clements L. Robertson of the Saint Louis Museum of Art shows it to be an oil painting (telephone conversation with Henry Flood Robert, Jr., 14 July 1983). Therefore, there are either two works depicting the same subject in two different media, or the two titles refer to the same work and Chase duped the public and critics by convincing them that it was an egg tempera painting, making it eligible for inclusion in major watercolor shows such as that of the American Watercolor Society.

12. William M. Chase, "Address of Mr. William M. Chase Before the Buffalo Fine Arts Academy, January 28, 1890," *The Studio* 5, no 13 (1 March 1890), p. 122.

13. Ibid., p. 127.

14. Kenyon Cox, "William M. Chase, Painter," *Harper's New Monthly Magazine* 78 (March 1889), p. 556.

15. Charles De Kay, "Mr. Chase and Central Park," *Harper's Weekly* 35, no. 1793 (2 May 1891), p. 327.

16. "Original Notes of William M. Chase on his Talk to His Students in Philadelphia," n.d., copy in possession of the author.

17. Katherine Metcalf Roof, "William Merritt Chase: An American Master," *Craftsman* 18 (April 1910), p. 45.

18. No works by Sargent appear in auction records or have descended through the Chase family, yet Chase stated in 1912 that he owned a Sargent he "would not part with at any price " ("Whistler Painting is Sold for $825," *The New York Times*, 9 March 1912, p. 13).

19. It is important to note that this is a cumulative analysis based on auction records for 1896, 1912, and 1917. Chase may have owned works by other artists which were disposed of in other ways and thus have not been recorded.

20. "William Merritt Chase," *The Outlook* 114 (8 November 1916), p. 537.

21. "Many Art Works to be Rushed In," *The New York Times*, 20 June 1909, Section 3, p. 2.

22. "Notes from Talks by William M. Chase: Summer Class, Carmel-By-The-Sea, California, Memoranda from a Student's Note Book," *The American Magazine of Art* 8 (September 1917), p. 433.

23. Walter Pach, *Queer Thing, Painting* (New York: Harper & Brothers, 1938), p. 34.

24. Ernest Knaufft, "Sargent, Chase, and Other Portrait Painters," *The American Review of Reviews* 36 (December 1907), pp. 693-95.

25. *For the Little One*, The Metropolitan Museum of Art; *Hide and Seek*, The Phillips Collection, Washington, D.C.

26. A.E. Ives, "Suburban Sketching Grounds: Talk with Mr. W.M. Chase, Mr. Edward Moran, and Mr. Leonard Ochtman," *The Art Amateur* 25, no. 4 (September 1891), p. 80.

27. Collection of Thomas and Rebecca Colville.

28. William M. Chase, "Artists' Ideals," *The House Beautiful* 23, no. 3 (February 1908), p. 12.

29. "Notes from Talks," p. 433.

30. Chase, "Address — Buffalo," p. 123.

31. Other European artists represented in Chase's collection were: W.L. Bruckman (6), Mariano Fortuny y Carbó (4), Emile Auguste Carolus-Duran (1), Gaston de La Touche (4), Franz von Lenbach (2), Jules Bastien-Lepage (1), Hans Makart (1), Georges Michel (5), Louis Mettling (5), Adolphe Monticelli (8), Jean François Raffaelli (2), Martin Rico Ortigo (3), José Villegas Cordero (4), Joaquin Sorolla y Bastida (1), and Frank Bragwyn (2).

32. Pach, *Queer Thing, Painting*, p. 36.

33. "Notes from Talks," p. 437.

34. Ibid., p. 434.

35. Cox, "William M. Chase," p. 549.

36. "William Merritt Chase," p. 537.

37. Ibid.

38. "Original Notes."

39. Chase, "Address — Buffalo," p. 126.

40. Roof, *Chase*, pp. 180-81.

41. Marietta Minnegerode Andrews, *Memoirs of a Poor Relation* (New York: E.P. Dutton, 1927), pp. 393-94.

42. *Reflection*, collection of Mr. and Mrs. Raymond J. Horowitz; *At the Seaside*, The Metropolitan Museum of Art.

43. "A School on the Sands," *The Brooklyn Daily Eagle*, 14 October 1894, p. 9.

44. Ibid.

45. "Notes from Talks," p. 434.

46. Gerdts, *American Impressionism*, p. 24.

47. *Flowers, On the Lake, Study of Flesh Color and Gold, Grey Day*, and *Peonies* have not been positively identified at present. *Boat House, Prospect Park* is in a private collection. These works were all lent by Mr. Potter Palmer to Chase's one-man show at the Chicago Art Institute in 1897. *Flowers* was lent by Mr. H.O. Havemeyer to the Society of American Artists' 1892 exhibition, and was later sold as *Vase of Flowers* in April 1930 at the Anderson Galleries auction of Mrs. H.O. Havemeyer's collection.

Chapter 12

1. "Eleven Painters Secede," *The New York Times*, 9 January 1898, p. 12.

2. Edward Simmons, *From Seven to Seventy: Memoirs of a Painter and a Yankee* (New York: Harper & Bros., 1922), p. 221.

3. Dorothy Weir Young, *The Life and Letters of J. Alden Weir* (New Haven: Yale University Press, 1960), p. 199.

4. "American Painters' Display," *The New York Times*, 30 March 1898, p. 6.

5. "The Note Book," *The Art Amateur* 38, no. 2 (February 1898), p. 56.

6. National Gallery of Art, Washington, D.C.

7. Six of them, Benson, Hassam, Metcalf, Simmons, Tarbell, and Weir, were on the jury for the exhibition; Dewing and Reid were on the hanging committee, along with only one other artist, Dwight Tryon, whose aesthetic ideals would have conformed with theirs. The two major awards, the Webb Prize and the Shaw Prize were won by Metcalf and Benson.

8. *The New York Times*, 28 March 1896, p. 5.

9. In 1895 eight of the Ten were represented in the Society's show by a total of twenty-nine works; in 1896 nine of The Ten were represented with twenty works. In 1897 four of the Ten exhibited a total of seven works; only three (Dewing, Simmons, and Benson) were included on the jury of twenty-seven, and none were included on the hanging committee.

10. Young, *J. Alden Weir*, p. 198.

11. William H. Gerdts, *American Impressionism* (Seattle: Henry Art Gallery, University of Washington, 1980), p. 77.

12. James Carroll Beckwith, *Diary*, 1890 (National Academy of Design, New York), 20 April 1890.

13. James Carroll Beckwith, *Diary*, 1898 (National Academy of Design, New York), 2 April 1898.

14. "The Resignation from the Society of American Artists," *The New York Times*, 15 January 1898, p. 46.

15. Sadakichi Hartmann, *A History of American Art*, 2 vols.(Boston: L.C. Page & Co., 1902), vol. 2, pp. 247-48.

16. Simmons, *From Seven to Seventy*, pp. 221-22.

17. Ibid., p. 221.

18. Chase in a letter to Childe Hassam, dated 2 April 1905, American Academy of Arts and Letters, NAA-2:024. The Ten began exhibiting at the Montross Gallery at this time.

19. Charles De Kay, "The Society of Ten and the Other Society," *The New York Times*, 16 April 1905, Section 4, p. 8.

20. "Paintings at the Society," *The New York Times*, 11 April 1905, p. 11.

21. " 'Get Together,' Says Mr. Chase to Fellow Artists," *The New York Times*, 21 May 1906, p. 3.

22. Benson had already become an academician the previous year, and Weir and Dewing had been elected members long before The Ten had formed. In 1906, three of The Ten (Dewing, Hassam, and Weir) even exhibited at the last show of the Society of American Artists. Weir also exhibited at the Society's 1901 show.

23. "The Ten American Painters," *Arts and Decoration* (May 1913).

24. Collection of Dr. and Mrs. John J. McDonough.

25. *Self-Portrait (Portrait of the Artist)*, Art Association of Richmond, Richmond, Indiana; this particular still life is unidentified at present.

26. "The Ten Make a Good Show," *American Art News* (11 March 1916), p. 2.

27. Simmons, *From Seven to Seventy*, p. 221.

Chapter 13

1. William M. Chase, "Address Given at The Metropolitan Museum of Art, New York City, January 15, 1916 — 8 p.m.," cit. A. Milgrome, *The Art of William Merritt Chase* (Ph.D. diss., University of Pittsburgh, 1969), p. 116.

2. Roof mentioned two instances when Chase organized a Fourth of July party while abroad; once at Polling, while still a student, and many years later in Haarlem for his class of American students (Katherine Metcalf Roof, *The Life and Art of William Merritt Chase*, (1917; New York: Hacker Art Books, 1975), p. 51; 204).

3. "Chase's Americanism," *The Literary Digest* 53 (11 November 1916), p. 1251.

4. "The Conditions of Art in America," *North American Review*, no. 210 (January 1866), p. 1.

5. Lewis Mumford, *The Brown Decades: A Study of the Arts in America, 1865-1895* (New York: Dover Publictions, 1955), p. 190.

6. John Moran, "Artist-Life in New York," *The Art Journal* 6 (1880), p. 123.

7. William Merritt Chase, "Address Given Before the Buffalo Fine Arts Academy, January 28, 1890," *The Studio* 5, no. 13 (1 March 1890), p. 125.

8. "American and Foreign Art," *The New York Times*, 9 November 1879, p. 4.

9. "The Pastel Exhibition," *The Art Amateur* 10, no. 6 (May 1884), p. 123.

10. Montague Marks, "My Note Book," *The Art Amateur* 34, no. 3 (February 1896), p. 56. This article reported that "the gross receipts were barely $21,000. The highest sum offered for any of the artist's own work was $610...." An entry in J. Carroll Beckwith's diary indicates that little changed in the next ten years: "Gellatly calls on matter of sale of Twachtman's picture to Met. Museum. They seem singularly indifferent to American work" (James Carroll Beckwith, *Diary*, 1906, National Academy of Design, New York, 29 April 1906).

11. J. Walker McSpadden, *Famous Painters of America* (New York: Thomas Y. Crowell & Co., 1907), p. 352.

12. "Artist Chase Delights Few," *Bridgeport Daily Standard*, 12 March 1910, p. 1.

13. "Chase's Americanism," p. 1250.

14. McSpadden, *Famous Painters*, p. 350.

15. Ibid., p. 351.

16. "Original Notes of William M. Chase on his Talk to His Students in Philadelphia," n.d., copy in possession of the author. Chase was proud of earlier American artists as well as his contemporaries. Roof claimed that "for the early American painters Chase had the greatest respect and admiration. In one of his public talks on art he remarked that Copley, Stewart, [sic] Morse, Inman and Sully deserved to rank among the great painters" (*Chase*, p. 297). Chase owned a portrait of George Washington attributed to Gilbert Stuart, and *The Guitar Player* by Thomas Sully.

17. William Merritt Chase, "Talk on Art by William M. Chase," *The Art Interchange* 39 (December 1897), p. 127.

18. W.H. de B. Nelson, "Pennsylvania, III," *The International Studio* 63, no. 229 (March 1916), p. vii.

19. Royal Cortissoz, *American Artists* (New York: Charles Scribner's Sons, 1923), p. 166.

20. Chase, "Original Notes."

21. William Howe Downes, "William Merritt Chase, A Typical American Artist," *The International Studio* 39, no. 154 (December 1909), p. 29.

22. "Chase's Americanism," p. 1251.

23. "The Chase Exhibition," *The Outlook* 94 (29 January 1910), p. 230.

24. William M. Chase, "The Import of Art: An Interview with Walter Pach," *The Outlook* 95 (25 June 1910), p. 442.

25. Fr. Pecht, "A German Critic on American Art," *The Art Amateur* ll, no. 4 (September 1884), p. 78.

26. The Parrish Art Museum, Southampton, New York.

27. For example, *Portrait of a Lady in White (Emily Clark)*, collection of Mr. and Mrs. Meredith Long.

28. William M. Chase, "How I Painted My Greatest Picture," unidentified article, c. 1908, clipping file, Corcoran Gallery of Art, Washington, D.C.

29. Ibid.

30. John C. Van Dyke, *American Painting and Its Tradition* (New York: Charles Scribner's Sons, 1919), p 201.

31. *Putnam's Magazine* 7 (March 1910), pp. 757-58.

32. "My Note Book," *The Art Amateur* 30, no. 3 (October 1895), p. 84.

33. A.E. Ives, "Suburban Sketching Grounds: Talk with Mr. W.M. Chase, Mr. Edward Moran, and Mr. Leonard Ochtman," *The Art Amateur* 25, no. 4 (September 1891), p. 80.

34. "The Slaughter of Mr. Chase's Pictures," *The Art Amateur* 24, no. 5 (April 1891), p. 115.

35. "Paintings and Pastels by William M. Chase," *The Critic* (7 March 1891), p. 128.

36. Kenyon Cox, "William M. Chase, Painter," *Harper's New Monthly Magazine* 78 (March 1889), p. 556.

37. "The Conditions of Art in America," p. 1.

38. Charles De Kay, "Mr. Chase and Central Park," *Harper's Weekly* 35, no. 1793 (2 May 1891), p. 328.

39. Chase, "The Import of Art," p. 442; "Some Students' Questions Briefly Answered by Mr. W.M. Chase," *The Art Amateur* 36, no. 3 (March 1897), p. 68.

40. T., "A Boston Estimate of a New York Painter," *The Art Interchange* 17, no. 12 (4 December 1886), p. 179.

41. Perriton Maxwell, "William Merritt Chase — Artist, Wit and Philosopher," *The Saturday Evening Post*, 4 November 1899, p. 347.

Chapter 14

1. James Huneker, "The Seven Arts," *Puck* 18 (September 1915), p. 10.

2. Walter Pach, *Queer Thing, Painting* (New York: Harper & Brothers, 1938), p. 31.

3. Ishmael, "Through the New York Studios," *The Illustrated American* 5, no. 52 (14 February 1891), p. 619.

4. Rockwell Kent, *It's Me, O Lord* (New York: Dodd, Mead & Co., 1955), p. 81.

5. Awards (although unconfirmed) are listed in: The Art Gallery, University of Santa Barbara, *First West Coast Retrospective Exhibition of Paintings by William Merritt Chase*, exh. cat., text by Ala Story (Santa Barbara, 1964), unpaginated.

6. Negotiations to place *Dorothy and Her Sister* in the Luxembourg were never consummated, due to the outbreak of World War I. The painting is now in a private collection.

7. One source claimed that Chase was not asked to show at the Panama-Pacific Exposition until "his followers — and there are thousands of them, including his students and art lovers generally — began to make their influence felt, although Mr. Chase had said never a word, nor raised a hand to pull a wire. Personally I am convinced that no slight to Mr. Chase was intended and that, from the outset, Mr. J.E.D. Trask, the director of the art exhibition at the fair, had planned to honor the artist by placing a special gallery at his disposal" (Gustav Kobbe, "Whole Gallery for Chase," *New York Herald Magazine*, 27 June 1915, p. 4).

8. Pach, *Queer Thing, Painting*, pp. 20-21. Chase also disapproved of the Rodin drawings Alfred Stieglitz exhibited in his gallery '291': "William M. Chase had come to the photographic shows and enjoyed them. But when the Rodin drawings were shown Mr. Chase had become enraged, because of their possible effect on his students whom he had been bringing to the photographic shows, and had banged his silk hat down so hard that it was smashed" (Herbert Seligmann, *Alfred Stieglitz Talking* (New Haven: Yale University Library, 1966), p. 111).

9. Pach, *Queer Thing Painting*, p. 36.

10. "Wm. M. Chase's Picture for the Luxembourg," *Boston Transcript*, 15 October 1913.

11. " 'Cubist Fakers,' Cries Wm. Chase," *The New York Times*, 28 February 1914, p. 5. Chase was probably reacting to the "Exhibition of Contemporary Art" at the National Arts Club, New York, 5 February-7 March, 1914.

12. Eugene Castello, "An Art Battle," *American Art News* 12, no. 12 (27 December 1913), p. 9.

13. Daniel Catton Rich, ed., *The Flow of Art: Essays and Criticisms of Henry McBride* (New York: Atheneum Publishers, 1975), pp. 50-51.

14. "William M. Chase," *The American Magazine of Art* 8, no. 2 (December 1916), p. 74.

15. "William Merritt Chase — Painter (1849-1916)," *The Index of Twentieth Century Artists* 2, no. 2 (November 1934), p. 271.

16. Beckwith to Chase, dated 28 July 1916, copy in possession of the author.

17. Willard Huntington Wright, *Modern Painting* (New York: John Lane Company, 1915), p. 337.

18. William M. Chase, "Painting," *The American Magazine of Art* 8, no. 2 (December 1916), pp. 50-51.

19. William M. Chase, "Address Given at The Metropolitan Museum of Art, New York City, January 15, 1916 — 8 p.m.," cit. A. Milgrome, *The Art of William Merritt Chase* (Ph. D. diss., University of Pittsburgh, 1969), p. 119.

20. Georgia O'Keeffe in a letter to the author, dated 18 September 1972.

21. John I.H. Baur, *Joseph Stella* (New York: Praeger Publishers, 1971), p. 25.

22. Transcript of a recorded interview of Charles Sheeler by Martin Friedman, 18 June 1959, Walker Art Center, Minneapolis.

23. *John Sloan's New York Scene*, ed. Bruce St. John, intro. Helen Farr Sloan (New York: Harper & Row, 1965), diary entry for 15 March 1910, p. 398.

24. Jerome Myers, *Artist in Manhattan* (New York: American Artists Group, 1940), p. 38.

25. "Three Hundred of his Portraits, Landscapes, Marines, Street Scenes, and Still Life Pieces to Be Sold," *Boston Transcript*, 11 May 1917.

26. Pach, *Queer Thing, Painting*, p. 37.

27. Chase, "Painting," p. 51.

28. Chase's subject matter was considered mundane when compared to the religious, spiritual, or allegorical themes treated by contemporary artists such as Kenyon Cox, Will H. Low, John La Farge, or Edwin Blashfield.

29. Duncan Phillips, "William M. Chase," *The American Magazine of Art* 8, no. 2 (December 1916) pp. 49-50.

30. Samuel Isham, *The History of American Painting* (New York: The MacMillan Company, 1936), p. 384.

31. Arthur Hoeber, "Winter Exhibition of the National Academy of Design," *The International Studio* 36 (February 1909), p. cxxxvii.

32. "Mr. Chase's Paintings at the New Vose Galleries," *Boston Transcript*, 20 December 1909.

33. "William M. Chase — Painter," *The Art World* 1 (December 1916), p. 156.

34. "W.M. Chase," *The Nation*, 103, no. 2679 (2 November 1916), p. 429.

35. "William M. Chase Improved," *The New York Times*, 21 October 1916, p. 8.

36. Annie Traquair Lang's account of Chase's illness and death is taken from a letter to Estelle Manon Armstrong, dated 3 November 1916, Estelle Manon Armstrong Scrapbook, copy in possession of the author, courtesy Mr. Joseph J. Roberto.

37. "Chase Improved."

38. "William M. Chase No Better," *The New York Times*, 25 October 1916, p. 11. Chase left no will according to the press. His estate was estimated to be worth only $40,000, $25,000 in personal property and $15,000 in real estate ("Artist Chase Left $40,000," *The New York Times*, 10 November 1916, p. 13).

39. "Chase," *The New York Times*, 27 October 1916, p. 8.

40. "William M. Chase Buried," *The New York Times*, 28 October 1916, p. 13.

41. James Carroll Beckwith, *Diary*, 26 October 1916, National Academy of Design, New York.

42. J. Carroll Beckwith, "A Great American Painter," *The New York Times*, 29 October 1916, Section 7, p. 2.

43. Frank Alvah Parsons, "William M. Chase," *The American Art Student* 1 (November-December 1916), p. 10.

44. "W.M. Chase," p. 428.

45. "William M. Chase, Noted Artist, Dies," *Philadelphia Bulletin*, 26 October 1916.

46. Phillips, "William M. Chase," p. 45.

47. Gifford Beal, "Chase — The Teacher," *Scribner's Magazine* 61 (February 1917) p. 258.

Akron Art Museum, *William Merritt Chase: Portraits.* exh. cat., text by Carolyn Kinder Carr (Akron, 1982).

Andrews, Marietta Minnegerode. *Memoirs of a Poor Relation.* New York: E.P. Dutton, 1927.

"Angry Husband Thrashed Chase." *The New York Herald* (6 May 1898), p. 12.

Armstrong, Mrs. Estelle Marion. Scrapbook. c. 1915-16. Courtesy Mr. Joseph J. Roberto. Copy in possession of the author.

The Art Gallery, University of Santa Barbara, *First West Coast Retrospective Exhibition of Paintings by William Merritt Chase.* exh. cat., text by Ala Story (Santa Barbara, 1964).

"Artist Chase Delights Few." *Bridgeport Daily Standard* (12 March 1910), p. 1.

"Artist Chase Off to Meet Roosevelt." *The New York Times* (2 June 1910), p. 20.

"An Artist's Collection." *The Collector* 2 (1892), p. 32.

"Artists Receiving." *The New York Times* (5 March 1882), p. 9.

"Artists' Receptions." *The Art Journal* 7 (1881), pp. 93-94.

"Art News and Notes." *The Art Amateur* 39, no. 6 (November 1898), p. 130.

"Art School's Trip Abroad." *The New York Times* (4 September 1904), p. 5.

Baer, William J. "Reformer and Iconoclast." *The Quarterly Illustrator* 1 (1893), pp. 135-41.

Baynes, Lillian. "Summer School at Shinnecock Hills." *The Art Amateur* 31, no. 5 (October 1894), pp. 91-92.

Beal, Gifford. "Chase — The Teacher." *Scribner's Magazine* 61 (February 1917), pp. 257-58.

Beckwith, James Carroll. Diaries, 1878, 1883, 1884, 1888, 1889, 1890, 1898, and 1916. The National Academy of Design, New York.

_____. "A Great American Painter." *The New York Times* VII (29 October 1916), p. 2.

_____. Letter to William Merritt Chase. 28 July 1916. Copy in possession of the author.

"A Beloved Portrait by William M. Chase." *The Art Digest* (1 April 1928), p. 11.

Benjamin, S.G.W. *Our American Artists.* Boston: D. Lothrop and Company, 1879.

Bisland, Elizabeth. "The Studios of New York." *The Cosmopolitan* 7, no. 1 (May 1889), pp. 3-22.

"Blum and Chase Teaching Contrasted By a Member of the Art Students League Who Studied Under Both Masters." *The Art Amateur* 35, no. 5 (October 1896), p. 91.

Boyle, Richard J. *American Impressionism.* Boston: New York Graphic Society, 1974.

The Brooklyn Museum, *Triumph of Realism: An Exhibition of European and American Realist Paintings 1850-1910.* exh. cat., text by Axel von Saldern (Brooklyn, 1967).

Brownell, William C. "American Pictures at the Salon." *The Magazine of Art* 6 (1883), pp. 492-501.

_____. "The Younger Painters of America." *Scribner's Monthly* 20, no. 1 (May 1880), pp. 1-15.

Brumbaugh, Thomas B. "William Merritt Chase Reports to St. Louis from Munich: A Correspondence." *The Bulletin,* The Missouri Historial Society (January 1959), pp. 118-24.

Bryant, Lorinda Munson. *American Pictures and Their Painters.* New York: John Lane Company, 1917.

Buel, Clarence C. "Log of an Ocean Studio." *The Century Magazine* 27, no. 3 (January 1884), pp. 356-71.

Burke, Doreen Bolger. *American Paintings in The Metropolitan Museum of Art, Volume III: A Catalogue of Works by Artists Born Between 1846 and 1864.* Edited by Kathleen Luhrs. New York: The Metropolitan Museum of Art, 1980.

Burnet, Mary Quick. *Art and Artists of Indiana.* New York: The Century Company, 1921.

Butler, Howard Russell. "Chase — The Artist." *Scribner's Magazine* 61 (February 1917), pp. 255-57.

Bye, Arthur Edwin. *Pots and Pans, or Studies in Still Life Painting.* Princeton: Princeton University Press, 1921.

Caffin, Charles H. *The Story of American Painting.* New York: Frederick A. Stokes Company, 1907.

Carter, Susan N. "Street Life in Madrid." *The Century Magazine* 39, no. 6 (November 1889), pp. 32-41.

"Centenary Exhibition at Philadelphia." *Brush and Pencil* 15 (March 1905), pp. 148-50.

Champney, Elizabeth W. *Witch Winnie at Shinnecock.* New York: Dodd, Mead & Co., 1894.

_____. *Witch Winnie's Studio.* New York: Dodd, Mead & Co., 1892.

Chapellier Galleries, *William Merritt Chase: 1849 to 1916.* exh. cat., (New York, 1969).

Chase, William Merritt. "Address of Mr. William M. Chase Before the Buffalo Fine Arts Academy." *The Studio* 5, no. 13 (1 March 1890), pp. 121-27.

_____. "Artists' Ideals — The Aims of Painters and Actors." *The House Beautiful* 23 (February 1908), pp. 11-12.

_____. "The Danger of Art Schools." *Metropolitan Magazine.* Unidentified clipping, copy in possession of the author.

_____. "How I Painted My Greatest Picture." Unidentified clipping, artist's clipping file, Corcoran Gallery of Art, Washington, D.C.

_____. Letter to Samuel A. Coale. 12 June 1873. Copy in possession of the author.

_____. "The Import of Art: An Interview with Walter Pach." *The Outlook* 95 (25 June 1910), pp. 441-45.

_____. "Painting." *The American Magazine of Art* 8, no. 2 (December 1916), pp. 50-53.

_____. "Talk on Art by William M. Chase." *The Art Interchange* 39 (December 1897), pp. 126-27.

_____. "The Two Whistlers — Recollections of a Summer with the Great Etcher." *The Century Magazine* 80 (June 1910), pp. 218-26.

_____. "Velasquez." *Quartier Latin* 1, no. 1 (July 1896), pp. 4-5.

"Chase." *The New York Times* (27 October 1916), p. 8.

"Chase Collection an Admirable One." *Bridgeport Daily Standard* (3 March 1910), p. 3.

"The Chase Exhibition." *American Art Illustrator* (December 1886), p. 99.

"The Chase Exhibition." *The Outlook* 94 (29 January 1910), pp. 229-30.

"The Chase Exhibition." *The Outlook* 115 (28 February 1917), p. 344.

"A Chase Landscape." *Toledo Museum of Art News* no. 53 (March 1929), unpaginated.

"Chase Memorial." *Boston Transcript* (26 May 1923). Artist's clipping file, Boston Public Library.

"Chase, Nettled, Leaves Art School He Founded." *The New York World* (21 November 1907), p. 8.

"Chase Paintings Bring Low Prices." *The New York Times* (8 March 1912), p. 13.

"The Chase School of Art and the Art Students League." *The Art Amateur* 35, no. 5 (October 1896), pp. 91-92.

"Chase Studio Auction Sale." *The New York Times* (11 January 1896), p. 14.

"Chase's Americanism." *The Literary Digest* 53 (11 November 1916), pp. 1250-51.

"Chase's Court Jester." *The Art Journal* 4 (1878), pp. 257-58.

"Chase's Long Island Studio." *The Brooklyn Daily Eagle* (19 January 1896).

"Mr. Chase's Paintings at the New Vose Galleries." *Boston Transcript* (20 December 1909). Artist's clipping file, Boston Public Library.

"Chase's Portrait of Whistler." *Boston Transcript* (31 December 1917). Artist's clipping file, Boston Public Library.

Cikovsky, Nicolai, Jr. "William Merritt Chase's Tenth Street Studio." *Archives of American Art Journal* 16, no. 2 (1976), pp. 2-14.

"The Collection of William M. Chase." *The New York Times* (3 January 1896), p. 4.

"The Collector." *The Art Amateur* 40, no. 6 (May 1899), p. 115.

Cook, Clarence. *Art and Artists of Our Time.* New York: Selmar Hess, 1888.

_____. "The Painters in Pastel — A Noteworthy Little Display." *The Springfield Republican* (27 June 1888).

Coon, Spencer H. "The Work of William M. Chase as Artist and Teacher." *Metropolitan Magazine* 5, no. 4 (May 1897), pp. 307-13.

Cooper, W.A. "Artists in Their Studios." *Godey's Magazine* 130, no. 777 (March 1895), pp. 291-303.

Cortissoz, Royal. *American Artists.* New York: Charles Scribner's Sons, 1923.

_____. "The Field of Art." *Scribner's Magazine* 81, no. 16 (February 1927), pp. 216-24.

Cox, Kenyon. "William M. Chase, Painter." *Harper's New Monthly Magazine* 78 (March 1889), pp. 549-57.

Crisp, Ada. "William M. Chase in His Studio." *The New York Times Magazine* (23 July 1899), p. 3.

"Cubist Fakers, Cries Wm. Chase." *The New York Times* (28 February 1914), p. 5.

De Kay, Charles. "Mr. Chase and Central Park." *Harper's Weekly* 35, no. 1793 (2 May 1891), pp. 324-28.

_____. "The Society of Ten and the Other Society." *The New York Times* IV (16 April 1905), p. 8.

Downes, William Howe. "William Merritt Chase, A Typical American Artist." *The International Studio* 39, no. 154 (December 1909), pp. 29-36.

_____. and Robinson, Frank Torrey. "Later American Masters." *New England Magazine* 14 (April 1896), pp. 134-35, 141.

E.B. Crocker Gallery, *Munich and American Realism in the 19th Century.* exh. cat., essays by Michael Quick and Eberhard Ruhmer (Sacramento, 1978).

Emmet, Rosina H. "The Shinnecock Hills Art School." *The Art Interchange* 31 (October 1893), pp. 89-90.

"An Exhibition Defeating Itself." *The Literary Digest* (28 August 1915), pp. 404-05.

F.B., F.W. "Society of American Artists." *The Aldine — The Art Journal of America* 9, no. 9 (1879), pp. 275-82.

Foster, Captain Wallace. "Recollections of Wm. Chase." *Indianapolis Star* (31 January 1910), p. 6.

Fox, W.H. "Chase on 'Still Life.'" *The Brooklyn Museum Quarterly* 1 (January 1915), pp. 197-200.

Fraser, W. Lewis. "William Merritt Chase." *The Century Magazine* 45, no. 1 (November 1892), pp. 155-56.

"From a Talk by William M. Chase with Benjamin Northrup of The Mail and Express." *The Art Amateur* 30, no. 3 (February 1894), p. 77.

Garland, Hamlin. *My Friendly Contemporaries.* New York: The MacMillan Co., 1932.

Gerdts, William H. *American Impressionism.* Seattle: The Henry Art Gallery, University of Washington, 1980.

_____. *Painters of Humble Truth: American Still Life Painting; Masterpieces of American Still Life Painting 1801-1939.* Columbia, Missouri: Philbrook Art Center and University of Missouri Press, 1981.

Gerwig, Henrietta. *Fifty Famous Painters.* New York: Thomas Y. Crowell Co., 1926.

" 'Get Together,' Says Mr. Chase to Fellow Artists." *The New York Times* (21 May 1905), p. 3.

Golwin, O. "Amerikanische Malerie." *Kunst für Alle* 16 (15 March 1901), p. 279.

Goodrich, Lloyd. *Thomas Eakins* 2 Vols. Cambridge: Harvard University Press, 1982.

Gray, Eunice T. "The Chase School of Art at Carmel-By-The-Sea, California." *Art and Progress* 6, no. 4 (February 1915), pp. 118-20.

"Guy Pène Du Bois." *Life* Magazine (20 June 1949), pp. 66-71.

Hartmann, Sadakichi. *A History of American Art* 2 Vols. Boston: L. C. Page & Co., 1902.

Heckscher Museum, *The Students of William Merritt Chase.* exh. cat., text by Ronald G. Pisano (Huntington, New York, 1973).

"Here and There." *The Arts* 6 (December 1895), pp. 184, 186.

Hoeber, Arthur. "William M. Chase." *Woman's Home Companion* 37 (September 1910), p. 50.

Homer, William Innes. *Robert Henri and His Circle.* Ithaca: Cornell University Press, 1969.

"Hoosier Artist Popular — New York is Discussing the Work of William Merritt Chase." *Indianapolis News* (5 February 1906), p. 3.

Howard, W. Stanton. "A Portrait by W.M. Chase." *Harper's Monthly Magazine* 113 (October 1906), p. 698.

_____. "Portrait of a Lady by W.M. Chase." *Harper's Monthly Magazine* 110 (February 1905), p. 436.

Howell, Frank J. "Recalls Early Days of William M. Chase." *Indianapolis News* (5 December 1916), p. 11.

Huneker, James. "The Seven Arts." *Puck* 18 (September 1915), pp. 10, 20-21.

"Interesting Notes About Wm. M. Chase." *The New York Times* IV (2 December 1906), p. 4.

Isham, Samuel. *The History of American Painting.* 2nd ed., with supplement by Royal Cortissoz, 1905. New York: The MacMillan Company, 1936.

Ishmael. "Through the New York Studios — William Merritt Chase." *The Illustrated American* 5, no. 52 (14 February 1891), pp. 616-19.

Ives, A.E. "Suburban Sketching Grounds; Talk with Mr. W.M. Chase, Mr. Edward Moran, and Mr. Leonard Ochtman." *The Art Amateur* 25, no. 4 (September 1891), pp. 80-82.

James, Henry. "Of Some Pictures Lately Exhibited, 1875." In *The Painter's Eye,* Edited by John L. Sweeney. London: Rupert Hart-Davis, 1956.

"Janitor Brother Tells How Chance Aided W.M. Chase." *Indianapolis Star* (25 March 1917). Artist's clipping file, Indiana State Library.

John Herron Art Museum, *Chase Centennial Exhibition.* exh. cat., text by Wilbur D. Peat (Indianapolis, 1949).

Johnston, Ella Bond. "Acquiring a Self Portrait." *Parnassus* 8 (March 1936), pp. 15-16.

Justice, Maibelle. "New York's Newest Art School." *Demorest's Family Magazine* 33, no. 6 (April 1897), pp. 305-10.

Kellum, Robert W. "Famous Hoosier Artist Born Eighty-Two Years Ago Today." *Indianapolis Star* (1 November 1931). Artist's clipping file, Indiana State Library.

Kent, Rockwell. *It's Me, O Lord.* New York: Dodd, Mead & Co., 1955.

Knaufft, Ernest. "An American Painter — William M. Chase." *The International Studio* 12, no. 4 (January 1901), pp. 151-58.

_____. "Sargent, Chase, and Other Portrait Painters." *The American Review of Reviews* 36 (December 1907), pp. 692-95.

Kobbe, Gustav. "The Artist of Many Studios." *The New York Herald Magazine* (20 November 1910), p. 11.

_____. "A Whole Gallery for Chase." *The New York Herald Magazine* (27 June 1915), p. 4.

Koehler, S.R. "The Works of the American Etchers: William M. Chase." *The American Art Review* 2 (1881), p. 143.

Lang, Annie Traquair. Letter to Miss Estelle Marion. 3 November 1916. Copy in possession of the author.

"The Lounger." *Putnam's Monthly* 7 (March 1910), pp. 757-58.

McBride, Henry. "Exhibitions at the New York Galleries: Chase Memorial Exhibition." *Fine Arts Journal* 35 (March 1917), pp. 223-25.

McSpadden, J. Walker. *Famous Painters of America.* New York: Thomas Y. Crowell & Co., 1907.

"Many Art Works to be Rushed In." *The New York Times* III (20 June 1909), p. 2.

"Many-Sided Chase in Retrospective Display at Metropolitan." *The Christian Science Monitor* (23 February 1917), p. 8.

Marks, Montague. "My Note-Book." *The Art Amateur* 34, no. 3 (February 1896), p. 56.

Marling, Karal Ann. "Portrait of the Artist as a Young Woman: Miss Dora Wheeler." *The Bulletin of the Cleveland Museum of Art* 65, no. 2 (February 1978), pp. 47-57.

Mather, Frank Jewett. *Estimates in Art.* New York: Henry Holt & Company. 1931.

Maxwell, Perriton. "William Merritt Chase — Artist, Wit and Philosopher." *The Saturday Evening Post* (4 November 1899), p. 347.

"Memorial Exercises Attending the Unveiling of a Bust of William Merritt Chase." New York University, 29 May 1923.

The Metropolitan Museum of Art, *Loan Exhibition of Paintings by William M. Chase.* exh. cat., (New York, 1917).

Milgrome, Abraham David. "The Art of William Merritt Chase." Ph. D. diss., University of Pittsburgh, 1969.

M. Knoedler & Co., *William Merritt Chase (1849-1916).* exh. cat., text by Ronald G. Pisano (New York, 1976).

Montezuma. "My Note Book." *The Art Amateur* 25, no. 3 (August 1891), p. 48.

Moran, John. "Studio-Life in New York." *The Art Journal* 5 (1879), pp. 343-45.

Morehouse, Lucille. "Chase Art Mirrors His Life." *Indianapolis Star* IV (27 November 1949), p. 12.

Morice, John H. "The First Out-of-Door Art School in the United States." Privately published, n.d.

Morris, Harrison S. *Confessions in Art.* New York: Sears Publishing Company, Inc., 1930.

Myers, Jerome. *Artist in Manhattan.* New York: American Artists Group, Inc., 1940.

National Collection of Fine Art, *Academy: The Academic Tradition in American Art.* exh. cat., text by Lois Marie Fink and Joshua C. Taylor (Washington, D.C.: Smithsonian Institution Press, 1975).

Newhouse Galleries, *Paintings by William Merritt Chase, N.A., LL.D.* exh. cat., foreword by Royal Cortissoz (St. Louis, 1927).

"Newhouse Galleries — Paintings by William Merritt Chase." *Creative Art* (April 1933), pp. 319-20.

Northrup, Benjamin. "Great Artist's Struggle." *Indianapolis News* (14 January 1899), p. 9.

"Notes from Talks by William M. Chase: Summer Class, Carmel-By-The-Sea, California — Memoranda from a Student's Note-Book." *The American Magazine of Art* 8 (September 1917), pp. 432-38.

"On the Realist and the Idealist: The Fish of William M. Chase and The Figurines of Arthur B. Davies." *Arts and Decoration* 8 (November 1917), pp. 34-37.

"Original Notes of William M. Chase on His Talk to His Students in Philadelphia." n.d. Copy in possession of the author.

Pach, Walter. *Queer Thing, Painting.* New York: Harper & Brothers, 1938.

"The Painter of the Cover." *The Literary Digest* 85, no. 1 (4 April 1925), p. 35.

"Painters and Their Work." *New York Daily Tribune* (6 November 1881), p. 5.

"Paintings and Pastels by William M. Chase." *The Critic* no. 375 (7 March 1891), p. 128.

"Paintings at the Society." *The New York Times* (11 April 1905), p. 11.

"The Paintings by Mr. Chase." *Academy Notes* [Buffalo] (February 1909), pp. 143-49.

Paris, W. Francklyn. "William M. Chase." In *Personalities in American Art* I. pp. 105-12. New York: Architectural Forum, 1930.

The Parrish Art Museum, *William Merritt Chase: A Retrospective Exhibition.* exh. cat., text by M.L. D'Orange Mastai (Southampton, 1957).

_____. *William Merritt Chase in the Company of Friends.* exh. cat., text by Ronald G. Pisano (Southampton, 1979).

Parsons, Frank Alvah. "William M. Chase." *The American Art Student* 1 (November-December 1916), p. 10.

"Pastels by William M. Chase." *New York Herald* (31 December 1883), p. 8.

Pattison, James William. "William Merritt Chase, N.A." *The House Beautiful* 25 (February 1909), pp. 50-56.

Pecht, Fr. "A German Critic on American Art." *The Art Amateur* 11, no. 4 (September 1884), pp. 76-79.

"The Pedestal Fund Loan Exhibition." *The Art Amateur* 10, no. 2 (January 1884), pp. 41-48.

Pène Du Bois, Guy. *Artists Say the Silliest Things.* New York: American Artists Group, Inc., 1940.

The Pennsylvania Academy of the Fine Arts, *In This Academy: The Pennsylvania Academy of the Fine Arts, 1805-1976.* exh. cat., text by Frank H. Goodyear, Jr. et al. (Philadelphia, 1976).

Phillips, Duncan. "William M. Chase." *The American Magazine of Art* 8, no. 2 (December 1916), pp. 45-50.

"The Picture That First Helped Me to Success." *The New York Times* V (28 January 1912), p. 5.

Pisano, Ronald G. "Prince of Pastels." *Portfolio* 5, no. 3 (May-June 1983), pp. 66-73.

_____. "The Teaching Career of William Merritt Chase." *American Artist* (March 1976), pp. 26-33, 63-66.

_____. *William Merritt Chase.* New York: Watson-Guptill, 1979.

"Putnam's and the Reader." *Putnam's Monthly* 5 (December 1908), p. 372.

"The Reward of Art." *The Art Amateur* 34, no. 5 (April 1896), p. 107.

Roof, Katharine Metcalf. *The Life and Art of William Merritt Chase.* 1917. New York: Hacker Art Books, 1975.

_____. "William Merritt Chase: An American Master." *Craftsman* 18 (April 1910), pp. 33-45.

_____. "William Merritt Chase: His Art and His Influence." *The International Studio* 60, no. 240 (February 1917), pp. 105-10.

_____. "William Merritt Chase: The Man and the Artist." *The Century Magazine* 93 (April 1917), pp. 833-41.

Ruge, Klara. "Amerikanische Maler." *Kunst und Kunst Handwerk* 6 (October 1903), pp. 406-13.

Saint-Gaudens, Homer. "William M. Chase." *The Critic* 48 (June 1906), pp. 514-15.

"A School on the Sands." *The Brooklyn Daily Eagle* (14 October 1894), p. 9.

Sherman, Frederic Fairchild. "William M. Chase." *Art in America* 28 (1940), pp. 134-35.

"Six Modern American Portrait Painters." *The Mentor* 12 (October 1924), pp. 30-44.

"The Slaughter of Mr. Chase's Pictures." *The Art Amateur* 24, no. 5 (April 1891), pp. 115-16.

"Some Students' Questions Briefly Answered by Mr. W.M. Chase." *The Art Amateur* 36, no. 3 (March 1897), p. 68.

Speed, John Gilmer. "An Artist's Summer Vacation." *Harper's New Monthly Magazine* 87, no. 517 (June 1893), pp. 3-14.

Stein, Leo. "William M. Chase." *The New Republic* 10 (3 March 1917), pp. 133-34.

"A Storied Cod." *The Mentor* 16 (February 1928), p. 62.

"Studio Effects Sold at Auction." *The New York Times* (9 January 1896), p. 9.

T. "A Boston Estimate of a New York Painter." *The Art Interchange* 17, no. 12 (4 December 1886), p. 179.

" 'The Ten' Make a Good Show." *American Art News* (11 March 1916), p. 2.

"Three Hundred of His Portraits, Landscapes, Marines, Street Scenes, and Still Life Pieces to Be Sold." *Boston Transcript* (11 May 1917).

Townsend, James B. "Annual Exhibit of the Ten." *American Art News* 6 (21 March 1908), pp. 2-3.

———. "Chase at National Art Club." *American Art News* 8 (15 January 1910), p. 6.

Townsley, C.P. "William M. Chase — A Leading Spirit in American Art." *Arts and Decoration* 2, no. 8 (June 1912), pp. 285-87, 306.

Van Dyke, John C. *American Painting and Its Tradition.* New York: Charles Scribner's Sons, 1919.

———. *Art for Art's Sake.* New York: Charles Scribner's Sons, 1893.

Van Rensselaer, Marianna Griswold. "American Etchers." *The Century Magazine* 25, no. 4 (February 1883), pp. 483-99.

———. "William Merritt Chase — First Article." *American Art Review* 2 (January 1881), pp. 91-98.

———. "William Merritt Chase — Second and Concluding Article." *American Art Review* 2 (February 1881), pp. 135-42.

"Whistler Painting is Sold for $825." *The New York Times* (9 March 1912), p. 13.

"Mrs. William M. Chase." *The Daily Graphic* (17 February 1887). Artist's clipping file, New York Public Library.

"William M. Chase." *The New York Times* V (29 October 1916), p. 18.

"William M. Chase." *Fine Arts Journal* 34 (November 1916), unpaginated.

"William M. Chase." *The American Magazine of Art* 8, no. 2 (December 1916), p. 74.

"William M. Chase." *American Art News* 15 (19 May 1917), p. 7.

"William M. Chase and His Friend Whistler." *Boston Herald* (28 March 1911). Artist's clipping file, Boston Public Library.

"William M. Chase Dead." *American Art News* 15 (28 October 1916), p. 3.

"The William M. Chase Exhibition." *The Art Amateur* 16, no. 5 (April 1887), p. 100.

"William M. Chase — Ferargil Galleries." *The Art News* 25 (12 March 1927), p. 9.

"William M. Chase, His Life and Work." *Arts for America* 7, no. 4 (December 1897), pp. 197-201.

"The William M. Chase Memorial Exhibition." *The New York Times* V (18 February 1917), p. 13.

"William M. Chase — Newhouse Galleries." *The Art News* 31 (11 March 1933), pp. 5-6.

"Willam M. Chase, Noted Artist, Dies." *Philadelphia Bulletin* (26 October 1916).

"William M. Chase — Painter." *The Art World* 1 (December 1916), p. 156.

"William M. Chase Sale." *American Art News* 15 (19 May 1917), p. 7.

"Mr. William M. Chase's Art." *The Art Interchange* 12, no. 13 (19 June 1884), p. 148.

"William M. Chase's Recent Work." *Harper's Weekly* 46 (8 November 1902), p. 1627.

"William M. Chase's Studio Sale." *The New York Times* (5 January 1896), p. 21.

"William Merritt Chase." *The Outlook* 114 (8 November 1916), pp. 536-38.

William Merritt Chase in the Company of Friends. exh. cat., text by Ronald G. Pisano (Southampton, 1979).

"W.M. Chase." *The Nation* 103, no. 2679 (2 November 1916), pp. 428-29.

"W.M. Chase, the Noted Artist, Five of Whose Pictures Are at Herron Institute, is Living Proof That Good Does Come Out of Brown County." *Indianapolis News* (15 December 1906), p. 14.

"W.M. Chase to Paint Wilson's Portrait." *The New York Times* (6 January 1913), p. 9.

"The Wm. M. Chase Exhibition." *The Critic* (5 March 1887), p. 115.

"Wm. M. Chase Forced Out of New York Art School; Triumph for the 'New Movement' Led by Robert Henri." *New York American*, 20 November 1907, p. 3.

"Wm. M. Chase, The Artist, Is Typically American." *Indianapolis Star* (19 January 1910), p. 6.

"Wm. M. Chase's Picture for the Luxembourg." *Boston Transcript* (15 October 1913).

Italic numeral indicates illustration.

A

Abbey, Edwin Austin, 49, 50, 78, 174
Academic art, 27, 39, 63, 78, 149, 164
Académie Julian, 97, 135
Acton, Harold, 138
Alla prima technique, 28, 182
Alma-Tadema, Sir Lawrence, 137
Alte Pinakothek, 27
American art: lack of support for, 39, 40, 45, 68, 70, 95, 174; national character in, 135, 145, 171, 175
American Art Association, 150
American Art Club (Munich), 29
American Art Galleries (New York), 16
The American Spirit in Art, 17
American Watercolor Society, 41
Amsterdam, 25, 80, 135, 136
Anderson, Abraham Archibald, 57, 58, 59; *Farewell to Sandy Hook*, 59
Anshutz, Thomas Pollock, 111
Antwerp, 57, 58, 59, 78, 80, 140, 149
Apprentice series, 29
Armory Show, 1913, 181
The Art Amateur, 40, 67
Art Club (New York), 41
Art for art's sake, 40, 59, 97, 145
"Art for the sake of the ladies' cabin," 57, 59, 63
The Art Institute of Chicago, 105
"Artistic truth," 27, 28, 89, 181
Art Journal, 42
L'Art Moderne, 149
Arts and Decoration, scholarships, 140, 142
Art Students' League, 13, 30, 39, 40, 41, 95, 96, 97, 105, 121, 145
Art Treasures of America, 39
Art Village. *See* Shinnecock Summer School of Art
Ashbridge, Samuel, 110
Astor, Mrs., 121
Athens, 135
Avery, Samuel P., 39, 41

B

Baird, William C., 49
Barbizon school, 39, 63, 121, 137
Baroque art, 27
Bartholdi, Frédéric-Auguste, 63
Bartholdi Pedestal Fund Art Loan Exhibition, 63-64, 67
Bastien-Lepage, Jules, 78
Beal, Gifford, 123, 145, 183
Beal, Reynolds, 44, 123, 125
Beaux, Cecilia, 70
Beckwith, James Carroll, 18, 41, 45, 57-60, 63, 64, 67, 68, 70, 97, 157, 164, 180, 183; *The Comet*, 59

Belgium, 140-42. *See also* Antwerp; Bruges; Brussels
Belmont, August, 39
Belmont, Mrs. August, 121
Benson, Frank Weston, 163, 164
Berlin, 25, 135
Bierstadt, Albert, 42
Blackstone, Harriet, 140
Blashfield, Edwin Howland, 67
Blommers, Bernardus Johannes, 153
Blum, Robert Frederick, 46, 57, 59, 60, 67, 68, 70, 149, 157, 183; *The Emigrant Model*, 59; *Flying the Great Kite*, 59
Böcklin, Arnold, 135
Boldini, Giovanni, 39, 52, 60, 63, 153, 175
Bonheur, Rosa, 24
Boston, 24, 63, 64, 70, 81, 150, 179
Boston Art Club, Chase's one-man exhibition in, 68, 70, 81, 150
Botticelli, Sandro, 27
Boudin, Eugène-Louis, 149, 153
Boughton, George Henry, 137, 174
Bouguereau, Adolphe William, 97
Braekeleer, Henri de, 138
Brangwyn, Frank, 135, 137
"Briareus," 50
Bridgeport, Connecticut, 174
Bronberg, Louis, 70
Bronson, Mrs. Arthur, 32
Bronzino, Agnolo, 27
Brooklyn Art Association, 40, 41, 95
Brooklyn Art School, 121
The Brooklyn Museum, 140
Brooks, Maria, 70
Brown, William Mason, 25
Bruges, 140-42
Brush, George de Forest, 138
Brussels, 80, 149
Budd, Katherine, 126
Buel, Clarence C., 59
Burke, Doreen Bolger, 145

C

Carles, Arthur B., 108
Carlyle, Thomas, 78
Carmel-by-the-Sea, California, 93, 142
Carmencita, 45
Carnegie, Mrs. Andrew, 121
Carolus-Duran, Emile Auguste, 57
Carr, Lyell, 70
Cassatt, Mary, 150, 154, 171, 174
Centennial Exhibition, Philadelphia, 1876, 40
The Century Magazine, 40, 49, 52, 59
Cézanne, Paul, 140, 180
Champney, Elizabeth, 44
Chapman, Carleton Theodore, 70
Chardin, Jean-Baptiste Siméon, 168, 182
Chase, Alice Dieudonnée (Cosy), 46, *46*, 68, *96*, *111*, 135, *118*
Chase, Alice Gerson, 46, *46*, 57, 68, 77, 78, *96*, *108*, *109*, *114*, 126, 135, 140, 142, 183
Chase, Amanda, 23
Chase, Carrie, 23
Chase, David Hester, 23, 24, 25
Chase, Dorothy Bremond, *46*, *117*, 135, 142

Chase, George, 23, 25
Chase, Hattie, 23, *98*
Chase, Hazel Neamaug, *46*, 124
Chase, Helen Velasquez, *46*, 126, *127*
Chase, Koto Robertine, *46*
Chase, Mary Content, *46*
Chase, Robert Stuart, *46*
Chase, Roland Dana, *46*, 140
Chase, Sarah Swaim, 23
Chase School of Art, 13, 93, 95-100; curriculum of, 96; exhibitions of. *See also* New York School of Art

CHASE, William Merritt:

Life and Career

Art organizations, involvement in, 13, 29, 40, 41, 49-53, 57, 63-64, 67-71, 88, 149, 163-68. *See also* individual art organizations
Auctions of works, 16, 68, 95, 174
Childhood, 23-24
Death, 182-83
Education, 24, 27-30, 92, 171
Family, 23-24, 46, 68, 71, 150, 182-83. *See also* Chase, Alice Gerson
Financial struggles of, 15-16, 25, 29, 32, 57
Friends and colleagues. *See* individual entries
General public, relation to, 41, 42, 44-45, 64, 81, 96, 126, 183
Iconoclast and progressive, as, 13, 29-30
Image and personality, 13, 19, 41-42, 44, 77, 87, 97, 145, 179, 182
Patrons of, 25, 27, 29, 32, 40, 121
Pictured, *frontis.*, *6*, *20*, *46*, *58*, *77*, *83*, *88*, *178*
Portraits of, 78, 80-82, *144*, 145, 168. *See also* Self portraits
Prices of works, 16, 17
Studios of: New York, Tenth Street, 13, 16, *36*, *38*, 39, 44, 40, 42-45, 171, 174; New York, Y.M.C.A. building, 24; Monterey, 142; Philadelphia, 110; Saint Louis, 25; Shinnecock, 71, 123, 126
Summer house, Shinnecock Hills, *121*, 123, 138. *See also* Shinnecock Summer School of Art
Travels of, 30, 41, 50-53, 57-60, 63, 68, 77-80, 95, 127, 135-142, 145, 168, 174, 179
Tributes to, 15, 16-17, 145, 183
Villa Silli (Florence), 138-40
U.S. Navy, service in, 24, 171

Art

Abstract qualities in, 180
American art, commitment to, 13-16, 17, 87, 145, 171, 174, 183; contribution to, 13-15, 16-17, 19, 183; Chase as typical American artist, 17, 175-77; Chase as un-American artist, 17
American artists, influence of, 25, 153-57, 171
Awards and honors, 29, 40, 57, 58, 63, 70, 138, 140, 149, 163, 179

Brushwork in, 14, 41, 108, 140, 149, 154, 181, 182
Collector of, 13, 150-53, 154, 157, 181; of objets d'art, 138, 140. *See also* Studio props; Travels
Color in, 140, 149, 154, 168
Conservative trends in, 108, 179-81
Contemporary art, view of, 78, 140. *See also* Modern art
Critics, and, 15-19, 40, 44, 45, 63, 64, 67, 68, 70, 81, 82, 88, 95, 105, 111, 121, 149, 150, 153, 174, 175, 177, 180, 182, 183
Eclecticism of, 89, 150, 171, 175
European contemporaries, influence of, 25, 27-28, 29, 57-58, 68, 71, 135, 149-57
Exhibitions. *See* individual entries
Exhibitions, one-man, 16, 17, 68, 70, 81, 105, 150, 179
Finish, lack of, 28, 150, 154
Fish, and, 15, 30, 140, 142, 167-68
Forgeries of, 18
Impressionism and, 111, 149, 150, 154, 157
Light in, 24, 57, 125, 140, 149, 154
Models for, 15, 46, 111, 175
Munich school, and, 27-28, 32, 58, 149, 177
Old masters, influence of, 27, 57, 135, 149, 177. *See also* Old masters, copies of
Palette of, 14, 32, 58, 149, 154
Progressive trends in, 149
Realism, 82, 89, 181
Studio props in, 24, 25, 29, 30, 59, 67, 140, 182
Style, evolution of, 14-15
Subjects. *See* individual entries
Technique, 13, 14-15, 18, 24, 28, 32, 70, 71, 82, 154, 157, 181-82
Tonality in, 14, 154
Versatility of, 67, 70, 82, 105, 157, 181, 182
See also Academic art; "Art for the sake of the ladies' cabin"; Etchings; Figure studies; Interiors; Landscapes; Monotypes; Nudes; Old masters, copies of; Park scenes; Pastels; Plein-air painting; Portraits; Self portraits; Sketches; Still lifes; Watercolors; *and* individual titles

Teaching

Career as teacher, 13, 15
Criticism, view of, 88
Critiques of students' work, 88, 125, 126, 135, 137, 140, 142
Demonstration paintings, 43, 96, 97, 105, 137, 140, 142, 145
Education, view of, 89-92
Private instruction, 13
Pupils of, 13, 17, 93. *See also* individual entries
"Queering contests," 125
Shinnecock Summer School of Art, 71, 93, 121-27, 135, 142, 154, 174
Style, development of, 89, 92
Summer classes: Carmel-by-the-Sea, California, 100; Bruges, 140-142; Europe, 93, 126; Holland, 135-36; Italy, 138-40, 142; London, 136-37; Madrid, 137; Shinnecock. *See* Shinnecock Summer School of Art

Teaching, 13, 28, 39, 41, 44, 71, 78, 82, 87-145, 150, 154, 157, 171, 180-81, 183; teaching methods, 24, 28, 82, 89, 96, 111, 125, 135, 157. *See also under* Chase, William Merritt: **Life and Career**, Image and personality; *and* **Art**, Tributes; Conservative trends in; Progressive trends in; Eclecticism of

Works

Afternoon by the Sea, 70
Afternoon in the Park, 75
The Antiquary Shop, 32
The Artist Eduard Grützner, 29
At the Seaside, 154, *156*
At the Shore, 60
Azaleas, 43
Back of a Nude, 69
The Bayberry Bush, *120*, 123, 154
The Big Brass Bowl, 167
Bit of Holland Meadow, 63
A Bit of the Terrace (Early Morning Stroll), 86
The Blue Kimono (Girl in Blue Kimono), *139*, 175
Blue Plums, 24
Boat House, Prospect Park (Boats on the Lake, Prospect Park), 157, *159*
Boy Smoking (The Apprentice), 31
Broken Jug, 40, 41
Canal in Holland, 63
Carmencita, 45
Catawba Grapes, 24
Children on the Beach, 130
The Cloisters (Italian Cloister), 35
Cockatoo Tile, 49
Coquette, 27
A Countryman, 54
C.P. Townsley, 142
Did You Speak to Me?, 113
The Dividing Line, 63
Dorothy and Her Sister, 179
The Dowager, 29, 40
Dutch Canal, 63
Dutch Orphan, 63
The East River, 61, 154
Fish, 182
Fish Still Life, *83*, 168
A Fishmarket in Venice (engraving after), 31
A Fishmarket in Venice (The Yield of the Waters), 30-32, 34
The Flame, 142
A Florentine Villa, 134
Flower Girl, 40
Flowers, 157
For the Little One, 153, 154
A Friendly Call, 163, *165*
Garden of the Orphanage, Haarlem, Holland (Courtyard of a Dutch Orphan Asylum, 62, 63
Girl in White, 110
The Golden Lady, 106
Gravesend Bay, 76
Grey Day, 157
Hall at Shinnecock, 71, 74, 123
Hattie, *98*
Head of a Girl (The Artist's Daughter), 119
Hide and Seek, 152, 154, 183
Hugo von Habermann, 29

Idle Hours, 12, 123
An Infanta, A Souvenir of Velasquez (Helen Velasquez Chase), 127
Interior of the Artist's Studio (The Tenth Street Studio), 38, 44-45, 150
In the Baptistery of Saint Marks, 32
In the Studio (c. 1892), *112*
In the Studio (Interior: Young Woman Standing at Table) (1892), 71, 123
In the Studio (Virginia Gerson) (c. 1884), 73
James Abbott McNeill Whistler, 79
The Japanese Print, 136
J.M. Taylor, D.D., President of Vassar College, 100
Keying Up — The Court Jester, 29, 31, 40
Lady in Pink, 92
Landscape, 149
Landscape, Shinnecock, Long Island, 131
The Leader, 29
Lilliputian Boat-Lake — Central Park (Central Park), 91
Little Miss H., 70
Lydia Field Emmet, 104
Making Her Toilet, 68
Meditation, 90
A Mediterranean Memory, 59
Memories (Woman in White), 101
The Mirror, 98
Modern Magdalen, 64
Monkeying with Literature, 30
Mother and Child in a Park, 157
Mother's Love (Mrs. Chase and Cosy), 46
Mr. J. Henry Harper, 70
Mrs. Chase as the Señorita, 108
Mrs. Meigs at the Piano Organ, 94
My Daughter, Alice, 111
Near the Beach, Shinnecock, 129
North Sea, Holland, 63
Nude, 66
The Nursery, 8
The Old Road to the Sea, 16
The Old Sand Road, 16
On the Lake, 157
Outskirts of Madrid, 56, 60
Over the Hills and Far Away, 132
Park Scene, 176
Peonies, 157
Portrait of a Lady, 99
Portrait of a Lady in White (Emily Clark), 170
Portrait of a Lady in Pink (Portrait of [Mrs.] Leslie Cotton), 102
Portrait of a Woman (1878), 27, 28
Portrait of a Woman (c. 1888), 100
Portrait of a Woman (c. 1895), 115
Portrait of James Abbott McNeill Whistler, 78, 79, 80-82
Portrait of Miss Dora Wheeler, 63, 172, 175
Portrait of Miss E. (Lydia Field Emmet), 103

Portrait of Miss F. DeForest, 116

Portrait of Miss Frances V. Earle, 168, *169*

Portrait of Mrs. C. (Lady with a White Shawl), 105, *173*, 175

Portrait of Mrs. C. (Portrait of a Lady in Black), 84

Portrait of Mrs. C. (Portrait of Mrs. Chase), 114

Portrait of Peter Cooper (The Burgomaster), 60

Portrait of the Artist's Daughter (Dorothy), 117

Portrait of Virginia Gerson, 47

Portrait Sketch (Girl in Middy Blouse), 133

Portrait Study (Portrait of a Young Woman), 45

The Potato Patch (Garden, Shinnecock), 122

Priam, The Nubian Ganymede, 50, *51*

Pure, 70

Ready for the Ride, 29, *30*, 41, 46

The Red Sash (Portrait of the Artist's Daughter), 107

Reflection (Reflections), 154, *155*

Rest by the Wayside, 125

Reverie: A Portrait of a Woman, 143

Ring Toss, 148

Seated Woman Seen From the Back, 54

Self Portrait (c. 1879), 55

Self Portrait (Portrait of the Artist) (1915-16), 19, *162*, 168

Self Portrait (Self Portrait with Hat) (c. 1911), *184*

Shell Beach at Shinnecock, 160

Shinnecock Hills, 48

Shinnecock Indian Girl, 123, 124

Shinnecock Landscape, 124

Sketch for a Picture — Columbus Before the Council at Salamanca (Christopher Columbus Before the Spanish Council), First Version, 29-30, *31*

Sketch for a Picture — Columbus Before the Council at Salamanca (Christopher Columbus Before the Spanish Council), Second Version, 29-30, *31*

Sketch — Children Playing Parlor Croquet, 151

The Smoker (Frank Duveneck), 29, 57-58, 149

Spanish Bric-à-Brac Shop, 63

A Spanish Girl (Portrait of Mrs. William Merritt Chase in a Spanish Shawl), 109

Spanish Gypsy, 137

Still Life (Brass and Glass), 71, 72

Still Life, Fish, 140, *166*

Still Life, Flowers, 43

Still Life (Still Life with Cockatoo), 42

Still Life with Fruit, 24-25

Still Life with Fruit and Pitcher, 24-25

Still Life with Watermelon, 22, 24

A Study in Curves (Reclining Nude), 65

Study of Flesh Color and Gold, 157

A Subtle Device, 52, 53, *53*

Sunlight and Shadow, 146, 149, 150, 175

A Sunny Day at Shinnecock Bay, 161

Swollen Stream at Shinnecock, 128

The Tamborine Girl (Mrs. Chase as a Spanish Dancer), 109

The Tenth Street Studio, 36, 44, 45

Terrace at the Mall, Central Park, 158

Under a French Sky, 59

Unexpected Intrusion (Turkish Page), 26, 29, 40

Venice, 32, 33

View of Fiesole, 141

The White Rose (Miss Jessup), 71, 150

Woman with a Basket, 28

Young Girl in Black (Artist's Daughter Alice in Mother's Dress), 118

Young Girl Reading, 63

Young Girl with Flowers, 93

Chicago, 17, 105

Chicago Inter-State Industrial Exposition, 40, 70

Christy, Howard Chandler, 123, 126

Church, Frederick Stuart, 45, 46

Ciardi, Emma, 142

Civil War, 23; Chase's participation in, 24, 171

Clark, Emily, *170*, *173*, 175

Cleveland, 17

Coale, Samuel A., 25, 27, 29

Coffin, William Anderson, 70

Columbus, Christopher, 29-30, *31*

Conant, Alban Jasper, 25

Connah, Douglas John, 96, 100

Corcoran Gallery of Art (Washington), 39, 168, 179

Corot, Jean-Baptiste-Camille, 137

Cortissoz, Royal, 82, 175

Cotton, Mrs. Leslie (née Marietta Benedict), 84, 102

Courbet, Gustave, 27

Cox, Jacob, 24

Cox, Kenyon, 15, 18, 70, 150, 177, 180

Crane, Bruce, 164

Crystal Palace Exhibition, Munich, 1883, 63

Cubism, 179

Currier, J. Frank, 29, 181

D

Dabo, Léon, 181

Dagnan-Bouveret, Pascal-Adolphe-Jean, 63, 126; *Madonna*, 126

Daniel, 50, 52

Daugherty, James H., 108

Davies, Arthur Bowen, 99

Davis, Charles Harold, 181

Davis, Erwin, 58, 63

Day, Francis, 70

De Camp, Joseph Rodefer, 105, 163

Decorative art. *See* The Tile Club

Degas, Edgar, 63, 71, 150, 154, 157; *The Ballet*, 63

De Kay, Charles, 150

Delaróche, Paul, 27

Demuth, Charles, 13, 108

De Nittis, Guiseppe, 39, 63, 71, 154, 157; exhibition at Place de la Concórde, Paris, 63

Denman, Herbert A., 57, 70

Dennis, James M., 24

"Depressionists," 100

Detaille, Jean-Baptiste-Edouard, 63, 105

Deuteronomy, 50

De Voll, F. Usher, 97

Dewing, Thomas Wilmer, 157, 163

Dielman, Frederick, 29, 46, 50, 52, 164-67

Dietrich, 135

Dietz. *See* Diez, Wilhelm von

Diez, Wilhelm von, 29, 135

Dodd, Samuel M., 25

Donoho, Gaines Ruger, 181

Dove, Arthur G., 183

Du Bois, Guy Pène. *See* Pène Du Bois, Guy

DuMond, Frank Vincent, 97

Durand-Ruel Gallery: New York, 64, 150, 164; Paris, 81

Dürer, Albrecht, 27

Düsseldorf, 27, 39

Düsseldorf school, 39

Duveneck, Frank, 18, 29, 30, 32, 57, 105, 149; *The Turkish Page*, 29; *The Whistling Boy*, 29

Dyck, Sir Anthony van, 27, 177

E

Eakins, Thomas, 17, 105, 171

Eaton, Charles Warren, 70

Eaton, Joseph Oriel, 24, 25

Ecole des Beaux-Arts (Paris), 41

Edwards, George Wharton, 59

Eichbaum, George Calder, 25

The Eight, 99

Emmet, Lydia Field, *103*, *104*, 123, 126

Etchings, 16, 67

Exposition Universelle, Paris, 1900, 179

F

"Father, Son, and Holy Ghost," 29

Fauvism, 179

Fifth Avenue Art Galleries (New York), 16

Figure studies, 14, 30, 40, 67, 137, 138. *See also* individual titles

Fitz, Rutherford Benjamin, 95

Fitzgerald, Harrington, 110

Flexner, James Thomas, 17

Florence, 138-40, 142, 180

Fortuny y Carbó, Mariano José María Bernardo, 39, 59, 60, 175

Fortuny y Carbó, Mrs. Mariano José Maria Bernardo, 142

Fox, W. H., 140

Franco-Prussian War, 27

Franklin, Indiana, 23

Freer, Frederick Warren, 63

From Seven to Seventy, 164

Futurism, 179, 180

G

Gardner, Mrs. Jack (Isabella Stewart), 45

Gay, Patricia, 140

Gerdts, William H., 25

Gérôme, Jean-Léon, 27

Gerson, Alice. *See* Chase, Alice Gerson

Gerson, Julius, 45-46

Gerson, Julius, Jr., 46

Gerson, Minnie, 46

Gerson, Virginia, 46, *47*, *73*

Gifford, Robert Swain, 49, 50, 52

Gilder, Helena de Kay, 40

Gilder, Richard Watson, 32, 40

Giorgione, Giorgio del Castelfranco, 27

Glackens, William James, 99

Glessing, Thomas B., 24

Gonzalès, Eva, 154

Gookins, James Farrington, 24

Goya, Francisco, 137

Grand Canyon, 142

Greatorex, Kate Honora (née Kathleen), 67

El Greco, 13, 97, 137

Gregg, Frederick James, 180

Griffin, Walter, 157

Groome, Esther M., 140

Grosvenor Gallery, 121, 149

Group of XX. *See* Les Vingt

Guild Hall, London, 137

H

Haarlem, 80, 135, 136

The Hague, 25, 136

Hale, Philip Leslie, 181

Hals, Frans, 13, 27, 50, 95, 135, 136, 137, 149

Harper, William Saint John, 95

Harrison, Alexander, 135

Hartmann, C. Sadakichi, 164

Haseltine Galleries (New York), 70

Hassam, Frederick Childe, 70, 163, 164, 167, 181

Hatch, Emily Nichols, 123

Havemeyer, Horace O., 39, 157

Hawthorne, Charles Webster, 88, 100, 123, 157

Hays, Barton S., 23, 24

Hecker, Caroline, 67, 70

Heckscher Museum (Huntington, N.Y.), 17

Helleu, Paul César, 153

Henri, Robert, 97-100, 179, 181

Heustis, Louise Lyons, 123

Hobbema, Meindert, 136

Hodges, Captain W.R., 25

Holbein, Hans, 27

Holland, 53, 59, 60, 63, 67, 68, 71, 78, 82, 95, 121, 135-36, 149, 150, 174, 177. *See also* Amsterdam; Haarlem; The Hague

Homer, Winslow, 17, 49, 164, 171

Hovenden, Thomas, 105

Howland, Judge Henry E., 121

Hoyt, Mrs. William, 121

Hudson River school, 52, 142, 177

Hunt, Richard Morris, 42

Hunter, Sam, 17

Huntington, Daniel, 64

I

Impressionism, 14, 70, 100, 110, 121, 140, 149, 150, 153, 154-57, 163, 164, 181; American, 18, 157, 163, 164, 181; French, 14, 63, 64, 71, 149, 150, 157, 164

"Impressionistic" painting, defined, 149; 70, 121, 149-50

Indianapolis, 23, 24, 179

Indianapolis Art Society, 24

Interiors, 14, 15, 32, 44-45, 63, 123, 154, 181, 182. *See also* individual titles

International Fine Arts Exposition, Buenos Aires, 1910, 179

International style, of painting, 149, 157, 175

Irwin, Benoni, 70

Israëls, Jozef, 39, 136, 177

Ives, Sarah Noble, 140

J

Japanese objets d'art and studio props, 63, *68*, 70, *74*, *136*, *139*, 142

John Herron Art Museum (Indianapolis), 17

Johnson, Eastman, 40, 64

Johnston, James Boorman, 42

Johnston, John Taylor, 39, 64

Jones, Francis Coates, 67, 70

Jones, Hugh Bolton, 67, 70

Jones, William, 25

Jongkind, Johan Barthold, 153

Julian, Rudolph, 97

K

Kaemmerer, Frederik Hendrik, 39

Kaulbach, Wilhelm von, 27

Kay, Helena de. *See* Gilder, Helena de Kay

Keith, Dora Wheeler. *See* Wheeler, Dora

Keller, Arthur Ignatius, 97

Kelly, James Edward, 46

Kent, Rockwell, 121, 123, 126, 179

Kimono series, *68*, *69*, 70, *136*, *139*, 142, 175

Knauth, Antonio, 49

Knight, Daniel Ridgway, 174

Knoedler, M., & Company (New York), 17

Knoedler, Mr. 135

Kobbe, Gustav, 49

Koekkoek, Barend Cornelius, 39

L

La Farge, John, 70

Laffan, William M., 49, 50, 52

Landscapes, 14, 17, 53, 59, 60, 63, 68, 69, 70, 108, 121, 137, 138, 142, 149, 150, 154, 177, 181, 182. *See also* individual titles

Lang, Annie Traquair, 123, 138, 182, 183

La Touche, Gaston de, 63

Lavery, Sir John, 135, 153

Lawson, Ernest, 99, 157

Leibl-Kreis, 27, 29

Leibl, Wilhelm Maria Hubertus, 27-28, 29, 175; *Kokotte*, 27, *28*, influence of on Chase, 27

Lenbach, Franz Seraph von, 135

Lewenburg, Dr., 49

Lieber, Herman, 24

The Lido (Venice), 142

Loeser, Charles, 140, 180

London, 68, 77, 78, 80, 81, 135, 136-38, 140, 142, 145, 149. *See also* Shinnecock Hills; Shinnecock Summer School of Art; Southampton; The Tile Club

The Louvre (Paris), 57

Los Angeles, 17

Low, Will Hicox, 40

Lucas, George A., 39

Ludwig II of Bavaria, 27

Lungren, Ferdinand, 59

Luxembourg Palace, Musée du, 179

M

McCutcheon, S.G., 67

McEwen, Walter, 67

McKim, Meade & White, 123

Madrid, 57, 60, 77, 78, 81, 96, 135, 137

Mancini, Antonio, 153

Manet, Edouard, 13, 27, 58, 63, 64, 105, 149, 150, 154, 181; *Boy with a Sword*, 58, 63, 105; *Toreador*, 63; *Woman with a Parrot*, 58, 63

Marin, John, 183

Marr, Carl, 135

"Masher of the Avenues," 13, 81

Mather, Frank Jewett, 16, 17

Matisse, Henri, 16, 140, 180

Maurer, Alfred Henry, 157

Mauve, Anton, 153

Maynard, George Willoughby, 164

Medici, Lorenzo De', 27

Meeker, Joseph Rusling, 25

Meissonier, Jean-Louis-Ernest, 27, 63, 97

Mesdag, Hendrik Willem, 135, 153

Metcalf, Willard Leroy, 163

The Metropolitan Museum of Art (New York), 16, 39, 58, 81, 82, 105, 145, 180

Miller, Charles Henry, 40, 42

Miller, Francis Trevelyan, 67

Miller, Joaquin [Cincinnatus Heine Miller], 46

Miller, Juanita, 46

Modern art, 58, 105-108, 140, 145, 149, 179-81; Chase's influence on, 93, 145, 180; Chase's reaction to, 13, 140, 145, 178-81

Monet, Claude, 89, 149, 150, 154, 164

Monotypes, 14, 16, 67, 142

Monte, Louis G., 138

Monticelli, Adolphe Joseph Thomas, 63

Moore, W.P., Art Galleries (New York), 16, 67
Mora, Francis Luis, 97
Moran, John, 45
Morisot, Berthe, 154
Morris, Harrison S., 105, 110, 145
Mount, William Sidney, 53
Mowbray, Henry Siddons, 63
Mulvaney, John, 25
Munich, 13, 25, 27, 28, 29, 30, 32, 39, 40, 41, 80, 92, 135, 150, 174, 175, 181
Munich school, 14, 25, 32, 58, 82
Munich Secession, 135
Munkácsy, Mihály von, 39
Murillo, Bartolomé Esteban, 27, 137
Musée Plantin (Brussels), 140
Museum of Fine Arts (Boston), 39
Myers, Jerome, 181

N

National Academy of Design (New York), 24, 27, 40, 52, 99, 126, 167; exhibitions of, 24, 40, 99, 100, 150, 164, 167, 179, 182
National Gallery (London), 136-37
Nazarene movement, 27
New Gallery (London), 137
Newhouse Galleries (Saint Louis), 17
New York, 13, 16, 17, 24, 30, 32, 39, 40, 41, 42, 45, 57, 58, 63, 64, 70, 78, 80, 81, 88, 93, 95-100, 105, 121, 126, 138, 140, 142, 145, 149, 150, 154, 171-74, 177, 179
New York Etching Club, 41
New York School of Art, 13, 96-100, 137. See also Chase School of Art
The New York Times, 95, 163, 164
The New York Tribune, 81
New York University, 145, 179
Niemeyer, John Henry, 67
Nudes, 70. See also individual titles

O

O'Donovan, William Rudolph, 49, 50, 52
O'Keeffe, Georgia, 13, 93, 145, 180
Old masters, 14, 42, 57, 59, 60, 77, 78, 135, 136, 137; copies of, 27, 57, 95, 137; See also under Chase, William Merritt: **Art,** Old masters, influence of

P

Pach, Walter, 105-108, 138, 140, 154, 179-80, 181
Paderewski, Ignace Jan, 45
Painters in Pastel. See Society of Painters in Pastel
Palmer, Potter, 157
Palmer, Walter Launt, 67
Panama-Pacific Exposition, San Francisco, 1915, 179
Pan-American Exposition, Buffalo, 1901, 179
Paris, 25, 27, 28, 40, 41, 57, 58, 60, 63, 71, 97, 108, 135, 137, 138, 140, 142, 150, 174, 179, 180
Paris Salon, 57, 59, 60, 63, 135, 149
Paris, Walter, 49, 50, 70
Paris, W. Francklyn, 145
Park scenes, 14, 121, 150, 177. See also individual titles

The Parrish Art Museum (Southampton, N.Y.), 17
Parrish, Samuel L., 121
Parsons, Charles, 25
Parsons, Frank Alvah, 183
Pasini, Alberto, 63
Pastels, 13, 14, 16, 17, 63, 67-71, 150, 154, 157. See also individual titles
Patrons of the arts, 25, 27, 29, 32, 39, 40, 42, 64
Peat, Wilbur D., 17
Pedestal Fund Art Loan Exhibition. See Bartholdi Pedestal Fund Art Loan Exhibition
Pène Du Bois, Guy, 87, 88, 97, 145
Pennell, Joseph, 82
Pennsylvania Academy of the Fine Arts, 13, 95, 105-111, 127, 183; curriculum of, 105; exhibitions of, 100, 105
Philadelphia, 24, 40, 97, 105, 126, 179, 180, 183
Phillips, Duncan, 183
Picasso, Pablo, 179
Piloty, Karl Theodor von, 27, 29, 30, 39, 89, 135, 171, 174; children, Chase's portraits of, 29, 30, 40, 135
Pissarro, Camille, 150
Pitti Palace (Florence), 138
Pittsburgh, 126
Plein-air painting, 14, 53, 68, 108, 121, 124, 126, 135, 137, 138, 142, 149, 154
Porter, Mrs. Henry Kirke, 121
Portraits, 14, 17, 29, 30, 40, 41, 45, 46, 50, 57, 70, 95, 100, 105, 108, 142, 154, 167-68, 175, 181-82. See also individual titles
The Prado (Madrid), 57, 137
Prendergast, Maurice B., 99
Priam, 50, *51*

Q

Quartley, Arthur, 49, 50, 52, 59; *Moonlight through the Lifting Fog*, 59; *Petrels Following in the Steamer's Wake*, 59

R

Rand, Ellen G. Emmet, 123, 126
Realism, 27, 82
Redon, Odilon, 149
Reevs, George M., 95
Reid, Robert, 70, 163, 164, 167
Reinhart, Charles Stanley, 49, 50
Rembrandt Celebration, Leyden, 138
Rembrandt, Harmensz van Rijn, 27, 135, 136, 138, 180
Renaissance masters, 142
Renoir, Pierre Auguste, 149, 150, 154
Ribera, José (Jusepe) de, 27
Ribot, Théodule Augustin, 63, 153
Riley, James Whitcomb, 13
Rittenberg, Henry R., 135
Robinson, Theodore, 70, 157, 181
Rodin, Auguste (René François), 174

Rolshoven, Julius, 138, 142
Romaine, 124
Roof, Katherine Metcalf, 16, 46, 57, 58, 138; biography of Chase by, 16
Rosenthal, Albert, 110
Rosenthal, Toby Edward, 29
The Royal Academy of Arts in London, 137
Royal Academy, Munich, 13, 25, 27, 29, 39, 92, 171; American students in, 29; curriculum of, 27; extracurricular education at, 29
Roybet, Ferdinand, 63, 153
Rubens, Peter Paul, 27, 59, 149
Ruskin, John, 25
Ruysdael, Salomon van, 136
Ryder, Albert Pinkham, 17, 171

S

Sackett, Edith, 70
Saint-Gaudens, Augustus, 63, 64
Saint Louis, 17, 23, 25, 27
Salmagundi Club, 41
Sargent, John Singer, 45, 57, 60, 89, 137, 145, 149, 154, 171, 174, 177, 181; influence on Chase, 150, 153; paintings by, *144*, 145, 168, 175; paintings compared to Chase's, 153, 154; *Portrait of William M. Chase*, *144*, 145, 168
Sarony, Napoleon, 46, 50, 52
Schamberg, Morton Livingston, 108
Scribner's Monthly, 49, 50
Self portraits, 19, 52, 53, 67, 138, 168
Seurat, Georges Pierre, 150
Shannon, Sir James Jebusa, 137
Shaw Prize, 163
Sheeler, Charles, 108, 137, 181
Sherwood, Rosina Emmet, 24, 70, 121, 126
Shinn, Earl, 39, 49, 50, 52
Shinn, Everett, 99
Shinnecock Hills, New York, 14, 105, 121, 123-24, 126, 135, 138, 177
Shinnecock Indians, 124
Shinnecock Summer School of Art, 13, 14, 71, 93, 121-27, 135, 142, 154, 174; curriculum of, 126; exhibitions of, 125; patrons of, 121
Shirlaw, Walter, 29, 40, 41, 46, 95
Simmons, Edward Emerson, 163, 164, 167, 168
Sienese school, 140
Simonetti, Attilio, 39
Sisley, Alfred, 150
Sketches, 32, 57, 64, 150
Sloan, John, 99, 100, 111, 181
Smith, Francis Hopkinson, 49, 50, 52, 64, 149
Society of American Artists, 13, 68, 126, 163, 164-67; exhibitions of, 40, 41, 46, 88, 149, 163; formation of, 40; and The Ten, 163-168
Society of Painters in Pastel, 13, 67-71
Sorolla y Bastida, Joaquin, 137, 138
South Carolina Interstate and West Indian Exposition, Charleston, 1901, 179

Southampton, New York, 121, 145
Spain, 16, 57, 59, 60, 63, 95, 137. See also Madrid; Toledo
Statue of Liberty, 63
Stein, Gertrude, 180
Stein, Leo, 16
Stella, Joseph, 13, 123, 181
Stevens, Alfred, 39, 57-58, 60, 63, 78, 138, 149, 153, 175
Stewart, Alexander Turney, 39
Still lifes, 14, 17, 24-25, 30, 67, 95, 105, 111, 140, 142, 167-68, 181, 182. See also individual titles
Story, Ala, 17
Strahan, Edward. See Shinn, Earl
Stuck, Franz von, 135
"The Students of William Merritt Chase," 17
Studios, of Chase. See under Chase, William Merritt: **Life and Career,** Studios

T

Tarbell, Edmund Charles, 163, 167
Teaching methods, 24, 27, 28, 105; of Chase, 24, 28, 82, 89, 96, 111, 125, 135, 157. See also under Chase, William Merritt: **Teaching**
The Ten American Painters, 157, 163-168; exhibitions, 164
Tenth Street Studio. See under Chase, William Merritt: **Art,** Studios of
Tenth Street Studio Building, 13, 42
Thayer, Abbott Handerson, 164
Thomson, Henry Grinnell, 44
Tiffany, Louis Comfort, 64
The Tile Club, 41, 49-53, 57, 59
Tintoretto, Jacopo Robusti, 27
Tissot, James Joseph Jacques, 63, 153, 175
Titian (Tiziano Vecellio), 27
Toledo, Spain, 60
Tonalism, 181
Townsley, Channel Pickering, 135, 142
Turner, Ross Sterling, 67
Twachtman, John Henry, 29, 30, 52, 70, 71, 157, 163, 164, 181

U

Uffizi Gallery (Florence), 138; Chase's commission to paint self portrait for, 138, 179
Uhde, Fritz (Friedrich Karl Hermann) von, 135
Ullman, Eugene Paul, 100, 135
Ulrich, Charles Frederick, 67, 68
Union League Club (New York), 41
Universal Exposition, Saint Louis, 1904, 179
U.S. Navy, Chase in, 24, 171

V

Vanderbilt, Cornelius, 64
Vanderbilt, Mrs. William Kissan, 121
Vanderbilt, William Henry, 39
Van Rensselaer, Mariana Griswold, 41
Velasquez, Diego Rodriguez de Silva, 13, 27, 57, 58, 59, 77, 89, 97, 126, 135, 137, 149, 150; compared to Whistler, 77; influence on Whistler, 77; *The Infanta Margarita* (Madrid), 126, *126*
Venice, 30, 32, 57, 70, 142
Vienna, 25, 135
Villa Silli (Florence), 138-40
Les Vingt, Chase exhibiting with, 149
Vinton, Frederick Porter, 59, 60, 63
Vollon, Antoine, 63, 150, 168

W

Wagner, Alexander von, 27
Walker, Henry Oliver, 70
Wallace Collection (London), 137
Waller, Frank, 40
Ward, John Quincy Adams, 40
Watercolors, 17, 67, 150
Webb, Jacob Louis, 70
Weir, Julian Alden, 49, 50, 52, 58, 70, 81, 157, 163, 164, 181
Weitzenhoffer, Frances, 58
Wenzell, Albert Beck, 97
Wheeler, Candace Thurber, 64, 121
Wheeler, Dora, 44, 121, *172*, 175
Whistler, James Abbott McNeill, 13, 68, 71, 77-82, 87, 92, 149, 154, 171, 174, 175, 179, 181; Chase's portrait of, 78, *79*, 80-82; compared to Chase, 71, 153; compared to Velasquez, 77; and critics, 82; image of, 77, 78, 80, 81; influence of Velasquez on, 77; influence on Chase, 153; pictured, *77, 80*; portrait of Carlyle, 78; portrait of Chase, 78, 80-82; technique of, 78; *Portrait of Miss Alexander*, 77; *Snow*, 63; *Woman in White*, 81
Whitney, Mrs., 121
Whitney Prize, 137
Whittredge, Thomas Worthington, 40, 64
Wiggins, Guy Carleton, 157
Wiles, Irving Ramsey, 44, 70, 97, 145
Williamsburg, Indiana, 23, 24
Wilmarth, Lemuel Everett, 24, 40
Wimbridge, Edward, 49, 50
Witch Winnie's Studio, 44
World War I, 145
Wright, Willard Huntington, 180
Wunderlich & Co., 70

Y

Young, Dorothy Weir, 58, 81
Y.M.C.A. Building (New York), 24

Z

Zurbarán, Francisco de, 27

Designed by Douglas Wadden Edited by Joseph N. Newland

Photograph Credits

Unless otherwise noted, photographs were supplied by the owners of the works.

Staff of the Henry Art Gallery

Harvey West, Director
Vickie R. Maloney, Assistant Director
Joseph N. Newland, Editor of Publications
Chris Bruce, Manager, Collections and Exhibitions
Krista Jensen Turnbull, Curator, Textile Collection
James R. Crider, Curator, Textile Collection
Judy D. Sourakli, Registrar, Textile Collection
Patricia Powell, Secretary to the Director
Paul A. Cabarga, Bookstore Manager
Lynn Caddey, Editorial Assistant

Mrs. John E. Z. Caner, Director, Henry Gallery Association

The Art Gallery, University of California, Santa Barbara, 74, 104; Art Resource/SCALA, 127; Dirk Bakker, Detroit Institute of Arts, 14, 34; Photo Services, Ball State University, 125; Chisolm, Rich & Associates, 170; Geoffrey Clements, 54; Cleveland Museum of Art, 94; Coe-Kerr Gallery, 66; Denver Art Museum, 128; Chris Eden, 53, 55, 68, 86, 98 (1), 99, 116, 117, 124, 132, 168; Ali Elai, Camerarts, 159; George Flemming, 22; Hardmann Photographers, 169; Helga Photo Studio, 73, 159; Indianapolis Museum of Art, 162; Bruce C. Jones, 91, 184; Kennedy Galleries, Inc., 33, 122; Lightworks, 51; L. Lorenz, 12; Joseph Marchetti, 93; Richard Meyer, 120; Photographic Services, The Metropolitan Museum of Art, 98 (r), Newhouse Galleries, Inc., 31; Karl Obert, 92, 130; Pacilio, Munson-Williams-Proctor Institute, 101; Piaget, 62; Eric Pollitzer, 69; David Preston, 42, 139; Queseda/Burke, 109; Nathan Raban, 192; Sotheby's, 75, 76, 161; Stadt Galerie, Cologne, 27; Lee Stalsworth, 107; Joseph Szasfai, Yale University Art Gallery, 56; Wiedergabe, Munich, 136; Marjorie de Wolfe, Smith College, 141; Steven J. Young, dust jacket.

Set in Bookman by Paul O. Giesey/Adcrafters, Portland, Oregon.
Separations and lithography by Graphic Arts Center, Portland, Oregon.
Bound by Lincoln & Allen, Portland, Oregon.
Printed on 80 lb. Karma Matte Text, bound with Filare Milano Brown endpapers.
Edition: 10,500